TADDEO ZUCCARO

TADDEO ZUCCARO

HIS DEVELOPMENT
STUDIED IN HIS DRAWINGS

J. A. GERE

London
FABER AND FABER

First published in 1969
by Faber and Faber Limited
24 Russell Square London WC1
Printed in Great Britain by
R. MacLehose and Company Limited
The University Press, Glasgow
All rights reserved

SBN 571 08756 6

CONTENTS

[9]

PREFACE

This study is a consequence of the decision to devote the next volume in the series of catalogues of the Italian drawings in the British Museum to the Roman school of the later sixteenth century. A preliminary scrutiny of the material emphasized the cardinal importance of the part played by Taddeo Zuccaro (1529–66) and his younger brother Federico (1540/1–1609) in the development of the later, classicizing phase of the Roman *maniera*, and did nothing to dispel a vague but persistent impression that of the two the elder was the more interesting and considerable figure. At the same time it proved unexpectedly difficult to grasp the essentials of Taddeo's personality or to distinguish satisfactorily in every case between his drawings and his brother's. It seemed at first as if this problem, which evidently needed some clarification before any general survey of the period was attempted, could be dealt with adequately in a longish article or two; but material came to light in such unexpected abundance and proved to be of such unexpected variety and interest as to call for treatment on this more extended scale.

Taddeo Zuccaro died on the threshold of middle age, after a relatively brief working life of less than twenty years. The epitaph which his brother placed over his tomb in the Pantheon compares him to Raphael and makes much of the coincidence that both were natives of Urbino and that each died when he had just reached the age of thirty-seven. Though it cannot in itself be any bar to posthumous fame to be cut off at the same age as Raphael, Taddeo had the additional misfortune to be survived for nearly half a century by a namesake and faithful imitator who reduced his style to a series of stock formulas. Federico formed his style exclusively on Taddeo and during the last six or seven years of Taddeo's life often worked in close collaboration with him, so that between them there are innumerable opportunities for confusion; and Taddeo's achievement has been so far eclipsed by that of his less talented, but longer-lived and indefatigably productive younger brother that we have no clear picture of him as a distinct artistic personality. We are, on the other hand, unusually well informed about the out-

ward events of his life. If he was fated to die young, then it is impossible not to feel thankful that he died exactly when he did, for Vasari, whose account of him in the 1568 edition of the *Lives* (published a bare two years after Taddeo's death) is almost our only source of information, might well have hesitated to include a full-length biography of a youthful artist who was still alive and active. If Taddeo had lived even a few weeks longer, we would probably have had to rely on the scanty documentary references dug out by Bertolotti, perhaps supplemented at best by a page or two in Baglione who was not only a much more perfunctory biographer than Vasari but one who in this case would have been under the additional disadvantage of being born five years after the death of his subject. Vasari, on the other hand, was already a man of thirty-eight when the eighteen-year-old Taddeo made his debut in Rome with the façade of the Palazzo Mattei. He knew Taddeo personally, and the reliability of his long and detailed biography is confirmed by a contemporary witness whose knowledge of the subject was even more intimate, and whose corroboration is all the more convincing for his undisguised hostility. Federico Zuccaro's annotations in the margins of his Vasari, printed by Milanesi in his edition of the *Lives*, reveal a personal rancour against the writer which led him to seize on every opportunity of finding fault; that he was able to do so only over one or two trivial points of detail is as good a testimony to Vasari's accuracy as could be hoped for.

The fact remains that there is no readily accessible substantial body of authentic work on which to base an estimate of Taddeo Zuccaro's artistic achievement. The first step towards remedying this state of affairs is to bring together as many as possible of his drawings. I should make it clear at once that this book is not intended to be a full-scale critical monograph. It is true that as many as possible of Taddeo's paintings are reproduced, but he is an artist whose drawings cannot be properly studied outside the context of his painted work, and no body of reproductions (other than the few indifferent illustrations in Venturi and Voss) exists to which the reader can be referred. To those expecting a full-scale monograph, a study devoted mainly to questions of attribution may prove something of a disappointment; but European art from the Renaissance onwards provides its students with an unparalleled opportunity of examining their subject in the closest possible detail – under the microscope, as it were – in terms not simply of broad stylistic tendencies but of the complex interaction of a host of distinct individuals. The historian's first task, therefore, must be to define as exactly as possible the personalities of his chosen period. In the field of literary scholarship, the establishment of as accurate a text as possible is an essential preliminary to any more general criticism. My purpose here has simply been to clear the ground for a catalogue of drawings of a particular school by bringing together a body of examples by

one of that school's leading personalities; or – to pursue the analogy with textual criticism – to restore a text which in the course of four centuries has become unintelligibly corrupt.

To say that Taddeo's drawings form an essential complement to his paintings is not to imply that he was one of those artists for whom painting and drawing are alternative means of expression and who make drawings as finished works complete in themselves. Though he was a draughtsman of unusual range and versatility to whom the act of drawing came naturally and who was able to express his ideas with the utmost fluency in this medium, the impression made by his drawings as a whole is that the drawing itself was never the end-product. All of them, from the rough, sometimes incoherent, pen and ink scribbles in which he noted down his thoughts as fast as they came into his head, to the sculptural studies of single figures highly wrought with the brush-point, are part of the pre-paratory material leading up to a painting. Each marks a stage in a continuous creative process, and it is only when the finished work is studied in relation to the train of thought that preceded it that the complexity of this process and the richness of the artist's creative imagination can be fully appreciated. A second reason for concentrating on his drawings is that so much of the work recorded by Vasari is now lost that it is impossible to grasp the extent of Taddeo's achieve-ment without taking them into account. Of the recorded work of the first five or six years of his independent career, for example, nothing at all remains, and it is only from drawings that the course of his development between 1548 and 1553 can now be reconstructed. And a third reason is that his drawings are in particular need of study. His activity as a painter is so fully described by Vasari that such paintings as still exist, almost all of them in Rome or the immediate neighbour-hood, are easily identifiable and present few problems to the student other than the physical obstacles of inaccessibility or bad condition, while such problems as they do present – the extent of his share in the decoration of Caprarola, for ex-ample – are most profitably approached by way of the related drawings. But apart from one or two studies for paintings identified in the 1920's by Hermann Voss, some illuminating attributions at Windsor and in the Ashmolean Museum put forward in more recent years by Mr Popham and Sir Karl Parker, and a few odd drawings reproduced here and there in exhibition catalogues, there is remark-ably little published material on which an accurate idea of his draughtsmanship can be based; and the name 'Zuccaro' has in the past been so indiscriminately used as a convenient label for disposing of any problematical late-sixteenth-century work – one could almost say, as an elegant variation for 'Mannerist' in general – that in most printrooms a request for drawings by Taddeo Zuccaro is likely to elicit a bewildering medley by many hands of every school and period.

[13]

The survival of a sound tradition for an artist's drawings is a matter of chance, as can be seen when Taddeo's fate in this respect is compared with that of a contemporary of roughly equivalent stature. The contents of Federico Barocci's studio must have been carefully preserved after his death in 1612, for more than eleven hundred drawings by him are known including two groups of about four hundred in the Uffizi and in the Berlin Printroom. How greatly this accident has encouraged the study and appreciation of Barocci is shown by the appearance, long before that of Dr Olsen's complete monograph, of the full-length studies devoted solely to his drawings by Schmarzow (1904–14) and de'Pietri (1919). Even when all allowance is made for Taddeo's very much shorter career, the largest recorded concentration of drawings by him, the sixty-seven *disegni su carta . . . del S.r Thadeo* listed in the inventory of Federico's effects made after his death in 1609, is by comparison small and has long since been dispersed. Of the drawings now kept in printrooms under his name, many have little or no connexion with him and, conversely, a high proportion of those here attributed to him came to light under other names. His eclectic formation and versatility as a draughtsman have caused some of his drawings to be given to his predecessors, Michelangelo, Raphael, Correggio, Peruzzi, Polidoro da Caravaggio and his collaborator Maturino, Daniele da Volterra, Perino del Vaga, Francesco Salviati, Parmigianino, Primaticcio and Niccolò del'Abbate, all of whom influenced him in one way or another; others to such contemporaries as Barocci, Tibaldi, and Muziano; others to younger artists whom he in his turn influenced, his brother Federico, Raffaellino da Reggio, Cesare Nebbia and Niccolò Trometta; others to Florentines ranging from Andrea del Sarto and Pontormo to Vasari, Naldini, Poppi, Cigoli, and Tempesta; others to a wide variety of North Italians, from Titian and Sebastiano del Piombo to Giuseppe Porta, Aliense, Demio, Ligozzi, Farinati, and Alessandro Turchi; and others to an even more heterogeneous group which includes Lorenzo Costa, Beccafumi, Bertoja, Pirro Ligorio, Giulio Romano, Pellegrino Munari, Camillo and Giulio Cesare Procaccini, Cambiaso, Viviani, Schidone, Stradanus, the Cavaliere d'Arpino, Allegrini, Villamena, Martin Fréminet, Francesco Curia, Cherubino Alberti, Lanfranco, and Goltzius. For one drawing the name of Fuseli was even invoked! The problem is thus unlike that presented by the drawings of an artist with a strongly marked and consistent style who has never fallen out of sight. The drawings of a Cambiaso, or a Rembrandt, or a Guercino, have tended to remain under the right name along with a mass of others by followers and imitators, so that the efforts of students have been mainly devoted to bringing the master's personality into focus by detaching these accretions from his *oeuvre*. But with Taddeo Zuccaro it is not so much a matter of removing accretions to reveal a substantially intact underlying

structure as of gathering together the now widely scattered fragments of the structure and rebuilding it almost from its foundations.

Taddeo's responsibility for some drawings is established by their connexion with paintings known to be by him, and a few others are authenticated by inscriptions in the hand of Federico Zuccaro, or by Vasari whose attribution to a contemporary and personal acquaintance can safely be accepted. These constitute the framework of this reconstruction, but the great majority are attributed solely on grounds of style – in other words, on the basis of my own conception of the artist's personality. What that conception is, will, I trust, be apparent from the illustrations, for while it is one thing to recognize the hand of a particular artist in a drawing, language is too clumsy an instrument to capture all the elusive shades which combine to make up the total impression of an artistic personality, and it is often impossible to put one's reasons satisfactorily into words. Connoisseurship (in the technical sense of that branch of art history concerned with assigning works to particular hands) is not a 'science', if by that is meant a rational system of inference from verifiable data: when exponents of 'scientific' connoisseurship justify their attributions by laboriously comparing the forms of ears and fingers it is difficult sometimes not to suspect them of arguing backwards in an attempt to rationalize conclusions arrived at by an instantaneous intuitive process that defies analysis. Most of the attributions here put forward were based on nothing more substantial than personal conviction (though an encouraging proportion were subsequently confirmed by external evidence) and I can only hope that as the reader turns the plates he will share my belief that they illustrate the consistent development of an individual personality.

The catalogue of drawings includes every one known to me that I believe to be by Taddeo himself, but makes no claim to be definitive. This artist's drawings are scattered under such a wide range of attributions that to achieve even theoretical completeness it would have been necessary to scrutinize, however rapidly, the greater part of every European and American collection. This I am far from having done, but my lack of enterprise has been to some extent offset by Dr Gernsheim's invaluable *Corpus Photographicum* and by the kindness of friends and colleagues who have indicated drawings in collections which I have not visited; and though fresh drawings by Taddeo are always coming to light, I believe that the selection illustrated here will be found adequately representative of the varied aspects of his draughtsmanship. The catalogue itself errs on the side of over-inclusiveness, but no useful purpose would have been served by the rigid exclusion of every-thing not acceptable as a work of the artist's own hand. An old copy is often of more interest than an insignificant original, and no study of an artist who was at the head of a large studio for much of his career would be complete unless the

[15]

studio-assistants' drawings are also taken into account. The 265 items thus include about 60 drawings which in my opinion are not by Taddeo himself, comprising copies of lost drawings (copies of known drawings are listed without being numbered) or of otherwise unrecorded compositions, and studies connected with his later, large-scale undertakings which though not from his own hand were evidently produced in his studio on his indications and under his supervision. In an attempt to simplify the catalogue as much as possible I decided, after some hesitation, to omit references to the provenance of drawings except in those few cases where this seemed to have some bearing on their critical history.

The Introduction deals with certain particular problems. The first chapter discusses the question, never previously investigated, of Taddeo's early style and the influences that went to its formation; in the second, a nucleus of drawings is assembled connected with the Mattei Chapel in S. Maria della Consolazione which occupied him from 1553 to 1556, and with the Frangipani Chapel in S. Marcello al Corso on which he was intermittently engaged from 1558 or 1559 until his death in 1566; the last deals with his later works, including the Sala Regia in the Vatican and the Farnese palaces in Rome and at Caprarola, and the difficult problem of the confusion between Taddeo's later drawings and the early drawings of his brother and pupil Federico – a confusion further complicated by the problem of drawings which seem not necessarily to be by either brother and are thus presumably the work of studio-assistants. To this vexed question a satisfactory answer one way or the other is not always possible; but even if a problem cannot for the time being be solved, it is at least a step in the right direction to define it.

Other aspects of Taddeo's activity which could not be fully dealt with here, either because they required disproportionately lengthy treatment or because of the impossibility of illustrating all the necessary comparative material, are treated in a series of articles in *The Burlington Magazine*: Taddeo's designs for maiolica (August 1963); two previously unidentified panel-pictures, the *Adoration of the Magi* in the Fitzwilliam Museum (October 1963) and the *Agony in the Garden* in Zagreb (November 1963); the decoration of the Villa Giulia (April 1965); his two last commissions, the decoration of the Pucci Chapel in S. Trinità dei Monti (June 1966) and the high-altarpiece for S. Lorenzo in Damaso (July 1966), both posthumously completed by Federico; and his share in the design of Muziano's early fresco of the *Flight into Egypt* in S. Caterina della Ruota (August 1966). In an article in *Master Drawings* (Winter 1963) I tried to clarify the question of one of his closest followers and, at times, most deceptive imitators, Niccolò Trometta da Pesaro. Drawings in the Uffizi by Federico Zuccaro, including a group particularly important in this context of studies for early commissions datable within Taddeo's lifetime, and by Federico's pupil Raffaellino da Reggio, who though

[16]

never in direct contact with Taddeo has a better claim than Federico to be described as his 'artistic heir', are discussed and many of them reproduced in the catalogue of an exhibition held in the Uffizi in the Summer of 1966. An exhibition of drawings by the two Zuccaros in the Louvre was held in the Summer of 1969.

The table of dates in Taddeo's life and in Federico's until 1566 is appended for the convenience of the reader. It is based on Vasari and on documents published or summarized by Bertolotti, Fumi, Friedlaender, Körte and Ackerman, and includes no new material other than references to documents recently discovered in Rome by Mr Partridge and Professor Hibbert relating respectively to the decoration of Caprarola and to an otherwise unrecorded commission for a painting in the Oratory of S. Orsola della Pietà. My own archival researches were limited to an examination of Julius III's account-books in the vain hope of finding some documentary evidence for Taddeo's share in the Villa Giulia decoration.

The illustrations are arranged in roughly chronological order. Taddeo's early drawing-style of around 1548 to around 1555–56 is well defined, and at the other extreme a fixed point is established by the inscription in Federico's hand identifying a drawing now in the Ashmolean Museum as the last one made by his brother. In between come a number of studies for recorded commissions, many of them datable more or less closely, but since it is impossible to date Taddeo's drawings from the mid-1550's onwards with any certainty on style alone, the order of the plates should not be taken as implying any hard-and-fast chronological sequence. Though I have not set out to reproduce his surviving painted *oeuvre* in its entirety, his frescoes (or those designed by him) in the three Roman churches of S. Maria della Consolazione, S. Marcello al Corso and S. Maria dell'Orto, and those in the Sala Regia in the Vatican, the Palazzo Caetani in Rome and the Castello Odescalchi at Bracciano are all illustrated as completely as possible. It was obviously out of the question to reproduce every painting in every one of the ten rooms decorated by Taddeo at Caprarola, but I was relieved of the impossible task of making an adequately representative choice of a mere half dozen or so by Mr Partridge's intention of undertaking in the near future a completely illustrated monograph on the architecture and decoration of the palace; and since the present study is concerned primarily with Taddeo's drawings, I have limited my illustrations to some of the less well known paintings for which preparatory studies exist and of which adequate photographs are obtainable. In order to illustrate the problem of his later drawings it seemed essential also to reproduce one or two examples which are on the borderline and in my opinion probably not from his own hand.

I am grateful to Her Majesty the Queen for gracious permission to reproduce two drawings in the Royal Library at Windsor, and to all others who have allowed

me to publish drawings in their possession or under their care. It would be impossible to acknowledge individually the assistance of every kind which I have received from collectors, curators, and dealers in this country, on the Continent, and in the United States, but I am under a particular obligation to those in charge of the two most important collections of drawings by Taddeo and Federico Zuccaro, where much of my time has necessarily been spent: M. Serullaz and Mlle. Bacou in the Louvre, and in the Uffizi D.sse Forlani Tempesti and Fossi Todorow. Of the many others who have contributed in various ways to the task of bringing together and elucidating the material of this study, my greatest debt of gratitude is to my former colleague in the British Museum, Mr Philip Pouncey, for his continuous encouragement and criticism; for the generosity with which he made me free of all his own discoveries; and for the privilege – how valuable, perhaps only fellow-students of Italian sixteenth-century drawings will fully appreciate – of being able to discuss with him all difficulties and doubtful points as they arose. Others whose help is here acknowledged with much gratitude are Mr Keith Andrews, Mr Jacob Bean, Mr Michael Hirst, Mr Michael Jaffé, Dr Konrad Oberhuber and, in particular, Dr Walter Vitzthum, who have all indicated drawings which I would otherwise have missed; Mr Loren Partridge, for sharing with me the results of his researches into the decoration of Caprarola, including further information about drawings which I had not found; Miss Bernice Davidson for help in defining the debatable borderline between Taddeo and Perino del Vaga; D.ssa Maria Vittoria Brugnoli Pace, Dr D. Redig de Campos, Dr Detlef Heikamp, Mr John Leslie, Dr Milton Lewine, Comm. Avv. Ilo Nuñes, Mr A. E. Popham and Mrs Angus Franz, for assistance and information on specific points; Signorina Myrtha Schiavo and Mr Jack Newman, through whose kindness I was able to make a thorough but fruitless search for traces of Taddeo's activity in the Palazzo del Governo (formerly the Palazzo Ducale) at Pesaro; Count Donato Sanminiatelli, who made it possible for me to see Taddeo's paintings in the castle at Bracciano and was also kind enough to photograph them for me; Dr Carlo Bertelli, Director of the Gabinetto Nazionale Fotografico in Rome, who responded to many requests for photographs with promptness and imperturbable good humour; Mr H. M. Calmann, Mr Peter Claas, Mr Richard Day, Mrs Angus Franz, Miss Yvonne ffrench, Dr Walter Gernsheim, Mr Janos Scholz, Mr James Byam Shaw, Dr Walter Vitzthum, and Professor Hermann Voss for photographs; Professor Waterhouse for the loan of his unique collection of photographs of the Caprarola frescoes; Mr Benedict Nicolson, Mr Michael Hirst and Mr Byam Shaw for reading and criticizing the manuscript, to its great advantage; and Miss Margot Holloway for her invaluable assistance in reducing it to order.

[18]

DATES IN THE LIFE OF TADDEO ZUCCARO AND IN THAT OF FEDERICO ZUCCARO UP TO 1566

1529, 1 September	Taddeo born at S. Angelo in Vado, near Urbino (Vasari, vii, p. 73).
1540/41	Federico born at S. Angelo in Vado. There is some doubt about the year of his birth (cf. Körte, p. 70). Körte's arguments in favour of 1543 fail to take into account Federico's inscription on a drawing in the Uffizi dated 1565 (and datable between September and December: see below) stating that he is in his 25th year.
1543/44	Taddeo went to Rome: 'solo se n'andò di quattordici anni a Roma' (Vasari, vii, p. 74).
1548	Taddeo completed the decoration of the façade of the Palazzo Mattei in Rome (Vasari, vii, p. 78).
1550	Federico brought to Rome by his parents and left there with Taddeo (Vasari, vii, p. 79).
7 February	Election of Julius III (del Monte), for whose coronation Taddeo made 'alcune instorie e tele di ciaro e schuro' (note by Federico in Vasari, vii, p. 79).
1551	Taddeo painted Julius III's device of *Occasion and Fortune* in the villa outside the Porta del Popolo ceded to him by Cardinal Poggio (Vasari, vii, p. 81; see also *B. Mag.*, cvii (1965), p. 201). Taddeo summoned to Urbino by Duke Guidobaldo II, to complete the decoration of the choir of the cathedral (calculation from Vasari: see below).
1552	Taddeo accompanied the Duke to Verona (Vasari, vii, p. 80; for the date of the Duke's visit to Verona, see J. Dennistoun, *Memoirs of the Dukes of Urbino*, ed. E. Hutton, 1909, iii, p. 103).
1553, April–June	Taddeo returned to Rome: 'finalmente avendo il duca a partire per Roma per andare a ricevere il bastone, come generale di Santa Chiesa . . . Taddeo, dopo aver perduto duoi anni di tempo, se n'andò a Roma; dove trovata il duca, si scusò destramente'

[19]

(Vasari, vii, p. 81). The Duke went to Rome in April 1553 (cf. Dennistoun, op. cit., iii, p. 104) and seems to have remained there until the end of June (cf. *B. Mag.*, cvii (1965), p. 200, note 6).

1553, April Decoration of the Villa Giulia begun (cf. *B. Mag.*, cvii (1965), p. 200 and Vasari, vii, pp. 81 f.).

Decoration of the Mattei Chapel in S. Maria della Consolazione begun in 1553 (calculation from Vasari, vii, pp. 83f.: 'Taddeo... la condusse in quattro anni . . . e l'opera fu scoperta l'anno 1556').

1555, 23 March Death of Julius III. Decoration of the Villa Giulia already completed.

23 May Election of Paul IV (Caraffa).

11 November to

1556, 4 February Payments to Taddeo for painting in the Vatican 'alcune stanze a fresco dove stava il cardinale Caraffa, nel Torrone sopra la guardia de'Lanzi' (Vasari, vii, p. 84. Payments, 11 and 26 November, 18 December 1555 and (the last) February 1556: J. S. Ackerman, *The Cortile del Belvedere*, Rome, 1954, pp. 172 f.). 'Qui Federico cominciò a manegiar colori' (note by Federico in Vasari, loc. cit.).

Decoration of the Mattei Chapel completed in 1556 (Vasari, vii, p. 84).

1558, 5 March Payment to 'Thadeo pittore per un disegno di una madonna fatta per un paliotto che si haveva da fare per la cappella di Sisto' (A. Bertolotti, *Artisti Urbinati in Roma prima del secolo XVIII: estratto dal periodico 'il Raffaello'*, Urbino, 1881, p. 17).

1558/59 Federico, aged eighteen, decorated the façade of the house of Tizio da Spoleto, opposite S. Eustachio (Vasari, vii, p. 89).

Taddeo probably began decoration of the Frangipani Chapel in S. Marcello al Corso (inference from Vasari, vii, p. 86: 'tornato dunque Taddeo a fornire in S. Marcello l'opera del Frangipane, non pote lavorare molto a lungo senza essere impedito' by the commission for the

1559, 4 March Obsequies of the Emperor Charles V, celebrated in Rome in S. Giacomo degli Spagnuoli: 'furono allogate a Taddeo (che il tutto condusse in venticinque [corrected by Federico to *quindici*] giorni) molte storie de'fatti di detto imperatore e molti trofei ed altri ornamenti').

18 May Resolution of the Chapter of Orvieto Cathedral authorizing the 'soprastanti . . . di condurre per picture alla Cappella dello stucco et per la tavola Mastro Taddeo (L. Luzi, *Il Duomo di Orvieto*, Florence, 1866, p. 497; cf. also Vasari, vii, p. 87 and below, p. 89, note 1). Terms of his employment decided 11 June (L. Fumi, *Il Duomo di Orvieto e i suoi restauri*, Rome, 1891, p. 411, doc. clxxvii).

29 September Resolution of the Chapter of Orvieto Cathedral to pay Taddeo 30 scudi 'con questo che lui habia da restare et pingere tutti i quatri, dove bisognano i ponti, et ancho pingere fino alla fiera di

San Brizio proxima [i.e. Nov. 13], et che havendo finito prima detti quatri che prima gli s'habbia da dare licentia per 20, o 25 giorni, acciò possa andare a fare le sue faccende' (Fumi, loc. cit., doc. clxxviii).

18 August	Death of Paul IV.
26 December	Election of Pius IV (Medici).
1559	Date inscribed on painting in semi-dome above the high altar of S. Sabina, Rome (cf. Vasari, vii, p. 131, and below, p. 91). In the *Memorie riguardanti il nostro Convento di Santa Sabina dal 1412 al 1678* (printed by J.-J. Berthier, *L'Eglise de Saint-Sabine à Rome*, Rome, 1910, pp. 523 ff.) a payment of 100 scudi is recorded in 1560 from 'il Cardinale d'Augusta' (i.e. Otto Truchses) 'per pittura del nicchio' of the *cappella maggiore*.
1559–60	Taddeo and Federico decorated two rooms for Paolo Giordano Orsini in the castle at Bracciano, 'poco dopo' the obsequies of Charles V (Vasari, vii, p. 86). Orsini's marriage to Isabella de'Medici, for which occasion these rooms were redecorated, took place in October 1560 (cf. L. Borsari, *Il Castello di Bracciano*, 1895, pp. 24f.).
1560, 3 May to 30 November	Payments to Taddeo for work in the Vatican and the Palazzo di Aracoeli (Bertolotti, op. cit., p. 17): 'pittura che fa nel palazzo apostolico alla sala de Palafrenieri [i.e. the restoration of Raphael's *Apostles*] et alla prima camera di Aracoeli (3 May); friezes in the Palazzo di Aracoeli (20 June–13 July); 'pittura che lavora [for the visit of Cosimo de'Medici and Eleonora of Toledo] nella loggia del piano dello appartamento d'Innocenzo (30 Sept.–31 Oct.); 'pittura ne'duoi camerini dello appartamento dove alloggia ... Cardinale Borrommeo' (30 Nov.). Vasari (vii, pp. 90 f.) says that Federico collaborated in the first three of these commissions. He does not mention the fourth. 'Quasi nel medesimo tempo che lavoravano in Aracoeli' Taddeo went to Urbino to paint the portrait of the Duke's daughter, Virginia della Rovere, on the occasion of her marriage to Federico Borromeo (Dennistoun, op. cit., iii, p. 125, says that the marriage took place in 1560) and while there was commissioned to make designs for a service of maiolica which the Duke intended as a present for the King of Spain (Vasari, vii, p. 90).
8 September	Taddeo elected one of the *Virtuosi al Pantheon* in his absence. Formally enrolled, 17 November. (See *Repertorium für Kunstwissenschaft*, xxxvii (1915), pp. 26 and 32.)
1561, 31 August	Payment to Taddeo 'a buon conto di più opere di pittura fatte nelle stanze di Torre Borgia' (Bertolotti, op. cit., p. 17).
November	Payment to Federico for work in the 'Boschetto', i.e. the Casino of Pius IV (W. Friedlaender, *Das Kasino Pius des Vierten*, Leipzig, 1912, p. 130).

December	Payment to Federico for further work in the Casino, 'e per lo fregio del Torre Borgia e per la Rota' (Friedlaender, ibid.). According to Vasari (vii, p. 92) Federico painted figures of *Justice* and *Equity* on either side of Pius IV's arms in the Tribunale della Ruota.
	Decoration of Caprarola probably begun in 1561. According to documents recently discovered by Mr Loren Partridge in the Archivio di Stato in Rome no painting seems to have been carried out in the period before 20 February 1561, but the ceilings of the Sala di Giove and the four Camerine delle Stagioni on the ground floor were completed by 15 January 1562.
1562, January–October	Payments to Federico for work in the Casino (January to May); in the Ruota, the Casino and the Belvedere (June); in the Casino and the Belvedere (August); and for unspecified 'pitture' (October). (Friedlaender, ibid.).
17 September	Date of document referring to the maiolica service for the King of Spain as completed (cf. *B. Mag.*, cv (1963), p. 306, note 5).
21 November	Date of Annibale Caro's letter giving iconographic programme for Stanza di Aurora at Caprarola (Vasari, vii, pp. 115 ff.).
1563, 8 June	Date of contract between Taddeo and the Archbishop of Corfù for the decoration of the lower part of the north transept (the Pucci Chapel) in S. Trinità dei Monti (Bertolotti, *Artisti bolognesi, ferraresi . . . in Roma*, pp. 46 ff., in *Documenti e studj pubblicati per cura del R. Deputazione di Storia Patria per le provincie di Romagna*, i, Bologna, 1886).
8 June	Payment to Federico for work in the Belvedere (Ackerman, op. cit., p. 178).
8 September	Payment to 'Maestro Federigo Zuccaro et Maestro Lorenzo Costa, et compagni . . . per resto et completo pagamento di più opere . . . nelle opere palatine forniti che sieno certi pochi residui . . .' (Ackerman, loc. cit.).
October	Payment to Federico 'd'ordine di Lorenzo Costa, per residuo di più lavori di pittura e stucco in diversi luoghi a Belvedere e per detto Federigho a Taddeo Zucchero suo fratello' (Bertolotti, *Artisti Urbinati*, p. 19, giving the date of the document as 3 Oct.; Ackerman, p. 179, refers to what is apparently the same document under 11 Oct.).
1563, 11 November	Death of Francesco Salviati, after which Taddeo was commissioned by Cardinal Ranuccio Farnese to complete the Sala dei Fasti Farnesiani (or 'Salotto Dipinto') in the Palazzo Farnese in Rome (Vasari, vii, p. 97).
1564, March	First payment to Taddeo for paintings in the Cortile della Libreria in the Vatican (Bertolotti, *Artisti Urbinati*, p. 17).
4 May	First payment to Taddeo for his painting in the Sala [Regia] in the Vatican 'sopra la porta della scala quale scende verso Roma': i.e.

the *Donation of Charlemagne* (Bertolotti, op. cit., p. 18; cf. Vasari, vii, p. 94).

June Probable date of Taddeo's visit to Florence, apparently his only one (see Vasari, vii, p. 99) 'per un San Giovanni' (i.e., the festival celebrated there on St John's Day, 24 June: see *Paragone*, 205 (1967), p. 57). Vasari does not specify the year but goes on to say that Taddeo, on his return from Florence to Rome, 'messe mano alla . . . capella della Trinità' and that Federico was still away in Venice. The contract for the Pucci Chapel in S. Trinità dei Monti is dated 8 June 1563, but Federico did not leave Rome for Venice until after the following October. Taddeo's visit to Florence cannot have been in June 1566, since Federico had returned to Rome in the previous January. This leaves only 1564 and 1565 as possible years, and of these the former is the more likely because Federico does in fact seem to have returned briefly to Rome in July 1565.

19 August Letter from Cosimo Bartoli in Venice to Vasari, reporting that Federico was then at work in the Grimani Chapel in S. Francesco della Vigna (D. Frey, *Vasaris Literarische Nachlass*, ii, 1930, p. 107). Federico's altarpiece in the chapel, of the *Adoration of the Magi*, is dated 1564. (cf. Vasari, vii, pp. 95 f.).

5 November Taddeo commissioned by the Arciconfraternità della Pietà dei Fiorentini to paint a 'quadro in fresco' in the oratory of S. Orsola della Pietà 'per prezzo di scudi ottanta doro dj Gulj undicj'. Payment on account to him of 25 scudi. (S. Giovanni dei Fiorentini, Archivio della Confraternità della Pieta, vol. 210, *Mandati . . . 1652–1656* [sic]. I am indebted to Professor Howard Hibbard for this reference). See p. 77, note 1.

22 December Interim payment to Taddeo for two paintings in the Sala Regia: 'l'uno sopra la porta della scala ecc. [the *Donation of Charlemagne*] l'altro sopra la porta della cappella Paolina' (Bertolotti, op. cit., p. 18; cf. Vasari, vii, p. 94 f.). Bertolotti refers to further payments for the Sala Regia in the following year, but gives no details.

1565, 15 May Letter from Annibale Caro giving iconographic programme for the Stanza della Solitudine at Caprarola (*Lettere familiari*, Padua, 1725, ii, p. 410).

July (?) Temporary return of Federico to Rome (see p. 118, note 1).

9 September Letter from Vincenzo Borghini in Poppiano to Vasari in Florence, discussing the arrangements for the ceremonial entry of Joanna of Austria (cf. Vasari, vii, p. 100): on one of the triumphal arches were to be 'due istorie che n'ho data l'inventione al [Federico] Zucchero' (Frey, op. cit., ii, p. 206).

21 September Letter from Vasari in Florence to Borghini in Poppiano (Frey, op. cit., ii, p. 209) reporting that Federico was at work on his 'tela': i.e. the drop scene, representing a hunting party, for a play

to be performed in the Sala dei Cinquecento of the Palazzo Vecchio on 26 December as part of the celebrations of the wedding of Francesco de'Medici and Joanna of Austria (cf. Vasari, vii, p. 100). The *modello* for the drop scene, in the Uffizi (11074F; 1966 Exh., no. 48) is signed by Federico and dated 1565, with the words ETATS.SVE.XXV.

28 October	Death of Cardinal Ranuccio Farnese, which put a stop to Taddeo's activity in the Palazzo Farnese (Vasari, vii, pp. 100 f.).
9 December	Death of Pius IV, which put a stop to Taddeo's activity in the Sala Regia (Vasari, ibid.).
1566, 7 January	Election of Pius V (Ghislieri).
16 January	Federico returned to Rome (Vasari, vii, p. 100).
25 May to 18 August	Payments to Federico for work carried out by unspecified 'pittori' at Tivoli (i.e. in the Stanza della Nobiltà and the Stanza della Gloria in the Villa d'Este: see D. R. Coffin, *The Villa d'Este at Tivoli*, 1960, pp. 56 f., also Vasari, vii, p. 102).
2 September	Taddeo died in Rome (Vasari, vii, p. 104).

WORKS REFERRED TO
IN ABBREVIATED FORM

B.	Adam Bartsch, *Le Peintre-Graveur*, 21 vols., Vienna, 1803–21.
BdH	J. C. J. Bierens de Haan, *L'Oeuvre gravé de Cornelis Cort*, The Hague, 1948.
B. Mag.	*The Burlington Magazine*, London, from 1902.
Gernsheim	*Corpus Photographicum*, by Walter Gernsheim (photographs of drawings in public and private collections).
Körte	Werner Körte, *Der Palazzo Zuccari in Rom*, Leipzig, 1935.
Louvre, 1969 Exhibition	*Musée du Louvre: Dessins de Taddo et Federico Zuccaro. XLIIᵉ Exposition du Cabinet des Dessins. Catalogue par John Gere.* Paris 1969.
Lugt	Frits Lugt, *Les Marques de collections de dessins et d'estampes*, Amsterdam, 1921. *Supplément*, The Hague, 1956.
Popham-Wilde	A. E. Popham and Johannes Wilde, *The Italian Drawings of the XV and XVI Centuries in the Collection of His Majesty the King at Windsor Castle*, London, 1949.
Sirén	Osvald Sirén, *Italienska Handteckningar fran 1400- och 1500-talen i Nationalmuseum [Stockholm]*, Stockholm, 1917.
Uffizi, 1966 Exhibition	*Gabinetto di Disegni e Stampe degli Uffizi: Mostra di disegni degli Zuccari . . . e Raffaellino da Reggio. Catalogo critico a cura di John Gere*, Florence, 1966.
Vasari	*Le vite de' più eccellenti pittori, scultori ed architettori scritte da Giorgio Vasari [1568 ed.] . . . con nuove annotazioni e commenti di Gaetano Milanesi*, 9 vols., Florence, 1878–85.
Venturi	Adolfo Venturi, *Storia dell'arte italiana*, 11 vols. (from vol. vi onwards subdivided into parts), Milan, 1901–39.
Voss, *MdSR*	Hermann Voss, *Die Malerei der Spätrenaissance in Rom und Florenz*, Berlin, 1920.
Voss, *ZdISR*	Hermann Voss, *Zeichnungen der italienischen Spätrenaissance*, Munich, 1928.
Weigel	Rudolph Weigel, *Die Werke der Maler in ihren Handzeichnungen*, Leipzig, 1865.
Wickhoff	Franz Wickhoff, *Die italienischen Handzeichnungen der Albertina*. Published in *Jahrbuch der kunsthistorischen Sammlungen der Allerhöchsten Kaiserhauses*, Vienna, xii (1891), pp. ccv ff. and xiii (1892), pp. clxxv ff.

INTRODUCTION

I

For the best part of three hundred years, from the beginning of the sixteenth century until well on into the eighteenth, Rome was a centre of continuous and intense artistic activity. It is thus one of the more curious anomalies of the history of art that she never succeeded in fostering a native school of painting. But Rome stands apart from the other great artistic centres of Italy in being what would nowadays be called an 'official capital'. The rapid succession of the Popes and their tendency to bring in artists from outside – often from their own native cities – and the inevitably diverse taste of the cosmopolitan papal court, were factors all making for discontinuity in patronage and inhibiting the gradual development of a local tradition such as emerged naturally during the same period in Florence and Venice. It is significant that of the innumerable artists who are classified as members of the Roman School, it is hardly possible off hand to think of more than one who was actually a native of Rome; and as if to emphasize the singularity of his birth, this solitary exception is always known as Giulio the Roman. But Giulio Romano apart, none of the other artists active in Rome during the first half of the sixteenth century – Michelangelo and Raphael, Peruzzi and Sebastiano del Piombo, Daniele da Volterra, Francesco Salviati, Perino del Vaga and Polidoro da Caravaggio – was born there, and only Polidoro can be considered as completely Roman by training. However powerfully the art of the others was affected and enriched by the Roman *genius loci*, the elements that seem characteristically 'Roman' were grafted onto a basic style that had been formed elsewhere.

But though it is impossible to attach any very precise meaning to the term 'Roman School', it is undeniable that by the middle of the century a distinctively Roman *style* was beginning to emerge. Of the artists born in the 1520's, who were responsible for this development, Taddeo Zuccaro resembles Polidoro da Caravaggio in being a Roman in everything but his place of birth. S. Angelo in Vado, where he was born on September 1 1529, is in the Marches, in the Duchy of

Urbino; but he was only fourteen when he came to Rome, and it was entirely there – if we can discount the elementary instruction which he received from his father and from another, equally obscure, local master, Pompeo da Fano[1] – that his style was formed. In the early 1540's, when Taddeo arrived in Rome, the artistic scene there was dominated by the aged Michelangelo, whose *Last Judgement* had been unveiled in 1541, and who began the frescoes in the Pauline Chapel – his last paintings – in the following year. Others active there in that decade were Perino del Vaga, whose chief works between his return to Rome in 1538/39 and his death there in 1547 were the decoration of the Massimi Chapel in S. Trinità dei Monti and of the state-apartments of the Castel Sant'Angelo; Daniele da Volterra, whose Orsini and Della Rovere Chapels, also in S. Trinità, date respectively from the middle and end of the decade; and Francesco Salviati, whose S. Giovanni Decollato *Visitation* is dated 1538, and who began the Cappella del Pallio in the Cancelleria in 1548. All these artists were to influence Taddeo in one way or another, but there is nothing to show that he came into direct personal contact with any of them at this stage in his career. In Florence or Venice at that time a youth of obvious promise could hardly have failed to find his way into the well-organized studio of some established master where he would have received a thorough grounding. The unsatisfactorily haphazard condition of artistic education in Rome is shown by Vasari's detailed account of Taddeo's early years which must have been based on first-hand information and which gives a vivid picture of the hardships he endured in a very humble stratum of the art-world where he drifted unhappily from one obscure master to another: from his kinsman, Francesco da Sant'Agnolo, who began by turning him away and refusing to help him; to Giovanni Piero, il Calabrese, and his stingy wife, who did not give him enough to eat and even prevented him from copying their drawings by Raphael; to Jacopone Bertucci da Faenza; and finally to Daniele Porri da Parma. Of these, only the last seems to have played any significant part in Taddeo's education, and that only as the intermediary through which he acquired his knowledge of Correggio and Parmigianino. For Taddeo, as for so many others, the chief teacher was Rome herself. Several of the series of drawings by Federico Zuccaro of events in Taddeo's early life show him copying antique and modern works of

[1] A sheet of pen drawings, with a battle-scene on one side and on the other a group of five men fighting, inscribed in Federico Zuccaro's hand and in his characteristic style *schizzo de mano di pompeo da fano*, recently appeared on the London market (no. 93 in Mr H. M. O'Nians's exhibition of Old Master Drawings, June 1966) and now belongs to Mr T. P. P. Clifford. Federico's attribution to an old family friend can safely be accepted. Mr Pouncey has attributed two other drawings to this hand: a frieze-shaped composition of prisoners being led before a judge, at Edinburgh (D. 719) and a sheet of figure-studies at Stockholm which include a group copied from an early drawing by Taddeo, datable *c.* 1548 (105). The principal influence on Pompeo's style as a draughtsman seems to have been Girolamo Genga.

art:[1] the Laocoön group, an antique relief, Raphael's frescoes in the loggia of the Farnesina, Michelangelo's *Last Judgement*, and a painted façade presumably by Polidoro da Caravaggio. As will be apparent when we come to consider his drawings in detail, Taddeo's style was an eclectic one based on close study of his Roman predecessors; but he possessed a power of synthesis which enabled him to weld these varied elements into a personal idiom which was to become the point of departure for the distinctively Roman style of the second half of the century.

Taddeo's earliest work recorded by Vasari was a series of frescoes – two Evangelists, two Sibyls, two Prophets, and four small scenes from the life of Christ and the Virgin – carried out under Porri's supervision in the church of S. Maria at Alvito, in the Abruzzi.[2] This was followed by an independent commission in the very centre of Rome. The decoration of the façade of Jacopo Mattei's palace with nine scenes from the life of the Roman hero Furius Camillus, which Taddeo completed in 1548, so impressed Vasari that he went to the trouble of transcribing the Latin inscriptions which identified the subjects of the scenes. He adds that this façade was 'greatly praised by the whole of Rome, and with good reason; for though Taddeo was only eighteen years old, no-one since the time of Polidoro and Maturino, and Tamagni and Peruzzi, had done anything better of this kind'. The largest and most elaborate of Federico's series of drawings shows Taddeo at work on this façade, watched from the street below by an admiring crowd which includes the leading artists in Rome at that time: Siciolante da

[1] The series seems to have consisted altogether of twenty-four drawings: sixteen scenes from Taddeo's early life, four allegorical representations of pairs of Virtues, and symbolic portraits of Taddeo, Michelangelo, Raphael and Polidoro da Caravaggio. A set of twenty (lacking the four portraits), certainly from Federico's own hand, is in the Rosenbach Foundation, Philadelphia (see p. 200). They were formerly in the Lawrence, Woodburn, and Phillipps-Fenwick Collections and apart from being described in the catalogue of the 7th exhibition of the Lawrence Gallery (1846) are unpublished. Copies of eighteen (including the portraits) together with a version of one of the scenes which could be by Federico himself, are in the Uffizi (cf. D. Heikamp, *Rivista d'arte*, xxxii [1957], pp. 200 ff.).

[2] A drawing attributed (unconvincingly) by Padre Resta to Daniele Porri is in the British Museum (cf. A. E. Popham, *Correggio's Drawings*, London, 1957, p. 117). A damaged drawing of part of a circular composition of the *Flagellation* in the Uffizi (14064[F], as 'Anonymous') is attributed on the mount to 'Danielle da Parma', with the following inscription in an early eighteenth-century hand: *Danielle de Por detto Danielle da Parma Scolare del Coreggio in una Cappella di S. Maria di Alvito di La dà Sora; L'opera andò a suo nome, ma in esso fece fare quattro Istorie di Iesu Xrto a Taddeo Zucchero una della quale è questo, et un altro L'ha Monsig[re] Marchetti nel Tom 2º della Sua Serie in quattro Tomi. Adesso queste pitture non più ci sono in Alvito, poichè certi preti ignoranti gl'hanno fatto dare di bianco, così mi fu riferito il dì 15. ottobre 1700. Quando Taddeo sotto à Danielle dipinse queste quattro Istorie haveva solam[te] 14 anni, perciò si puo credere, che qsto Disegno glelo facesse Danielle, onde in appresso Taddeo mantenne sempre La maniera, & stile di lui, di sorte che fa dubitare possi haver fatto lui med[o] q[sto] Disegno per l'opera, che fece nella Consolazzione di Roma, tornato di fresco da Alvito.*
Parlando di Danielle di Por, ò da Para, ognuno quasi ignora il Suo nome; io pero lo trovo notato ne Libro de Morti della Comp[a] detta de Virtuosi di S. Giuseppe di Terra Santa in rotonda di Roma, dopo la Partita di Danielle da Volterra.

There is a certain general resemblance, in the scale of the figures and their placing, between this drawing and the fresco by Taddeo in S. Maria della Consolazione, but this is not close enough to justify connecting the two.

Sermoneta talking to Daniele da Volterra, Michelangelo on his mule attended by his servant Urbino, and Vasari discussing a detail of the façade with Francesco Salviati. This drawing forms the climax of the series and represents the successful outcome of Taddeo's early struggles; for the Mattei commission was soon followed by others, which included four small scenes from the life of St Ambrose with a frieze of 'puttini e femine a uso di termine' in the choir of S. Ambrogio, a façade with six episodes from the life of Alexander the Great, and some of the temporary decorations for the coronation of Julius III in 1550. These evidently caught the Pope's eye, for in the following year he commissioned Taddeo to paint his favourite device of *Occasion and Fortune* on a ceiling in a house on his *vigna* outside the Porta del Popolo.

It was not long before news of Taddeo's success in Rome reached Urbino. In 1551 Duke Guidobaldo II, anxious to complete the decoration of the choir of the cathedral in Urbino which Battista Franco had begun in 1545, called Taddeo back to paint scenes from the life of the Virgin on the side-walls. The designs which Taddeo made for these seem to have reached the cartoon stage, but the vacillation of the Duke and – as Vasari seems to hint – some kind of intrigue directed against Taddeo, prevented them from being carried out. When the Duke went to Rome in April 1553 to be installed as Captain-General of the Church, Taddeo took the opportunity of returning there himself, with little to show for the two years he had spent in the Marches except some portraits, including one of the Duke, an unfinished *Conversion of St Paul* which he left behind him, the decoration of a small room (Vasari's word is *'studiolo'*) in the palace at Pesaro, and on the façade of the palace a large painting of the Duke's arms. Taddeo's short working life of eighteen years was almost entirely spent in or near Rome, so that this stay in Urbino at the age of twenty-two is of some importance in his development since it gave him his only direct contact with the art of North Italy. In 1552 he accompanied the Duke on a visit to Verona. On their way they would have passed through Ferrara, and Antal has suggested that Girolamo da Carpi's mythological frescoes in the castle there may have influenced Taddeo's paintings of similar subjects in the Villa Giulia, where he was working soon after his return to Rome in 1553;[1] it is perhaps also possible to see, in the little fresco of the *Triumph of Flora* in the Nymphaeum of the Villa (Pl. 36), a faint echo of Titian's *Bacchus and Ariadne*, then in the collection of the Duke of Ferrara. But the influence was not necessarily all on one side. Vasari merely says of Taddeo's stay in Verona that while there he painted a copy of Raphael's *Perla* for the Duke, but in Bartolommeo dal Pozzo's *Vite de' Pittori . . . Veronesi*, published in 1718, a list is given of ten obscure pupils of Felice Brusasorci, one of whom, named Tadeo Zuccaro, painted a frieze

[1] 'Observations on Girolamo da Carpi' in *Art Bulletin*, xxx (1948), p. 98; reprinted in *Classicism and Romanticism, with other Studies in Art History*, London, 1966, p. 149.

on the front of a house in Verona and a fresco of the Holy Ghost above the door of the church of S. Spirito. It has been taken for granted that this otherwise un-recorded painter cannot be identified with the Roman Taddeo Zuccaro; but the name is an unusual one; the Roman is known to have been in Verona; and one of the two works by this artist which dal Pozzo records in Verona was a façade-decoration which was the Roman's speciality at this period. It may well be, therefore, that the MS source from which dal Pozzo derived his list of names preserved – if in somewhat garbled form, for Felice Brusasorci was only ten years old in 1552 – a reliable old tradition, and that the Roman Taddeo Zuccaro left behind him in Verona some tangible record of his presence which may have had some influence on the Veronese artists of his own generation.[1]

2

Such are the bare outlines of Taddeo's early career, before his return to Rome in the summer of 1553. They are necessarily bare, because none of the work recorded before this date has survived. Inevitably the façade-paintings have disappeared; nothing remains at S. Maria at Alvito; the decorations for Julius III's coronation went the way of all such *ephemerae*; the villa in which Taddeo painted the Pope's device, mistakenly identified by Milanesi and others with the still extant Villa Giulia, has long ago been pulled down; S. Ambrogio was demolished in the seventeenth century to make way for S. Carlo al Corso; the unfinished *Conversion of St Paul,* and perhaps the cartoons for Urbino Cathedral, are last heard of in the inventory of Federico's property made after his death in 1609; neither the identifi-cation, nor the attribution to Taddeo, of the so-called portrait of Guidobaldo II in the Palazzo Pitti are reliable; and though the Palazzo Ducale (now the Prefet-tura) at Pesaro contains traces of cinquecento decoration, there is no room in it which can be identified with the *studiolo* which Taddeo decorated.[2]

[1] There may be some echo of this hypothetical Veronese façade by Taddeo, which would presumably have been in the manner of Polidoro da Caravaggio (see pp. 34 ff.), in the two Polidoresque *grisaille* friezes of a Roman triumph on the ceiling of the Sala della Bussola in the Doges' Palace which Paolo Veronese decorated in the year following Taddeo's visit to Verona. Taddeo's drawing of a river-god (212. Pl. 19) has a certain Veronese flavour, especially in the proportion and type of the head.

[2] It could be argued that the *studiolo* decorated by Taddeo was not in the Palazzo Ducale in Pesaro itself but in the ducal Villa Imperiale outside the town, where most of the sixteenth-century decoration has survived. An inventory of the contents of the Villa, drawn up in 1631, refers to 'otto camere dipinte variamente si dicono opere di Taddeo Zuccaro, Raffaello dal Borgo, e due fratelli ferraresi de Dudosij [sic]' (G. Gronau, *Documenti artistici urbinati*, Florence, 1936, p. 144). But Vasari's actual words are: 'alcune pitture in uno studiolo a Pesaro, ed un arme grande a fresco nella facciata del palazzo', whereas when he refers to the Villa Imperiale he does so as follows: 'sopra Pesaro, al Palazzo dell'Imperiale' (v, p. 99); 'all' Imperiale' (ibid.); 'all' Imperiale, luogo del duca d'Urbino, vicino a Pesero' (vi, p. 276); 'nel monte del Imperiale sopra Pesaro' (vi, p. 318); 'all' Imperiale, villa del detto duca' (vii, p. 595).

The total disappearance of every recorded work from the first five or six years of Taddeo's independent activity, from about 1548 to 1553, emphasizes the necessity of studying his drawings, since it is only from them that we can now hope for light on this otherwise obscure period; but their attribution cannot be based on the secure ground of connexion with a documented work, but only on an intuitive recognition of the personality revealed in Taddeo's later paintings and the studies related to them. Among the many drawings here attributed to him on such subjective grounds are a number which cannot be satisfactorily fitted into the sequence of his development except at the very beginning, and which agree with what Vasari implies about the sources of his style.

Vasari says something about two of Taddeo's early masters which throws some light on this problem: that Francesco il Sant'Agnolo, who subsequently thought better of his inhospitable conduct, was a journeyman employed by Perino del Vaga to paint grotesques;[1] and that Daniele Porri had worked as an assistant to Correggio and later to Parmigianino, and imparted to his own pupil the secret of the softness ('morbidezza') of their technique. This indirect contact with Correggio and Parmigianino explains the Emilian elements which though conspicuous in Taddeo's style are unexpected in a Rome-trained Marchigian who (so far as we know) was never even in the neighbourhood of Parma, but it would be an oversimplification to think of him as little more than a belated follower of Correggio, for the Emilian strain in his formation was only one of many. The influence on him of Perino del Vaga, for example, is so obvious as to suggest on the face of it a closer contact than can be explained by the tenuous link of Francesco il Sant'Agnolo. Any direct contact would have been brief, for Perino died in October 1547; but it has been suggested – and in the account of Taddeo in Thieme-Becker the suggestion is promoted to the status of established fact – that Taddeo was one of Perino's assistants in the Castel Sant'Angelo and that he there executed, on Perino's designs, the friezes in the Camera di Perseo and the Camera di Psiche. The absence of his name from the published documents relating to the decoration of the Castel Sant'Angelo by Perino and his assistants between 1545 and 1547 proves nothing one way or the other, but it is surely inconceivable that Vasari should have omitted any reference to Taddeo's close association with Perino del Vaga – one of the leading artists of the day, and one of very different calibre from Bertucci, Porri and the rest of his early masters – in a detailed account of his early years which must have been based on information

[1] Mr Pouncey has kindly told me of a drawing in the collection of Mr T. P. P. Clifford with an inscription in the hand of Padre Sebastiano Resta attributing it to Francesco da Sant'Agnolo: *questa . . . arscila (?) è di Franc^co di S. Angelo in Vado detto delle Grottesche scol^o di Perino che non volle far cortesia al povero giovinotto Taddeo Zuccaro suo parente finche non lo vidde in credito.* The drawing is a design for a section of a frieze. Its condition makes it difficult to judge, but it would seem to be a product of Perino del Vaga's studio.

supplied by himself; and even if we admit the theoretical possibility that Vasari might have been guilty of such an omission, his lapse would not have escaped the hostile scrutiny of Federico Zuccaro. Furthermore, neither Perino del Vaga nor the Castel Sant'Angelo make any appearance in Federico's series of drawings, though if Taddeo had worked there under Perino between 1545 and 1547, this would have been the outstanding event of his career during those years.

This apparently precise and categorical assertion rests, in fact, on no contemporary or even traditional source, but can be traced back to a suggestion made by Frederic Antal as recently as 1928.[1] Antal adduces in support of his attribution of these friezes to Taddeo a comparison with paintings in the Palazzo Ducale at Castiglione del Lago on Lake Trasimene, but this is merely using one doubtful hypothesis to prop up another, for the resemblance between the friezes in the Castel Sant'Angelo and any paintings at Castiglione del Lago is of the most general kind – at most, one could say that whoever painted the latter might have been familiar with Perino's late works – and there is no evidence that Taddeo ever worked there or that he was even anywhere in the neighbourhood. Antal is right to stress Taddeo's debt to Perino, but it must be emphasized, since the point can affect the stylistic dating of Taddeo's works, that there is no reason to assume any direct contact between them. If there had been, it would be natural to place at the outset of Taddeo's career those works of his in which the influence of Perino is most marked; but this influence, though powerful, was intermittent, for some of his most Perinesque works – the maiolica designs, for example, or the paintings at Bracciano, which Antal mistakenly describes as early – are datable as late as c. 1560.

Venturi is the only other critic to discuss in any detail the problem of Taddeo's earliest activity. He proposed, as early works by him, the *Vesting of St Hyacinth* on the left-hand side-wall of the right-hand chapel in S. Sabina, Rome, and the *Birth of the Virgin* and *Death of the Virgin* on either side of the choir of S. Maria del Piano at Capranica, near Viterbo. Though Taddeo certainly worked in S. Sabina, his painting in the semi-dome above the high altar is dated 1559 and Vasari mentions no previous connexion with the church. The *Vesting of St Hyacinth* is in fact a characteristic late work by Federico Zuccaro.[2] The saint was not even

[1] In 'Zum Probleme des Niederlandischen Manierismus' in *Kritische Berichte zur Kunstgeschichtlichen Literatur*, 1928/29, Heft 3/4, p. 217 (in English in *Classicism and Romanticism, with other Studies in Art History*, London, 1966, p. 59). He repeats the suggestion in *Fuseli Studies*, 1956, p. 62, note 91.

[2] Venturi, ix⁵, p. 851. In fairness to Venturi it should be added that this attribution has the support of tradition – though not one of particularly long standing. The eighteenth-century Roman guide-books (e.g. Titi, 1763; *Roma Antica e Moderna*, 1765; Vasi, 1791) give the whole chapel to Federico; modern ones describe it as a joint work by Taddeo and Federico. I have not been able to trace this error back beyond the first edition of Melchiorri's *Guida Metodica di Roma e suoi Contorni* (1834, p. 298: 'il quadro a destra è di Federico . . .l'altro di Taddeo suo fratello').

c
G.T.Z.

canonized until 1594, and this fresco was quite clearly executed at the same time as the one on the opposite wall and the one on the vault signed by Federico and dated 1600. The two paintings at Capranica have not even this remote connexion with Taddeo: they clearly date from the seventeenth century, and have in recent years been attributed to Francesco Cozza (1605–82) and to Antonio Carracci (d. 1618).[1]

What seems at first as if it might be a more reliable clue to Taddeo's early style is the drawing at Windsor identified by Mr Popham as a study for the oval stucco relief of Julius III's device of *Occasion and Fortune* on the ceiling of one of the ground-floor rooms of the Villa Giulia.[2] This drawing appears in the Windsor catalogue under Taddeo's name on the strength of a universally misinterpreted passage in Vasari which in fact refers not to this relief but to a painting in a neighbouring villa belonging to Julius III which has long since disappeared. There is, therefore, no external evidence for attributing this drawing to Taddeo. A study by the same hand for one of the frescoes on the same ceiling is in the Louvre. Nothing about the style of either drawing suggests Taddeo's authorship, and in my opinion both are by Prospero Fontana, who was in charge of the decoration of the Villa.

<div style="text-align:center">3</div>

To point out that none of the suggestions so far made about the nature of Taddeo's earliest activity is at all convincing when examined closely is a negative conclusion which has merely cleared the ground. But if we look again through Vasari in search of some possible clue, we find it in the comment which Taddeo is said to have made soon after his return from Urbino in 1553 when he was asked to undertake the decoration of the Mattei Chapel in S. Maria della Consolazione: that he did so 'very willingly, though the fee offered him was small, in order to show those who said that he was only good for painting façades and other such works in chiaroscuro, that he could do equally well in colour'. This can only mean that between 1548, when he established his reputation in Rome with the Palazzo Mattei façade, and 1551, when he went to Urbino, the greater part of his activity had been devoted to the decoration of façades.

The name of one artist of the previous generation is almost synonymous with this particular branch of painting in Rome. Polidoro Caldara, more usually known from his birthplace in Lombardy as Polidoro da Caravaggio, had achieved an

[1] Venturi, *op. cit.*, p. 848. The frescoes at Capranica were attributed to Cozza by R. Longhi, according to C. Lopresti in *Pinacoteca*, i (1928/29), p. 333; to Antonio Carracci by L. Salerno in *Bollettino d'arte*, ser. 4, ix (1956), p. 31.

[2] 5990. Popham-Wilde, no. 1066, pl. 85. See also *B. Mag.*, cvii (1965), pp. 200 f., repr. fig. 43.

absolute pre-eminence in Rome as a façade-decorator in the years between the death of his master Raphael in 1520 and the Sack of Rome in 1527. To the nature of his speciality Polidoro owes his fame among his contemporaries and his subsequent near-oblivion, for these exterior paintings, long since obliterated by time and weather, must once have been among the most familiar of all modern works of art in Rome, freely accessible at all times for everyone to study and copy. From written sources and from the innumerable copies of his façade-paintings which have survived, it is clear that this was a recognised part of every Roman artist's training until well into the seventeenth century. If Rubens and Pietro da Cortona could be fascinated by Polidoro to the extent of making careful copies after him, his influence on a near-contemporary aspiring to emulate him in his own particular field is likely to have been intense; and that he did in fact obsess the imagination of the young Taddeo is shown by an anecdote which Federico Zuccaro recorded in the margin of his Vasari and illustrated in two of his series of drawings. Taddeo, exhausted by his sufferings in the household of Giovanni Piero il Calabrese, was on his way home to his parents in S. Angelo in Vado and stopped to rest beside a river. He awoke delirious 'fancying that the stones in the river-bed were painted like the façades by Polidoro which he had admired in Rome. He accordingly collected as many stones as he could carry and brought them back as a present for his mother, telling her that they were very precious things'. A likely place, therefore, in which to begin a search for traces of this earliest phase of Taddeo's activity is among the mass of drawings which down the centuries have accumulated in all old collections around the name of Polidoro da Caravaggio. Some of these are by Polidoro himself, whose drawing style is well defined, and the great majority are copies after him; but every now and then one comes across drawings which are clearly original studies by other hands, and it is my contention that some of these reveal in embryo the characteristics of Taddeo's later work.

One or two drawings in this early, Polidoresque group are traditionally attributed to Taddeo. One of these, in the album in the Ambrosian Library in Milan assembled by the late seventeenth-century connoisseur Padre Sebastiano Resta, is of a triumphal procession of Roman soldiers marching from right to left (128. Pl. 4). Against it Resta has inscribed *Taddeo Zuccaro figlio d'ottaviano nell'istoria di Furio Camillo à Mattei*. Resta's attributions and the comments which he made about the drawings he collected prove as often as not to be the wildest guesswork, but in this case there is more than one reason why he deserves to be taken seriously. In the first place, the drawing is not obviously recognisable as by Taddeo, and without some compelling reason for doing otherwise a connoisseur of Resta's period would certainly have given it to Polidoro; nor, in the second place, does it represent one of the well-known incidents in the history of Camillus – the

Schoolmaster of Falerii, for example, or Brennus throwing his sword into the scales – which might have suggested a connexion with the Mattei façade on purely iconographic grounds; and, in the third place, since these paintings were still visible in Resta's day – as late as 1763 the third edition of Titi's *Descrizione delle Pitture . . . in Roma* speaks of the 'vestigie delle pitture a chiaroscuro' on the façade of the palace – it seems likely, especially in view of the matter-of-fact phrasing of the inscription, that Resta had noticed the connexion between his drawing and what must then have been a well-known Roman landmark. If so, the significance of the drawing is threefold: it confirms the stylistic attribution to Taddeo of this group of Polidoresque drawings; it tells us something about the appearance of his lost early masterpiece; and it establishes a fixed point in the reconstruction of his early style. What may be an alternative design for the same section of frieze is a drawing in the British Museum, attributed to Perino del Vaga when in the Lawrence Collection (105. Pl. 5). This differs from the Ambrosiana study in representing a procession of soldiers leading prisoners, but there is a close similarity between the two in the movement and rhythm of the whole group of figures, while the pose of the prisoner being hurried along slightly to right of centre in one is identical with that of the soldier holding his shield over his head exactly in the centre of the other.

Jacopo Mattei's palace, the oldest and smallest of the four which constitute the so-called '*isola Mattei*', is the low two-storied house facing the Piazza Mattei directly opposite the Fontana delle Tartarughe. The present disposition of its doors and windows differs from that of the palace in Federico's drawing,[1] which has a high rusticated basement above which is a single row of evenly spaced windows, five on the main front and three (or possibly four) on the façade facing the side-street on the left; but if the drawing does represent the palace as it was in the sixteenth century, then Taddeo's *chiaroscuri* covered the entire wall-surface above the rustication, with upright scenes in the spaces between the windows, single figures in the narrower spaces at either extremity of the row of windows, and a continuous frieze between the top of the windows and the cornice. Even in the best version of the drawing, in the Rosenbach Foundation, the scenes between the windows are too sketchily indicated for their subjects to be identified even with the help of the inscriptions transcribed by Vasari. The frieze, on the other hand, appears plainly as a triumphal procession moving from right to left and headed by a group of four or five figures carrying some long object on their shoulders. These precede two figures in a chariot, presumably Camillus crowned by Victory, while a line of walking figures brings up the rear. If Resta was right in connecting the drawing in the Ambrosiana with this façade, then it and the related drawing

[1] See above, p. 29.

[36]

in the British Museum could be studies for this last section of the procession. A painted version of Federico's drawing in the Museo del Palazzo di Venezia in Rome is badly damaged, but one detail of the façade can be made out. Of the five figures on the left of the frieze, three are carrying between them on their shoulders what looks like a long pole, the fourth, so much smaller than the others that his head comes below the level of the pole, is walking between the centre and left-hand bearers, and the fifth figure heads the procession on the extreme left of the group. This corresponds in essentials with a drawing in my own possession, attributed to Polidoro when in the Lawrence Collection, of a party of Roman soldiers marching from right to left and carrying on their shoulders a model of a captured city supported on long poles (119. Pl. 2). The poses of two of the three foreground bearers agree well enough with the figures in the painting, but a more significant parallel is the presence in the drawing of the small figure between the centre and left-hand bearers. Allowing for the inevitable simplification of the painted copy, the similarity is close enough to permit the suggestion that this drawing may be a study for the extreme left-hand section of the same frieze.

Subject-matter, on the other hand, provides the only basis for the suggestion that a drawing in the Louvre, also traditionally attributed to Polidoro (181. Pl. 3), may be a study for another detail of the same decoration. The scene represented, of a line of women in classical robes holding small objects in their hands which they are waiting their turn to give to a man in Roman armour sitting at a table, can only be the episode described in the sixth inscription given by Vasari, *Matronalis Auri Collatione Votum Apolloni Solvitur*: the Roman matrons giving their jewels to propitiate Apollo who had been angered by Camillus's failure to fulfil a vow that he would dedicate part of his spoils to the god. It seems improbable that Taddeo would have treated this unusual subject on more than one occasion.[1] (If Federico's drawing is an accurate record, then the fact that the Louvre composition is frieze-shaped need not exclude the connexion: if the upright scenes between the windows numbered four on the main front and two, or at most three, on the other, then at least two, and possibly three, of the total of nine scenes must have been in the frieze.)

Though the subjects of the nine scenes on the façade cannot all be identified with certainty from the inscriptions, it is curious that none of these seem to refer

[1] A drawing in the Ashmolean Museum, Oxford (P. II. 752) has been claimed as a possible study by Taddeo for this detail of the façade (*Kunstchronik*, xiv (1961), p. 70). It was believed to be by Taddeo at the time of its acquisition in 1945 (see *Ashmolean Museum Report*, 1945, p. 23). In the 1956 catalogue it appeared under the correct attribution to Federico, but with a suggestion that it may represent this subject, and a reference to the Mattei façade, which are clearly vestiges of the period when the attribution to Taddeo was preferred. The identification of the subject is highly doubtful and the drawing itself characteristic of Federico both in handling and in composition. It is probably one of his early essays in the manner of Polidoro (cf. e.g. Uffizi 11186F; 1966 Exh., no. 32, repr.).

to the best-known and most often represented episode in the whole legend of Camillus: that of his chief opponent, the Gaulish leader Brennus, flinging his sword into the scales on which the defeated Romans were weighing out their indemnity. But even if this scene did not eventually find its way onto the façade itself, it is unlikely that it was never at any stage contemplated. It is possible, therefore, that a drawing of it in the British Museum, with an old attribution to Polidoro going back at least as far as the early eighteenth century, may also be connected with the Mattei commission (110. Pl. 16). If so, the squarish format of the composition suggests that it was intended for one of the spaces between the windows. Another drawing of similar format also with an old attribution to Polidoro, of a priest or soothsayer standing between two groups of soldiers, in the Teyler Museum, Haarlem (84), has recently been published by Mr Jaffé in connexion with a copy of the same composition by Rubens. In many ways this drawing resembles the British Museum *Camillus and Brennus*, but it is weaker in handling and more incoherent, and seems more likely to be a copy of a lost study by Taddeo. The Rubens copy is narrower in format and there are other discrepancies which show that it was not taken directly from the Haarlem drawing or from the hypothetical lost original. The subject is difficult to identify and cannot with certainty be related to any of the nine inscriptions, but the Rubens copy agrees in shape with the spaces between the windows in Federico's drawing of the façade and the scale and placing of the figures is not incompatible with Federico's very slight indications of the scenes. If a copy of the whole façade ever turns up, it would not be surprising to find that Rubens was copying a detail from it.

To these drawings connectible, for different reasons and in varying degrees of certainty, with the Palazzo Mattei façade, can be added a number of others which treat subjects from Roman history in the same archaeologizing spirit and must also be studies for façade decorations in the manner of Polidoro. A frieze with a procession of lictors in the British Museum, reworked by Rubens, close in handling to the frieze of soldiers and captives in the same collection and likewise attributed to Perino del Vaga in the early nineteenth century (103); an upright composition in the Louvre, classified as 'after Polidoro', of a Roman general on horseback leaning forward to address a suppliant (182. Pl. 1); a drawing of three trumpeters walking from right to left, among the anonymous Italian drawings in the same collection, which is evidently a detail of a frieze of a triumphal procession (197); a drawing of an antique sacrifice in the École des Beaux-Arts in Paris, there attributed to Francesco Salviati (168. Pl. 11); a composition of a group of Roman soldiers with horses in the collection of Mr David Rust in Washington (250. Pl. 9) which once belonged to William Young Ottley, who believed it to

be by Polidoro (not surprisingly, for the conspicuous figure in the left foreground is directly taken, the only difference being in the transposition of the arms, from one of the groups between the windows in Polidoro's Palazzo Milesi façade in the Via della Maschera d'Oro); and a design for two separate strips of frieze, one composed of sea-monsters and nymphs, the other part of a procession of figures with sacrificial offerings, with a traditional attribution to Parmigianino, in the Victoria and Albert Museum (113). Another drawing in the same collection (112), of a group of women and children with wine-jars – an indeterminate subject that in the eighteenth century might have been called a '*capriccio*' – is so faded and damaged that it now more easily studied in the admirable facsimile engraving in Ottley's *Italian School of Design*. This drawing differs from the others in being more complex in composition with greater emphasis on perspective in depth, but Ottley may nevertheless be right in describing it as part of a design for a frieze – though he was no doubt influenced by his belief that Polidoro was the draughtsman. A study of a group of women and children in the Uffizi, attributed in an old hand to Francesco Morandini, il Poppi, comes very close to the Victoria and Albert drawing in spirit and in handling and might even be a study for another part of the same composition (51. Pl. 10a). In the Budapest Museum, under the name of Francesco Villamena, is another drawing with rather the same flavour, of a rustic festival with shepherds dancing round a bonfire (16. Pl. 6), which at once brings to mind Peruzzi's famous drawing in the Uffizi of a festival in the Roman Campagna with a ring of dancing shepherds watched by a group of women and children, the shape of which also suggests a design for a frieze.[1]

Of the drawings in this early, Polidoresque group with old attributions to Taddeo, the one identified by Resta as a design for part of the Mattei façade has already been discussed. Another is the sheet of studies of a nude man brandishing a cutlass, in the Uffizi, inscribed in an old hand *viene da Taddeo Zuccaro* (72. Pl. 15). This is not a copy, as the inscription seems to imply. The thin, wiry line, the 'fish-face' of the half-length figure on the right and the simplified curve of his cranium, and the flipper-like right hand of the central figure, are all characteristic of Taddeo's early drawing style. The absence of any particular compositional relationship between the figures, and the way they seem to be flattened against the front picture-plane with cast shadows indicated on a flat surface immediately behind them, suggest that they are detail studies for a façade painting. Two other such drawings illustrate the care which Taddeo devoted to these compositions. The attribution to him of the sheet of red chalk figure-studies in the Metropolitan Museum, inscribed in an old hand with the name of Polidoro's shadowy *alter ego* Maturino, was subsequently confirmed by the observation that the unusually

[1] Uffizi 658E. Repr. S. J. Freedberg, *Painting of the High Renaissance in Rome and Florence*, 1961, pl. 489.

large and fully realised drawing of a nude man on the *recto* (143. Pl. 12) is a study for the soldier holding the horse's bridle in the centre of Mr Rust's study for a composition of Roman soldiers with horses (250. Pl. 9). The three soldiers sketched on the *verso* of the same sheet (Pl. 14) no doubt appeared in a battle-scene on the same façade. A study for the group in the right foreground of the composition of an Antique sacrifice of which there is a drawing in the École des Beaux-Arts (168. Pl. 11) is in the Ashmolean Museum (160. Pl. 13). In the drawing of the complete composition the group is enlarged by one figure, the principal figure in it is a woman, and the child with the pan-pipes is turned away from the spectator, but the connexion is established beyond doubt by the figure lightly drawn on the left of the Oxford sheet who appears fully realised in the background of the other as a priest entering the temple with hands upraised. The Oxford study was attributed to Polidoro in the Lawrence Collection, but in Sir Karl Parker's catalogue of the Italian drawings in the Ashmolean Museum it appeared with a tentative attribution to Taddeo. At this point I must gratefully acknowledge my indebtedness to Sir Karl, for in 1956, when his catalogue appeared, the nucleus of this group of early drawings had already been assembled but their authorship was still a mystery, and it was his suggestion which in a flash revealed the answer. The elusive nature of Taddeo's personality is brought home by the comment in the catalogue that the drawing is 'particularly difficult to place. Suggestions ranging from Abbate to Franco have been made; two of the heads suggest a distant influence of Parmigianino'. The acuteness of this last observation is underlined by the more overtly Parmigianinesque character of the related drawing in the École des Beaux-Arts, in which the feathery penwork and loosely handled white heightening suggest knowledge of such drawings by Parmigianino as the Louvre *Holy Family* or the Uffizi *Adoration of the Shepherds*:[1] a modification of its basically Polidoresque style that is only to be expected, in view of the role played by Daniele Porri in Taddeo's education.

The main difficulty confronting students of sixteenth-century Roman façade decoration is lack of data. With hardly an exception the paintings themselves have disappeared, while most of the references to them in early literature merely allude to the existence of a façade by a particular artist without even specifying the subject-matter of the paintings. Vasari does, however, describe two other façades by Taddeo in addition to the Palazzo Mattei: one with six scenes from the life of Alexander the Great on a house near S. Lucia della Tinta, and that of the house belonging to the Postmaster Mattiuolo in the Campo Marzio which he decorated with 'storie di Mercurio, messaggiero degli Dii che furono molto belle; ed il restante fece dipingere ad altri con disegni di sua mano'. Giulio Mancini in the

[1] Louvre 6446 and Uffizi 747[E]: A. E. Popham, *The Drawings of Parmigianino*, 1952. pls. IX and XXI.

early seventeenth century mentions his decoration of a master-mason's house in the Via dei Farnesi composed of 'tutti gli instrumenti di simil professione',[1] and in the Campo Marzio 'la facciata alle lettere d'oro'.[2] In his life of Federico Zuccaro Baglione says that the two brothers together decorated a façade in the Piazza Colonna with a *Pietà* between St Peter and St Paul, Federico being responsible for the St Paul and Taddeo for the rest. No trace of any of these remains, and though there are any number of sixteenth-century engravings of details from Polidoro's façades – their quantity reflects his preeminence in this field – I have not found even one which can be demonstrated to be after Taddeo, nor anything attributable to him in Enrico Maccari's publication of such façade paintings as were still extant in Rome in about 1880.[3] Another, earlier source of information is the volume of sixty-two engravings published in 1791 by C. M. Metz under the title *Schediasmata Selecta ex Architypis Polidori Caravagiensis* which reproduces in facsimile an album or book of drawings then in the collection of Sir Abraham Hume. Most of these are frieze-shaped and represent classical battle-scenes and the like and several reproduce compositions well-known to be by Polidoro, so it is only natural that they should have been attributed wholesale to him in the eighteenth century. But to judge from the way many of them either break off altogether or are continued in outline just as a *sgraffito* painting would do if damaged by weather, it seems more likely that the book consisted of a late-sixteenth or early-seventeenth-century collection of copies of Roman façade paintings. Plate 7, which reproduces a design composed of two rows of gigantic capital letters with figures grouped round them (Pl. 25), and plate 6, of a single

[1] Giulio Mancini, *Considerazioni sulla Pittura*, ed. A. Marcucci, with notes by L. Salerno, Rome, 1956/7, i, pp. 280 and 312. The façade is described in one place as being in the 'vicolo per venire alla Morte' and in the other as in the 'vicolo di S. Girolamo della Carità'. Salerno identifies the 'vicolo' with the present Via dei Farnesi (i.e. the street running along the north side of the Palazzo Farnese) and claims that the decoration 'ancora esiste'. I have been unable to detect any trace of it.

[2] Mancini, op. cit., i, p. 282.

[3] *Secolo XV. XVI. Saggi di archittetura e decorazione italiana illustrati da M. Giovanni Iannoni: Graffiti e chiaroscuri esistenti nell'esterno delle case riprodotti in rame per cura di Enrico Maccari*, Rome, n.d. After this book was in the hands of the printer Dr Tilman Falk pointed out to me that Maccari's engraving of a row of seven windows, each inscribed F DE MONTE, with single full-length female figures in the spaces between them, entitled *Avanzi di un chiaroscuro esistente fuori di Roma nella Via Flaminia a un chilometro circa di distanza*, must reproduce a façade-decoration by Taddeo described by Baglione in his life of Vignola: 'incontro al qual'edificio [the palace added by Pius IV to Julius III's fountain in the Via Flaminia, on the corner of the Via dell'Arco Oscuro] alcune Virtù, che in quel muro basso della strada di color giallo furono finte, sono pitture di Taddeo Zucchero sotto Giulio iii, con quegli ornamenti lavorate'. An early nineteenth-century engraving by Luigi Rossini of a view looking north up the Via Flaminia shows this long, low building, with a single row of windows alternating with full-length figures, immediately opposite the fountain on the other side of the road. One of the figures in Maccari's engraving is seated, holding a book or tablet on her knee. Dr Falk suggested that the drawing of a seated Sibyl in the Uffizi (69. Pl. 33) might have been made in connexion with this project.

capital 'M' with two figures (Pl. 24b) which evidently formed part of the same scheme, immediately bring to mind Mancini's cryptic allusion to a façade 'alle lettere d'oro'; and the probability that these two plates may in fact reproduce part of this otherwise unrecorded work by Taddeo is strengthened by a drawing in the Herzog Anton Ulrich-Museum at Brunswick inscribed in an old hand with the word *Zuccaro*, certainly by Taddeo and from its style datable around 1550, of a very similar group of *Prudence* with two *putti* combined with a large-scale capital 'L' (12. Pl. 24a).[1]

The value of this collection of engravings as evidence is of course diminished by the fact that they reproduce the original paintings, themselves no doubt somewhat faded and damaged, at two removes, reinterpreted first by the copyist and again, much later, by the engraver, with the result that the finer shades which distinguish compositions by Polidoro himself from those by Taddeo in his manner have been obliterated. Nevertheless, one or two of the other plates are perhaps worth mentioning. For example, it is evident even from the engraving that the composition of *Jupiter suckled by Amalthea* on plate 1 (Pl. 25) is not by Polidoro but is much closer to Taddeo, and it is also possible that Taddeo was responsible for the escutcheon with four allegorical female figures on plate 53. Plate 45 is of a frieze in three sections, beginning on the left (right in the reversed engraving) with the Birth of *Alexander the Great*, continuing with *Alexander and Bucephalus* and the *Cutting of the Gordian Knot*, and ending in what seems to be intended for some kind of curved moulding. If these three scenes were balanced by three more on the other side of this interruption, the complete frieze would correspond exactly with Vasari's description of the façade decorated by Taddeo near S. Lucia della Tinta: 'piena di storie di Alessandro Magno, cominciando dal suo nascimento, e seguitando in cinque storie i fatti piu notabili di quell'uomo famoso'.

How far does this scanty evidence enable any general conclusion to be drawn about Taddeo Zuccaro as a decorator of façades? Everything suggests that he was content to carry on from where Polidoro left off twenty years before, without (except possibly in such *jeux d'esprit* as the façade 'alle lettere d'oro' and the one for the master-mason) any departure from the established formula. It is significant that a high proportion of the drawings discussed above were traditionally attributed to Polidoro, and that one or two of them are so Polidoresque in style that in default of a precise attribution they could perfectly well be catalogued as contemporary or near-contemporary copies of otherwise unrecorded compositions by the older master. (The early group of drawings by Taddeo includes only one

[1] The style of the drawing suggests a date not later than the mid-1550's. A rather similar combination of figures and large-scale capital letters datable in the first half of that decade is the frieze composed of winged *putti* playing round the letters of the name of Julius III (1550-55) in one of the private apartments in the Vatican (repr. *Commentari*, xviii (1967), p. 61).

[42]

copy actually after Polidoro; and this, at Christ Church, Oxford (164), reproduces not a façade painting but the fresco of the *Meeting of Janus and Saturn*, formerly in one of the rooms of the Villa Lante on the Janiculum, and now in the Palazzo Zuccari.) Only in Federico's drawing of the Palazzo Mattei has any record been preserved of the appearance of a complete façade by Taddeo, and here he seems to have kept to the pattern established by Polidoro in such façades as those of the Palazzo Milesi and the Palazzo Ricci, of horizontal friezes in grisaille dividing the rows of windows and smaller upright scenes, varied sometimes by vases, trophies or single figures, between the windows. Polidoro's façades were always in monochrome, either black and grey or yellow and brown; and their colour, together with the absence of true perspective in the friezes in which the figures move with an emphatic sideways rhythm and seem, as it were, to be compressed into the immediate foreground plane, show that the decoration was intended to simulate antique sculpture built into the wall. Polidoro's starting point was the convention of the Roman sarcophagus relief, which he reinterpreted in the idiom of Raphaelesque Mannerism. But how closely the antique prototype and the reinterpretation approach one another is shown by a drawing in the British Museum of a group of fighting horses, which might perfectly well have been included along with those listed above as yet another study by Taddeo for part of a Polidoresque frieze but proves in fact to be a faithful copy of part of an Antique sarcophagus of the *Fall of Phaeton* which in the middle of the sixteenth century stood outside the door of S. Maria in Aracoeli in Rome (99. Pl. 18). A later stage in Taddeo's absorption of the Antique is marked by the Louvre drawing of the Roman general with the suppliant (182. Pl. 1) which is a free version of one of the Hadrianic reliefs formerly on the Arco di Portogallo and now in the Museo dei Conservatori.

<h2 style="text-align:center">4</h2>

The Parmigianinesque elements in the École des Beaux-Arts drawing of the Antique sacrifice remind us that Taddeo's early style is not to be defined solely in terms of Polidoro da Caravaggio. Where drawings are concerned, Perino del Vaga is an even greater potential source of confusion. Even between Taddeo's most Polidoresque drawings and drawings by Polidoro himself the distinction is hardly ever in doubt for more than a moment or two, but there are several which hang precariously in the balance between Perino and Taddeo. Perino was still active in Rome for three or four years after Taddeo's arrival, and though there is no reason for assuming that there was any direct contact between them, it is significant that the suggestion that Taddeo worked under Perino in the Castel Sant'Angelo should have been put forward in all seriousness and has been generally

accepted as plausible. Taddeo's susceptibility to Polidoro's influence was the natural consequence of his early ambition to excel as a façade painter, and seems not to have persisted beyond the few years during which this was his main interest, but as late as 1560, in the frescoes at Bracciano and in some of his designs for maiolica, we find him reverting to Perino as a source of inspiration; while Perino's variations on Polidoresque themes in the Sala degli Trionfi in the Palazzo Doria in Genoa anticipate the spirit in which Taddeo was to treat similar subjects nearly twenty years later.[1] But a close stylistic affinity does not necessarily depend on direct contact between the artists concerned: Raffaellino da Reggio, for example, was only sixteen years old when Taddeo died and had not even come to Rome, yet he showed himself infinitely more capable than his actual master, Federico Zuccaro, of understanding and creatively developing Taddeo's ideas; similarly it is Taddeo, and not Siciolante da Sermoneta or Luzio da Todi or Marco Pino or any other of Perino's actual associates during his last decade in Rome, who has the best claim to be described as Perino's 'artistic heir'.

An example of the kind of drawing which hangs in the balance between Perino and Taddeo is one at Düsseldorf (27) which since the eighteenth century has gone without question under the name of Perino. It represents a ring of mythological figures, mostly tritons, fighting and embracing, and is a design for the decoration of the rim of a circular dish evidently inspired by the similar design by Raphael for which there is a study at Windsor. This Raphaelesque derivation, and the fact that one pair of tritons even corresponds with a much copied composition by Perino, have made the traditional attribution seem entirely plausible – until the discovery, in the Rosenbach Foundation in Philadelphia, of a rough sketch for the same design on the other side of a sheet of studies by Taddeo for the Mattei Chapel frescoes (211 recto. Pl. 44). When the attribution is reconsidered in the light of this second drawing, it is at once obvious, from such typical features as the areas of coarse regular hatching, the ribbon-like locks of hair, and the facial type of the triton blowing a conch immediately to the left of the pair of wholly human figures, that the Düsseldorf drawing is also by Taddeo. Perino has also passed unchallenged until recently as the author of two closely related drawings in the Uffizi, both projects for the decoration of the same small room. In each of these is an identically spaced pair of identically proportioned doorways, between

[1] An example of a late drawing by Perino which in some ways comes close to early drawings by Taddeo is one of an Antique sacrificial scene in the Louvre (6080), formerly attributed to Polidoro and strongly influenced by him in subject-matter and treatment. Perino's authorship was first pointed out by Mr Pouncey, and the attribution is confirmed by Miss Davidson's identification of the drawing as a study for part of the *basamento* in the Stanza della Segnatura in the Vatican which Perino executed in the 1540's (*Mostra di disegni di Perino del Vaga e la sua cerchia*, Uffizi, 1966, no. 47, repr.).

which in one drawing (35. Pl. 27) is a fireplace and in the other a console table (36. Pl. 26). Above the fireplace is a composition of *Venus in Vulcan's Smithy* surrounded by a heavy moulding, and the doors on either side are surmounted by allegorical female figures one of whom is setting fire to a trophy of armour and can thus be identified as *Peace*. In the other drawing, the group over one doorway consists of a figure of *Fame* with two *putti,* and that over the other Venus attended by Cupid and embraced by Mercury. The persistent tendency to connect the fireplace drawing with the Palazzo Baldassini in Rome, where Perino was working in the early 1520's, does not go back further than a suggestion made in 1880 by Milanesi who had been struck by the resemblance between this drawing and Vasari's description of a detail of Perino's decoration: 'sopra il camino di pietre, bellissimo, una Pace la quale abbruggia armi e trofei'. But the drawing differs from this description in one essential detail, for in it the figure of *Peace* is a subsidiary element, not over the chimneypiece but over a door to one side; and furthermore, as Miss Davidson was the first to point out, the connexion with the Palazzo Baldassini is excluded by the letters GV VB DX over the doorways in the companion drawing, which show that the decoration was designed for Duke Guidobaldo II of Urbino and must date from after his succession to the Duchy in 1538. The drawing with the fireplace contains so many Perinesque motifs – an engraving by Giorgio Ghisi which in essentials corresponds with the scene sketched over the chimney-piece is inscribed PIRINVS IN – that if it were considered in isolation one might well hesitate to take it away from Perino; but the scribbly yet plastically rounded handling of the figures in the companion study is entirely Taddeo's, and when the two are considered in the context of his drawings as a whole, there can be no doubt that he is the author of both. The attribution to Taddeo is given further support by the inscriptions over the doors, for while there is no reference to the Duke of Urbino in Vasari's detailed account of Perino's last years in Rome from about 1538 onwards, Taddeo returned to Urbino to work for him on at least two occasions, once in 1551 and again in 1560. The style of these drawings suggests the first visit rather than the second, for some of the faces – for example, that of Venus in the scene over the chimneypiece and in the group over the right-hand door in the other drawing – can be matched in drawings datable around 1550. It is tempting, therefore, to connect these two designs with the room in the palace at Pesaro which Taddeo decorated for the Duke during his first visit, between 1551 and 1553. The few remaining traces of sixteenth-century decoration in the palace include nothing which can be identified with Taddeo's work, but Vasari's word 'studiolo' implies a small room, and (for what it is worth) the Duke's initials are carved in exactly the same form on the lintels of many of the doorways.

Another drawing which might have been made in the course of the same visit

[45]

is a careful design for a rectangular ornamental panel consisting of an escutcheon supported by Minerva holding an olive-branch and another female figure holding a bough of oak and thus identifiable as *Fortitude*, surrounded by an ornate border of swags and ribbons with masks and *putti* (155. Pl. 17). Sir Karl Parker suggested that this allegory of the union of Peace with Strength might be an allusion to the della Rovere family, on whose arms an oak-tree is the principal charge, but went on to object that the absence of papal insignia above the escutcheon precluded any connexion with Pope Julius II who, on his hypothesis that Baldassare Peruzzi was the artist responsible, was the only member of the family likely to have been concerned. But it must be emphasized that there is no traditional basis for the attribution of this drawing to Peruzzi; and though no attribution put forward by Parker can be lightly dismissed, if the reader will compare this drawing with the one reproduced on the opposite plate in the Ashmolean catalogue, or with those illustrated in the catalogue of drawings by Raphael and his Circle in the British Museum (to name two of the more easily accessible publications illustrating drawings by Peruzzi) he may perhaps ask himself whether the resemblance in handling is more than superficial; whether the two figures have anything of the matronly *gravitas* and marmoreal solidity of Peruzzi's normal female type; and, in short, whether the design is not altogether too developed and sophisticated in taste for Peruzzi, who was born in 1481 and who remained, especially in his decorative designs, a conservatively High Renaissance artist whose style was firmly rooted in the *quattrocento*. Some years ago I argued that the Ashmolean drawing must be the work of someone belonging to a later generation, influenced by Francesco Salviati and Niccolò dell'Abbate. These stylistic cross-bearings converge at a point not far from Taddeo Zuccaro; but though at the time Mr Pouncey urged the resemblance between this drawing and the British Museum *Camillus and Brennus* (110. Pl. 16), I was not then persuaded that the two were necessarily by the same hand. Now that I am more familiar with the extent of Taddeo's potentialities, however, I agree that the Ashmolean drawing is by him. It is unusually deliberate in handling, but it seems to me that his hand can be seen in the touch of the pen on the paper and in the way the light falls across the draperies. The comparison with the drawing of *Camillus and Brennus* is particularly convincing in the facial types: the saturnine mask decorating Minerva's helmet is identical in type and psychology with the face of Brennus, and the *putto* with the torch in the lower left-hand corner might be twin brother to the round-faced, round-eyed boy who peers round the neck of Brennus's horse.

Given that this drawing is by Taddeo, and that Parker was right in suggesting some connexion with the Della Rovere family, what is its purpose likely to have been? The scale and elaborate detail suggest something smaller, and intended to

[46]

be seen from closer to, than the 'arme grande a fresco' which Taddeo painted on the façade of the palace in Pesaro: possibly a relief of some kind, to judge from the flatness of the modelling and the indication of the cast shadows. One explanation of this drawing could be that it was a design for a stucco panel over a fireplace (perhaps even an alternative to the one with *Venus in Vulcan's Smithy* in the Uffizi drawing) and that the disproportionately massive plinth supporting the figures is the upper part of the chimneypiece itself. At least one chimneypiece with a finial of this shape is in the ducal Villa Imperiale outside Pesaro,[1] and in the middle of the sixteenth century there seems to have been a local fashion for elaborate overmantel panels in stucco. One or two, which from their style must belong to the period of Guidobaldo II and are probably by the local *stuccatore* Federico Brandani, are still to be seen in the palace in Pesaro.[2]

Taddeo's main business in Urbino, however, was with the series of scenes from the life of the Virgin in the Cathedral. Vasari tells us that 'una parte di quelli [disegni] è appresso Federigo suo fratello, disegnati di penna e chiaroscuro' and against this passage Federico has noted 'li quali disegni sono trasordiniarmente belli e studiati, e grandi di quatro e sei fogli reali l'uno'. The Royal sheet of paper measured about eighteen inches by twenty-four[3] so that these drawings would seem to have been cartoons or full-size *modelli*, and it is tempting to identify them with the 'tre disegni del S.r. Thadeo d'acquerello su carta incollati su tela uno la Natività di N.S. et l'altro la circoncisione e l'altro l'adorate de magi' which were among Federico's effects at the time of his death and which must have been exceptionally large, to judge from their being mounted on canvas and listed separately in the inventory.[4] The subjects of these, the *Nativity*, the *Circumcision* and the *Adoration of the Magi*, are not thought of as being primarily from the life of the Virgin, but she plays a prominent role in all three and if the proposed series of frescoes was a large one these scenes might well have been part of it. One episode, however, that would almost certainly have been included in any such cycle is the *Birth of the Virgin*, and for a composition of this subject two related studies by Taddeo are known, both datable from their style about 1550. One of

[1] See B. Patzak, *Die Renaissance-und Barockvilla in Italien*, iii: *Die Villa Imperiale in Pesaro*, Leipzig, 1908, p. 90, fig. 56.

[2] One is reproduced by G. Vaccaj, *Italia Artistica: Pesaro*, Bergamo, 1909, p. 33 and G. Masson, *Italian Villas and Palaces*, London, 1950, pl. 105. Two others, by Federico Brandani, in the Castello dei Brancaleoni at Piobbico, near Urbino, are repr. in *Commentari*, xviii (1967), p. 65.

[3] See C. M. Briquet, *Les Filigraines*, Paris, 1907, i, pp. 3 f.

[4] Körte, p. 83. These drawings perhaps resembled the full-scale *modello* by Pellegrino Tibaldi for his *Adoration of the Shepherds* of 1548 in the Borghese Gallery (see p. 60, note 1), fragments of which are in the Uffizi and the British Museum (*British Museum Quarterly*, xxvi (1962), pls. xxii and xxiii). This *modello*, which was presumably the same size as the picture, that is 60 by 40 inches, was executed with the point of the brush in dark brown wash, with a few touches of white heightening.

these, in the Uffizi (38. Pl. 28), is there attributed, like the two designs for the decoration of a room, to Perino del Vaga. In such details as the pose of the woman seated on the right and the coiffures and negroid features of some of her companions this drawing comes so close to Perino as to explain the general acceptance of the old attribution[1]; but anyone with his eye in for Taddeo's early style will immediately recognise such a characteristic detail as the foreshortened head, tilted away on the end of a long neck, of the figure in the centre background. Fortunately, however, the other study for the same composition, in the Albertina under the name of Paolo Farinati (245. Pl. 29), makes it unnecessary to labour the point: Perino could never for a moment be considered a possible author of this drawing, which immediately and unequivocally reveals Taddeo's authorship.

A red chalk drawing in the collection of Lord Methuen (24. Pl. 31), inscribed with Taddeo's name in an old hand, of a woman sitting on a low stool with a baby in her arms, who is evidently intended as a figure in the foreground of a birth-scene, can be dated at about the same time as the two composition-studies. It still reflects the influence of Polidoro in the handling of the red chalk and the treatment of the drapery (there is perhaps even some echo of his tendency to *genre* realism in the pulling up of the skirt to reveal the petticoat), while the claw-like right hand is exactly matched in the Metropolitan Museum's large-scale red chalk study for a figure in a Polidoresque façade decoration (Pl. 12). The motif does not occur in either of the two composition-studies, but these are rapid sketches which do not necessarily represent the eventual solution: a careful study of a single figure would probably not have been made until the composition had attained its final form. A second such study, of two women sitting on the ground, one holding a baby and with a swaddling-band across her knees, is in the Albertina, also under the name of a Veronese master, but one of a later generation than Farinati – Alessandro Turchi (246. Pl. 30). Lord Methuen's drawing is undoubtedly in Taddeo's early manner, but Taddeo's drawings are not always so easy to date on stylistic evidence alone and the Albertina drawing may well prove to be somewhat later, perhaps even as late as the mid-1550's.

Yet another drawing of a subject relating to the Virgin can be dated around 1550 for reasons of style. This study, apparently for a large-scale altarpiece with an arched top (the present shape of the sheet is the result of trimming and the upper part of the composition seems originally to have been semicircular), in the Louvre, shows her as the *Assunta* attended by angels with God the Father above and Prophets and Sibyls below grouped on either side of the Beast of the Apocalypse (183. Pl. 32). There is no evidence that Taddeo was required to do more in

[1] Cf. also Perino's sketches of an *Adoration of the Shepherds* in the Ashmolean Museum (P. II. 229, as Figino).

Urbino Cathedral than decorate the side-walls ('facciate') of the choir with scenes from the life of the Virgin, but of all his recorded commissions in the period before 1553 this is the only one likely to have involved a project for a monumental altarpiece of this particular subject. Such an altarpiece would have been an appropriate accompaniment to Battista Franco's *Coronation of the Virgin* 'with Patriarchs, Prophets, Sibyls, Apostles, Martyrs, Confessors, and Virgins' on the vault of the choir; and in fact the painting over the high altar which was destroyed in 1789 when the choir collapsed was an *Assumption of the Virgin*, said to have been by Barocci.[1] Whether or not this attribution was correct it at least suggests that the lost picture was a work of the later sixteenth century, so it may well be that the choir was still without an altarpiece in 1551. If so, it seems more than likely that the artist commissioned to decorate the side-walls of the choir might also have suggested a possible way of dealing with the altar-wall. A drawing in the Uffizi of a seated Sibyl holding a tablet (69. Pl. 33) could be a study for the conspicuous figure in the right foreground of the composition.[2]

<div align="center">5</div>

The drawings so far discussed are of two kinds: those that are evidently studies for façade-paintings in the manner of Polidoro and those possibly connected with Taddeo's activity in Urbino and Pesaro between 1551 and 1553. There remain a few others belonging to the early group which fit into neither category. A study in the Louvre for a circular composition of a Pope opening the *Porta Santa,* for example, is the most securely datable drawing of the group and provides a valuable fixed point in this attempted reconstruction of Taddeo's early development (189. Pl. 8). The ceremony takes place only once in every quarter of a century, in a Jubilee Year, so this must be a design commissioned by Julius III, who, as we have already seen, was one of Taddeo's early patrons, for the, apparently never executed, reverse of a medal commemorating the Jubilee of 1550. Other drawings throw light on the relationship between Taddeo and two contemporaries whose acquaintance he seems to have made in the early 1550's, Girolamo Muziano and Bartolommeo Passarotti. Muziano, born in Brescia in 1532, studied chiefly landscape in Padua and Venice, but in 1549 came to Rome and spent the next five or six years there perfecting himself as a painter of figure subjects. It was no doubt then that he came to know Taddeo, in whose company, according to Ridolfi, one of his early biographers, he went about Rome making copies after modern and Antique works of art. But that Taddeo, three years his senior and already an accomplished figure painter, may have played a more

[1] See H. Olsen, *Federico Barocci*, 1962, p. 212.

[2] But see also above, p. 41, note 3.

significant role in his development than that of a mere companion on sketching expeditions is suggested by the apparent connexion between a drawing by Taddeo at Hamburg, of *The Angel warning St Joseph to fly into Egypt* (86. Pl. 78), and Muziano's altarpiece of the same subject in S. Caterina della Ruota.[1] According to Muziano's own account, this picture was painted during the first half of the 1550's; and this is the period to which – to judge from their style – the Hamburg drawing and the study for the group of angels in the upper part of the composition, in the Krautheimer Collection in New York (145. Pl. 81), also belong. There is no exact correspondence between the drawing in Hamburg and the painting, but the resemblance in general composition and in the pose and sentiment of the principal figures is so striking that if the two were by the same hand one would have no hesitation in declaring one to be a preparatory study for the other. In the sixteenth century it was not unheard of for artists to help one another in this way – the collaboration between Michelangelo and Sebastiano del Piombo is an obvious instance – and one possible explanation is that Muziano's *Flight into Egypt* owes its composition to Taddeo. But if so, there is no way of telling, without further evidence, whether Taddeo made these drawings especially for Muziano's benefit, or whether Muziano was adapting studies originally made for some other purpose.

For Passarotti, on the other hand, Taddeo does seem to have made drawings on purpose. This artist was born in Bologna in 1529 and was thus Taddeo's exact contemporary. According to his earliest biographer, Borghini, he worked with Taddeo and for a time even shared a house with him. Borghini does not enlarge on the nature of their collaboration nor is it clear from his account when it took place, but a document establishes Passarotti's presence in Rome in June 1551[2] so that he and Taddeo could have been in contact even before the latter's departure for Urbino sometime in that year; and that this was so is suggested by preliminary studies for two etchings by Passarotti, which in my opinion are by Taddeo and datable around 1550. A drawing of a standing St Peter in the Pierpont Morgan Library (143) corresponds, in reverse and with important differences in the position of the hands, with one of a set of etchings by Passarotti of single figures of Christ and five Apostles. In stance and in facial type and psychology another one of this set, representing St Paul, is so strikingly like the principal figure in the Ashmolean Museum study for a group in a sacrificial scene (160. Pl. 13) as to make it reasonable to suppose that all six are based on designs by Taddeo. The etched figures are the right way round – that is to say, Christ holds the standard in his

[1] See *B. Mag.*, cviii (1966), pp. 417 f.

[2] See A. Bertolotti, *Artisti bolognesi, ferraresi ... in Roma*, p. 41, in *Documenti e studj pubblicati per cura della R. Deputazione di Storia Patria, per le provincie di Romagna*, Bologna, i, 1886.

right hand, as does St Paul his sword and St Bartholomew his knife – and since the Pierpont Morgan *St Peter* is in reverse to the corresponding etching, the designs for the others were presumably likewise in reverse and thus the wrong way round. It is probable, therefore, that they were made on purpose for the etchings. The other etching by Passarotti which goes back to a design by Taddeo represents *Joseph and Potiphar's Wife*. The composition is generally given to Parmigianino, but a preliminary study, in my own possession, seems to me undoubtedly an early drawing by Taddeo of the same period as the Pierpont Morgan *St Peter* (120. Pl. 34).[1]

<div align="center">6</div>

The attribution of drawings to the period of Taddeo's activity from which no recorded or documented work has survived is based on my own conception of his artistic personality. I hope that the reader will agree that the group is both consistent in itself and a convincing prelude to Taddeo's earliest authenticated work. I have made no attempt to justify every attribution in detail but it may at this stage be helpful to single out some of the more obvious characteristics of the group as a whole. Nuances of facial type and expression are among the most reliable indications of an artist's personality, and there are certain faces that one soon comes to recognize: a pointed fox-like mask with eyes and eyebrows slanting sharply upwards; another rather similar face, with something of the half-human, half-animal melancholy of a faun or satyr; a roundish face with a receding double chin, sometimes seen foreshortened, tilted away from the spectator on the end of a long neck, and sometimes in 'fish-faced', open-mouthed profile; a negroid type with a flattened nose and thick lips; sometimes, too, one comes across the round-faced, round-eyed, flat-nosed mask that appears in so many of Taddeo's later drawings. Heads are sometimes drawn with a continuous spiral movement of the pen ending in a single vertical stroke to indicate the middle of the face, and profiles – often of an almost neo-classic regularity – by a single curving stroke for the nose and cranium over which curls of hair are added in a rapid looping scribble, while the eye is often nothing more than a dark blot. Hands tend to be

[1] Bartsch lists altogether fifteen etchings by Passarotti (xviii, pp. 2 ff.). B. 1 being *Joseph and Potiphar's Wife* and B. 6 to 11 the series of Christ and five Apostles. Of the remaining eight, B. 2 reproduces Salviati's S. Giovanni Decollato *Visitation* and B. 4 Raphael's *Aldobrandini Madonna*. A drawing in the British Museum (1946–7–13–448) corresponds in reverse with the allegorical figure of *Religion* (B. 12) and is presumably the preparatory drawing for it. It bears an old and no doubt correct attribution to Passarotti, and is by a hand quite distinct from, and weaker than, that responsible for the drawings connected with *Joseph and Potiphar's Wife* and *St Peter*. B.15, a Polidoresque composition of an antique sacrifice, probably reproduces a lost drawing by Taddeo for one of his façade decorations. I would be inclined to doubt whether B. 3 and 5 have any connexion with him, while reserving judgment about the allegorical figure of *Painting* (B. 13). I have not seen an impression of B. 14, '*La femme au lit*' or of the *Holy Family* which Bartsch lists without numbering under the heading '*Pièce douteuse*'.

<div align="center">[51]</div>

drawn in the same way, with a single curve for the line of the knuckles on which the fingers are superimposed, or else reduced to a rudimentary flipper springing straight from the arm with hardly any suggestion of a wrist. Taddeo's tendency towards a sculptural rounding-off of form is well illustrated, on the *verso* of the New York sheet of studies, by the stump to which the right arm of the left-hand figure is reduced and by the left hand of the figure in the centre which is drawn as a knob on the end of the arm with the fingers loosely attached (Pl. 14). At this early period Taddeo seems to have favoured a thinner and more wiry line than we find in his later drawings. The word 'wiry' suggests the arabesques of a calligraphic virtuoso like Battista Franco, but magnification of Taddeo's outlines reveals a succession of infinitesimal changes of direction and continuous variations of pressure and accent which combine to produce the effect of soft plasticity which is one of the most marked characteristics of his drawing style. This springy line, the sideways movement of the figures, and the obliquely-looking, turned away faces, give these drawings an elusive, glancing quality which is too subtle to define but which is apparent as soon as one of them is placed alongside a similar drawing by Polidoro.

Federico's series of drawings of the events of his brother's early life not only shows Taddeo copying works by Michelangelo, Raphael, and Polidoro, but includes as well symbolic portraits of these three artists along with one of Taddeo himself. How far is this implied analysis of Taddeo's artistic formation borne out by the drawings so far discussed, in which the style of his maturity can be seen in the process of development? The inclusion of Polidoro is entirely justified, for Taddeo's early compositions are so closely based on his that he must be considered as one of the principal formative influences on Taddeo's early style; but though no Roman artist in the 1540's could escape the by then widely diffused and all-pervading influence of Michelangelo and Raphael, there is little in Taddeo's early work to suggest direct study of either. Its basically Polidoresque character is modified, rather, by Perino del Vaga and, to a lesser extent, by Parmigianino. But though Parmigianino's influence can be detected here and there in Taddeo's early drawings, that of Correggio does not become apparent until after his return from Urbino in 1553, in the period of the Mattei Chapel. Similarly, it is not until even later, as his classicizing tendency increases from the end of the 1550's onwards, that we find him, in such drawings as his early design for the Frangipani Chapel *Blinding of Elymas* or the studies for the altarpiece in S. Lorenzo in Damaso, going directly back to Raphael for inspiration. At first he preferred the diluted and more easily assimilable Raphaelism developed by Polidoro and Perino and also – rather more surprisingly perhaps – by Sodoma. The loose stringing out of the figures in Sodoma's Farnesina frescoes, their languid movements and relaxed

contrapposto, the predilection for faces in profile and even some of the facial types, anticipate more features of Taddeo's early style than can be explained by mere coincidence.[1] Michelangelo's direct influence, on the other hand, seems to have been negligible. The red chalk male nude on the Metropolitan Museum sheet (Pl. 12) may owe something to studies by Michelangelo of the type of those in the British Museum for Adam and Haman on the Sistine Ceiling,[2] but at no stage in his career can Taddeo be described as a Michelangelo follower in the sense of which this can be said of his contemporary and, apparently, associate in the early 1550's, Pellegrino Tibaldi. When he essays the 'Michelangelesque' it is under the immediate inspiration of Tibaldi and Daniele da Volterra; and even when he takes motifs bodily from Michelangelo these have been, as it were, defused, emptied of their intense emotional content, and incorporated without incongruity into a suave decorative style which has more in common with Perino del Vaga.[3]

Once a number of drawings have been brought together and identified as the work of one particular hand, it is usually best to leave well alone and resist any temptation to blur the satisfactorily defined outline of the group by adding other drawings whose claim to be part of it is anything less than completely convincing. But one last drawing remains to be discussed which makes it necessary to end this

[1] One of Federico's drawings of Taddeo's early life shows him copying Raphael's frescoes in the loggia of Psyche on the ground floor of the Farnesina, but that he also knew the first floor is shown by the appearance in one of the friezes in one of the upper rooms of the Villa Giulia of an entire group lifted from Peruzzi's frieze in the Sala dei Prospettivi, which adjoins the room with Sodoma's frescoes of Alexander the Great (cf. *B. Mag.*, cvii (1965), p. 206).

[2] 1926–10–9–1 *recto* and 1895–9–15–497 *recto* (Wilde 11 and 13).

[3] Antal's suggestion (*Kritische Berichte*, 3/4 (1928/29), p. 217 and *Classicism and Romanticism, with other Studies in Art History*, London, 1966, p. 59) that Marco Pino, Taddeo's slightly older Sienese contemporary, was one of the principal influences on his early style, is repeated by Briganti (*Il Manierismo e Pellegrino Tibaldi*, Rome, 1945, p. 92) and others and has now become one of the accepted axioms of Italian art-history. Marco Pino's *Resurrection* in the Oratory of S. Lucia del Gonfalone in Rome certainly offers a close parallel to Taddeo's Mattei Chapel frescoes of 1553–56, but the assumption that it influenced them depends on the erroneous belief that it is a work datable c. 1549, belonging to the artist's earliest Roman period (cf. Venturi, ix⁵, p. 515). The *Resurrection* in fact dates from well after Taddeo's death in 1566, for the decoration of the oratory was not even begun by Bertoja until about 1569, and this particular fresco, the last in the cycle of scenes from the Passion, seems to have been executed even after Federico Zuccaro's *Flagellation* which is dated 1573. Recently (*Paragone*, 151 (1962), p. 28) an attempt has been made to reconcile this fact with the hypothesis of Taddeo's dependence on Marco Pino by claiming that in the Mattei Chapel Taddeo 'non fa che riprendere soluzioni di movimento attuate da Marco dieci anni prima nella volta della Sala Paolina' of the Castel Sant'Angelo (i.e. the scenes from the life of Alexander the Great on the ceiling, a payment for which is recorded in 1546). But there is surely no resemblance between these two sets of frescoes that cannot more reasonably be explained by their common indebtedness to Perino del Vaga and Salviati; and it is surely most improbable that Taddeo, with everything in Rome to choose from, should have gone out of his way to take as models these rather clumsy and undistinguished prentice works which show Marco Pino doing his best to adapt the style which he had acquired from his master Beccafumi in Siena to the more up to date Roman *maniera*.

attempt to define Taddeo's early style on a note of uncertainty. This drawing, in the Royal Library at Windsor,[1] is a carefully finished representation of an unexplained allegorical subject with a woman in a helmet (Minerva?) distributing lengths of chain to a group of old men. Some time ago I referred to it briefly apropos of the design for a decorative panel with an escutcheon and two allegorical figures in the Ashmolean Museum (155. Pl. 17) and suggested that the two might be by the same hand. Though I now feel convinced that the Ashmolean drawing is by Taddeo, and though the other is strongly suggestive of him in such details as the heads of some of the soldiers in the centre background and, especially, that of the youth wearing a hat behind the horse on the left, it seems to me impossible to see in the Windsor drawing the personality which reveals itself so plainly in the group of early drawings which have been discussed. Nevertheless, the conclusion that the Windsor drawing cannot be by Taddeo has to be reconsidered in the light of the discovery on the *verso* of one of his early drawings in the Uffizi (51. Pl. 10b) of a group of figures corresponding exactly with those in the extreme left background of the Windsor composition. It must follow, either that the Uffizi drawing is a copy by Taddeo of a detail in a composition by someone else, or that the Windsor drawing represents an unfamiliar aspect of his early manner; and while the appearance of the former is perfectly consistent with its being a copy, it is possible to pick out isolated details of the latter which do suggest Taddeo's hand.

[1] Windsor, Royal Library 01234 (Popham-Wilde no. 399, pl. 83, as Pirro Ligorio, an attribution suggested by Antal). Ligorio's name has been associated with a number of other drawings, all Polidoresque in style, which I used at one time to think might prove to be by the early Taddeo: Chatsworth 46 (traditionally Peruzzi, attributed to Ligorio by Mr Popham); Chatsworth 128 (traditionally Ligorio); Oxford, Christ Church 0192, Gernsheim 41328 (traditionally Ligorio); London, British Museum 1895-9-15-560 (formerly unattributed, attributed to Ligorio by Mr Popham); Windsor, Royal Library 5073 (Popham-Wilde, no. 395, fig. 82, traditionally Ligorio). Others are: Copenhagen Printroom, Ital. Mag. xi, 29 (traditionally Giulio Romano); London, Victoria and Albert Museum 8643 G (traditionally Polidoro da Caravaggio); London, formerly Wrangham Collection (sold Sotheby's, as Polidoro da Caravaggio, 1. vii. 1965, lot 8, repr. in catalogue). Yet another may have been copied in the drawing at Stockholm here catalogued (230) as being possibly after a lost early drawing by Taddeo. Like Windsor 01234, these drawings contain isolated features suggestive of Taddeo, though the total impression in each case is of another personality. There is no very evident similarity between them and the well-defined group which are immediately recognizable as by Ligorio, but too little is still known about the course of his development for the possibility to be entirely ruled out that they may represent an as yet unfamiliar phase of it; certainly the fact that more than one of them is traditionally attributed to him must have some significance. Ligorio's activity, described by Baglione, as a façade-painter in Rome probably dates from the 1540's. No trace remains of his façade-paintings, but Baglione's reference to one '*de chiaro oscuro, e di color giallo finto di metallo . . . vi si veggono trofei, storie, e fregi di magnificenze Romane*' suggests that (like Taddeo's) they were in the manner of Polidoro. If this group of drawings is by Ligorio, then it is likely, from their generally Polidoresque style, that they date from the period of his activity as a façade-painter; and if this was in the 1540's, then he and Taddeo would have been working along similar lines, both under the inspiration of Polidoro, and may well have been in contact. This would account for the elusive but unmistakable resemblance between the 'Ligorio' group of drawings and Taddeo's of around 1550 and might explain how a detail from one of the 'Ligorio' group comes to be copied on a sheet of studies by Taddeo.

The probabilities are so nicely balanced that until some fresh piece of evidence appears to turn the scale one way or the other it seems best to consider the attribution of the Windsor drawing to Taddeo as 'not proven'. The failure of this drawing to fit in with the rest of the early group need not necessarily exclude the possibility of its being by Taddeo, for it is only when an artist is brought up exclusively under one master, or in a very strong local tradition, that one can expect to find an entirely consistent pattern of stylistic development. Taddeo's artistic training was extraordinarily haphazard, and the enigma of the Windsor *Allegory* remains to remind us to reckon with the possibility that in the period before his style was fully formed, Taddeo experimented along lines which he did not develop.

II

Taddeo Zuccaro's two earliest surviving works were both begun soon after his return to Rome from Urbino in the Summer of 1553. The decoration of the Villa Giulia was already under way by April of that year and was completed by the time of Julius III's death in March 1555; that of the Mattei Chapel in S. Maria della Consolazione, if Vasari is right in saying that it took him four years and was completed in 1556, must also have been begun in 1553.

It has been generally assumed that Taddeo was responsible for the entire decoration of the Villa Giulia, but the paintings in the two principal rooms, on the ground floor on either side of the entrance vestibule, are clearly the work of two different hands. Documentary evidence confirms what Vasari implies, that the artist in charge of the decoration was his own contemporary and close associate, the Bolognese painter Prospero Fontana. Such evidence as there is suggests that the frescoes in the room on the left of the entrance were designed and executed by Fontana, and that those in the room opposite were painted by Taddeo, possibly on Fontana's indications. Taddeo was probably also responsible for the friezes which constitute the only decoration of the three first-floor rooms, but the one place in the Villa where his hand seems unmistakably recognisable is in the small mythological frescoes, most of them much damaged, in the lower loggia of the Nymphaeum (Pls. 36 and 37).[1] Only three drawings connected with the Villa Giulia decoration are known. These are all for the ground-floor room on the left of the entrance, and since none of them is by Taddeo it is unnecessary to discuss them here.[2]

[1] See *B. Mag.*, cvii (1965), p. 202. Miss Jennifer Montagu has pointed out to me that the four frescoes in the Nymphaeum which I had described as 'triumphs of the Gods, treated in a light-hearted, even frivolous spirit' in fact represent the four Seasons, and that their iconography is closely paralleled in a series of four anonymous woodcuts (photographs in Warburg Institute) which must from their style be Flemish, probably from Antwerp, and datable around 1520. *Spring* (Pl. 36) is represented by Flora in a chariot, accompanied by Apollo and the Muses and the Zodiacal Signs *Aries*, *Taurus* and *Gemini*; *Summer* (Pl. 37) by Ceres and Apollo in a chariot accompanied by harvesters and the Zodiacal Signs *Cancer* and *Virgo*; *Autumn* (too badly damaged to be reproducible) by Bacchus and Pomona in a chariot accompanied Silenus and the Zodiacal Signs *Sagittarius* and *Scorpio*; *Winter* (*B. Mag.*, ut cit., p. 204, fig. 50) by Janus and Vulcan in a chariot accompanied by *Crapula* riding a pig, *Desidia* riding a donkey and the *Tenebrae* carrying lanterns, and by the Zodiacal Signs *Capricornus*, *Pisces* and *Aquarius*.

[2] Repr. *B. Mag.*, ut cit., figs. 42, 43 and 45.

The Mattei Chapel is Taddeo's most important surviving work. Vasari tells us that he accepted a low fee for the commission because it would give him an opportunity of displaying his full powers, and that the decoration took four years to complete because he worked on it only when he felt in the mood to do his best. 'The figures are not large . . . he painted everything with his own hand . . . so carefully and delicately that it seems more like a miniature painting than a work in fresco': Vasari's description of a comparable *tour de force*, the Massimi Chapel in S. Trinità dei Monti on which, some fifteen years before, Perino del Vaga had likewise lavished unusual pains in the hope of reestablishing his position in Rome after an absence of several years, applies exactly to the paintings in the Mattei Chapel by which Taddeo Zuccaro set out to show that he was capable of more than the façade-paintings by which he had initially made his name.

The paintings in the chapel represent the events of the Passion. The ceiling is a shallow cross-vault divided naturally into four triangular spaces, in each of which is a fresco in the shape of a square with the upper corners cut off. These four frescoes, the *Washing of the Feet* (Pl. 70), the *Last Supper* (Pl. 71), the *Agony in the Garden* (Pl. 69), and the *Betrayal* (Pl. 57), fit together to form a wide-armed cross, leaving pendentives in the angles of the vault in which are half-length figures of Evangelists (Pls. 61 and 65). On the left-hand side-wall is the *Flagellation* (Pl. 73) with the much-damaged and almost illegible *Christ before Pilate* in the lunette above, and on the wall opposite, the *Ecce Homo* (Pl. 72). If Vasari is to be believed, the lunette-shaped space on the right-hand wall, now occupied by a window, contained a painting of *Christ before Caiaphas*. On the altar-wall full-length figures of Prophets (Pl. 76) flank an altarpiece of the *Virgin and the Holy Women at the Foot of the Cross* (Pl. 75), also in fresco, framed in a heavy stucco moulding which continues into the lunette above and is surmounted by an ornate superstructure of swags and volutes on which are perched two *putti* supporting an escutcheon of the Mattei arms. What remains of the flat surface of the lunette on either side is taken up with painted figures of Sibyls, apparently reclining on the volutes of the stucco superstructure (Pl. 65).

2

The drawings discussed in the previous chapter illustrate the variety of influences to which Taddeo responded at the outset of his career. The frescoes in the Mattei Chapel reveal an even more widely ranging eclecticism. Their debt to Correggio, for example, is evident once we think of them in relation to such late works of his as the Louvre *Allegory of Virtue*; and, as Professor Voss was the first to point out, the group in the right foreground of the *Betrayal* is even adapted directly

from a composition by him. The subject of this composition, it should be noted, is not the Betrayal but an incident which occurred at the same time: 'there followed Him a certain young man, having a linen cloth cast about his naked body; and the young men laid hold on him: and he left the linen cloth, and fled from them naked' (Mark, xiv, 51–52). It is essentially a study of two figures, the young man and the pursuing soldier, in violent movement, with Christ and Judas barely visible in the distance. Taddeo added a counter-balancing group of running soldiers in the left foreground, but by still keeping the main group in the background produced something which differs in intention from his prototype: a characteristically Mannerist extension, and inversion, of a High Renaissance motif. Baumgart[1] notes the derivation of the swooning Virgin and Holy Women in the altarpiece from Daniele da Volterra's S. Trinità *Deposition*, as well as parallels between the *Washing of the Feet* and Raphael's *School of Athens* and between the *Last Supper* and his *Fire in the Borgo*. In the *Fire in the Borgo*, which shows Raphael moving so far in the direction of Mannerism that it is often given to Giulio Romano, the foreground is likewise filled with a crowd of subsidiary figures and the main incident, of Leo IV extinguishing the fire, relegated to the background in the same way as the table with Christ and the Disciples in the *Last Supper*. The resemblance even extends to such details as the two figures with a basin between the columns on the right of the *Last Supper* which are plainly inspired by the pair with water vessels between the similarly placed columns in the other. The thickset man leaning against a pillar in the *Last Supper* and the similar onlooker in the foreground of the *Washing of the Feet* are singled out by Baumgart as incongruously realistic elements, but their direct ancestor – though rather more idealized – is surely the man giving alms to the beggar in the left foreground of Peruzzi's S. Maria della Pace *Presentation*, another 'proto-Mannerist' composition analogous in some respects to the *Fire in the Borgo*. (Taddeo's interest in Peruzzi at this moment is shown by the section of frieze in the Villa Giulia which repeats part of the frieze in the Sala degli Prospettivi in the Farnesina.)[2] The landscape background of the *Agony in the Garden* argues knowledge of Muziano as well as of Polidoro. The pose of the gesticulating youth on the left of the *Ecce Homo* is almost identical with that of Bacchus in Titian's *Bacchus and Ariadne*, which Taddeo could have seen if he had passed through Ferrara on his way to Verona in 1552. One could go on with the game of picking out echoes from other masters, and it would be easy to give the misleading impression that the paintings in the Mattei Chapel are hardly more than an ingeniously fitted together patch-

[1] Fritz Baumgart, 'Zusammenhänge der niederländischen mit der italienischen Malerei in den zweiten Hälfte des 16. Jahrhunderts' in *Marburger Jahrbuch für Kunstwissenschaft*, xiii (1944), pp. 207 ff.

[2] See above, p. 53, note 1.

work of borrowed motifs. Taddeo was undeniably an eclectic, but given the circumstances of his birth and training, this was inevitable; and whether an artist seeks inspiration in the work of other artists or in 'nature' is ultimately less important than the use he makes of his sources. Taddeo – and this is a fundamental difference between him and his brother – was able to transmute his borrowings into a style which is intensely personal and entirely expressive.

But these paintings are not analysable solely in terms of Taddeo's predecessors. They must also be considered in the light of the actual artistic situation in Rome in the early 1550's. During the two years he spent in Urbino, between 1551 and 1553, Taddeo seems to have been content to mark time; but his reaction, as reported by Vasari, to the offer of the Mattei Chapel commission shortly after his return suggests awareness that some fresh advance was expected of him if he was to hold his own in the more competitive arena in which he now found himself. This, then, was a moment in which he is likely to have been particularly receptive to new ideas, and the Mattei frescoes do in fact represent a brief phase of submission to the then dominant style of high Roman Mannerism. Critics now tend to avoid using this much-abused term, but recently a well-reasoned attempt at a closer redefinition was made by John Shearman, who argued, very convincingly, that it should be confined to the style developed in Rome by Polidoro da Caravaggio, Perino del Vaga, Parmigianino and Rosso Fiorentino, in the period between the death of Raphael in 1520 and the Sack of Rome in 1527.[1] As we have already seen, the first three of these four artists played a preponderating role in Taddeo's early development; and the qualities which Shearman notes as especially characteristic of the Mannerist style – effortless resolution of difficulties, complexity of form, fantasy, invention, sophistication, intricacy and caprice – apply exactly to Taddeo's paintings in the Mattei Chapel. One might also add that content tends to be subordinated to the formal exigencies of an intricate surface pattern (for this, the influence of the antique relief on Perino and, even more, on Polidoro, was no doubt partly responsible) and that effortless resolution of difficulties can become an end in itself. Vasari's description of Michelangelo's *Last Judgement* as 'l'esempio degli scorci e di tutte l'altre difficultà dell'arte' – as if Michelangelo's main concern had been to produce an academic exercise in the rendering of the nude figure from every possible angle – is characteristic of the Mannerist aesthetic,[2] and in front of the Mattei Chapel frescoes it is sometimes difficult not to feel that one is watching

[1] 'Maniera as an Aesthetic Ideal' in *Studies in Western Art: Acts of the Twentieth International Congress of the History of Art*, New York, 1965, pp. 200 ff. The argument was amplified and more fully illustrated in *Mannerism*, London, 1967.

[2] In some of Cherubino Alberti's engravings of single figures from the *Last Judgement* (B. xvii, p. 74, 67 to 69) and the Cappella Paolina *Conversion of St Paul* (B. xvii, p. 102, 143), these are surrounded by ornate cartouches as if to emphasise their isolation.

a *bravura* performance by an artist concerned above all to create a succession of carefully studied figures and groups to be admired as objects in themselves, irrespective of the subject-matter of the compositions in which they feature. In the *Ecce Homo*, for example, the detail that most visitors to the chapel probably best remember is the conspicuous young man in the left foreground; but his gesture, for all its extravagance, is ambiguous and undynamic, and the figure gives the impression of having been conceived as an isolated object for the spectator to admire in the same spirit as he might a bronze statuette. This state of mind in the artist may partly explain the strange compositional convention – carried to its furthest limits in the lunette of *Christ before Pilate* – whereby the main action is relegated to the far distance while the foreground is crowded with large-scale supernumeraries who play no part except as unconcerned onlookers: a convention reduced *ad absurdum* by the early seventeenth-century engraver Jacob Matham who in all innocence inscribed his engraving of the Mattei Chapel *Last Supper* with the title *Marriage at Cana*.

In the Rome of the early 1550's Francesco Salviati was the leading exponent of the *maniera* at its most extravagant and fantastic. The close affinity between the Mattei paintings and Salviati's Roman work which is generally agreed to belong to the same period – the *salone* of the Palazzo Sacchetti, the Sala dei Fasti Farnesiani in the Palazzo Farnese, and above all the small scenes from the life of the Virgin in S. Marcello – suggests that at this moment he exercised a decisive influence on Taddeo. Another younger artist who was drawn into Salviati's orbit about then was Taddeo's Bolognese contemporary, Pellegrino Tibaldi, who had come to Rome in 1547 and remained there for the next seven years. He and Taddeo both worked for Julius III, so they can hardly have failed to make one another's acquaintance; and though very little of Tibaldi's Roman work has survived, his drawings of this period have so much in common with Taddeo's that it seems reasonable to suppose a considerable degree of mutual influence. Tibaldi was a year or two older than Taddeo, and the contrast between his *Adoration of the Shepherds* in the Borghese Gallery, dated 1548,[1] and Taddeo's designs for the Mattei façade, datable in the same year but still basically Polidoresque and by comparison rather old-fashioned, suggests that Tibaldi was temperamentally more in sympathy with Salviati's *outré* brand of Mannerism and that the stylistic initiative is more likely to have been with him rather than Taddeo.

The paintings in the Mattei Chapel and Salviati's Roman work of the same period are the final manifestations of this phase of the Roman *maniera*, for the

[1] Miss Davidson (*Mostra di disegni di Perino del Vaga e la sua cerchia*, Florence [Uffizi], 1966, under no. 68) reads the date as 1549. There is a small vertical stroke after the date M.D.XLVIII, but this does not seem necessarily to be a numeral.

mid-1550's saw a change of style. It is now generally admitted that Mannerism was not so much an abrupt reaction against the High Renaissance, as its logical consequence: that it was a development of tendencies already apparent in the ceiling of the Sistine Chapel (especially the corner spandrels) and in the late work of Raphael, the Stanza dell' Incendio, the *Battle of Constantine*, and the *Transfiguration*. The ensuing phase of 'Classicizing Mannerism' or 'Counter-Mannerism', which coincided with the Tridentine insistence on decorum and realism in religious art is, equally, not an abrupt reaction but a shift of emphasis towards other aspects of the High Renaissance, an attempt to reaffirm the 'classical' values of lucidity, balance and order. In considering Taddeo Zuccaro's development it should be remembered that he belonged to the same generation as Paolo Veronese (died 1588), Tibaldi (died 1596), and Giambologna (died 1608), and that if he had lived for the normal span of life the Mattei Chapel would appear in clearer perspective as an early and still experimental work. Not only was the fundamental bias of his mind towards classicism but he was in the vanguard of change, for the shift of style is even apparent in the Mattei Chapel itself. If by some mischance the *Flagellation* on the left-hand side-wall had perished without trace, one would have imagined it as a counterpart to the *Ecce Homo* opposite, with the group of Christ and the executioners in an elaborate architectural setting, barely visible in the distance above the heads of a jostling crowd of spectators in every kind of studied and contorted pose. The reality is totally different. Christ and the executioners, their figures modelled with academic thoroughness, form a compact group so large in scale that it fills nearly the whole picture-area, while the setting, a pillared hall, is reduced to an almost abstract pattern. In the *Ecce Homo*, the treatment of space and the spatial relation of the figures to one another is quite arbitrary; in the *Flagellation* the space is logically finite and all the figures in the intricate group have their relative positions defined exactly by the placing of their feet on the regularly patterned pavement. Taddeo's *Flagellation* is obviously inspired by the one painted by Sebastiano del Piombo on Michelangelo's design in S. Pietro in Montorio, but it is interesting to analyse the resemblances and differences between the two. In Michelangelo's, the torsion of Christ's body produced by the direction of the head and the twisting of the right leg round to the back of the column, and the oblique placing of the two principal executioners, combine to impart a rotatory movement to the whole group of figures so that it seems to be revolving in slow motion round the axis of the central column. Taddeo's Christ repeats, in reverse, the pose of the other except for the position of the head and left leg, but these are now so placed that all sense of torsion is lost; and though the two principal executioners are still set obliquely, the group has been enlarged by a second pair, symmetrically posed on either side, with the

[61]

result that the movement of the group is arrested and the whole nature of Michel-angelo's conception transformed by the imposition upon it of a static, frozen symmetry.

It would hardly be an exaggeration to describe the Mattei Chapel as the stylistic watershed of the middle sixteenth century in Rome. Rarely does a change of style announce itself so unequivocally – so dramatically even – as here. On one side-wall we look back to the elegant, complicated, fanciful Mannerism of Salviati and Tibaldi, Polidoro and Perino; on the other, forward to Muziano, Federico Zuccaro, Roncalli, the Cavaliere d'Arpino, and the other exponents of the 'Counter-Mannerism' which was to shape Roman painting for the next forty years, until the arrival of Annibale Carracci in the 1590's.

3

Only one of the known drawings connected with this commission is a scheme for the decoration as a whole. This study for the left-hand side-wall and altar-wall, in my own possession (121. Pl. 43), differs from the chapel in that the altar-wall is considerably wider than the other, but the off-centre placing of the altar itself shows that this is a freehand sketch drawn without regard for accuracy of scale; and though the three frescoes indicated are not scenes from the Passion but represent the *Adoration of the Shepherds* in the place eventually occupied by the *Flagellation*, the *Adoration of the Magi* instead of *Christ before Pilate* in the lunette above, and in the lunette on the altar-wall a composition of the *Resurrection* instead of the two Sibyls and the upper part of the frame of the altarpiece, the lower part of the altar-wall is essentially the same as in the chapel. From the cross above the altar it is an easy transition to the altarpiece with the crucified Christ, and on either side are the same square-headed niches containing single figures of Prophets holding books. The geometrical patterning of the pilasters and altar-wall is also paralleled in the chapel itself, but the connexion is established beyond doubt by the doubled pilasters at the entrance to the chapel in the drawing and the corresponding double moulding above them. The chapel itself is not exactly square in plan, for the left-hand side-wall is longer than the wall opposite, so to make the partitioning of the cross-vault as regular as possible a narrow wedge-shaped strip of moulding had to be inserted immediately within the entrance arch. This strip tapers away on the right, but on the left, where it meets the wall, it is supported, exactly as in the drawing, by a second pilaster coupled with the one supporting the arch.

For the paintings as finally executed only one complete composition-study has so far come to light: the large drawing in Berlin identified by Voss as a study for the *Betrayal* (9. Pl. 56). The absence of *pentimenti* and the very close correspondence

[62]

with the final result (the only difference being the eventual suppression of the Michelangelesque figure with its back turned on the right of the background group) show that this is a fair copy or *modello* made at a very late stage in the evolution of the design. It must have been the culmination of a long series of composition-studies, as well as many more studies for separate details than the two which happen to have survived: one in the Louvre for the entire background group of Christ and Judas (186. Pl. 55), the other, in the Cooper–Hewitt Museum in New York, for the running soldier in the left foreground (140. Pl. 54), both further from the final result than the corresponding figures in the Berlin *modello*. In handling and technique these studies for details still resemble some of the early designs for façade-decorations in which the forms are contained within thin, almost hesitant, pen outlines and are carefully built up with wash and white bodycolour. The *modello*, by contrast, already reveals all the characteristics of the drawing style of Taddeo's maturity.

A drawing of the *Last Supper*, in the Albertina (247), corresponds with Taddeo's fresco except for the group in the left foreground. It cannot, however, be a preliminary study, for not only is it not by Taddeo himself (who at this stage in his career seems not to have employed studio-assistants) but the composition has been made up to a rectangle. The outlines are indented, and in every respect, including size, the drawing agrees exactly with an engraving by Aliprando Caprioli, dated 1575. It was presumably made in connexion with this engraving, well after Taddeo's death, on the basis of a discarded design. The man reclining on the floor in the left foreground is in a different pose from the similar figure in the fresco, looking towards the centre of the composition with his head turned away from the spectator. A drawing of a nude man in the Uffizi (60), attributed to Taddeo in an old hand, is perhaps a study for this figure. In handling it is rougher than the Louvre and Cooper–Hewitt figure-studies; and the vigorous forward thrust and violent *contrapposto* of the over-muscled torso would tempt one to think of Tibaldi, were it not for the old inscription. Another study in the Uffizi, of a man in a hat standing in profile to the left (45), authenticated by an inscription in the hand of Federico Zuccaro, could be for the standing figure in the right foreground of the *Ecce Homo*.[1]

For the Sibyls above the altar several studies are known. The one in the British

[1] What seems at first sight to be a rapid preliminary sketch for the *Last Supper*, in pen and black ink and grey wash and red chalk, heightened with white, in the Uffizi (434S, as Nebbia), agrees with the fresco in the general placing of the figures, with Christ and the Disciples sitting round a table in the centre background and the foreground on either side occupied with attendants and servants. The foreground figures differ from those in the fresco except for the presence in both of the pair, one of whom leans forward to hand a dish to the other, at the back of the right-hand group. Nevertheless, I cannot see TZ's hand in the drawing, which seems to me to be a variation on the theme of the fresco by someone else.

Museum (98. Pl. 64) corresponds with the left-hand Sibyl only in the position of the head and left arm, but the concave moulding against which she sits, though relatively larger in scale, corresponds with the smaller stucco volute in the chapel. The late-seventeenth-century connoisseur, Padre Resta, gave this drawing to Pellegrino Munari da Modena, an attribution perhaps suggested by a certain Emilian flavour which it has; but it is not of that shadowy follower of Raphael, nor even of Pellegrino Tibaldi (an emendation ingeniously suggested by Ragghianti), but, rather, of Niccolò dell'Abbate and Primaticcio that one is reminded by the refined oval of the face, the position of the disproportionately massive leg and the arrangement of the drapery on it, and the delicate mesh of hatching in white bodycolour. Primaticcio went to France in 1532 and returned only briefly to Rome in 1540 and 1546, so he is unlikely ever to have been in personal contact with Taddeo. Niccolò dell'Abbate did not go to France until about 1551 and was in Bologna in 1547, so that Tibaldi could conceivably have met him before his own departure for Rome in 1547. But however knowledge of one or other or both these artists was transmitted to Taddeo, this drawing suggests that the Emilian element in his formation was enriched and complicated by their influence. In an earlier study for the same Sibyl, at Hamburg (85. Pl. 62), the penwork is rougher and more vigorous and the wash and white bodycolour are used to suggest the broad masses of the drapery rather than the niceties of its folds. Just as one drawing betrays knowledge of Niccolò dell'Abbate and Primaticcio, so the other seems to show Taddeo attempting to emulate the drawing technique of Correggio himself. (He explicitly proclaims his allegiance to Correggio in the lower right-hand corner of the British Museum drawing, where he has sketched, too lightly for it to be visible in the reproduction, the group of Jupiter and Antiope from Correggio's painting in the Louvre.) Mr Carter Jonas's study for the right-hand Sibyl (125. Pl. 63) is close to the painted figure except for the greater prominence of the frontmost knee. It has this feature in common with the British Museum study, but the drawing itself is rougher and more rapid, and more obviously typical of Taddeo in such details as the areas of regular coarse hatching within the shadows and the attenuation of the legs, as well as in the forward movement of the body which emphasizes the bulk of the massive torso and in the abrupt protrusion from it of the head and neck which are also features of the figure in the left background of the *Ecce Homo* and of the Uffizi study for one in the foreground of the *Last Supper* (60).

At the top of the British Museum sheet is part of a summary sketch in black chalk of the pose of the Sibyl. Rough sketches of the same type, some in black chalk and some in red, on one side of a sheet in the Rosenbach Foundation, Philadelphia (211. Pl. 46) include two for the same Sibyl, the rougher of which,

[64]

far from being the artist's first thought for the figure, corresponds exactly (so far as it goes) with the final solution. On the same sheet is a rough sketch for a soldier in the foreground of the *Betrayal* and a study for the head of the man standing on the extreme right of *Christ Washing the Disciples' Feet*. A similar sheet of sketches in the collection of Mrs Krautheimer in New York (146. Pl. 47) has on one side studies in black chalk for the Virgin in the altarpiece of the chapel and on the other a study in red chalk for the drapery of a figure in the *Washing of the Feet*. All these drawings correspond too closely with the final result to be Taddeo's first ideas, as their sketchy roughness might at first tempt one to suppose. There are traces of red chalk off-setting on one sheet which suggest that it might have formed part of a sketchbook, presumably used for working out details at an advanced stage in the design. A third drawing which seems to belong to the same group is a study of Christ on the Cross in the Ambrosian Library (127. Pl. 45). It is in the same technique of loosely handled black chalk, and might be for the figure in the altarpiece of the Chapel.

The half-length figures of Evangelists in the pendentives are much damaged, but two are still identifiable: St Matthew with his angel is in the north-west corner, while the Evangelist diagonally opposite – that is, on the left of the altar-wall – differs from the other three in being a beardless young man, and so must be St John. On the altar-wall the pendentives are kite-shaped, but in the two others the tapering lower part has been cut off to form an irregular pentagon. A study for a kite-shaped pendentive containing a full-length figure identifiable from his book as an Evangelist and as St John from both his youthful appearance and the long-necked bird, which must be meant to be an eagle, on the left of the composition, is in the Louvre (202. Pl. 59). Both in shape and in the perspective of the feigned reveal of the opening this drawing corresponds exactly with the pendentive with St John, and must be an early design for this detail of the Chapel. Since full-length Evangelists were contemplated at one stage, Lord Methuen's squared drawing of a full-length St Luke framed in an irregular pentagon can reasonably be identified as a discarded design for one of the pendentives on the entrance-wall (25. Pl. 60). Yet another drawing of a full-length St Luke in a pendentive is in the Museum at Kremsier (88. Pl. 58). The pendentive is triangular, but from its style this drawing can hardly be much later than the middle 1550's, so it may represent an even earlier stage in the plan, before the partitioning of the vault was determined. In the proportion of the legs to the body and in the treatment of the drapery, the Louvre St John resembles the British Museum study for the Sibyl, and it may be that the full-length figures in the pendentives were abandoned because of the awkward juxtaposition of the two on the altar-wall with the full-length Sibyls which would have been considerably larger in scale. As it is, the

E [65] G.T.Z.

half-length figures of Evangelists are on the same scale as the Sibyls. An intermediate stage in the design of the pendentive with St Matthew and the angel is preserved in an old copy of a lost drawing in the Uffizi (44 *verso*). The figure is seen half-length and in much the same position as in the pendentive itself, except that there the saint is looking over his shoulder toward the angel, who is thus formally and psychologically integrated into the composition. In the drawing, the saint is looking downwards, with the angel hovering above his head: a less satisfactory solution and one less suited to the shape of the pendentive.

That so perceptive a connoisseur as Antal should have attributed to Francesco Salviati the study at Windsor for two disciples in an *Agony in the Garden* (259. Pl. 68), illustrates the strength of Salviati's influence on Taddeo at the period of the Mattei Chapel. But there can be no doubt that this drawing is by Taddeo, for in conception and sentiment the figures so closely resemble their counterparts in the Mattei Chapel *Agony in the Garden* that but for its even closer connexion with another treatment of the subject, one would unhesitatingly have described this drawing as a discarded study for the fresco. In a small panel in the Strossmayer Gallery in Zagreb (Pl. 67), a study for which is in the possession of Mr H. M. Calmann (117), the pose of the disciple in the right foreground is identical with that of the right-hand figure in the drawing, but is seen from a different viewpoint, having been rotated clockwise through an angle of forty-five degrees (a similarity and a difference which suggest that Taddeo, like so many other artists of this period, was in the habit of studying the poses of his figures from clay or wax models). It is possible, however, that the Zagreb composition is a by-product of the other, and that the Windsor drawing was in fact made in connexion with the Chapel. Another drawing of two sleeping figures in a landscape is in the Kunsthaus at Zürich (261. Pl. 66). This has a positive claim to be connected with the Mattei *Agony in the Garden*, for not only is the foreground figure identical, but for the position of his right arm, with the centre disciple of the three in the fresco, but a further argument in favour of the connexion is provided by the diagonal stroke in the upper left-hand corner which does not seem to form part of the landscape background of the drawing. Its purpose is not immediately clear, but if the group is imagined on the left-hand side of the fresco the stroke at once makes sense as an indication of the oblique upper edge of the composition.

Hitherto Taddeo has been considered in relation to the influences which went to form his style. With the Zürich drawing the balance begins to tilt the other way, and for the first time he can in his turn be seen as a formative influence on younger artists. Most people's first reaction to this drawing would probably be to think, not of Taddeo, but of his younger contemporary and fellow-Marchigian, Federico Barocci. The technique of pen and wash with white bodycolour over

black chalk on blue paper is one which Barocci particularly favoured, and the treatment of the background, drawn very freely with the brush-point, at once brings to mind the well-known landscape studies in the Uffizi, the British Museum and the Lugt Collection. The events of Barocci's early life are obscure but it is probable that he was born in about 1535[1] (which would make him some five years younger than Taddeo) and that he first came to Rome in the middle 1550's. During his youth in Rome he was certainly in contact with Taddeo, and may even have been one of the 'giovani forestieri, che sono sempre in Roma e vanno lavorando a giornate per imparare e guadagnare' whom Taddeo employed as his commissions multiplied. But whatever the nature of their formal relationship, the Zürich drawing suggests that Taddeo exercised a fundamental influence on Barocci's early development. An attribution that narrowly misses the mark is sometimes very instructive (that of the Windsor drawing of sleeping Disciples to Francesco Salviati is an example) and it is significant that many years ago Mr Popham had provisionally catalogued the British Museum study for the Sibyl as an early work by Barocci of the period of his paintings in the Casino of Pius IV.

4

The handful of drawings so far discussed, all in varying degrees connectible with the decoration of the Mattei Chapel in its eventual form, can only be a small proportion of all those which Taddeo must have made in the course of planning and executing this long-drawn-out and important commission. The early sketch for the whole decoration (121. Pl. 43) which shows that a different iconographic programme was originally contemplated for the chapel, enables a number of other drawings to be tentatively identified as studies for an earlier stage or stages of the project. In the Budapest Museum, for example, there is a sketch in black chalk (15 *recto*. Pl. 48), loosely handled in a way exactly matching that in the Rosenbach and Krautheimer studies (Pls. 46 and 47), of two crouching men one of whom holds his hand over his eyes in a gesture which suggests that he and his companion are two of the dazzled soldiers guarding the tomb in a *Resurrection*. It is possible that this is a study for the *Resurrection* indicated in the lunette above the altar of the chapel in the early sketch. On the *verso* of the sheet is a drawing of a man with a sword in his hand kneeling over the prostrate body of another. If an explanation of this study is to be looked for in the context of the chapel, it could be for the group of Peter and Malchus in the *Betrayal*.

On the left-hand side-wall, in the place eventually occupied by the *Flagellation*

[1] 1528 is the year traditionally given for Barocci's birth. The question is very fully discussed by H. Olsen (*Federico Barocci*, Copenhagen, 1962, p. 20) who comes to the conclusion that there is not enough evidence for it to be definitely settled, but that he was probably born 'circa 1535'.

and *Christ before Pilate*, the early design shows the *Adoration of the Shepherds* with the *Adoration of the Magi* in the lunette above. A group of drawings of *Adorations* by Taddeo can be dated in the early 1550's on grounds of style. One of the *Adoration of the Shepherds* is at Chatsworth (19. Pl. 50), a close variant of which, too faded and damaged to be reproduced, is in the Uffizi (57). A large-scale variant in black chalk of the Uffizi composition, simplified and with its elements pushed together so that it is upright in format, is preserved on two fragments of a large double-sided sheet in the Stockholm Museum (227, 228), on the other side of which (Pl. 77) is a study for one of the few easel-paintings which can with certainty be attributed to Taddeo himself, the *Adoration of the Magi* in the Fitzwilliam Museum (Pl. 79). It does not necessarily follow that this picture must have been the end-product of the whole sequence of studies, for the differences between the Chatsworth drawing and the derivation from it at Stockholm are all towards simplification and suggest that the artist was adapting a discarded composition to some purpose other than the one for which it was originally designed. The possibility is worth considering, therefore, that the Chatsworth and Uffizi drawings may be studies for the *Adoration* which was to go on the left-hand side-wall of the chapel. The composition is still so agitatedly Parmigianinesque (the youthful shepherd in the Phrygian cap, for example, is an echo of the one in Parmigianino's well-known treatment of the subject engraved by Caraglio in 1526) that it can hardly be datable much later than the middle 1550's; and not only is it identical in shape with the composition indicated on the side-wall in the early sketch, but comparison of the two shows that one is essentially an elaborated development of the other. The group on the left is composed of the same elements – in both there is a kneeling shepherd with a lamb in the centre of the foreground and behind him a figure leaning forward with a wallet on his hip – but in the Chatsworth drawing the Virgin and Child have been moved to the centre and a second group of shepherds added on the right: an alteration perhaps dictated by the need to differentiate this composition as far as possible from the *Adoration of the Magi* which was to have been immediately above.

A feature of the Chatsworth drawing and of its derivations in the Uffizi and at Stockholm is that in all three the right-hand group includes a figure seated on the back of an ox and adoring the Infant Christ. The same motif is repeated in a drawing in the Louvre (201. Pl. 49) of the Virgin holding up the Child towards a figure seated on an ox, which must be a study for the same composition. The loose pen and wash technique is the equivalent in another medium of the black chalk technique of the Budapest *Resurrection* study and shows Taddeo's draughtsmanship at its wildest and most Correggiesque. Studies at Christ Church (167. Pl. 51) and at Windsor (258) for groups of shepherds respectively on the left and right-

hand sides of another and more crowded *Adoration*, though never actually part of the same sheet, may well be studies for the same composition. They are on the same scale and both are on paper washed thinly with yellow bodycolour; and when the two sheets are placed so that the figures are on the same level, the adoring gaze of the shepherds converges on the same spot.

Another drawing at Chatsworth which the early design may help to explain is the large and carefully finished study of a group of men and horses (18. Pl. 52), an earlier sketch for which was until recently kept under the name of Titian in the Uffizi (50). From the direction of their gaze it is evident that these figures are part of a larger composition and that the main action is taking place out of the drawing to the right. Mr Popham had already pointed out that they must be the retinue of the Magi, and their likeness to the group on the left of the lunette on the side-wall in the early design suggests that this second pair of Chatsworth and Uffizi drawings may also be studies for an *Adoration* intended for the Mattei Chapel. If so, the rectangular format of both shows that in its elaborated form this was intended for the lower part of one of the side-walls. Less obvious is the purpose of a study of which a fragment, showing a group of kneeling women, is in the Rome Print-room (219 *recto*. Pl. 53); for though these figures are clearly in the act of adoring someone or something, I can think of no precedent for so massive a contingent of female worshippers accompanying either the Magi or the Shepherds. But on the *verso* of the sheet, unfortunately too damaged and indistinct to be reproduced, is a rough sketch of an *Adoration of the Magi* which corresponds in the general placing of the figures with the principal group of the composition sketched in the lunette.[1]

A composition of the *Descent from the Cross* is known from a drawing by Taddeo in the Budapest Museum (14. Pl. 74) and a small panel – from his own hand, to judge from its high quality – in Lord Methuen's collection at Corsham Court. The panel, which has a shallow gable top, and on the other side a representation of Christ on the Cross with a pelican 'in its piety' – a symbol of the Eucharist – above, must have been the door of a tabernacle. Its style suggests a date not much earlier than *c*. 1560, while the drawing could be considerably earlier. Easel-pictures are so exceptional in Taddeo's œuvre that it is doubtful whether he would have gone to the trouble of making such an elaborate design for a small picture of this kind. The Corsham picture has, rather, the look of a reduction of something originally conceived on a larger scale. Two of Taddeo's rare easel-pictures, the Fitzwilliam *Adoration of the Magi* and the Strossmayer *Agony in the Garden* are possibly – though in neither case is the suggestion capable of definite proof – 'by-

[1] It corresponds even more closely with Federico Zuccaro's altarpiece, dated 1564, in the Grimani Chapel in S. Francesco della Vigna in Venice.

products' of discarded designs for the Mattei Chapel; it is perhaps also possible that the Budapest drawing represents Taddeo's first idea for the altarpiece of the chapel. The connexion is not immediately obvious for the altarpiece does not even represent the same subject, but the two are in fact derived from the same source. The old attribution of the Corsham picture to Daniele da Volterra is natural (indeed, almost inevitable) in view of the fame of Daniele's S. Trinità dei Monti *Deposition*; but it is significant that Tancred Borenius, evidently relying on his memory, should have described it in his catalogue of the Methuen Collection as a copy of Daniele's picture, for though the two compositions are quite different Taddeo's is clearly inspired by the other and could with perfect accuracy be described as a free variation of it in reverse. The altarpiece, though it does not represent the Descent from the Cross but the Virgin and the Holy Women at the foot of the Cross on which the body is still hanging, is an abridged but (so far as it goes) even closer, variation, also in reverse, with the upper part drastically simplified. But why, it may be asked, did Taddeo, having once gone to the trouble of absorbing and digesting Daniele's composition to produce this perfectly satisfactory result, reject it for a cruder and more literal adaptation? A possible answer is suggested by the contrast between the *Ecce Homo* and the *Flagellation* on the side-walls. Taddeo's change of style involved a tendency to enlarge the scale of his figures; did he perhaps decide to substitute a composition with fewer but larger figures at a late stage when there was no time to work out the design at leisure?

Finally, what might be a discarded design for one of the ceiling frescoes is preserved in three damaged fragments of the same sheet in the National Gallery of Scotland (29, 30, 31). The figures in this composition are on two levels, on an arrangement of curving steps or tiers which when placed in the correct relation to each other show the disposition of the three groups before the sheet was divided. In the left foreground two men are disputing and a third sits holding open a large book. These are balanced in the right foreground by a bearded man seated with crossed legs who supports a book on an ornate console. He and his counterpart on the other side are gazing up towards the two figures in the centre on the upper level, a bearded man and a woman in an attitude of supplication. If, as seems likely from his facial type, the man is Christ, his companion is presumably the Woman taken in Adultery and the figures below the protesting Scribes and Pharisees. The figures are so like those in the Mattei Chapel frescoes (those in the left-hand fragment, for instance, may be compared with the group in the left foreground of the *Washing of the Feet*) that the drawing must be datable at the same time; the pyramidal arrangement of the three groups would fit the shape of the divisions of the vault; and an iconographic programme extending from the *Nativity* to the *Resurrection*, as indicated in the early design, could have embraced

[70]

this, or indeed any other, episode in the life of Christ. Two similar fragments which might have been part of a companion study are at Zürich (262, 263), but there is not enough of these for the subject to be identified.

The early sketch differs from the final result not only in the subject-matter of the frescoes but also in their decorative setting. Stuccowork plays a more important part in the design. The lunettes were to have been bounded by massive bands of conventionalized fruit and foliage, while the mouldings round the frescoes on the walls are wider and heavier than their eventual counterparts and the frescoes themselves smaller. The massive superstructure above the altarpiece has not yet made its appearance, but the lower part of the side wall, which in the chapel itself is no more than a low dado decorated with a simple geometrical pattern, is an elaborate *basamento* composed of an oval cartouche flanked by female terms holding heavy swags. This was no doubt inspired by the type of *basamento* evolved by Daniele da Volterra for the side-walls of the Orsini Chapel in S. Trinità dei Monti[1] (of which his *Descent from the Cross* is the altarpiece) and by Perino del Vaga in his early study at Budapest for the Massimi Chapel in the same church.[2] Daniele's *basamento* was painted, but Perino's and also – to judge from the indication of the cast shadow – Taddeo's, were probably meant to be carried out in stucco. Studies by Taddeo for a similar *basamento*, even more elaborate but composed of the same elements, are on the *verso* (Pl. 42) of a drawing of *Alexander and Bucephalus* at Christ Church (162. Pl. 41). This *basamento* may have been part of an ecclesiastical decoration in spite of the secular subject on the *recto*, for the figure holding a tablet or book in the central cartouche seems to be either a Sibyl or an Evangelist. Two Sibyls and four Evangelists feature in the Mattei Chapel, but there would not have been room for more than two such *basamenti*; so if this drawing is for the *basamento* of the Chapel, Taddeo may at one stage have considered placing his Sibyls on the lower part of the side-walls.

5

Taddeo's success with the Mattei Chapel brought him a similar commission which was to occupy him on and off for the rest of his life. The exact date when he contracted to decorate Mario Frangipani's family chapel in S. Marcello al Corso is not known, but this must have been between 1556 and 1558. Vasari says that he received the commission after the unveiling of the Mattei Chapel in 1556, and had not long begun work when he had to break off in order to decorate another church in Rome for the obsequies of the Emperor Charles V. This ceremony took place on March 4, 1559, so that the decoration of the Frangipani

[1] See *B. Mag.*, cix (1967), pp. 554 ff.
[2] Repr. *B. Mag.*, ut. cit., p. 555, fig. 5 and cii (1960), p. 12, fig. 17.

Chapel is likely to have been begun, at the latest, by the end of 1558. Working single-handed and only when he felt in the mood to do his best, Taddeo completed the Mattei Chapel in less than four years. It is some indication of the subsequent demand for his services that even with the help of assistants he had still not quite finished the other by the time of his death in September 1566. He concentrated all his energies on the Mattei Chapel and reached the final stage with the impetus of his inspiration undiminished; in the Frangipani Chapel, which dragged on, with many interruptions, for twice as long, some quality seems to have evaporated in the interval between the first conception as we know it from drawings – and some of Taddeo's finest are among the studies for this commission – and the final result.

The paintings in the chapel illustrate the life of St Paul. The altarpiece represents his *Conversion* (Pl. 104);[1] the large frescoes on the side-walls, the *Blinding of Elymas* (Pl. 89) and the *Healing of the Cripple* (Pl. 91); and the three smaller scenes on the barrel-vaulted ceiling, the *Shipwreck of St Paul* (Pl. 90), the *Raising of Eutychus* (Pl. 85), and the *Martyrdom of St Paul* (Pl. 83). The lunette above the altar is largely taken up with the two sections of the semi-circular broken pediment of the frame of the altarpiece and the narrow window between them (Pl. 98). On either side of the window, in the space bounded by the concave curve of the lunette, the convex curve of the pediment and the vertical edge of the window, is a figure, attended by child angels, apparently reclining on the pediment. On the entrance-pilasters are standing Prophets in square-headed niches (Pl. 107).

The Mattei Chapel *Flagellation* shows Taddeo moving away from the Mannerism which he had developed in parallel with Salviati and Tibaldi. The same classicizing tendency continues in the Frangipani Chapel. In the altarpiece, for example, he does not follow the centrifugal pattern set in the previous decade by Michelangelo's *Conversion of St Paul* in the Pauline Chapel and Francesco Salviati's in the Cappella del Pallio in the Cancellaria, in both of which the figures are flying out in all directions from the fallen saint in the centre. By contrast, Taddeo's composition is emphatically centripetal: it has the compactness of a sculptured relief, with the figures compressed into a close-packed rectangular mass. In the *Blinding of Elymas* and the *Healing of the Cripple* the influence of the Sistine Ceiling is still evident, but these carefully balanced compositions with their studied *contrapposto* and frozen movement seem less inspired by the corner spandrels than by the *Drunkenness of Noah* and *Noah's Sacrifice* in the centre of the vault, compositions which – as has often been observed – are conceived as the pictorial

[1] The altarpiece, painted on slate, is so badly damaged that it seemed better to reproduce the small replica on copper in the Palazzo Doria-Pamphili.

equivalent of reliefs. An early design for the *Blinding of Elymas*, at Windsor (257. Pl. 88), is derived from an even more impeccably classical prototype. St Paul and Elymas confront one another in the foreground, symmetrically balanced to left and right of the Procurator enthroned in the centre, in a way that plainly reveals knowledge of Raphael's tapestry. In the fresco itself, however, not only have the three principal figures been shifted round, the Procurator to the background on the extreme left, Elymas to the centre background, and St Paul to the middle distance on the right, but they are enacting their rôles behind a screen of gesticulating onlookers occupying the immediate foreground.

Intermediate stages between these two extremes are preserved in drawings at Chicago (22. Pl. 94) and Stockholm (222). On the Chicago sheet a large study for the figure of the Procurator, drawn with the point of the brush in red wash, is surrounded by some twenty rapid pen jottings of the same pose and five thumbnail composition-sketches, two of which are for the *Blinding of Elymas*. The Procurator and Elymas occupy more or less their final positions, one on a high throne on the left-hand side and the other on the right, reeling backwards with arms upraised; but the onlookers are in two groups on either side between which, in the centre foreground, St Paul stands dominating the scene with his back turned to the spectator.[1] The Stockholm drawing, a free copy by Rubens of a finished drawing or *modello* by Taddeo, differs from the Chicago sketches in certain respects, notably in the pose of St Paul and in showing only one figure on the step of the throne, but it agrees with them in the placing of the three main figures and in the absence of the foreground spectators, as well as in such details as the seated woman with a child on the right who corresponds with the roughly drawn figure holding two children who occupies the same position in the lower of the two Chicago sketches. It is hard to see why Taddeo chose to abandon this treatment of the subject, which even in this summary sketches is more dramatic and effective than the solution which eventually found its way on to the wall. On the *verso* of a study for the cripple in the *Healing of the Cripple* on the opposite wall, in the Princeton University Museum (218), is a sketch of a group of women and children with their gaze concentrated on some event taking place to the left, which could be a study

[1] Both sketches have been trimmed away on the left, but it is possible that that part of the hypothetical finished drawing in which Taddeo elaborated the idea adumbrated the left-hand group of the *Disputation of St Catherine* which Federico Zuccaro painted c. 1570 in the choir of S. Caterina dei Funari. Federico, who made use of his brother's discarded drawings, seems to have had a particular affection for the figure of the enthroned Procurator: he appears as Pharaoh in his *Plague of Flies* in the Vatican Belvedere, as Caesar in one of his designs for maiolica, and as the tyrant Maximinus in his *Disputation of St Catherine*. In this last composition he is seated, as in the *Blinding of Elymas*, on a high throne in the left background, and in the study by Federico in the Ashmolean Museum (P. II. 751) for the figures on the steps of the throne the pair on the right make up between them a pose which is in essentials that of the single figure seated on the right of the steps in both sketches on the Chicago sheet.

for the group on the right of the *Blinding of Elymas* preserved in Rubens's copy. The studies on the Princeton sheet must be Taddeo's, but the study for the cripple shows his draughtsmanship in an unusually schematic, even arid, moment. Of the other sketches on the *verso* it is only possible to make out one of a group of figures in the upper right-hand corner, which if considered in isolation might be dated considerably earlier than the Frangipani Chapel. Similarly, one would otherwise be inclined to connect with the altarpiece of the Mattei Chapel the complete composition of a *Lamentation over the Dead Christ* on the *recto* and the slighter sketches surrounding it for the body of Christ and its immediate attendants.

Three other composition-sketches are on the Chicago sheet. The two on the right at the bottom, a *Holy Family* and a composition of two standing saints with a figure in the sky between them, cannot be connected with the decoration of the chapel or with any other work by Taddeo (the *Holy Family* may indeed be nothing more than an elaboration of the group of women with two children on the right of the neighbouring sketch for the *Blinding of Elymas*: one can imagine the artist, pen in hand, idly playing with the idea of transforming the motif into a Virgin and Child with the Infant Baptist). The third study, in the top right corner, could be a discarded design for the chapel. It shows a crowd of onlookers massed on the left of an open portico, on the other side of which is a wide flight of steps ascending to a dais on which stand two figures, with others grouped on either side. In the immediate foreground, figures are emerging from a second flight of steps only the top of which is indicated. In the context of the other sketches on the sheet, the most likely explanation of the subject is that it is the *Sacrifice at Lystra*: the conspicuous personages on the dais could be Paul and Barnabas, and the indeterminate but bulky object which two figures in the background seem to be supporting, the sacrificial ox. If Taddeo did at one stage intend this spacious and grandiose composition for one of the side-walls of the chapel, it is impossible, once again, not to regret his abandonment of it.

Composition-studies for two of the ceiling frescoes, the *Martyrdom of St Paul* and the *Raising of Eutychus*, are in New York, one in Mr Robert Lehman's collection (146. Pl. 82) and the other in the Metropolitan Museum (142. Pl. 84), and studies for the figures in the boat in the foreground of the third, the *Shipwreck of St Paul*, are on a sheet in the Uffizi (56. Pl. 86). In the final version of the *Martyrdom*, the executioner and the standard-bearer on the left are less static in pose than their counterparts in the drawing and the background figures are reduced to five instead of the large crowd so brilliantly suggested there. In the *Raising of Eutychus*, the group of the fallen man and his supporters corresponds exactly with the drawing, but the left-hand side of the composition is dominated by the figure of St Paul who in the drawing is merely one of three equally spaced

[74]

standing figures in the left foreground. A closely related solution known from old copies at Christ Church and in the Uffizi (74) is composed of the same elements as the Metropolitan Museum study, arranged in much the same way. The principal group likewise consists of a compact block of standing figures, the three most conspicuous being in a row in the foreground with St Paul on the right; but they differ in pose from their counterparts in the Metropolitan Museum drawing, and Eutychus lies alone on his back with his head towards the spectator. This solution is even more spacious than the other, being elaborated still further by the introduction of a second tier of figures craning round the columns of a portico in the background.[1] In both the *Martyrdom of St Paul* and the *Raising of Eutychus* the final result has become simpler and more compact and at the same time more animated in composition – a modification presumably dictated by the height of the chapel and the need to make the scenes on the vault tell as clearly as possible.

Though these two composition-studies, in the Lehman Collection and the Metropolitan Museum, are for adjacent frescoes and so presumably date from about the same time, they offer a curious stylistic contrast. The composition of the martyrdom-scene in the drawing, with the saint and his executioner hemmed in on either side by a standing soldier and at the back by a solid wall of figures, seems to have been inspired by Perino del Vaga's monochrome frescoes of the history of Alexander the Great in the Castel Sant'Angelo (or by his studies for them which come even closer to Taddeo's drawing[2]); in the other the dramatic chiaroscuro and the use of blue paper, the Tintorettesque twisting movement of the group of Eutychus and his supporters, and above all the pose and drapery of the figure standing with its back turned in the centre foreground, combine to suggest not Rome but Venice, and one Venetian draughtsman in particular.

[1] A similar subject is treated by Taddeo in a drawing in the collection of Professor Perman in Stockholm (231. Pl. 40). In the centre of the composition, which is set in a wide piazza, are two figures supporting the body of a third. To the left is a group of soldiers and to the right a figure standing with one arm raised, evidently in the act of healing or resuscitating the one in the centre. It is tempting to see in this a first thought for the *Raising of Eutychus*. On the other hand, the figure on the right is attended by a diminutive train-bearer – an unlikely companion for St Paul – and the very rough sketches on the *verso* include four groups of *putti* playing with objects so roughly drawn as to be unidentifiable except in the case of one, which seems to be a triple monticule. This was one of the heraldic devices of Julius III, and it is possible that a roughly circular object held by the adjoining group is his other device of a wreath. If so, the drawing is likely to date from the years of Julius's pontificate (1550–1555), before Taddeo received the Frangipani Chapel commission.

Three of the groups of *putti* are arranged in line, as if in a frieze. In view of the mutual influence which Taddeo and Pellegrino Tibaldi apparently had on one another in the early 1550's, it may be relevant to note that the decorations which Tibaldi carried out for Julius III in the Vatican Belvedere included 'un fregio dipinto a chiaroscuro, ove vi sono molti putti, che scherzano con Monti, alludenti all'arme del suddetto Pontefice' (see J. Ackerman, *The Cortile del Belvedere*, Rome, 1954, p. 69, note 3). A drawing by Tibaldi at Windsor (Popham-Wilde, no. 945, pl. 111) is evidently a study for this project.

[2] One repr. *B. Mag.*, cii (1960), p. 17, fig. 25.

Taddeo's somewhat older contemporary, Giuseppe Porta, also called Giuseppe Salviati, was a Tuscan by birth and training (the name by which he is often known is an allusion to his master, Francesco Salviati) but a Venetian by adoption, who developed a hybrid style combining Venetian and Tuscan-Roman features. The resemblance between this drawing and drawings by him seems too close to be explained simply by his and Taddeo's common indebtedness to Francesco Salviati or by Taddeo's brief visit to Verona in 1552 which gave him his only direct contact with the art of North-West Italy. It is true that Porta worked alongside Taddeo in the Sala Regia in the 1560's, but if Vasari is to be believed he did not come to Rome until after the death of Francesco Salviati in November 1563; and a study for part of the vault of the Frangipani Chapel, which would for obvious practical reasons have been decorated first, is likely to date from well before then. The mutual cross-fertilization between Venice and Rome in the middle of the sixteenth century is a subject still awaiting detailed investigation. When it is investigated, the study for the *Raising of Eutychus* is a piece of evidence that will have to be taken into account.

<p style="text-align:center">6</p>

If one had to pick out a single drawing to illustrate the range and variety of Taddeo's draughtsmanship, one's choice would probably fall on the sheet of studies in Chicago which displays, in intimate juxtaposition, two diametrically contrasting aspects of his way of drawing and two distinct stages in his creative process. The small pen and ink sketches in which he strikes out his first thoughts are rapid to the point of incoherence, for he is thinking as he goes along with ideas crowding to the point of his pen faster than he can clearly express them. But in the large study for the enthroned Procurator the first flow of inspiration has crystallized, and the figure is elaborated with the utmost deliberation in red wash applied with a fine brush-point: a medium and technique which Taddeo adopted in the late 1550's, the combination of which seems to have been peculiar to him. Another such drawing is the study for St Paul in the *Healing of the Cripple*, at Windsor (256), in which there is the same contrast between the sculptural, highly wrought solidity of the drapery and the sketchy indication of the body and limbs. This contrast is also a feature of one of Michelangelo's studies for the Erythraean Sibyl, in the British Museum, which has even been attributed to Taddeo on the strength of its resemblance to the Windsor study for St Paul.[1] Dr Wilde's explanation of this drawing as a drapery study made according to the method practised in Florence in the early sixteenth century, from a clay model on which draperies

[1] See L. Goldscheider, *Michelangelo Drawings*, London, 1951, p. 180.

of fine cloth soaked in liquid clay were arranged in the required folds and left to harden, must also apply to Taddeo's drawings of this type. The study of two sleeping disciples at Windsor (259. Pl. 68) has already prompted the suggestion that Taddeo used small models of clay or wax for studying the poses and draperies of his figures. The group on the *verso* of the Chicago sheet (22. Pl. 95), though more roughly drawn than the figure on the *recto*, gives the same impression of sculptural compactness and self-sufficiency and may likewise have been drawn from a model. At first sight this seems to be for a *Lamentation* or *Entombment*, for it is clearly derived from Michelangelo's unfinished marble group, now in Florence Cathedral but in Taddeo's time in Rome;[1] but in the context of the other studies on the sheet it seems more likely that the motif was the germ of the group of Eutychus and his supporters in the fresco on the ceiling of the chapel.

Other drawings of single figures by Taddeo, many of them in the same technique, resemble the Chicago and Windsor studies in the sharp sculptural isolation in which the figures stand out on the paper, and were no doubt also made from small models. Like the Windsor drawing, several of these represent a bearded man in heavy draperies with a book under his left arm and his right hand raised in a gesture of command. A brush drawing in brown wash, in the Louvre, corresponds very closely with the eventual form of St Paul in the *Healing of the Cripple* (169); an earlier study for the same figure, in pen and wash, is in the Albertina (241); and others – a red wash drawing in the Stockholm Museum, later transformed by Taddeo into a St Andrew by the addition of a cross (223 *recto*. Pl.

[1] In their *Trattato della Pittura* of 1652 (see Steinmann-Wittkower, *Michelangelo Bibliographie*, 1927, p. 272), Giovanni Domenico Ottonelli and Pietro Berrettini allude to two *Pietà* groups by Michelangelo, one certainly identifiable with the Florence Pietà, 'di tanta bellezza, che Taddeo Zucchero stimò bene impegiata le sua fatica in disegnarle, colorirle, e ridurle in opera: come vedesi in Roma nella Madonna de' Monti, e nella Pieta del Consolato'. Steinmann and Wittkower comment that 'die Kopie der Pietà Michelangelos, die sich im Dom von Florenz befindet, sieht man noch heute in S. Maria dei Monti', but this picture, in the third chapel on the right, has no connexion with Taddeo. It is a copy (by Antonio Viviani, according to Baglione) of a painting by Lorenzo Sabbatini, based on the Michelangelo group, in the Sacristy of St Peter's (Venturi, ix⁶, fig. 258). The 'Pietà del Consolato dei Fiorentini' was the Oratory, annexed to S. Giovanni dei Fiorentini, of S. Orsola della Pietà, where Taddeo and Federico 'dipinsero ambedue in quattro giorni per un ricco apparato, che fu fatto per lo giovedi e venerdi santo, di storie di chiaroscuro tutta la Passione di Cristo nella volta e nicchia di quello oratorio, con alcune profeti ed altre pitture' (Vasari, vii, p. 87). To judge from the context of this passage in Vasari, the date of this commission was probably 1560. In November 1564 Taddeo was commissioned to paint another fresco (the subject of which is unspecified in the document) in the Oratory. The Oratory was demolished in 1889 and, so far as I have been able to discover, no record of its decoration survives.

In Taddeo's composition in the Pucci Chapel in S. Trinità de' Monti of *God the Father with the Dead Christ and Angels holding the instruments of the Passion* (repr. *B. Mag.* cviii (1966), p. 287) the figure of Christ is inspired by Michelangelo. The frontal position of the body and the placing of the arms are derived from the presentation drawing made for Vittoria Colonna and engraved by Bonasone and Beatrizet (see C. de Tolnay, *Michelangelo*, v, figs. 159 and 340 etc.). God the Father, on the other hand, seems to be an echo of Nicodemus in the Florence *Pietà*.

100), a close variant of the same figure, in the Museum at Baltimore, in pen and wash with white bodycolour (3), and a brush drawing in grey wash in the Albertina (244. Pl. 101) – could be for St Paul in either of the scenes on the side-walls or in the *Raising of Eutychus* on the ceiling. A red wash drawing in the Venice Accademia of an old man in a hat and heavy cloak craning forward to see something to his left is probably a discarded study for an onlooker at one of these miracles (235. Pl. 102); another, in the Louvre (178. Pl. 103), is of a young man standing with a large book under his left arm and pointing downwards with his right hand, who can be identified as one of the Evangelists by the book and as St John by his youthful appearance and by his likeness to the figure in Raphael's tapestry of *St Peter and St John healing the Cripple at the Beautiful Gate*. Taddeo's interest in the Raphael tapestries at the period of the Frangipani Chapel is shown by the derivation of his early design for the *Blinding of Elymas* from Raphael's treatment of the subject. The purpose of the Louvre *St John* is unknown but the drawing is of exactly the same type as studies for the chapel, so in theory it is possible – though admittedly there is no other evidence to support the suggestion – that at some stage other episodes from the *Acts* than those directly involving St Paul may have been contemplated.

The resemblance between Michelangelo's drapery studies and Taddeo's, though striking at first sight, is a superficial one which can be accounted for by their being made for the same purpose in the same way: after due allowance is made for his greater stylistic affinity with Michelangelo, it could still be argued that Taddeo's drawings are equally close to studies of this type by Leonardo da Vinci and Fra Bartolommeo. Michelangelo's technique is entirely unlike Taddeo's, for he uses the brush to put in the main masses of the drapery and achieves the effect of sharp, sculptural modelling by a superimposed mesh of fine pen strokes, hatched and cross-hatched in all directions. Taddeo seems, rather, to have developed his tech-nique in emulation of a type of drawing produced in Rome in the 1540's by Daniele da Volterra – to whom, incidentally, Michelangelo's study for the Erythraean Sibyl has also been attributed – who obtained very much the same effect as Taddeo did with the brush-point, by hatching and stippling with a finely sharpened chalk. The similarity between the two techniques is shown by the frequency with which in old catalogues and inventories Taddeo's red wash drawings are described as being in red chalk. Drawings of this kind might be said to 'aspire to the condition of sculpture': contours are reduced to the minimum, there is a complete absence of accent, and the tension is evenly distributed over the form which is laboriously built up by a succession of minute strokes – or, to put it another way, is excavated from space as a figure is gradually released from the marble block.

The link between Daniele and Taddeo was probably Pellegrino Tibaldi, who worked under Daniele in S. Trinità dei Monti soon after coming to Rome in 1547. The influence of Daniele's way of drawing can be seen already in Tibaldi's studies for his Borghese *Adoration* of 1548 – the black chalk study in the British Museum for the Sibylline figure in the foreground, and the full-size *modello* of the whole composition drawn with the brush-point in dark brown wash, fragments of which are in the Uffizi and the British Museum[1] – and it persists in the red chalk drawings of Michelangelesque *ignudi*[2] which probably date from the period of his Palazzo Poggi decorations, soon after his return to Bologna in 1554. Taddeo, though he did not at once develop to the full the sculptural possibilities of the technique, was influenced by this kind of drawing well before the period of the Frangipani Chapel, for there is an obvious similarity between his red chalk study of a woman holding a baby, in Lord Methuen's collection (24. Pl. 31), which from its style must date from around 1550, and Tibaldi's study in the British Museum for the figure in the *Adoration*; and between both these and Daniele's black chalk drawing of a Sibyl in the Hermitage which is probably connected with the Orsini Chapel in S. Trinità which he decorated in the middle 1540's.[3] On the whole, Taddeo's chalk drawings tend to be looser and less highly wrought than those in wash, but an exception to this rule is the unusually dry and schematic red chalk study for the *Blinding of Elymas* at Windsor (253). The squaring and the exact correspondence with the fresco show that this is not a study in the sense of being a drawing in which the design is still in the process of excogitation: it is, rather, a precisely accurate fair copy made only after every detail of the composition had been finally settled, to serve as a basis for the full-size cartoon. In some studios – Raphael's, for example – this was a stage in the preparation of a fresco usually entrusted to an assistant; but the Windsor drawing, if not particularly attractive, is too intelligent and too lucid not to be from the hand of the master himself. Other studies in red chalk for single figures in the same composition are known. One of these, for the enthroned Procurator, recently came to light among the Parmigianino drawings in the Uffizi (77. Pl. 92). Though the *verso* is inscribed with Taddeo's name in an old hand it is possible to see how this mistake may have arisen, for in handling the drawing resembles the more careful kind of red chalk drawing by Parmigianino and there is a Parmigianinesque elegance and refine-

[1] Repr. *British Museum Quarterly*, xxvi (1962/63), pls. xxii–xxiv.

[2] e.g. in the Copenhagen Printroom (Ital. Mag. xiii, 16, as Tibaldi; unpublished). Another study of exactly the same type, of a Michelangelesque female nude, is in the Dijon Museum (Trimolet 53; repr. *Paragone* 87 (1957), pl. 39).

[3] Repr. M. V. Dobroklonsky, Catalogue of XV and XVI-century Italian Drawings in the Hermitage, 1940, pl. xx; S. H. Levie, *Album Discipulorum aangebodenaan Professor Dr J. G. van Gelder*, Utrecht, 1963, fig. 1.

ment about the type and proportion of the figure. I suspect that this was over-ingeniously misidentified as a study for the rather similar figure of Nero in Par-migianino's well-known composition of the *Martyrdom of St Peter and St Paul*. Studies of single figures in red chalk are on the back and front of a sheet in the British Museum (107. Pls. 93a and b). On one side is a man wearing a sweeping robe and a turbanlike headdress who turns away with one hand covering his face, a gesture which combined with the quasi-oriental style of his costume suggests that he is the blinded sorcerer Elymas. The suggestion is confirmed by the drawing on the other side of the sheet, of a bare-headed man who stands erect holding a book with his head turned sharply over his right shoulder and is evidently St Paul in the act of striking him blind. It may be indicative of Taddeo's tendency to conceive his figures in sculptural isolation that notwithstanding the intense and dramatic relation between Paul and Elymas, he should have chosen to draw these two studies on opposite sides of the same sheet.

Sculptural isolation is characteristic of the Prophets in niches on the entrance pilasters of the Chapel. Their descent can be traced from the Prophets flanking the altar in the Mattei Chapel, and even beyond them, from the Apostles etched by Bartolommeo Passarotti on designs by Taddeo. The Frangipani Prophets are more monumental than any of these, and are so tightly enclosed in their niches and so static in pose and evolved and deliberate in the arrangement of their draperies that but for their naturalistic colouring they might be *trompe l'oeil* statues. (Muziano's Prophets on the entrance-pilasters of the Gabrielli Chapel in S. Maria sopra Minerva, which closely resemble Taddeo's, are actually in monochrome simulating bronze.) A similar pair, also naturalistically coloured, for one of which there is a study by Taddeo in the Art Institute of Chicago (21), are on the side-walls flanking the high altar of S. Eligio degli Orefici in Rome;[1] and by the end of the century such pairs of Prophets had become one of the standard features of Roman chapel decoration. Studies by Taddeo for the figure on the left-hand pilaster of the Frangipani Chapel are in Munich (134) and Berlin (4. Pl. 106b), and one for its counterpart was in the Rayner-Wood Collection (126). A drawing of another figure of exactly the same type is at Angers (2. Pl. 106a) and old copies of yet another are in the Uffizi and elsewhere (37). By an aberration of connoisseurship traceable back at least as far as Padre Resta at the end of the seventeenth century, these drawings of single figures of prophets tend

[1] The same pair of figures reappears on either side of the altar in the chapel of the Villa d'Este at Tivoli, decorated on Federico's designs in 1572. Of the pair of Sibyls on the opposite wall, one corresponds (but for the absence of his beard) with the Prophet on the right-hand pilaster of the Frangipani Chapel; the other seems to derive from the allegorical female figure for which there is a study by Taddeo in the Albertina (238). See D. R. Coffin, *The Villa d'Este at Tivoli*, 1960, pp. 48 f. and figs. 51 and 52; also Ugo da Como, *Girolamo Muziano*, 1930, repr. on p. 79.

to be attributed to Beccafumi on the strength of their superficial likeness to the full-length Apostles by him which are well-known from chiaroscuro woodcuts (see 135).

A sheet of studies for the lunette in the upper part of the altar-wall is in the collection of Count Antoine Seilern in London (124. Pl. 99). On the *recto* is a careful study in red chalk for the two *putti* in the space on the right of the central window, while the lower of the two figures in the lower left-hand corner of the *verso* corresponds in reverse with the figure reclining on the half-pediment on the other side of the lunette. Sketches in pen and ink for the entire lunette are also on the *verso*. They are too rough to be made out clearly, but in two of the designs for the right-hand space a figure is apparently being raised from the ground and in one of them he is lying over what looks like a fallen horse. If these are not just idle scribbles – and with so fluent a draughtsman as Taddeo it is impossible to be certain that they are not – they suggest that the *Conversion of St Paul* may at one stage have been intended for this relatively obscure position. Another of the sketches for the right-hand space, which includes a figure kneeling in an attitude which seems to be that of Christ in an *Agony in the Garden*, is even more puzzling, but is too slight and inconclusive to be construed as definite evidence of a radical alteration in the iconographic programme.

On the *verso* of the Berlin study for the Prophet on the left-hand pilaster (4) is a drawing of two child-angels on clouds. Another study for the same group is in the Leiden University Printroom (89. Pl. 97) and it appears again, apparently in its final form, with the most conspicuous angel holding a martyr's palm, in a highly finished *modello* for the decoration of a left-hand spandrel in the collection of Professor van Regteren Altena (1). Of these three drawings, the one in Berlin is on the same sheet as a study for part of the Frangipani decoration, while the one at Leiden has on the *verso* (Pl. 99a) a rapid pen and ink sketch of two *putti* above an arch, one astride a cloud in a pose almost identical with that of the angels in the upper part of the lunette. The chapel itself is barrel-vaulted and contains no spandrel-shaped space, but such a group might have been intended for the space above the entrance arch on the nave wall. The decoration of a chapel was often continued in this way (Sebastiano del Piombo's fresco of prophets above the entrance arch of the Borgherini Chapel in S. Pietro in Montorio is a familiar example) and iconographically this particular addition would have been appropriate to the Frangipani Chapel, for the martyr's palm could be an allusion to the subject of the fresco in the centre of the vault. It might be objected that the pilasters between the entrances to the side-chapels in S. Marcello are too wide to leave room for a painting of the shape of Dr van Regteren Altena's drawing, but since the rebuilding and redecoration of the church continued until well into

the next century (one of Giovanni Battista Ricci's scenes from the Passion in the upper part of the nave is dated 1613) the pilasters are more likely than not to date from long after the period of Taddeo's activity.

Vasari says that Taddeo made great use of the services of assistants in the Frangipani Chapel. For much of the last seven or eight years of his life, during which he was intermittently working on this commission, his principal assistant was his brother Federico, and the chapel is often described as a work of collaboration between them. For example, every Roman guide-book, from Titi in the seventeenth century to the latest (1962) edition of the T.C.I. Guide, attributes the altarpiece of the *Conversion of St Paul* to Federico; and recently Dr Rearick has argued from the resemblance between the frescoes on the side-walls and the *Conversion of the Magdalen* and the *Raising of Lazarus* which Federico painted on the side-walls of the Grimani Chapel in S. Francesco della Vigna in Venice in 1563–1564, that Federico had some share in the design of the former.[1] Though the persistent tradition that Federico was responsible for the *Conversion of St Paul* can be traced back as far as Baglione,[2] it is in direct contradiction to Vasari who explicitly attributes the picture to Taddeo and describes him as working in the chapel and completing the altarpiece during the Summer (presumably of 1564) after Federico's departure for Venice. I know of only two drawings connected with this composition:[3] a careful squared study in black chalk (with touches of red chalk on the faces) on blue paper for one of the angels in the upper part, in the Museo del Castello Sforzesco in Milan (129. Pl. 96), and a rough sketch, in pen and brown wash heightened with white, corresponding with the lower part of the composition, formerly in the Skippe Collection and now belonging to Dr Piero del Giudice (122). The first is an unusual kind of drawing for Taddeo, but in quality it seems worthy of him and I certainly cannot see Federico's hand in it. The relationship of the other to the picture is puzzling, for though it has every appearance of being a rough early sketch, it corresponds so far as it goes exactly

[1] W. R. Rearick, 'Battista Franco and the Grimani Chapel' in *Saggi e memorie di storia dell'arte*, no. 2, Venice, 1959, p. 131.

[2] The authorship of this composition seems always to have been in doubt. The first word of the inscription *Tadeus Zucarus inventor* on an engraving by Cherubino Alberti dated 1575 (B. xvii, p. 70, 57), was altered from *Federicus*. An undescribed early state, with the attribution to Federico and before the addition of the engraver's monogram and the date, is in the British Museum.

[3] A drawing of this subject at Windsor (6010; Popham-Wilde, no. 416, fig. 85) was published by Antal as a study by Taddeo for the Frangipani altarpiece (*Old Master Drawings*, xiii (1938/39), p. 37, pl. 41), an opinion which he reiterated in a review of Mr Popham's Windsor catalogue (*B. Mag.*, xciii (1951), p. 32) where the drawing had appeared under the name of Marco Marchetti da Faenza with the entirely just comment that its style differs 'radically and irreconcilably' from Taddeo's. In his rejoinder (*B. Mag.*, ut cit., p. 131) Mr Popham described it as a 'wretched pastiche' of the Frangipani composition, but it is difficult to see even that degree of resemblance between the two. If the Windsor drawing is derived from anything, it is from Michelangelo's fresco in the Cappella Paolina.

with the finished composition. In the Skippe Sale Catalogue Mr Popham suggested that this might be a cartoon made for the small-scale repetition of the picture now in the Doria-Pamphili Collection in Rome; but leaving on one side the question of whether the Doria version is autograph, any drawing made in that particular connexion would surely have been a detailed copy of the composition, careful to the point of dullness. But whatever the place of this drawing in the sequence of studies for the altarpiece, or whether (as is perhaps more likely) it is some kind of *ricordo* of the composition, it does seem to be from the hand of Taddeo himself. As for the question of Federico's share in the design of the scenes on the side-walls, it is true that their likeness to the Grimani Chapel frescoes does extend beyond mere general resemblance to the presence of almost identical motifs in both, and also that the chapel was not quite finished when Taddeo died and that it was completed by Federico; but we have Federico's own word for it that his share in the decoration involved 'pocho ho nullo di momento',[1] and the resemblance is more reasonably explained by Federico's stylistic dependence on his brother and his habit of borrowing motifs from him. However much Taddeo may have relied upon assistants in the intermediate stages of the lengthy and complicated process of the decoration, and perhaps even in the execution of the paintings, it is very unlikely that so inventive an artist would have needed help in their design.

But I have left to the last one puzzling drawing which on the face of it seems to confirm Dr Rearick's thesis. In a study of a group of gesticulating figures in the Uffizi (53. Pl. 87) the architectural setting corresponds exactly with the right-hand side of the *Healing of the Cripple* but the figures, except for the pair of women in the background, are entirely different. The old attribution to Federico is surely correct, which would seem to prove that he had a share in designing this particular composition; but there is a largeness of conception and a sureness in the placing of the figures that is as uncharacteristic of him as it is characteristic of his brother, and I would prefer to explain this drawing as a copy by Federico of a study by Taddeo. The technique, a combination of red chalk and red wash, is (so far as I know) without parallel in Federico's drawings, and suggests an attempt to reproduce, by less laborious means, the effect of the red wash medium which Taddeo favoured at the period of the Frangipani Chapel.

[1] Note in Vasari (vii, p. 97).

III

At the end of the last chapter we were abruptly confronted with the crucial problem of this study. The confusion between Taddeo Zuccaro's drawings and those of his younger brother and pupil Federico is one of long standing and particular difficulty, and any consideration of the last phase of Taddeo's career must begin by taking into account the part played by his brother during that period. The date of Federico's birth is not recorded, but the inscription on a drawing in the Uffizi stating that he was in his twenty-fifth year in 1565 shows that he cannot have been more than ten years old in 1550 when his parents brought him to Rome and left him in his brother's care. Many widely diverse elements contributed to the haphazard formation of Taddeo's style, but Federico's stylistic origins can be described in one sentence: he had no other master but his brother, from whom he took over, ready made, the vocabulary of form which Taddeo had gradually evolved as an expression of his own very different personality. During much of the period between about 1559, when Federico came to artistic maturity, and Taddeo's death in 1566, the two brothers worked closely together, but Federico's role in the partnership was always more than that of a mere assistant. From the very first he received independent or quasi-independent commissions in which he benefited from Taddeo's advice and practical help, so that drawings connected with works of this period by either brother could (in theory at least) be by the other. After Taddeo's death he was naturally called upon to carry out his unfinished commissions, and though in these posthumously completed works in which he overlaps with Taddeo Federico seems to have thought of himself as little more than an extension of his brother's personality, for him to transform Taddeo's original conception into a finished work that to our eyes appears entirely characteristic of himself required only infinitesimal adjustments and shifts of emphasis so slight that they could have even been made unconsciously; but even when, as in the S. Lorenzo in Damaso altarpiece, he modifies the original design out of all recognition, the result seemed to him to be fully in accordance with Taddeo's intentions – as he understood them.

The possibility of confusion does not arise over the works of Taddeo's earliest, Polidoresque phase, nor over those of the period of the Mattei Chapel. The start of Federico's independent career in the late 1550's coincided with Taddeo's shift

towards greater classicism of style; the paintings in the Frangipani Chapel which mark Taddeo's stylistic turning point were Federico's point of departure. The resemblance between these and the frescoes which Federico carried out in 1563–64 in S. Francesco della Vigna in Venice, extending as it does beyond general similarity to the appearance of a number of almost identical motifs in both sets of frescoes, has prompted Dr Rearick's suggestion that 'the universally recognized participation of Federico in Taddeo Zuccaro's works immediately preceding [Federico's] first trip to Venice may extend not only to a part of the execution of the Frangipani Chapel but even to the design itself'. But the converse explanation is to be preferred, both on grounds of general probability – that the elder and established artist is more likely to exert a decisive influence on the younger, rather than the other way about – and because it can be shown that elsewhere Federico was in the habit of taking motifs directly from Taddeo and incorporating them in his own compositions. As Mr Popham pointed out in his Windsor catalogue, an ultimately discarded figure from an early design by Taddeo for the Sala Regia *Donation of Charlemagne* reappears unaltered in a study by Federico for his *Flagellation* of 1573 in the Oratorio del Gonfalone, and I have already referred to the resemblance between Federico's Grimani Chapel altarpiece and a rough sketch of an *Adoration of the Magi* by Taddeo datable from its style in the early 1550's (219 *verso*) as well as to the possibility that part of Federico's *Disputation of St Catherine* in S. Caterina de'Funari (*c.* 1570) was based on a discarded study for the group surrounding the enthroned Procurator in the Frangipani *Blinding of Elymas*. The figure of the Procurator is one which Federico used more than once. One variant of the motif occurs in the *Plague of Flies*, a fresco belonging to a series of sixteen illustrating the story of Moses in Egypt which Federico painted in the Vatican Belvedere between June and October 1563, shortly before his departure for Venice. Not only is the figure of Pharaoh based on Taddeo's Procurator, but the man running forward with his arm across his face repeats, in reverse, the pose of the figure in the right foreground of the Frangipani *Conversion of Paul*.

Federico's habit of introducing into his own compositions figures and motifs taken from his brother's disposes of the only argument against restoring to Taddeo the two studies in the British Museum for a group of standing soldiers (95 and 97, Pl. 157), the attribution of which has always oscillated unsatisfactorily between him and Federico. The two principal figures of the group occur in another of Federico's Belvedere frescoes, *Moses and Aaron before Pharaoh*, as well as in a drawing of the *Adoration of the Magi* at Chatsworth which though traditionally given to Taddeo is certainly by Federico and probably an early design for the Grimani Chapel altarpiece of 1564. But it should be noted that in the Belvedere fresco the raised foot of the uppermost figure is supported on a rectangular block which

[85]

seems to have been introduced solely for the purpose of fitting the group into the composition since architecturally it makes no sense as part of the structure of the throne. This clumsy expedient suggests that Federico was making use of a study originally made in some other connexion; and everything about the two British Museum drawings themselves – the handling, the feeling for form, the evidence of intellectual struggle, and the expressive beauty, equally striking in either drawing, of the face of the uppermost figure – points to Taddeo as their author. The group occurs in no known composition by him, but as we shall see later, it is possible that this may be a discarded solution for the right-hand side of the *Donation of Charlemagne* in the Sala Regia.

The two British Museum drawings and the one in the Uffizi discussed at the end of the previous chapter between them illustrate very aptly the nature of the difficulty. The first are studies for a motif known only in two compositions by Federico while the other represents a discarded solution for one of Taddeo's frescoes in the Frangipani Chapel; in both cases the connexion is of a kind that would seem on the face of it to establish Federico's authorship of the first two and Taddeo's of the third; but neither conclusion is reconcilable with what we see in the drawings themselves. Internal evidence is the only reliable guide, but in seeking to distinguish between the work of two artists who are using an identical language of form we must not be misled by superficial similarities of handling and technique; the only sure touchstone for a drawing which hangs doubtfully in the balance is the artistic personality which lies behind it, for however slavishly one artist models himself on another his essential nature will sooner or later reveal itself in spite of any accidental similarities that may result from the common style. The key to the problem lies, therefore, in judging a drawing by the total impression which it makes, and in keeping a firm grasp of the difference between the personalities of Taddeo and Federico, a difference so fundamental that except in those few difficult cases of which the most likely explanation is that they show Federico making a fair copy of a design by Taddeo, the answer is almost always evident once the doubtful drawing is considered in the context of those demonstrably by one hand or the other.

Enough studies for two of Federico's earliest commissions, the façade in the Piazza S. Eustachio which he painted at the age of eighteen and the frescoes carried out in Venice in 1563–4 in the Palazzo Grimani and S. Francesco della Vigna,[1] have survived to reveal a personality which even in this embryonic phase is sharply distinct from Taddeo's. Licia Collobi's contention[2] that critics attempting a joint estimate of the Zuccaros end by taking sides and making exaggerated

[1] See Uffizi 1966 Exhibition, nos. 29–30 and 40–47.
[2] *Critica d'arte*, iii (1938), p. 71.

[86]

claims on behalf of one brother or the other, reflects the still generally held view that in point of artistic quality and achievement there is little or nothing to choose between them. But this view of things merely reflects the absence of any positive notion of Taddeo as a distinct personality, or of any recognition of the fact that Federico's historical significance far outweighs his intrinsic merits and that as a creative artist he is immeasurably his brother's inferior. Federico's many admirable qualities included a profound awareness of the dignity of his position as an artist, tireless industry, and a high level of technical efficiency, but these do not in any way make up for his lack of creative imagination and plastic sensibility. One feels that Federico's approach to his art was the conceptual one of an intellectual and a theorist: that painting and drawing were not for him a natural and inevitable means of expression, but that his starting-point was an abstract idea round which, so to speak, he drew a line. He had none of Taddeo's instinctive feeling for the volume and displacement of a form, nor his instinctive ability to create either a meaningful spatial relation between forms or a continuous modulation of a form in space. At the final analysis, his figures are two dimensional symbols without organic unity, and his compositions syntheses of stock poses and groups – the more effective as often as not lifted from Taddeo – neatly snipped out and dextrously fitted together according to a cut-and-dried compositional formula. Federico was not without a certain pedantic ingenuity and within his limitations was a thoroughly efficient craftsman, so that his defects may temporarily be obscured by the academic correctness – even 'brilliance', if of a rather mechanical kind – of his draughtsmanship; but his habit of padding out his compositions with motifs taken from Taddeo without first submitting them to any process of intel-lectual digestion argues both indolence of mind and inability to conceive a composition as an organic whole; and if my interpretation of the sequence of studies for the S. Lorenzo in Damaso altarpiece is correct,[1] then the travesty of Taddeo's intentions which he produced there is enough to demonstrate the width of the gulf between them.

It would, however, be misleading to imply that Federico's is a personality that can only be defined in negative terms: that he is little more than an impersonal 'waste-paper basket' to which all drawings which come close to Taddeo but do not seem quite good enough to be from his own hand can automatically be relegated. In its own way the flavour of Federico's personality is as idiosyncratic and as immediately recognisable as Taddeo's, and there are drawings, particularly of the careful 'fair copy' type, which do not carry conviction as being from the hand of Taddeo himself, but which equally have no positive indications of Federico's authorship. These all date from the late 1550's onwards when Taddeo

[1] See *B. Mag.*, cviii (1966), pp. 341 ff.

[87]

was at the head of a busy, well organised studio; and until more is known about the minor personalities involved it seems best, for the time being, to classify such drawings simply as products of the studio executed under Taddeo's supervision.[1]

2

That the Frangipani Chapel which Taddeo began at the end of 1558 or the beginning of 1559 was still unfinished when he died in September 1566 was due to the great number of commissions which he undertook during those eight years. It is indicative of the pressure under which he worked that he had hardly begun the chapel before breaking off to execute a rush order for temporary decorations in S. Giacomo degli Spagnuoli for the obsequies of the Emperor Charles V, and that only a month or so later he accepted a commission to decorate a chapel in Orvieto Cathedral. The repainted semi-dome of the apse of S. Sabina, on the Aventine, is dated 1559, and about then (or perhaps somewhat earlier) he decorated the *casino* of the Palazzo del Bufalo with a fresco of the *Muses on Mount Parnassus* and was also helping his brother with designs for his first public commission, the *cappella maggiore* of S. Maria dell'Orto. In 1559–60, with some assistance from Federico, he painted two small rooms in Paolo Giordano Orsini's castle at Bracciano and a similar set of decorations in Alessandro Mattei's palace in the Via delle Botteghe Oscure in Rome. In May 1560 he was paid for the restoration of Raphael's frescoes in the Sala de'Palafrenieri in the Vatican which had been destroyed by Paul IV, and in the course of the same year five further payments are recorded for work elsewhere in the Vatican or in the papal Palazzo del Aracoeli. In 1560, when

[1] Two technical differences between Taddeo's drawings and Federico's may be noted. Taddeo did not share Federico's taste for a decoratively elegant, but basically unfunctional, combination of black and red chalk. Of the few exceptions known to me, 211 *verso* is a sheet of rough sketches with each separate figure in one or other colour; in 80 there are touches of red chalk on the faces and hands, and in 224 only the lips of the figure are in red chalk; in 56 *verso* the underdrawing is in both colours. Federico was fond of drawing in pen and wash with white heightening on paper prepared as if for drawing in metalpoint. Taddeo occasionally uses paper covered with a very thin coat of opaque or semi-opaque yellow or brownish yellow colour, but Federico seems to have preferred the chalky texture of the true metalpoint ground, usually (though it is not unknown for him to draw on a brown ground) in such colours as lilac, pink, or pale blue.

Another difference between Taddeo and Federico is in the faces of their figures, a feature that betrays the psychology of the artist himself. Taddeo's faces are stamped with a look of intelligence and even nobility, while Federico tends to rely on a few stock types (two of the more frequent might be called 'The Skull' and 'The Soulful Dachshund') which have in common an expression of vacuousness blended with complacency which one soon comes to recognize. Federico's intellectual inferiority is also evident when he tries to imitate Taddeo's rapid shorthand way of drawing. Taddeo often expresses himself incoherently when putting down his first ideas, but even if we cannot always entirely elucidate the resulting jumble of lines and blots these always somehow seem to be the expression of a valid intellectual process. When Federico tries his hand at drawing in this way the scribble remains a mannerism, a wearisome trick of draughtsmanship, a mere calligraphic flourish in which one looks in vain for any evidence of fundamental brainwork.

he made a brief visit to Urbino to paint the portrait of the Duke's daughter on the occasion of her marriage, the Duke took the opportunity of commissioning a series of designs for a service of maiolica, which was completed by September 1562. It was probably in 1561 that he began the decoration of Cardinal Alessandro Farnese's new palace at Caprarola. This large and important undertaking must have been a continuous preoccupation from then onwards, but it did not prevent him from contracting in June 1563 to decorate the lower part of the Pucci Chapel in S. Trinità dei Monti, or from agreeing after the death of Francesco Salviati in the following November to complete the decoration of the Sala dei Fasti Farnesiani in the Palazzo Farnese in Rome; or from pulling every possible string to obtain the share in the decoration of the Sala Regia in the Vatican which was to occupy much of his time and energy from early in 1564 to the end of 1565. In November 1564 he received a first payment for a fresco in the oratory of S. Orsola della Pietà, and in the very last months of his life he was making designs for a monumental altarpiece for the church of S. Lorenzo in Damaso.

Taddeo seems, in fact, to have resembled Perino del Vaga as Vasari describes him in his later years, in being incapable of refusing any commission that came his way. Pressure of work obliged him, like Perino, to make as much use as possible of the services of a large body of studio-assistants, and like Perino he is still sometimes thought of as primarily an efficient *entrepreneur* whose greatest talent lay in the exploitation of his more gifted juniors. Vasari certainly stresses his capacity for organizing large-scale decorative enterprises – 'he showed the greatest good judgement in combining many different talents in one great undertaking, and in knowing how best to make use of their various skills so that the whole decoration appears to be the works of a single hand' – but however much he depended on the help of others for carrying out these schemes it would be wrong to dismiss him as nothing more than a latter-day Squarcione, for the drawings connected with a great enterprise like Caprarola show that his was the directing intelligence at every stage.

Nothing remains of Taddeo's work at Orvieto, nor have I found any drawings connectible with the two large figures of *Vita Activa* and *Vita Contemplativa* which Vasari says he painted 'nella facciata' of the same chapel, or any which might throw light on the rest of the decoration, including the altarpiece.[1] The oratory of

[1] The mid-sixteenth-century decoration of the nave of Orvieto Cathedral was swept away in 1877–80 (see L. Fumi, *Il Duomo di Orvieto e i suoi restauri*, Rome, 1891, p. 347). The elaborate complex of stucco-work and frescoes was totally destroyed and the only survivors of the archaeological rage for 'restoration' are the ten altarpieces from the side-chapels now in the Museo dell'Opera del Duomo. Fumi prints a detailed description of the *cinquecento* decoration by Girolamo Clementini (1658–1714) and illustrates one of the chapels – the third on the left-hand side, with the altarpiece of the *Pool of Bethesda* – in its unrestored state (op. cit., pp. 420 ff. and plate opp. p. 380). These show that the design of all ten side-chapels was the same: in the semi-dome of each curved niche were three frescoes, a circular or octagonal one in the centre,

S. Orsola della Pietà was demolished in 1889: he probably worked there on two separate occasions, and one of his paintings seems to have been a *Pietà* or a *Lamen-*

flanked by two ovals or elongated octagons; on the curving side-walls, single figures of saints with small rectangular frescoes, mostly related in subject to the saint in question, above and below; in the spaces on either side of the pediment surmounting the altarpiece and immediately below the semi-dome, smallish square frescoes; and above the entrance-arches of the chapels, alternate pairs of Prophets and Sibyls.

Clementini's identification of Taddeo's *Vita Activa* and *Vita Contemplativa* with the pair of square frescoes below the semi-dome in the fifth chapel on the left-hand side is impossible to reconcile with the contemporary account given by Vasari (vii, p. 87): 'condusse nella faccia d'una di dette cappelle due figurone grandi; l'una per la Vita attiva, e l'altra per la contemplativa ... e mentre che Taddeo lavorava queste, dipinse Federigo nella nicchia della medesima cappella tre storiette di San Paolo'. Vasari's emphasis on the large scale of Taddeo's figures, and on their position on the *faccia* of the chapel as opposed to the *nicchia*, establishes that they were painted on the wall above the entrance-arch in the place eventually occupied by a pair of Prophets or Sibyls. Clementini describes no scenes from the life of St Paul in this particular chapel, though according to him there were three in the second chapel on the right-hand side; but these are attributed by him to Cesare Nebbia, and two of them were above and below the figure of St Paul on one side-wall while the third was below the corresponding figure of St Peter. Federico's *storiette*, on the other hand, would have occupied the three spaces in the semi-dome if the decoration of the chapel in question had been carried out, as it presumably was, in the normal order from the top downwards.

It seems therefore that the iconographic programme of the decoration was changed and that this change involved the alteration or destruction of Taddeo's two *figurone* and of Federico's *storiette*. In a letter dated 22 January 1572 (Fumi, op. cit., p. 416, doc. ccii) Federico says that he was obliged 'l'anno passato di ritoccare e far quasi tutte di nuovo le pitture a fresco della volta [i.e. the semi-dome] et del frontespitio [i.e. the *faccia*] della cappella del Ciecho illuminato [i.e. the fifth chapel on the left-hand side, which contained the altarpiece of the *Healing of the Blind Man*]'. The figures above the entrance-arch of this chapel were the Libyan and the Persian Sibyls. The *Vita Activa* and *Vita Contemplativa* are usually typified by a pair of female figures, either Rachel and Leah or their New Testament counterparts Mary and Martha, and it would probably have been a fairly simple matter to transform these into a pair of Sibyls; the frescoes in the semi-dome of the same chapel represented three of Christ's miracles of healing which might – it is perhaps not too far-fetched to suggest – have been adapted from similar episodes in the Life of St. Paul.

The documents published by Luzi and by Fumi (see above, p. 20) provide no basis for the latter's statement (op. cit., p. 380) that the chapel which Taddeo was commissioned to decorate was one of those nearest to the main entrance of the cathedral; this is evidently an inference from Clementini's incorrect attribution to Taddeo of the altarpiece of the *Marriage at Cana* in the first chapel on the left-hand side. Mr Pouncey points out that this painting is in fact by Cesare Nebbia and that there is a study for it, traditionally and correctly attributed to him, in the Louvre (1365) and another in the Berlin Printroom (1096, as Francesco Vecelli). Milanesi (Vasari, vii, p. 87, note 2) identifies Taddeo's altarpiece with the *Healing of the Blind Man*, but that this was in fact designed and executed by Federico is established not only by the preparatory studies in the Ashmolean Museum (P.II.750) and in the Louvre (4417; 1969 Exhibition, no. 68, repr.) but also by a document dated 14 November 1568 commissioning it from him together with the other altarpiece of the *Raising of the Widow's Son* (Fumi, op. cit., p. 416, doc. cxviii).

Taddeo seems not to have taken the Orvieto commission very seriously: Vasari says of the two figures that they were 'tirate via con una pratica molto sicura, nella maniera che faceva le cose che molto non studiava'. There are no further references to the projected altarpiece, or indeed to Taddeo, in the published documents after 29 September 1559, and it may well be that the altarpiece never even reached the design-stage. Its subject is nowhere specified, and since there was apparently a change in the iconographic programme of the decoration it would be rash even to assume that this was necessarily one of the two subjects commissioned from Federico in 1568.

tation over the Dead Christ.[1] In the Vatican it is impossible to detect any sign of his hand in the Sala dei Palafrenieri. Most writers on Raphael from the time of Pasavant onwards have assumed that the *grisaille* Apostles in niches round the walls which constitute the principal feature of the decoration were also designed by Taddeo, but two of them correspond exactly with Raphael studio-drawings so it would seem that Pius IV required Raphael's original figures to be restored as exactly as possible.[2] An inscription in the room records further alterations in 1582 when the ornamental niches and decorative figures surrounding them were executed by Egnazio Dante and Cherubino Alberti respectively.[3] Apart from the Sala Regia there is no other trace of Taddeo's activity in the Vatican,[4] though a much damaged frieze in one of the rooms in the Belvedere decorated for Julius III between 1550 and 1553 has been attributed to him on the strength of its close resemblance to the frieze in one of the upper rooms in the Villa Giulia.[5] The painting in the semi-dome of S. Sabina is still intact, but I have not found any drawings connected with it.[6] A drawing in the Uffizi, not by Taddeo himself but inscribed with his name in an old hand and evidently a product of his studio (71), may be a study for one of the large scenes of the victories of Charles V which formed part of the decorations for the Emperor's obsequies.

3

So far as drawings are concerned, one of the more important of these later commissions was the series of maiolica-designs. I have already dealt with this in detail and need only summarize the arguments put forward elsewhere.[7] Vasari tells us no more about the service than that it was intended as a present from the Duke of

[1] See ante, p. 77, note 1

[2] See P. Pouncey and J. A. Gere, *Catalogue of Italian Drawings in the British Museum: Raphael and his Circle*, 1962, under no. 63.

[3] See *Bollettino d'arte*, series 4, xiii (1960), p. 230.

[4] Payments to Taddeo for paintings in the Cortile della Libreria (now del Papagallo) in the Vatican begin in March 1564. After his death they were valued by Girolamo Siciolante da Sermoneta at 700 scudi (Bertolotti, *Artisti urbinati in Roma*, Urbino, 1881, p. 18). No trace of them remains, but a nineteenth-century watercolour copy of the exterior frescoes in the Cortile del Papagallo, in the magazine of the Vatican Pinacoteca, shows a decoration composed of vases between the windows of the top storey, below which was a frieze with a geometrical arrangement of trellis-work combined with cartouches inscribed with the name of PIVS IIII and his coat-of-arms, and on ground-level trees with monkeys and birds in the branches.

[5] See *Rendiconti della Pontificia Accademia romana di archeologia*, xi (1936); p. 187, xii (1937), pp. 371 f. (two details of the frieze repr.); also *B. Mag.*, cvii (1965), p. 205.

[6] This was painted over the remains of an early Christian mosaic and is evidently a free adaptation of the original composition (see M. Salmi, *Nuovo bollettino d'archeologia cristiana*, xx (1914), part 2, pp. 5 ff. and pl. viii; also repr. J.-J. Berthier, *L'Eglise de Saint-Sabine à Rome*, Rome, 1910, p. 356).

[7] *B. Mag.*, cv (1963), pp. 306 ff.

Urbino to the King of Spain, but a contemporary account adds the important additional piece of information that the pieces were decorated with scenes from the life of Julius Caesar. The key to the reconstruction of this set of designs is a circular dish in the Victoria and Albert Museum attributed to the Fontana factory in Urbino and datable 1550–60, decorated with a composition of Roman soldiers demolishing a bridge for which two studies by Taddeo are known: a finished drawing in the collection of the Earl of Leicester at Holkham Hall (87) and a rougher sketch in the Stockholm Museum (225). An inscription on the latter, identifying the subject as 'Caesar destroying the Bridge at Geneva', is repeated on the underside of the dish itself. The four-fold coincidence of the place of manufacture and date of the dish, and the subject and designer of the painting on it, establishes this beyond any reasonable doubt as part of the service in question. The second clue is provided by the appearance of a rectangular adaptation of the painting on the dish on a stucco ceiling by the mid-sixteenth-century *stuccatore* Federico Brandani, formerly in a house in Urbino and now in a room of the Palazzo Ducale. The four other reliefs on this ceiling are likewise adapted from circular compositions, three of which, a *Combat of Gladiators*, the *Distribution of Food and Wine to the Roman People*, and a *Naval Battle*, occur on maiolica of the same type as the Victoria and Albert Museum dish, while of the fourth, representing a *Banquet in a Piazza*, there is a circular drawing in the Louvre, attributed by Mariette to Raffaellino da Reggio but undoubtedly by Taddeo (185, Pl. 106). This drawing is the most elaborately finished example known of the brush and red wash technique which seems to have been peculiar to him and to which he was addicted from the late 1550's onwards. It stands out from his other maiolica-designs in being unnecessarily elaborate for its purpose; unlike the graceful but facile designs which Battista Franco produced at about the same period and which are so exactly suited to their decorative function and to the mediocre capacity of the maiolica-painters who had to copy them, it suggests some failure on Taddeo's part to adjust means to ends, for it is a finished work of art in itself which would have lost much of its subtlety and quality when clumsily translated into a maiolica-painting. But it is possible that this unusually highly finished design was a kind of *modello* made to show the Duke the style of decoration that Taddeo had in mind.

No drawings related to the *Distribution of Food and Wine* have been found and only one old copy of the *Combat of Gladiators* (196); but for some reason the *Naval Battle* seems to have been particularly admired, for no fewer than ten drawings of this composition are known (see 100) mostly attributed to Polidoro da Caravaggio or Perino del Vaga but in one case (at Stockholm) to Taddeo. The only one of these that might even momentarily come into consideration as a possible original

[92]

is at Budapest, but (to judge from a photograph) this is probably also a copy though by a more sensitive hand than the others. Three circular compositions of scenes from Roman history occur on maiolica of the same type as the Victoria and Albert Museum dish and can be attributed to Taddeo on grounds of subject-matter and style: a *Battle with Elephants*, the *Crowning of a General in the presence of his Army*, and a *Skirmish of Horsemen and Footsoldiers outside a City* on a piece inscribed on the underside *Cesare conserva il cittadino*. No studies for these are known (though 204 may be a copy of one[1]) and conversely there are drawings by Taddeo of circular compositions which must be designs for the same service, though I have found no corresponding pieces of maiolica: *A Battle by a River*, of which there is a careful drawing in red chalk in the Uffizi (79) and a rough pen and wash sketch at Munich (133) inscribed *Cesare abbatte svizzeri all'sona* in the hand responsible for the inscription of the similar sketch in the Stockholm Museum for the *Destruction of the Bridge at Geneva*; a pen and wash drawing in the Albertina of *Soldiers digging a Canal* (237) and one identical with it in size, medium and handling in the Biblioteca Reale in Turin, of *An Army fording a River* (233). An old copy of the Turin drawing in the Louvre is mounted with another circular drawing by the same copyist of *Soldiers digging a Trench*, a better version of which, identical with the Albertina and Turin studies in size and medium and (to judge from a photograph) quality and handling, is in the Hermitage (92). Also in the Hermitage are a better version of the composition of soldiers with fantastic siege-engines of which there are drawings in the Louvre and at Haarlem (90), and a circular composition of an incident in a naval battle, showing a group of soldiers in a ship in the right foreground aiming spears at a man standing with a sword in his hand, apparently in the act of committing suicide, on the deck of a neighbouring ship (91). Both of these, to judge from photographs, could be original drawings by Taddeo himself. A circular composition of a *Chariot Race*, which from its style and subject-matter seems to be yet another of Taddeo's designs for this service, is preserved in four copies, three in the Louvre (179) and one in the Museum at Angers. Yet another circular composition of a *Combat of Gladiators* is known from a drawing in the Albertina (243).[2]

[1] A drawing in the collection of Dr Ephraim Schapiro in London shows the composition of the *Crowning of the General* in the form of an oval. At least two other circular compositions found on pieces of the 'Spanish Service' (the *Naval Battle* and the *Triumph of Caesar*) also occur in oval form on pieces of maiolica. Dr Schapiro's drawing, which seems to be a product of the Zuccaro studio, may be connected with an adaptation of this sort.

[2] In my article on Taddeo's maiolica designs (*B. Mag.*, ut cit., p. 314 and fig. 37) a drawing in the Louvre connected with what appears to have been a piece from the Spanish Service (4517; 1969 Exhibition, no. 38) was cited as evidence of Federico's participation in the design of the Service. I no longer believe in the attribution to Federico; it seems to me that the most likely explanation of the drawing is that it is an old (studio?) copy of a composition by Taddeo.

4

Taddeo's activity in the Castello Orsini (now Odescalchi) at Bracciano and in the Palazzo Mattei (now Caetani) in Rome may conveniently be discussed at the same time. Vasari says that Taddeo painted 'for Signor Paolo Giordano Orsini, two beautiful little rooms richly decorated with stucco and gilding: in one he painted the legend of Psyche and in the other, the decoration of which had been begun by someone else, he painted some histories of Alexander the Great and allotted others which still remained to be done to his brother Federico'. This commission can be dated 1559–60. Vasari says it was 'soon after' the celebration of Charles V's obsequies in Rome in March 1559, and the rooms were redecorated for Orsini's bride Isabella de'Medici, whom he married in October 1560. Of the other commission Vasari merely says that Taddeo 'painted for Messer Alessandro Mattei various scenes with figures in certain spaces ('sfondati') in the rooms of his palace in the Botteghe Oscure. Others he gave to his brother to paint in order that he might gain experience'. Since Federico was still regarded as a novice, this can hardly have been later than *c*. 1560; and the paintings, all of which illustrate the life of Alexander the Great, resemble those at Bracciano so closely, not only in subject-matter and treatment but also in general style and lay-out, that they must date from about the same time.

In both palaces the decoration is confined to the deeply coved ceilings of two smallish adjoining rooms. In the larger of the two rooms at Bracciano an escutcheon of the Orsini and Medici arms in the centre of the vault is surrounded by four rectangular scenes of the life of Alexander, one on each face of the coving: *Alexander with Roxana in his Tent* (Pl. 123b), the *Siege of (?) Tyre* (Pl. 122a), *The Family of Darius before Alexander* (Pl. 122b) and the *Triumph of Alexander and Thais* (Pl. 123a). In the adjoining room, the 'Stanza di Isabella', are five scenes illustrating the legend of Cupid and Psyche: a rectangular fresco in the centre of the vault, surrounded in the same way by four elongated ovals. The Alexander-scenes are in good condition, though some alterations to the ceiling must have been made later in the century, for the heraldic allegories in the roundels in the corners of the coving allude to the marriage of Virginio Orsini and Flavia Peretti in 1589. The Psyche-scenes were overpainted in the nineteenth century and are somewhat damaged. In the Palazzo Caetani the frescoes in both rooms illustrate the life of Alexander. In the centre of one ceiling an almost square composition of *Alexander and the High Priest of Ammon* (Pl. 126a) is surrounded by four elongated octagonal frescoes representing *The Family of Darius before Alexander* (Pl. 124a), *Alexander and his Army crossing the River Hydaspes* (Pl. 125a), *Alexander defeating Porus* (Pl. 125b), and *Alexander refusing the helmetful of Water offered him by the*

Macedonians (Pl. 124b). In the other room, an oblong fresco of the *Marriage of Alexander and Roxana* (Pl. 126b) in the centre of the vault was surrounded by four elongated oval frescoes which are now detached and hang in the adjoining gallery; *Alexander taming Bucephalus* (Pl. 127b), the *Cutting of the Gordian Knot* (Pl. 128b), *Alexander and Diogenes* (Pl. 129a) and *Timoclea before Alexander* (Pl. 129b). Each set of frescoes in the Palazzo Caetani was no doubt surrounded originally by the same kind of elaborate framework of gilded stucco as still exists in both rooms at Bracciano, but of this no trace remains.

For the incongruous combination at Bracciano of Alexander the Great and Cupid and Psyche a precedent existed in Rome which would have been well-known to Taddeo. Perino del Vaga's last work before his death in 1547 was the decoration of the top floor of the Castel Sant'Angelo for Paul III. In the Sala Paolina, the principal state-apartment, are episodes from the history of Alexander (in allusion to the Pope's baptismal name) while the frieze in the adjoining bed-room illustrates the legend of Psyche. The parallel does not end here, for the resemblance, in the simplified compositions and in the proportions of the figures and their scale in relation to the picture-area, between the Psyche-scenes in the Castel Sant'Angelo and those at Bracciano is too close to be coincidental and seems on the face of it to justify Antal's theory that Taddeo must have started his career as one of Perino's studio-assistants and that he executed the Castel Sant'Angelo frieze on Perino's design. There is, in fact, no reason for supposing that the two artists were ever in direct contact, but many of Taddeo's early drawings testify to the important role played in his development by Perino del Vaga. The Psyche-scenes at Bracciano, like the designs for maiolica-decoration made between 1560 and 1562, show that the change of direction taken by his style towards the end of the 1550's included a phase of renewed interest in Perino. The similarity between Perino's and Taddeo's treatment of the legend of Psyche is as evident as the contrast between their approach to the story of Alexander. Perino's colossal chiaroscuri in the Castel Sant'Angelo are conceived in a spirit of grandiose *terribilità* which emphasizes the function of the Sala Paolina as a ceremonial state-apartment; at Bracciano and in the Palazzo Caetani Taddeo never loses sight of the fact that he is decorating small intimate living-rooms, and treats the subject in a spirit of almost *rococo* lightheartedness appropriate to a boudoir. If we are to look for a contemporary or near-contemporary parallel, not so much in style as in sentiment, it is perhaps with the mock-heroic, mock-chivalric scenes from the *Aeneid* which Niccolò dell'Abbate painted in 1542 in the castle at Scandanaio and which are now in the Modena Gallery.

The only drawing which can definitely be connected with the Bracciano decorations is in the Albertina, traditionally attributed to Taddeo and identified by

Körte as a study for *The Family of Darius before Alexander* (248). Though it differs from the fresco only slightly, the differences are enough to rule out the possibility of its being a copy, but the drawing is of the carefully finished kind, without *pentimenti*, in which the distinction between Taddeo and Federico is not always immediately obvious; and since Federico is on record as having painted some of the Alexander-scenes, he has in this case a particularly strong claim. Nevertheless, in spite of certain passages which seem suggestive of Federico – notably the unsubstantial background figures and the handling of the figure of Darius's mother – on the whole it seems that this is a case for the benefit of the doubt, for whether or not Federico executed this particular scene, Taddeo is likely to have been responsible for the preliminary designs. A further point to be considered is the headdress worn by the wife of Darius. In the painting she wears an open crown, but in the drawing her hair is elaborately looped and braided and bound with a diadem of the concave shape much favoured by Perino del Vaga. This direct borrowing from Perino suggests Taddeo rather than Federico, but it is impossible to feel wholehearted belief in an attribution which has to be defended by such external arguments.

A drawing which might be connected with either commission is on the *verso* of the standing saint in red wash at Stockholm which is probably a study for St Paul in one of the Frangipani Chapel frescoes (223). This outline diagram, in pen and ink, of the stucco decoration of a ceiling with a rectangular central compartment surrounded by four elongated ovals separated by strips of grotesque decoration and with escutcheons at the angles of the coving, could equally well be for the Stanza di Isabella at Bracciano or the room in the Palazzo Caetani with the *Marriage of Alexander and Roxana*. It is indicative of Taddeo's increasing tendency towards classicization that a late eighteenth-century facsimile engraving by C. M. Metz of a study for the *Marriage of Alexander and Roxana* in the Palazzo Caetani should be inscribed with the name of Raphael: a mistake which can be explained by the fact that the composition is closely derived from Raphael's well-known treatment of the same subject. Mr Popham had already suggested, apropos of a version of the Raphael composition at Windsor, that Metz's engraving reproduces an adaptation of it by Taddeo, and his attribution is confirmed by the subsequent discovery of the fresco. There is no doubt about the connexion. The centre group corresponds almost exactly with the fresco, but the figures are smaller in relation to the total area and the *putti* on either side who are playing with Alexander's armour are different. A drawing corresponding exactly with the Metz facsimile and in reverse to it, has recently come to light in Munich, in the collection of Herr Herbert List (135). The sheet is somewhat damaged and is thus difficult to judge but it seems probably to be Taddeo's original. A study for the

[96]

oval fresco of *Timoclea and Alexander* from the ceiling of the same room is in the Albertina (236). In view of Taddeo's evident revival of interest in Perino del Vaga at this period, it is interesting that in the eighteenth century, when this drawing was in the Crozat Collection, it was engraved in facsimile with an attribution to Perino. The Albertina drawing is somewhat looser and freer in handling than the one belonging to Herr List, but in his studies for the Palazzo Caetani Taddeo seems, as usual, to have varied his technique, for among the as yet uncatalogued residue of drawings at Windsor is one which though too coarse and clumsy to be from Taddeo's own hand is clearly an old facsimile of a study for the fresco of *Alexander taming Bucephalus* from the ceiling of the same room, exact to the point of reproducing the technique of drawing with the brush-point in red wash which was so much favoured by Taddeo from the late 1550's onwards (254). Also at Windsor is an old copy of a study for one of the octagonal scenes in the other room, *Alexander refusing the water offered him by the Macedonians*, differing from it chiefly in the absence of the horse which eventually occupied the right foreground. This drawing was catalogued as 'after Taddeo Zuccaro' at the suggestion of Antal, who though unaware of the connexion with the Palazzo Caetani had been struck by the resemblance of the figures to those in the Albertina study for the Bracciano *Family of Darius before Alexander*. A livelier version in the Louvre (200) has a better claim to be taken seriously as a possible original by Taddeo, but Mr Pouncey was probably right in describing it, in a note on the mount, as a copy by Federico.[1]

5

Another work of collaboration between Taddeo and Federico which must date from about the same time was the decoration of the *cappella maggiore* of a church in the Trastevere, S. Maria dell'Orto. Here the major share was nominally Federico's. According to Vasari 'when Taddeo saw that Federico had gained enough confidence to work by himself and make his own designs with the minimum of help from others, he persuaded the Confraternity of S. Maria dell'Orto to commission him to decorate a chapel. He let them think, however, that he was

[1] Since this book went to the printer, the original of the Windsor copy and a study for another fresco in the same room, *Alexander cutting the Gordian Knot*, have come to light: one in the collection of Col. Joseph Weld at Lulworth (Pl. 127a), the other in that of Herr List in Munich (136. Pl. 128a). An anonymous sixteenth-century engraving of a youthful warrior kneeling before a High Priest (B. xv, p. 22, 1; A. M. Hind, *Catalogue of Early Italian Engravings . . . in the British Museum*, 1910 p. 314, no. 17) may reproduce a lost study for the principal group in *Alexander and the High Priest of Ammon* in the adjoining room. Behind the two figures in the engraving is Bramante's *tempietto* which appears on a smaller scale in the right background of the fresco.

prepared to undertake it himself because Federico was still so young that the commission would not have been given to him unaided. In order to satisfy the Confraternity, therefore, Taddeo painted the *Nativity* and the rest was carried out by Federico'. The clear implication of this passage is that of the four narrow upright frescoes placed in pairs one above the other on the curving walls on either side of the high altar, only the *Nativity* on the left-hand wall (Pl. 116) is by Taddeo, and that the *Marriage of the Virgin* above it (Pl. 114) as well as both scenes on the other side, the *Visitation* above (Pl. 115) and the *Flight into Egypt* below (Pl. 117), were designed and executed by Federico. But Taddeo's responsibility for the design of the *Flight into Egypt* is established by studies, all certainly from his hand, for three successive stages in the evolution of the design. A slight black chalk sketch in the Louvre (170 *verso*. Pl. 111) shows St Joseph leading the ass from left to right down a slope and slightly away from the spectator so that its forelegs are extended and its hindquarters fill most of the left foreground. This daring treatment of the subject, which would have appealed to Barocci, was perhaps thought to be too naturalistic and informal, for in the other two studies and in the fresco itself it gave way to a more conventional one with the ass pacing sedately from right to left. In these we can watch Taddeo improving his design by a continuous process of concentration and simplification. In all three, as in the first sketch, the upper part is occupied by the traditional motif of angels pulling down fruit-laden branches within reach of the Infant Christ; but in the second study, also in the Louvre (180. Pl. 112), St Joseph, standing with his back to the spectator, fills the left foreground; in the third study, in the British Museum (101. Pl. 113), the trees on the right are brought closer together and St Joseph, now walking forward to the left, has been given a less prominent position on the far side of the ass; finally, in the fresco itself, the composition is concentrated even further by making him turn his head to look up at the Virgin and Child.

The *Nativity* is one of a number of variations on the related themes of the Adoration of the Shepherds and of the Magi which stem from what may have been a discarded project for the Mattei Chapel. In an old copy, in the Louvre, of a pen and ink drawing by Taddeo of the *Adoration of the Shepherds* (171), the main elements of the S. Maria dell' Orto composition are combined in very much the same order; but all these variations form such a closely interrelated series that it is impossible to claim more for the lost original of the Louvre copy than that it could have been a study for this one in particular.

Another drawing in the Louvre is connected with the fresco of the *Marriage of the Virgin*, but the exact nature of their relation is also obscure. The principal group, of the High Priest standing in front of an arched niche about to join the hands of St Joseph and the Virgin who stand on either side of him, is essentially

the same in both, but in the drawing these three figures are more widely spaced and there are others to right and left of them so that the composition, unlike that of the fresco, is wider than high. The drawing in fact reproduces the centre part of an even more extended composition known in its complete form from a frieze-shaped drawing in the Rosenbach Foundation in Philadelphia (213). In this the three principal figures are in the recessed centre section of a structure which projects on either side to form columned porticos. In the left-hand portico stand a group of men, including the disappointed suitors with their staves; in the other, the women attending the Virgin. Though the symmetrical arrangement of the two principal figures on either side of the High Priest is a commonplace – indeed, almost unavoidable – way of treating this subject, the resemblance between the S. Maria dell'Orto fresco and the central group in both drawings, extending as it does to the presence of the same niche in the background of both, is close enough to make it very probable that one was derived from the other. Federico's name is inscribed on both drawings, but there is nothing particularly suggestive of him in either. They are closer to Taddeo though clearly not from his own hand, and can most satisfactorily be explained as fair copies or repetitions produced in his studio. The classical restraint and simplicity of the complete composition, with its echoes of Raphael, is characteristic of Taddeo in the late 1550's. The columns punctuate the line of standing figures and emphasize the position of the main group in the centre in a way that suggests knowledge not only of Raphael's tapestry of the *Healing of the Cripple at the Beautiful Gate* but also, perhaps, of an earlier work, the *Presentation of the Virgin* in the predella of the Vatican *Coronation*, which was then in Perugia but which Taddeo could have seen if he had chosen to take that route between Rome and Urbino. The original purpose of this frieze-shaped design is unknown. The shape suggests a predella; and though there is no record of one being proposed in any of Taddeo's commissions, such a reversion to High Renaissance practice would have been fully in keeping with the direction of his development from the late 1550's onwards.

Another commission which Taddeo got for his brother at about this time was for the decoration of the outside of the house of Tizio da Spoleto, opposite the church of S. Eustachio. Vasari tells the story of Taddeo's well-meant but violently resented interference with one of the paintings on this façade, and of his reconciliation with Federico after it had been agreed that though Taddeo might 'correct and alter Federico's cartoons and drawings as much as he liked' he was not to interfere with his paintings when they were actually in the process of execution. From this anecdote two significant facts emerge: Taddeo's over-anxious solicitude for Federico's success and Federico's willingness to accept help from Taddeo in the planning of his compositions. The S. Eustachio façade was carried out when

Federico was only eighteen years old (that is, in about 1558 or 1559), but the S. Maria dell'Orto commission may have been even earlier, if the order of Vasari's narrative is anything to go by. In any case, Taddeo would have been no less anxious for Federico to do himself credit. All the surviving studies for the façade are by Federico, and this does seem to have been an entirely independent work, which would explain his indignation at Taddeo's attempt to interfere with it; but in spite of what Vasari says about the respective shares of Taddeo and Federico in the S. Maria dell'Orto commission – and, more important still, in spite of what Federico does not say, for he made no annotation against this passage in Vasari – the studies for the *Flight into Egypt* show that Taddeo's share was greater than either Vasari knew or Federico was prepared to admit. Indeed, all four compositions are so characteristic of Taddeo that they must be counted among the more important of his surviving later works. In the fourth fresco, the *Visitation*, the architectural setting, far from being a mere decorative backdrop, plays no less integral a part than it does in the complete design of the *Sposalizio*. The classical buildings against which the scene is enacted are reduced to a few simple, almost abstract shapes which delimit the elements of the composition and enhance the hieratic grandeur of the figures. The picture area is divided vertically slightly to left of centre by the straight edge of a pier of masonry, part of a ruined building, against which the Virgin stands in profile with the front of her robe exactly in line with the edge of the pier so that she seems part of the structure itself, like a Caryatid. St Elizabeth advances from the right to embrace her, down steps on the uppermost of which are three standing women whose statuesque forms are echoed by the row of circular columns behind them. Beyond these columns can be seen part of an Ionic temple-front. It cannot be entirely a coincidence that columns and steps in the same oblique perspective and in the same position on the extreme right, and an identical temple in the background, are prominent features of Peruzzi's *Presentation of the Virgin* in S. Maria della Pace. The elements of this deceptively simple composition are fitted together with a calculated precision that can only have been the result of a long process of trial and error involving a whole sequence of studies. No such drawings are known, but if any should come to light it is safe to predict that they will be by Taddeo: the intellectual power and the capacity for formal design which this composition reveals are qualities wholly outside Federico's range, and would, indeed, be difficult to match in Roman painting during the century between the death of Raphael and the arrival of Poussin. They show that Taddeo's classicism was not a superficial change of style to suit contemporary taste, but an expression of the deepest level of his personality.

On the other side of the earlier of the two Louvre studies for the *Flight into*

Egypt is a drawing of a group of four women, one holding a lyre and another a book, attributes which show them to be Muses and so exclude any connexion between this side of the sheet and the S. Maria dell'Orto paintings (170 *recto*. Pl. 110). The drawing is a study for the left foreground of 'the Muses round the Castalian Spring' (Pl. 109) which Taddeo painted in fresco on the ceiling of the loggia of the *casino* or garden-house of the Palazzo del Bufalo, a building more generally remembered for Polidoro da Caravaggio's scenes from the legend of Perseus on the façade. Some of these, including one of almost the same subject, a group of Muses and Poets round the Fountain of Hippocrene, were detached when the casino was demolished in the 1880's and are now in the Museo di Roma. Taddeo's *Parnassus* was transferred to canvas at the same time and remained in the possession of the Bufalo family until 1925 when it was acquired by its present owner. The presence of a study for it on the same sheet as one for the *Flight into Egypt* in S. Maria dell' Orto enables it to be dated at about the same time, towards the end of the 1550's.

In attempting the subject of *Parnassus* at this point in his career and in this particular place, Taddeo could hardly have failed to have in mind two earlier, and widely differing, treatments of it, one by Raphael in the Stanza della Segnatura, the other by Polidoro on the façade of the Casino del Bufalo itself. His *Parnassus* resembles Polidoro's in being a compact rectangular composition on the same scale and of much the same size, 7 by $10\frac{1}{2}$ feet as against 6 by $9\frac{1}{2}$; but whereas Polidoro's followed the invariable convention of his façade-paintings in being in monochrome in simulation of an antique relief, Taddeo's is in colour and he has made some attempt to create a composition in depth. In the Louvre drawing the group of figures is compressed into the form of a narrow upright rectangle. In the fresco the seated Muse has been shifted to the right and the leftmost of her three companions brought down to the foreground so that the group is now enclosed, no less compactly, in a right-angled triangle. The remaining five Muses form a similar triangular group on the other side, and the two triangles converge in the centre of the foreground leaving a third, inverted, triangular space in which stand, in the background plane, the figures of Minerva and Apollo. Absurd though the comparison may seem at first, if we imagine an artist with a much smaller space at his disposal taking Raphael's *Parnassus* as his point of departure and reducing it to the two groups of figures in the immediate foreground plane on either side of the window, the result would not be unlike Taddeo's composition in its general outline. But here the likeness ends, and the result is a compromise, inevitably somewhat unsatisfactory, between two irreconcilable concepts of space; for in their dense grouping and studied, deliberate poses Taddeo's Muses are very much closer to Polidoro's, while his Apollo in no way resembles the

[101]

magical figure of Raphael's invention but is half way between sculpture and flesh-and-blood, in a stiff pose copied directly from an antique statue – or from what then passed for one.[1]

<div align="center">6</div>

When Pius IV was elected Pope in December 1559 he found the Sala Regia in the Vatican half-finished, as it had been for the past ten years. The decoration of this room, one of the chief ceremonial apartments in the Vatican Palace, had been begun in the 1540's for Paul III by Perino del Vaga, but he only lived long enough to complete the ceiling; and Daniele da Volterra, who succeeded him in the commission, had barely completed the stucco panels on the walls and was just beginning on the frescoes which these were intended to frame, when he was interrupted – for ever, as it turned out – by the Pope's death in November 1549. Neither of the two succeeding Popes did anything further: Julius III lavished all his resources on the Belvedere and the Villa Giulia, and Paul IV preferred to devote the Papal revenues to more utilitarian ends. But Pius IV determined to complete the Sala Regia, and put the matter into the hands of two of his Cardinals, Alessandro Farnese and Marcantonio Amulio. Daniele da Volterra's claim was supported by Michelangelo and by the Pope himself, but the influential Cardinal Farnese wanted the commission for Francesco Salviati. To resolve this deadlock the task was offered, in September 1561, to Vasari. He refused it, whereupon it was decided to parcel out the decoration among a number of younger painters, Giuseppe Porta, Girolamo Siciolante, Livio Agresti, Orazio Sammacchini and Giovanni Battista Fiorini. Much to his dismay, Taddeo Zuccaro was not included. Cardinal Farnese, in spite (or because) of being his patron, refused to intervene on his behalf, observing that there was more than enough at Caprarola to keep him occupied. Cardinal Amulio hoped to secure the entire commission for his fellow-Venetian Giuseppe Porta and was equally disinclined to help. Taddeo was undeterred by these rebuffs and in the end was rewarded for his persistence by being

[1] The figure corresponds in essentials with a statue in the Capitoline Museum (Salone 31; Reinach, *Repertoire de la statuaire*, i, p. 251, no. 954ᴰ). The lyre and arms of this statue are restorations, and the figure was originally one of the many versions of the *Pothos* of Skopas. Clarac (*Musee de Sculpture*, iii, 1850, under no. 928ᴬ) argues that the statue cannot have been restored in its present form before 1750; but Taddeo's painting seems to show that a *Pothos* restored in very much the same way was in existence in Rome in the middle of the sixteenth century. This may perhaps have been the figure described by Ulisse Aldrovandi in 1556 in one of the rooms of the Palazzo Bufalo itself: 'dentro una camera terrena a man dritta del porticale si truova una bellissima statua di uno Apollo intiero, poggiato sopra un tronco col braccio manco. nel qual braccio ha avolto il manto, che giù pende; tiene con mano un'Arpe; perchè gli attribuirono la Musica, come s'è più volte detto; & ha un bel Cigno a piedi.' (*di tutte le statue antiche, che per tutta Roma in diversi luoghi, e case particolari se veggono*, in Lucio Mauro's *Le antichità della città di Roma*, Venice, 1556, p. 286).

allotted one of the smaller spaces to be filled, above the door in the centre of one of the side walls.

The iconographic programme was that originally proposed by Paul III: over the doors, kings who had defended the Christian Faith, and on the walls episodes involving kings who had either won victories on behalf of the Church or who had submitted to Ecclesiastical authority. The subject of Taddeo's *soprapporta*, the first payment for which was made on 4 May 1564, is the Emperor Charlemagne confirming his father Pepin's gift of Ravenna to the Church (Pl. 155). Charlemagne is enthroned in the centre of the composition, between a page with an inkstand and another proffering the deed for his signature. Behind the latter appears the upper part of a secretary holding papers, balanced on the other side of the Emperor by the heads of two figures in the background. Flanking this central group, in the foreground plane and thus on a slightly larger scale, are pairs of *répoussoir* figures of soldiers, the foremost figure in each standing with one foot raised on the step of the throne and one arm aloft grasping a halberd. The composition is so emphatically symmetrical as to give at first a deceptive impression of simplicity: deceptive, because the longer one studies it the more one comes to appreciate the subtlety of the formal counterpoint between the groups on either side, and the skill with which they are varied while remaining exactly balanced. It has the concentration and the static monumentality of a sculptured relief and reveals a more complete absorption of the classical ideals of harmony and balance than do Taddeo's Polidoresque façade-decorations of some fifteen years before; for though these were designed in deliberate emulation of antique reliefs, in them the Antique is still refracted through the medium of Polidoro's idiosyncratic and personal interpretation.

The studies for the *Donation of Charlemagne* show that this apparently simple solution was the result of a long process of experimentation. From the very start the shape of his composition seems to have given Taddeo some trouble. Vasari, writing from first-hand knowledge of the problems involved, emphasises that it was Daniele da Volterra who between 1547 and 1549 'fece sopra ogni porta quasi un tabernacolo di stucco', so that the space which Taddeo had to fill was already determined. It is an awkward shape, for it is almost square, the width to the height being in the proportion of no more than 15 to 14. Studies in Berlin and Edinburgh show that Taddeo's first solution was to arrange his figures on two levels. In the Berlin drawing (5 recto. Pl. 153) Charlemagne is on the upper level along with the page holding the inkstand and the kneeling man who presents the document. Below this group is a figure seated on the steps of the throne, balanced by a second figure apparently emerging from an even lower level so that only his right arm and the back of his head and shoulders are visible. The Edinburgh

[103]

drawing (33. Pl. 152) is a fragment and shows to the right of Charlemagne and the kneeling secretary a pair of *répoussoir* figures standing one behind the other, the figure in front being on a lower level, with his head on a line with Charlemagne's knee.

The study in the British Museum (104. Pl. 154), comes nearer to the final solution. The central group, of Charlemagne, the page with the inkstand and the kneeling man, is now flanked, as in the fresco, by pairs of soldiers standing side by side, but a vestige of the two-level arrangement survives in the half-length figure in the right foreground and in the apparently disembodied head visible on the left behind the dog. The half-length figure eventually becomes the large plumed helmet lying on the lowest step of the throne in the fresco, while the head disappears altogether; and the composition is further simplified by the omission of all but two of the background figures, by the substitution of the less conspicuous second page for the kneeling man who is relegated to the background, and by the greater prominence given to Charlemagne himself.

In the British Museum drawing the only point of exact correspondence with the fresco is the pair of standing figures on the extreme right, which were an afterthought. To make this alteration, Taddeo simply cut off the right-hand end of the sheet, turned it over, and reattached it. The pair replaced a single figure, now on the *verso* of the sheet, who reappears in the right foreground on a lower level than the rest of the group in a drawing at Haarlem (83) made up of two fragments of what seems – apart from the addition of this one figure – to have been an exact repetition by Taddeo himself of the British Museum drawing. Thus even when the composition had almost attained its final form Taddeo was still thinking in terms of a two-level arrangement of figures, and to judge from the reluctance with which he seems to have abandoned it he had probably worked out this solution in some detail. It seems reasonable, therefore, to suggest that the group of soldiers for which there are two studies in the British Museum (95 and 97. Pl. 157) may have been intended for the right-hand side of the *Donation of Charlemagne*. The pair of figures on the right of the Edinburgh study (33. Pl. 152) are similarly placed one above the other; the stance of the uppermost figure in both British Museum studies, with his left foot up on a step and his right arm raised grasping a halberd, agrees in essentials with that of the figure in the right foreground of the fresco; the perspective of the step, identical with that of the upper steps of the throne in the Berlin composition-study (5 *recto*. Pl. 153), shows that the group was intended for a position at the same height above eye-level; Federico's fresco of *Moses and Aaron before Pharaoh* in the Vatican Belvedere, in which the same two figures appear, is datable towards the end of 1563, just at the time when Taddeo must have been working out the design of the *Donation of*

Charlemagne; and the rough sketch of a man standing with his back turned on the right of one of the British Museum sheets (97. Pl. 157), adumbrates the pose of the soldier in the right foreground of the fresco, while the uppermost of the two bearded heads drawn above could be a study for the old man's face which appears above and behind this figure's right shoulder. The two-level arrangement was no doubt abandoned for the same reason as ultimately made it necessary for the composition to be reduced to the fewest and largest possible elements: a composition of the required size and shape, with the figures on two levels, would have been too small in scale to tell effectively at that distance from the floor. Taddeo may also have felt that half or three-quarter-length figures in the lower register would have come into awkward proximity to the crouching *ignudi* in full relief which form the lower part of the sides of the already existing stucco frame.

Taddeo's importunity was justified, for the *Donation of Charlemagne* so impressed the Pope that he was entrusted with the decoration of the whole of the south end-wall of the Sala Regia. In this he was interrupted by Pius's death in December 1565 and the conclave which followed, so that when he himself died less than a year later, having completed the *Siege of Tunis* on the left of the entrance to the Pauline Chapel and the *soprapporta* of two allegorical female figures seated on the pediment above the doorway, the space on the right of the door was still unfilled and had to be completed by Federico (Pl. 159). We have no way of telling how Taddeo proposed to treat this section of the wall. He must have conceived the decoration of the wall as a unity and the iconographic scheme was presumably determined in advance, so it is likely that he had made designs of some sort for the subject eventually carried out by Federico, *Henry IV submitting to Gregory VII at Canossa*. But the only two known studies for this painting, in the Louvre and the British Museum,[1] are both by Federico, and it is impossible to see any trace of Taddeo's personality underlying this phlegmatic and uninspired solution – even allowing for Federico's power of transmuting gold into lead when executing Taddeo's designs. (One would also prefer to think that Taddeo was capable of hitting on a more satisfactory method of effecting the transition between this scene and the rest of the wall.)

Only two drawings by Taddeo himself for the paintings on the end wall are known to me. The rough sketch in the British Museum for the *Soprapporta* (108 *verso*. Pl. 158) shows that he still tended to begin his design on too small a scale, for in the painting the figures have once again become larger and the group simplified. The same tendency is apparent in the other drawing, a *modello* at Christ Church, Oxford (166. Pl. 156) for the *Siege of Tunis*, corresponding with the painting in the general arrangement of the figures but differing in detail and scale.

[1] Louvre 4452 (1969 Exhibition, no. 60, *repr.*) and British Museum 1946–2–9–32.

Taddeo exerted his full powers in the Sala Regia. His initial exclusion, his anxiety to be represented in one of the most important apartments in the Vatican, and the knowledge that he was competing with those who had in the first place been preferred to him, all combined to put him on his mettle, so that his paintings in the Sala Regia occupy a position among his works of the 1560's comparable with that of the Mattei Chapel in the previous decade. Similarly, his drawings for them provide a very complete picture of the range and quality of his draughts-manship at this period. For this reason I have taken the Sala Regia out of its proper chronological order and discussed it before Caprarola, for it will be useful to keep these drawings in mind as a standard of quality when considering the difficult problem of drawings connected with other commissions of the same period in which he took a less directly personal interest and relied more on the services of his studio-assistants.

Even in the Sala Regia the problem of studio intervention arises. Tidied up and elaborated versions of the two composition-studies in the British Museum for the *Donation of Charlemagne* and the other *soprapporta* on the end wall, are respectively at Windsor[1] and in the Fogg Museum. Both in the Popham and Mongan-Sachs catalogues these are given to Taddeo himself, but they are certainly the work of studio-assistants. Comparison with other drawings for the Sala Regia (in parti-cular the Christ Church *Siege of Tunis*, exactly analogous in being likewise a carefully finished drawing of an intermediate stage in the design) reveals a striking difference in quality and intelligence. There is an insipidity about the faces and a failure to relate the figures convincingly to one another which one does not find, for example, in the rather similar study in the Scholz Collection for the group in the foreground of the *Foundation of Orbetello* in the Palazzo Farnese, which though equally diagrammatic does seem to be by Taddeo himself (151. Pl. 164). As so often happens with the Zuccaro studio, the problem is complicated by the exis-tence of more than one version of one drawing. An exact repetition of the Fogg drawing, so exact as to be indistinguishable until they are laid side by side, recently passed through the London sale-room; and yet another is in the Biblioteca Reale in Turin.

7

It was probably in 1560 that Taddeo received the most important commission of his career, the decoration of the enormous palace which Cardinal Alessandro Farnese was building at Caprarola, some forty miles north of Rome in the centre

[1] The Windsor copy comes slightly nearer to the final result in the absence of the apparently disembodied head on the left in the British Museum drawing, and in the substitution of a helmet (though of a different shape from the one in the fresco) for the head and shoulders in the right foreground.

of the Farnese territories. The decoration was begun early in 1561, according to the documents recently discovered in Rome by Mr Loren Partridge, which show that by January 1562 Taddeo and his assistants had completed five rooms on the ground floor, the Sala di Giove and the four Camerine delle Stagioni. By the end of 1565 the five rooms immediately above these, on the piano nobile, which Vasari describes in his 1568 life of Taddeo, the Sala dei Fatti Farnesiani, the Anti-camera del Concilio, the Stanza di Aurora, the Stanza dei Lanefici and the Stanza della Solitudine, were also completed. The terms of Taddeo's agreement with the Cardinal are summarised by Vasari. Taddeo was to make all designs, drawings and cartoons for painting and stuccowork; the assistants were to be under his orders but paid by the Cardinal; and he himself was not required to be on the spot for more than two or three months in the year. This, then, was a highly organised enterprise involving a number of subordinate studio-assistants, and as with all such undertakings – the decoration of the Vatican loggia by Raphael and his studio is another example – the problem is to define the extent of the caposcuola's responsibility and the degree of independence allowed to the assistants.

The question was discussed briefly by Antal in 1928,[1] and at greater length in 1938 by D.ssa Licia Collobi.[2] In a footnote to his article, 'Zum Probleme der Niederländischen Manierismus', Antal attributed the ground-floor rooms to Federico, with the reservation that only the Sala di Giove was actually executed by him; the Sala dei Fatti Farnesiani to Taddeo; the Anticamera to Taddeo and assistants (including Federico); the Stanza di Aurora to Federico in collaboration with Giovanni dei Vecchi; the Stanza dei Lanefici to Federico, probably on designs by Taddeo; and the Stanza della Solitudine to Giovanni dei Vecchi. The Chapel he considered a joint work by Taddeo and Federico. It would be unjust to attach overmuch importance to what Antal himself described as 'the few pre-liminary and incomplete results' of a pioneer examination undertaken at a time when the study of Mannerist art was still in its infancy; but it should be observed that the attribution of the ground-floor rooms to Federico fails to take into account his annotation in Vasari, *tute queste picture e ornamenti sono di Tadeo mera-vigliose*, and that there is no reason for connecting Giovanni dei Vecchi with this earliest phase of the decoration. Baglione's vaguely worded reference to his activity at Caprarola could be so interpreted, but the rooms where he can be shown to have worked, the Camera de'Sogni, the Sala degli Angeli and the Sala del Mappo-mondo, were none of them decorated until the 1570's.

D.ssa Collobi defends Taddeo's authorship of the five ground-floor rooms and

[1] In *Kritische Berichte zur Kunstgeschichtlichen Literatur*, 3/4 (1928/29), p. 208 (in English in *Classicism and Romanticism, with other Studies in Art History*, London, 1966, p. 72).

[2] 'Taddeo e Federico Zuccari nel Palazzo Farnese a Caprarola' in *Critica d'arte*, iii (1938), pp. 70 ff.

stresses Federico's sole responsibility for the Chapel; but she seems to me to be on less sure ground when she concludes that 'la morte colse [Taddeo] quando egli aveva appena incominciato la sua opera nel primo piano'. Her contention that most of the paintings in the first-floor rooms, with the exception of those in the Stanza di Aurora and some of those in the Sala dei Fatti Farnesiani, are either independent works by Taddeo's assistants or were executed by Federico during the three years immediately after Taddeo's death when he was in charge of the decoration, again ignores the clear evidence of Vasari, corroborated, *ex silentio*, by Federico (who makes no annotation to the contrary), that these five rooms were decorated during Taddeo's lifetime by himself or by assistants under his supervision. The basis of her argument seems to be that while (as she claims) Federico's hand can be seen in a drawing in the Albertina (242) connected with the fresco of *Cardinal Alessandro Farnese entering Paris with Charles V and Francis I* in the Sala, as well as in the painting itself and its companion on the same wall, Federico was so much occupied elsewhere between 1559 and 1566 that it was physically impossible for him to have collaborated with Taddeo at Caprarola. But leaving on one side the question of Federico's responsibility for the Albertina drawing and the exact nature of its relation to the painting, which is not necessarily that of a straightforward preparatory study, the assumption that every moment of his time during those years can be accounted for to the exclusion of all possibility of collaboration at Caprarola does not stand up to close scrutiny. The documents printed by Körte show that Federico was occupied continuously in the Vatican and in the Casino of Pius IV for nearly a year, from October 1561 to August 1562. A further payment for the Casino is recorded in June 1563 together with one for work in the Vatican Belvedere, and it must have been soon after receiving the final payment for the Belvedere in October 1563[1] that Federico went to Venice to work for Cardinal Grimani. During this period there would undoubtedly have been other commissions for which documentary evidence is lacking, but for the first three or four of the five or six years during which Taddeo was engaged on the decoration of Caprarola, Federico was in Rome and in contact with him. Taddeo would certainly have needed help over the preliminary work for this exceptionally large and important commission, and for this help would certainly have looked first to his closest and most familiar collaborator. How greatly he depended on his brother's assistance is shown by his anxiety that Federico should return from Venice as soon as possible: 'per aversi

[1] The wording of this document, dated October 3 or 11 (see above, p. 22), is somewhat obscure, but if the phrase 'per detto Federigho a Taddeo suo fratello' is to be interpreted as meaning that Taddeo received on Federico's behalf the money due to him, then it seems possible that Federico may have left Rome before then and after September 8, the date of the previous record of payment which contains nothing to suggest that he was not paid in person.

dunque Taddeo tant'opere alle mani' says Vasari, 'ogni dì sollecitava Federigo a tornarsene'. In theory, therefore, Federico could have helped Taddeo with the designing and planning of the decoration at any time before his departure for Venice in 1563/64, and could have worked at Caprarola itself at any time when he was not working for the Pope. To go into this very complicated question in detail is beyond the scope of this study, but any discussion of it must begin by taking the related drawings into account. Their evidence is not uniformly conclusive, but it tends to support the traditional view of Taddeo's over-all responsibility for the planning and design of the decoration of the first ten rooms.

Federico's attribution of the paintings in the ground floor rooms to Taddeo is borne out by the paintings themselves: there is a lightness of touch and an imaginative fantasy about these little mythological scenes and the grotesques surrounding them, justly described by Jonathan Richardson the younger as 'beautiful as those of Pierino, and altogether as fine as any in the Vatican, and in the same manner'[1], that stamps them as Taddeo's own work.[2] Richardson claims that his father owned the study for the *Bacchanal*, one of the oval frescoes on the ceiling of the Camerino dell' Autunno (Pl. 139). This drawing, now in the Rosenbach Foundation in Philadelphia (217. Pl. 138), includes some of the same motifs as the fresco, but there are more figures and the composition itself is frieze-shaped, derived from an antique sarcophagus relief. Though the connexion with the fresco cannot be entirely ruled out, it cannot be said to be proved. Three other drawings are indisputably connected with paintings in these rooms. One, formerly in the Skippe (Rayner-Wood) Collection and now belonging to Lord Brooke (116. Pl. 132), is for the circular composition of the Infant Bacchus killed by the Titans and brought to life by Rhea, also in the Camerino dell'Autunno (Pl. 133). In the sale-catalogue of the Skippe Collection Mr Popham, who was unaware of the purpose of the drawing, rejected Skippe's attribution to Taddeo Zuccaro in favour of one to Federico; but I think that Skippe – whatever reason he may have had for so expanding the single word *Zuccaro* inscribed on the drawing – was right. In spite of the terms of his agreement with Cardinal Farnese, it cannot be assumed that Taddeo himself was necessarily responsible for every preliminary

[1] *An Account of Some of the Statues, Bas-Reliefs, Drawings and Pictures in Italy, &c. with Remarks*, London, 1722, p. 291.

[2] But it must be admitted that there is a stiffness and woodenness about the three large frescoes in the centre of the vault, of *Jupiter nursed by Amalthea*, *Nymphs conducting Amalthea to Mount Ida* and the *Apotheosis of Amalthea*, which is suggestive of Federico, and is particularly evident when these frescoes are compared with the beautiful *Europa and the Bull* in the same room, which is on the same scale and has every indication of being by Taddeo's own hand. It may well be that Federico did paint these three frescoes on Taddeo's designs, and that his failure to mention the fact is simply to be explained by the greater importance which in those days was attached to *invention* as opposed to *execution*, particularly in large decorative enterprises where many studio-assistants were involved.

[109]

drawing, and especially not for those like this one which contain no *pentimenti* and correspond exactly with the finished painting. Admittedly, the first impression which this study makes is of a rather unattractive hardness, but it is an explicit working drawing by a highly competent artist anxious to have every detail of the composition clear in his mind before embarking on the fresco, in which it would have been difficult to make any alteration. It seems too intelligent and too certain in touch for Federico, and the looser and more revealing passages, for example, the group in the background, reveal Taddeo's characteristic handling. Equally, there can be no doubt about his responsibility for the study at Christ Church for *Triptolemus teaching Mankind the Arts of Cultivation* in the Camerino dell'Estate (162. Pl. 137). The study for *Vulcan giving Jupiter a Shield made from the Skin of Amalthea* in the Sala di Giove (Pl. 131), formerly among the anonymous Italian drawings in the Louvre (191. Pl. 130), was attributed by Mr Pouncey to Federico, apparently without knowledge of its purpose. The drawings connected with Caprarola between them epitomize the difficulties confronting the student: some are certainly by Taddeo and others, as certainly, by Federico, but between these two extremes are some not necessarily by either and others which must be by one or the other but where the distinction is by no means obvious. The third drawing is one of these, but I think that one must accept it as by Taddeo. There is nothing in it that is in any way incompatible with him, and on grounds of general probability it is likely that he and not Federico would have been responsible for a sketch of this kind.

Of the five rooms on the *piano nobile*, the Sala dei Fatti Farnesiani[1] and the Anticamera del Concilio were public state-rooms, and the other three the Cardinal's private apartments. This difference in function is reflected in the style and subject-matter of their decoration. In the Sala and the Anticamera the theme is the grandeur and power of the House of Farnese. Walls and ceilings are covered with crowded historical compositions, representing in the Sala episodes in the secular and political history of the family, and in the Anticamera the career of Paul III. In the three private rooms the decoration is confined to the ceilings, and consists of small frescoes illustrating recondite literary allusions and conceits, surrounded by grotesques and stuccowork. Detailed iconographic programmes on the themes of 'Night and Sleep' and 'Solitude and Meditation' respectively for the Stanza dell'Aurora, the Cardinal's bedroom and for the Stanza della Solitudine, his private study, were laid down by the humanist Annibale Caro in letters dated 21 November 1562 and 15 May 1565. Caro was presumably also

[1] This room at Caprarola and the one begun by Francesco Salviati and completed by Taddeo Zuccaro in the Palazzo Farnese in Rome are referred to indifferently as the Sala dei Fatti or the Sala dei Fasti Farnesiani. To avoid confusion, I have used 'Fatti' for the room at Caprarola, and 'Fasti' for the other.

responsible for the iconography of the Stanza dei Lanefici, the dressing-room, where the paintings allude to the invention of spinning and weaving and the making of clothes, but his programme has not been preserved.

Though the historical scenes in the Sala and Anticamera have been so often engraved, reproduced and copied that they are the best known of all Taddeo's works they hardly show him at his best, for neither the semi-legendary exploits of the Farnese in the middle ages nor the political manoeuvres by which Paul III and his nephews sought to consolidate their dynasty were themes capable of touching the deepest springs of his creative imagination. The monotonous grouping and compositional over-simplification particularly noticeable in some of the paintings in the Sala are not necessarily to be interpreted simply as evidence of Taddeo's tendency towards an increasingly formalized classicism. The Farnese, a family of respectable rather than illustrious origin, intended Caprarola to be the central stronghold of the territories which they had been accumulating in the neighbourhood of Viterbo for the last thirty years; and it has been suggested that the apparently ingenuous style of these compositions was a sophisticated archaism designed to reinforce the myth that the Farnese were as much members of the medieval feudal nobility as the Orsini whom they had supplanted.[1]

Most of the known drawings for Caprarola are connected with the historical compositions in the Sala and the Anticamera. Rough sketches by Taddeo for two in the Sala, *Paul III creating Pierluigi Farnese Captain-General* (Pl. 145a) and the *Marriage of Orazio Farnese and Diane de Valois* are on a sheet in the collection of Mr Janos Scholz (149 *verso*. Pl. 146); another, for the *Battle of Cosa* on the ceiling of the Sala, is in the Rosenbach Foundation, Philadelphia (215. Pl. 147); a study for the *Armistice between Charles V and Francis I at Nice* in the Anticamera, corresponding closely with the final result, is in the Stockholm Museum on the other side of a sheet of sketches for the *Donation of Charlemagne* in the Sala Regia (229. Pl. 149); and a first rough sketch for another fresco in the same room, the *Excommunication of King Henry VIII of England* (Pl. 143), is in the Louvre (198. Pl. 142). A drawing of an enthroned Pope ceremonially handing a standard to a kneeling man in armour, in the Pennsylvania Academy Collection in the Philadelphia Museum (210. Pl. 144), could be a first sketch for either one of two frescoes in the Sala, *Eugenius IV creating Ranuccio Farnese Captain-General* (Pl. 145b) or *Paul III creating Pierluigi Farnese Captain-General* (Pl. 145a), though it differs from both of them in its upright format. Studies for the large-scale allegorical figures in the Sala and Anticamera, on the other hand, are by Federico, and it was presumably he who was entrusted with this subsidiary part of the decoration. Drawings in the Uffizi for *Charity* in the Anticamera (47), at Edinburgh for *Fame*

[1] See F. Zeri, *Pittura e Controriforma: l'arte senza tempo di Scipione da Gaeta*, 1957, pp. 40 ff.

and *Courage* on the vault of the Sala (32) and at Turin for their companion figure of *Sovereignty* (234) are in his characteristic combination of black and red chalk, and his hand can also be recognised in the pen and wash sketch in the Rosenbach Foundation at Philadelphia for *Abundance, the Daughter of Peace*, in the Anticamera (216).[1]

A later stage in the working-out of the historical compositions is marked by a well-defined group of highly finished drawings in pen and brown wash: two in the Louvre, for the *Marriage of Ottavio Farnese and Margaret of Austria* (175) and *Julius III restoring Parma to Ottavia Farnese* (208); four in the Uffizi, for the *Coronation of Paul III* (64), *Pietro Farnese entering Florence* (66), *Alessandro and Ottavio Farnese accompanying Charles V against the Lutherans* (65) and *Paul III creating Ottavio Farnese Prefect of Rome* (54); one in the Albertina for *Charles V, Francis I and Cardinal Alessandro Farnese entering Paris* (242); and one at Chatsworth for the *Marriage of Orazio Farnese and Diane de Valois* (20). A second version of *Paul III creating Ottavio Farnese Prefect of Rome*, also in the Uffizi (68), is squared in the same way as the other and is virtually indistinguishable from it unless the two are laid side by side. There are also two deceptively similar and identically squared drawings in the same pen and wash technique for Federico's figure of *Fame* on the vault of the Sala, at Besançon (10) and Brunswick (13). None of these drawings looks like a preparatory study in the true sense of the word. Carefully drawn in pen and brown ink and wash and, though squared in black chalk, lacking *pentimenti* or any other indication of creative struggle, they have in common a neat impersonality which makes them very hard to assess. Indeed, were it not for the differences between them and the finished compositions, which prove that they must form part of the preparatory working-material, one might be tempted to dismiss them as nothing more than contemporary copies of the frescoes. Most of them are traditionally given to Taddeo, but it is impossible to feel any certainty about their authorship or even that they are all necessarily by the same hand. In every respect – not only in their neatness and the impression of impersonality which they give, but also in the invariable addition of squaring and

[1] In the catalogue of the Uffizi 1966 Exhibition I described the drawings of *Alessandro Farnese entering Paris with Charles V and Francis I* and *Alessandro Farnese and Charles V at Worms* on either side of a sheet in the National Museum in Warsaw (249), which I knew only from small-scale reproductions, as probably *ricordi* of these compositions by Federico. Since then, however, I have had an opportunity of studying better photographs of both drawings, from which it can be seen that though the *recto* is very close in all essentials to the finished painting, it differs from it in certain details in which it corresponds with the *modello* in the Albertina (242). The drawings on this sheet must, therefore, precede the *modello* and be part of the preparatory material. Both of them have an overall lack of accent which one does not, for example, find in Mr Scholz's study for exactly the same stage of *Julius III restoring the Duchy of Parma to Ottavio Farnese* (148 recto), and which at first sight does suggest that they are copies; but in handling they are entirely compatible with Taddeo and I think they must be fair copies, by the artist himself, of compositions which he had already worked out in detail.

[112]

in the existence in some cases of two or more deceptively close versions – they resemble the group of drawings connected with Raphael's later works which were traditionally attributed to Raphael himself but are now generally agreed to be the work of his studio-assistant Giovanni Francesco Penni. Though some of these – those connected with the Old Testament frescoes in the Loggia of Leo X, for example – correspond closely with the compositions in their final form and may have served as basis for the full-scale cartoons which would have preceded the execution of the frescoes themselves, this is by no means true of them all, and it would seem that Penni's functions in Raphael's studio included the task of elaborating his master's indications into neat fair copies – 'compositional drafts' or 'intermediate *modelli*' – either to give the artist himself some idea of the effect of the final result or for submission to the patron. In a highly organised studio such as Taddeo's must equally have been, this intermediate stage may well also have been left to assistants.

A connecting-link between Taddeo's rough sketches and the compositional drafts, which provides perhaps the strongest argument in favour of attributing some of these to Taddeo himself, is the drawing on the *recto* of a sheet in the Scholz Collection (149. Pl. 148). So far as it goes, this corresponds exactly with the Louvre *Julius III restoring the Duchy of Parma to Ottavio Farnese*, which differs from the fresco in being a more extended composition with an additional group of figures in the left foreground. A solution that has reached the stage of being reduced to a compositional draft, even though eventually modified, would hardly have been evolved all at once: from what we know of Taddeo's methods, it must have been arrived at by a lengthy process of trial and error involving numerous studies of separate details like the one in the Uffizi for the figure of a mace-bearer in the eventually discarded group on the left-hand side (40). Thus the drawing on the *recto* of the Scholz sheet is not a rough preliminary sketch like the two on the *verso* (Pl. 146), but a rapid and summary fair copy made as the basis for the *modello*. As such it provides a close parallel to the *modelli,* and it must be admitted that it is not entirely incompatible with them in handling; but the distinction between a rapid fair copy by Taddeo himself cf one of his own compositions, and one elaborated under his supervision by a studio-assistant imbued with his mannerisms and doing his best to suppress his own personality is not an easy one to draw. In one or two of the *modelli*, the *Entry of Pietro Farnese into Florence*, for example, or the *Coronation of Paul III*, it is possible to pick out an isolated detail – a shade of facial expression or a passage rendered with particular intelligence or decision – that suggests Taddeo himself, but the total impression made by even the best of these drawings is one of an over-all softness and lack of accent which tilts the balance the other way. The study at Christ Church for the *Siege of Tunis* in the

Sala Regia (166. Pl. 156) or the one in the Uffizi for the battle-scene in the Palazzo Farnese in Rome (39. Pl. 166), both dating from about the same period as the Caprarola drawings and analogous to them in technique, subject-matter, degree of finish and (apparently) purpose, have exactly the accented touch and vigorous rhythm that the others lack. Both in their qualities and in their defects some of the better *modelli* can be more satisfactorily explained as works by Federico: another drawing in the Uffizi, strikingly like them in its general appearance, is his *modello* for the S. Caterina dei Funari *Martyrdom of St Catherine* of c. 1570.[1] But on the hypothesis of their purpose here put forward, even if some of the compositional drafts can be shown to be by Federico this does not mean that he was necessarily responsible for the design of the composition.

For the next stage in the working out of the design, on the other hand, Taddeo himself does seem to have been responsible. The impossibility of altering a fresco except by the laborious process of chipping out and replacing the plaster obliged the artist to formulate in advance as exact an idea as possible of what he intended to paint. The final stage in the preparatory process was a full-scale cartoon enlarged from a drawing or *modello* which was explicit in every detail. One example of such a *modello* is the meticulously executed drawing in red chalk at Windsor (253) which corresponds exactly with the Frangipani Chapel *Blinding of Elymas* and illustrates the care which Taddeo took to define every detail of the composition before embarking on the painting itself. A similar drawing, also squared, corresponding (but for slight differences in the head of one of the figures in the left foreground, in the absence of the books on the steps, and in the placing of the figures in the small group in the upper left-hand corner) with the fresco of the *Council of Trent* in the Anticamera at Caprarola, belongs to Dr Detlef Heikamp (260).[2] This drawing is in the brush-point and red wash technique that seems to have been peculiar to Taddeo himself, and there can be no question that it is from his own hand.

These three categories of drawings, the rough sketches, the intermediate *modelli* or compositional drafts, and the final *modelli*, are clearly defined. The general picture which they present is much as one would expect: Taddeo making the designs for the historical scenes and Federico those for the allegorical figures; the studio-assistants, including probably Federico, transforming these rough indications into neat working diagrams; and Taddeo himself (as Dr Heikamp's drawing seems to suggest) making the detailed *modelli* of the compositions in their final form to serve as basis for the cartoons. A few other drawings have still to be mentioned which do not fit into any of these three categories. They are not squared

[1] 1966 Exhibition, no. 57 (repr. pl. 40).

[2] Since this book went to press, Dr Heikamp has presented the drawing to the Uffizi.

but resemble the intermediate *modelli* in their neat finish and almost total lack of *pentimenti*. A study for *Paul III bestowing the Cardinal's Hat on four future Popes* is in the Hermitage (93) and the lower part of another is on the *verso* of one of the studies in Berlin for the Sala Regia *Donation of Charlemagne* (6). Both differ from the fresco in much the same way and represent two closely related intermediate stages in the design. A drawing in the Louvre (174), connected with another of the Anticamera paintings, *Charles V doing homage to Paul III on his return from Tunis,* shows the figures without the architectural setting and differs from the fresco in the placing of the figures and in the shape of the composition. A carefully detailed design in pen and wash, giving alternatives, for an ornate coffered ceiling with spaces for paintings and in the corners the arms of a Farnese cardinal, is at Capodimonte (137). This does not correspond with any of the ceilings in the palace but there is an inscription on the *verso* by a previous owner recording that he had acquired it along with 'certe cose di Gio de Vecchi' (who himself was to work at Caprarola in the 1570's) as Taddeo's design 'per li ripartimenti del Palazzo di Caprarola'. These drawings resemble the *modelli* in being too impersonal to be attributed with conviction to any particular hand, but given Taddeo's apparent responsibility for the invention of the compositions it is a point of hardly more than academic interest whether these drawings are by him or by a studio-assistant or assistants. I would not exclude the possibility that the Hermitage and Berlin drawings are by Taddeo himself, but I do not know either in the original and it is impossible to come to a definite conclusion solely on the basis of photographs. For the Louvre drawing of *Charles V doing homage*, on the other hand, he himself can hardly have been responsible. The placing of the horses' legs in the left foreground and the structure of the throne and canopy are misunderstood in a way that would be impossible if the draughtsman had himself excogitated the composition. One must be reluctant to invoke the shadowy and unsatisfactory personality of an 'Amico di Taddeo' with no apparent existence except in relation to his master, but it is difficult to explain this drawing except as the work of an unidentified studio-assistant copying something which he has not fully understood. The Capodimonte drawing, on the other hand, is presumably the work of some specialist in grotesque decoration who perhaps played the same role at Caprarola as Luzio Romano seems to have done in Perino del Vaga's studio in the 1540's.

Only a handful of drawings can be connected with the other rooms on the *piano nobile* completed in Taddeo's lifetime. In the Stanza di Aurora, for example, the only part of the decoration for which drawings are known are the circular compositions in the pendentives, and of these drawings only the Louvre study (194. Pl. 140) for *Sonno* (Pl. 141) can be accepted as by Taddeo himself. This

drawing is more detailed than Lord Brooke's study for the roundel in one of the ground-floor rooms, but the attribution to Taddeo as against Federico can be defended by exactly the same arguments, as well as by comparison with the drawings in the Victoria and Albert Museum connected with the roundels of *Brizio* and *Harpocrates* (114, 115) which stand in the same relation to them as does the Louvre drawing to *Somo* but are positively characteristic of Federico.

When he came to the Stanza dei Lanefici, Jonathan Richardson noted a painting 'In a Lozenge, one in a Tree gathering Fruit, another below, &c. My Father has the drawing; as he has also of some others of these Histories, but not remembering that he had them when I saw the Pictures, I did not inform myself what the Stories were'. (In fact, the objects being gathered from the tree in the scene he describes are not fruit but silkworms.) A drawing connected with this scene is in the Albertina (240) – probably not the one referred to by Richardson since there is no trace of his father's collector's mark – and in the Louvre are studies for two other frescoes on the same ceiling, *Hercules and Iole finding the Murex* (192. Pl. 134) and *Hercules giving Iole a garment dyed with Murex* (193. Pl. 135). The Albertina drawing is a rough sketch which agrees with the painting only in the action of the two principal figures and in their placing in relation to the tree; their individual poses are quite different and they are men, whereas their counterparts in the painting are female. Without the connexion with the fresco or the traditional attribution to Taddeo to prompt one, his name might not have come at once to mind, but the handling seems not incompatible with him and it is hard to see who else (except – in theory, at least – Federico, and the drawing is even less suggestive of him) would have made a sketch of this sort. External evidence must be the deciding factor, and one is forced to the conclusion that this drawing is by Taddeo but that it shows his drawing-style in an unfamiliar aspect.[1] The two Louvre studies, on the other hand, correspond closely with the finished compositions except for small details and in the shape of *Hercules and Iole finding the Murex*, the fresco of which is in the form of an elongated octagon. Like the study in the same collection for *Vulcan giving Jupiter a shield made from the skin of Amalthea* (191. Pl. 130) they were found among the anonymous Italian drawings by Mr Pouncey, who likewise attributed them to Federico Zuccaro without reference to their connexion with Caprarola. The distinction between Taddeo and Federico is equally difficult to draw, and if here too I find myself in disagreement with Mr Pouncey, it is with no very deep sense of conviction: in the words of Padre Resta, in another connexion, 'doppo mille considerationi ondeggianti io concludo per di Taddeo secondo mi'[2] – on the strength largely

[1] A better version has now appeared (Pl. 136) which shows that the Albertina drawing is an old copy.
[2] See A. E. Popham, *Correggio's Drawings*, London, 1957, p. 117.

of a crispness and decisiveness in the touch of the pen on the paper and an intelligence and sureness in the placing of the figures which seem to tilt the balance in his favour.

Of these ten rooms, the last to be decorated was probably the Stanza della Solitudine. The inferior quality of the paintings here to those in the Stanza dei Lanefici and the Stanza di Aurora bears out Vasari's statement that this room was decorated by Taddeo 'con l'aiuto de' suoi uomini'. Here, if anywhere, one might expect to find traces of Federico's collaboration, and in spite of the absence of any annotation by him to this effect his responsibility for the design of the two principal scenes on the ceiling, the 'Solitudine de' Cristiani' and 'Solitudine de' Gentili' would seem to be established by two related drawings in the Uffizi which are traditionally and correctly attributed to him (42, 43). These differ from the frescoes in being oblong whereas the frescoes themselves are upright in format with the compositions as it were upended and compressed. The obvious explanation of such a difference is that the drawings are preparatory studies, but to this there is a formidable obstacle in Federico's absence from Rome over the whole period in which the decoration of this room seems to have been carried out. The *terminus post quem* is 15 May 1565, the date of Annibale Caro's letter laying down the iconographic programme, and it seems almost certain that they were completed by the end of the same year. According to Vasari, Taddeo was able to turn his attention to the Pucci Chapel in S. Trinità dei Monti during the closing months of his life only after the deaths of Cardinal Ranuccio Farnese at the end of October 1565 and of Pius IV six weeks later had temporarily released him from his work in the Palazzo Farnese and the Sala Regia, and after he had completed 'un altro appartamento di stanze a Caprarola'. These three events probably took place at about the same time, for Vasari implies that Taddeo was already at work in S. Trinità when Federico returned to Rome in January 1566. Federico had been away from Rome for about two years. His *Adoration of the Magi* in the Grimani Chapel in S. Francesco della Vigna in Venice is dated 1564, and a document establishes his presence in Venice in August of that year. Vasari says that in spite of Taddeo's repeated appeals to him to return to Rome, Federico stayed on in Venice for some time after the chapel was finished, that he then went to Friuli and from there to Verona and other places in Lombardy, and eventually arrived in Florence when preparations were being made for the marriage of Francesco de'Medici and Joanna of Austria. His presence there in September 1565 is established by a letter from Vasari to Vincenzo Borghini reporting Federico's progress with the Hunting Scene which he was painting as part of the decoration for the wedding-festivities. After going to S. Angelo in Vado to see his family he returned to Rome, as Vasari records (with unusual precision), on 16 January 1566.

The chief problem of that part of the decoration of Caprarola carried out in Taddeo's lifetime is to determine the extent (if any) of Federico's share in the design. This cannot be answered satisfactorily from the evidence available. Except for Federico's brief annotation in Vasari attributing all the paintings in the five ground-floor rooms to Taddeo, documentary evidence appears to be lacking. The paintings themselves do not help, for though Taddeo's own hand can be recognized in some of those on the ground floor and here and there on the floor above (especially in the Stanza di Aurora) Federico's total stylistic dependence on Taddeo makes it impossible to draw any clear distinction between a composition wholly by him and one which he executed on Taddeo's design. There remains only the evidence of related drawings, but this is no less difficult to interpret, for, even apart from the *modelli*, few of the drawings here attributed to Federico have the appearance of preparatory studies in the true sense of the term: their neat finish and lack of *pentimenti* and their close correspondence with the painting as executed make it equally doubtful whether their design was due to Federico or whether they are merely fair copies worked up from Taddeo's sketches. All that can safely be concluded from drawings is that Federico gave Taddeo some assistance, and that he was almost certainly responsible for the design and execution of the allegorical figures in the Sala and Anticamera. It is, of course, impossible to establish the negative proposition that Federico cannot have made the designs for the Stanza della Solitudine, and that the Uffizi drawings must be later variations of the compositions, solely on the grounds of his absence from Rome at the material time. The documentary evidence is not necessarily complete: we know from Vasari that Taddeo kept in touch with Federico in Venice, and that he was greatly inconvenienced by the lack of his assistance, so it is perfectly conceivable that Taddeo, finding himself hard-pressed in the summer of 1565 with the Sala Regia and the Palazzo Farnese on his hands as well as Caprarola and the Frangipani Chapel, might have sent Annibale Caro's programme to Federico with the request that he should make the designs for it. It would satisfactorily explain the inferiority of the paintings in the Stanza della Solitudine if they could be shown to be executed by assistants on designs not by Taddeo but by Federico; but Federico's absence from Rome at the time introduces an irritating element of doubt into the question.[1]

[1] Since this book went to press, Mr Partridge has kindly informed me of a document which establishes that Federico did in fact return briefly to Rome in the Summer of 1565 (probably in July). In a letter to Fulvio Orsini, dated 30 June 1565, Annibale Caro writes that Cardinal Farnese 'vuole in ogni modo, che [Taddeo] vadia per dieci giorni a Caprarola, e non sa come fuggirla. Promette subito al ritorno darvi dentro insieme col fratello, che aspetta di corto' (Vat. Lat. 4105, fol. 217; Giuseppe Cugnoni, *Prose inedite del commendator Annibal Caro*, Imola, 1872, pp. 167 f.).

8

In choosing the glorification of his family as the subject of the paintings in the two principal state apartments at Caprarola, Cardinal Alessandro Farnese was following the example of his younger brother Cardinal Ranuccio, who on inheriting the Palazzo Farnese in Rome after the death of Paul III in 1549 had commissioned Francesco Salviati to decorate one of the rooms with a series of frescoes on this theme. When Salviati went to France in 1554 or 1555 he had completed the two side-walls of this room, the Sala dei Fasti Farnesiani, but he did not resume after his return to Rome a year or so later. When his death in November 1563 put an end to any hope that he might be prevailed upon to do so, Cardinal Ranuccio naturally turned to his brother's favourite painter and the artist of the similar scheme at Caprarola to complete the room by the decoration of the two end-walls.

Salviati's part of the decoration resembles that of his *salone* in the Palazzo Sacchetti, probably also a work of the early 1550's, in being a complex of overlapping and superimposed elements – historical scenes and personages, allegorical figures and decorative *ignudi*, feigned tapestries and *quadri riportati* – on different planes and at varying levels of illusion. The side-walls are unbroken except for a fireplace in the centre of one and small doorways, hardly higher than the dado, at either extremity of both. The end-walls gave Taddeo less scope: one is broken by three tall windows, the other by a wide doorway flanked by two smaller doorways exactly matching those in the side-walls. If Salviati had made designs for the end-walls these have not survived, so there is no way of telling to what extent, if at all, his successor was required to conform to an already existing scheme. Certainly Taddeo's treatment of the subsidiary doorways in the end-wall opposite the windows (Pl. 167) follows Salviati's: here, as on the side-walls, the door-frame appears to be continued into a wide pier in front of which is placed an allegorical figure, while the upper part of the pier is almost covered by a *quadro riportato* depending from the cornice. Between these piers, and filling the space above the central doorway, is a feigned tapestry. The equal height of the windows ruled out a similar treatment of the other wall. The space above the wide central window is again taken up with a feigned tapestry flanked by *quadri riportati* depending from the cornice, but the height of the side-windows only leaves room for a large-scale allegorical female figure seated on top of each window below the *quadro riportato*.

The contrast between the side-walls and end-walls of this room illustrates, more vividly than any verbal analysis, the crisis which the Roman *maniera* underwent

[119]

in the 1550's. The effect of the side-walls is one of movement and a bewildering richness of inventive fantasy; on the end-walls each element is distinct, and the effect is one of frigid restraint. Salviati's decoration annihilates the plane of the wall; Taddeo's emphasises it. The allegorical figures above the side-doors in the entrance-wall are half-way to being statues, unlike Salviati's *Fame* above the door on the right of the fireplace who is actually represented flying in the air with both feet off the ground and her back turned away from the room; and the feigned tapestry between them, stretched as flat as a roll of linoleum with tight regular scrolls on either side, makes only the most perfunctory gesture of illusion. One has only to look back to the Mattei Chapel frescoes to see how radically Taddeo's style had been transformed in the intervening ten years.

One drawing connected with Taddeo's part of the room, the study at Weimar (252) for the male allegorical figure above the left-hand door, was discovered and published by Voss in the 1920's. Studies for his female counterpart over the other door are in the Louvre (177. Pl. 163) and the Hermitage (94. Pl. 162), and for the figure above the right-hand window in the British Museum (96), the Rosenbach Foundation in Philadelphia (214) and the Biblioteca Marucelliana (34). The Weimar and Louvre drawings correspond very closely with the figures as painted, but the figure in the Hermitage study differs in details of drapery, in her dumpier proportions, and in holding her staff in her right hand and her sceptre in her left, rather than the other way about. This drawing seems (to judge from the photograph) to be coarser and less attractive than the one in the Louvre, so that in spite of its differences from the painting one might at first be tempted to reject it; but Dobroklonsky, who first attributed it to Taddeo, did so on the strength, not of its connexion with the Palazzo Farnese (of which, indeed, he seems to have been unaware), but of its resemblance to the Weimar drawing. This comparison seems most persuasive, for in both drawings the modelling of the head, the shade of facial expression, and the form of the right arm and hand, are identical. The most obvious difference between the Hermitage study and the figure as eventually executed is in the transposition of the staff and sceptre. The male figure above the left-hand door and the female above the right-hand door hold their staves respectively in their right and left hands and at exactly the same angle, thus producing the symmetry of a mirror image. The Hermitage figure agrees with the painting in looking over her right shoulder and so was presumably envisaged in the same position above the right-hand door, but she resembles the male figure in holding her staff in her right hand and her right arm raised in a gesture exactly echoing his. Was Taddeo perhaps trying to imitate Salviati's device of a calculated asymmetrical discord within a symmetrical scheme which we find, for example, in the friezes on the side-walls, in each of which are two pairs

[120]

of *ignudi* supporting escutcheons, one pair looking symmetrically inwards and one, unexpectedly, with both heads turned in the same direction?

Three composition-studies for the feigned tapestry representing the *Foundation of Orbetello*, above the main doorway, show successive stages of its evolution. Here, as in the Frangipani *Blinding of Elymas*, Taddeo progressively elaborates and deepens his composition by adding *repoussoir* groups on either side of the foreground. The earliest of these studies, in the British Museum (108 *recto*. Pl. 160) on the *verso* of a sketch for the *soprapporta* on the end wall of the Sala Regia, is a rough sketch which differs from the fresco both in the absence of the foreground *staffage* and in showing the group of Pietro Farnese and his retinue advancing from the other side of the composition.[1] The second, a squared drawing in the Scholz Collection (150. Pl. 161), is in the same direction as the fresco; the foreground figures have still to make their appearance but the main group has now achieved almost its final form. The third, formerly in the Berlin Printroom, agrees closely with the fresco except for the group in the right foreground. As at Caprarola, the problem of collaboration arises. Vasari says that Taddeo excused the inferiority of his part to Salviati's on the plea that he himself had only supplied the design and left the execution to his assistants: 'si difendeva con dire, che aveva fatto fare il tutto a' suoi garzoni, e che non era in quell'opera di sua mano se non il disegno, e poche altre cose'. From what we know of contemporary studio-practice this does not mean that Taddeo himself was necessarily responsible for every preliminary study, and comparison of these three drawings certainly suggests that the role of the assistants was not limited to the execution of the paintings. It is unnecessary to defend the attribution to Taddeo himself of the British Museum study; and even from a photograph it seems equally obvious that the ex-Berlin drawing cannot be by him. Mr Scholz's drawing occupies a less clearly defined position between the two. Though it is certainly closer to Taddeo than the ex-Berlin drawing, I find it hard to accept whole-heartedly as a work of his own hand, partly because of a certain insipidity in the faces and partly on the strength of a comparison with the study in the same collection for the group of three figures leading the procession on foot and the two figures seated in the foreground in front of them (151. Pl. 164). This has just those qualities that the other seems to lack – assurance in handling, an exact sense of placing and spatial interval, and in the faces a certain psychological intensity, even nobility – and though it seems dry and schematic when compared with the British Museum sketch for the whole composition, one

[1] Mr Pouncey has pointed out that this early rejected solution seems to have been inspired by Piero della Francesca's *Victory of Constantine over Maxentius* in S. Francesco at Arezzo. Interest in Piero, though unexpected in a Roman Mannerist of that generation, would not have been inconsistent with Taddeo's bias towards classicism. He could have passed through Arezzo on his way to Florence in June 1564 (or 1565?), just at the time when he was engaged on the decoration of the Palazzo Farnese.

[121]

is a rough jotting of the artist's first idea and the other a carefully thought-out statement of his final intention made as explicit as possible for the benefit of the executant.[1] In the *modello* at Christ Church for the *Siege of Tunis* in the Sala Regia (166. Pl. 156) there is more emphasis on plastic realisation and the figures are on a smaller scale, but the essential rhythm of the 'handwriting' is the same. The Christ Church drawing also helps to confirm the attribution to Taddeo himself of a large drawing in the Uffizi which corresponds so closely with the Battle-Scene in the feigned tapestry on the window-wall that one might at first be tempted to dismiss it as an old copy (39. Pl. 166); but if we imagine it elaborated and made more 'painterly' by the addition of white heightening and a richer use of wash, its effect would be identical.

Federico can hardly have been one of the *garzoni* who assisted Taddeo in the Palazzo Farnese; for though Vasari lists this among the unfinished commissions which he undertook to complete after Taddeo's death, Federico must have gone to Venice at just about the time when Salviati died in November 1563 (the *terminus post quem* for Taddeo's activity in the palace) and he did not return to Rome until January 1566.[2] 'by which time', according to Vasari, 'he was of little help to Taddeo, for the deaths of Pius IV (December 1565) and of the Cardinal Sant'Angelo (Ranuccio Farnese, died October 1565) had interrupted his work in the Sala Regia and in the Palazzo Farnese'. The only parts of the decoration that can be positively associated with Federico on the strength of related drawings are two of the four *quadri riportati*, subsidiary elements of the scheme that could well have been left to the end. A slight black chalk sketch of two youths kneeling on either side of an enthroned Pope, in the Uffizi (59), is a study for the group in the centre background of the *quadro riportato* above the right-hand door. That this one, at least, was carried out by Federico on Taddeo's indications is established by the inscription on the drawing *de mano de federigo de tadeo i(n)uenti [one]*, in Federico's hand. Squared composition-studies for two of the other three are in the Louvre (176) and in the Hessisches Landesmuseum at Darmstadt (26). The Louvre drawing, a carefully finished *modello* for the composition above the left-hand door, from which it differs in minor details, resembles in some ways the composition-study in the Scholz Collection for the *Foundation of Orbetello*. It does not seem to me to be by Federico or (*a fortiori*) Taddeo, but rather to be from the hand of some as yet unidentified studio-assistant. The Darmstadt drawing,

[1] Since this was written I have had another opportunity of seeing Mr Scholz's composition-drawing and now feel less convinced than I did that it cannot be from the hand of Taddeo himself. It is reproduced here as an example of a 'borderline case' and I have left the passage in the text unaltered to illustrate the difficulty of always arriving at a definite conclusion.

[2] But see p. 118, note.

for the composition above the right-hand window, is, in contrast, a rapid and lively sketch in which it is possible to see Federico's idiosyncrasies of style both in the proportions of the figures and in their facial types and expressions.

9

When a busy artist dies unexpectedly in mid-career leaving unfinished commissions to be completed or carried out by others, he is likely also to leave to posterity the problem of defining the exact limits of his stylistic development; however faithfully his posthumous collaborators respect his intentions, in his absence they are bound, perhaps even unintentionally, to introduce modifications and shifts of emphasis which must to some extent distort our whole idea of the master's later style. With Raphael, for example, the distinction between his share in the decoration of the Sala di Costantino and that of the studio-assistants who succeeded to the commission after his death is still a matter of argument. Similarly, Taddeo Zuccaro died before he could finished either of the two commissions for Roman churches on which he was working during the last months of his life. The decoration of the lower part of the Pucci Chapel in S. Trinità dei Monti and the altarpiece for S. Lorenzo in Damaso were both carried out by his brother, and in the process his original conception was radically and misleadingly transformed. But fortunately, enough studies for both survive to give a reasonably complete idea of how Taddeo himself would have executed these commissions, if he had lived.

The *terminus post quem* for Taddeo's activity in S. Trinità is 8 June, 1563, the date of the contract by which he undertook to complete the decoration of the lower part of the chapel in the north transept (most of the upper part had already been decorated by Perino del Vaga in the 1520's) with paintings of the *Death of the Virgin*, her *Assumption*, and *Augustus and the Sibyl*. He contracted to do this within eighteen months, by the end of 1564, but from what Vasari says it seems that he hardly began before the end of 1565 or beginning of 1566 and that when he was taken fatally ill in August 1566 he had completed only one scene, the *Death of the Virgin* on the left-hand wall, and was still working on the cartoon for the altarpiece of the *Assumption*. An inscription on the altarpiece records that it was completed by Federico in 1589, nearly a quarter of a century after Taddeo's death.

Taddeo's responsibility for the *Death of the Virgin* is established by the evidence of Vasari, whose description of the Chapel was written only a few months after Taddeo died and many years before its decoration was completed by Federico. It is chiefly this that makes it necessary to take seriously, as a possible drawing from the hand of Taddeo himself, a study for this composition in the British Museum

(109). The squaring and the differences from the finished work, slight though they are, show that this must be part of the preliminary material, but the drawing itself is so weak and impersonal that it is tempting to explain it as a product of the studio. It is impossible to feel absolute certainty one way or the other, but if this drawing should prove to be by Taddeo himself, then it reveals his draughtsmanship in a singularly uninspired moment.[1] On the other hand, the squared *modello* at Chatsworth for *Augustus and the Sibyl* on the upper part of the opposite wall, which stands in exactly the same relation to the finished work, is certainly by Federico;[2] and that it was he and not Taddeo who was responsible for the composition is suggested by its rigid and unimaginative symmetry, with the two principal figures exactly balanced on either side of the central vertical axis. The only clue to the way Taddeo may have intended to treat the subject is provided by a drawing in the Louvre of a more complex arrangement of the main group which is obviously inspired by the well known chiaroscuro woodcut after Parmigianino (190. Pl. 171). It seems reasonable enough to connect this drawing with the Pucci Chapel; so far as is known, Taddeo attempted the subject only on this one occasion; and in handling the drawing itself comes close to the study of an Apostle in the lower part of an *Assumption* in the Ashmolean Museum which Federico annotated as being his brother's very last drawing (157. Pl. 170).

The fresco on the lower part of the right-hand wall, of God the Father supporting the Dead Christ with angels on either side holding the Instruments of the Passion, though iconographically incongruous with the other paintings in the Chapel, forms part of the second, Zuccaresque, phase of the decoration. The only question is whether it was designed, if not necessarily executed, by Taddeo (as is

[1] The upper part of the fresco of the *Death of the Virgin* shows Christ seated on clouds, with angels on either side, looking down with arms outstretched in a gesture of benediction. A squared drawing in the Louvre, corresponding exactly with this part of the composition (4534; 1969 Exhibition, no. 56, *repr.*), in the same technique as the British Museum drawing and exactly the same width, was originally part of the same sheet: the placing of the vertical squaring-line corresponds, and the oblique pen strokes along the lower edge of one continue the pen lines in the other which indicate the top of the canopy above the bier. A *paraphe* preceded by a number in the lower right-hand corner of the British Museum drawing (Lugt 2951), though unlikely to be Crozat's as was traditionally supposed, certainly indicates a French provenance. The two parts of the sheet are stylistically inseparable, and the traditional attribution of the Louvre drawing to Federico is confirmed by the style and handling, unmistakably characteristic of him and not of Taddeo, of two earlier studies for the upper part on either side of a sheet which has only recently come to light in the British Museum among the unmounted residue of the Phillipps-Fenwick Collection (1946-7-13-1537). The *recto* drawing, in pen and wash, though less elaborately finished than the Louvre study, corresponds with it in every essential; but the black chalk sketch on the *verso* differs, and must be a first idea for the pose of the figure. These related drawings, which were not discovered until after this book was in the hands of the printer, show that Federico was involved in the commission apparently even to the extent of designing part of the one fresco in the chapel known to have been completed within Taddeo's lifetime, and establish that he and not Taddeo was responsible for the British Museum drawing of the *Death of the Virgin*.

[2] *B. Mag.*, cviii (1966), p. 288, fig. 6.

[124]

implied by the inscription *Tadeus Zuccarus inven.* on an anonymous engraving of the composition datable between 1572 and 1585) or whether it was an after-thought by Federico, as might be inferred from the fact that it is neither specified in the contract nor mentioned by Vasari. I had already argued in favour of Taddeo, simply on the grounds of the quality of the composition itself, and this con-clusion was subsequently confirmed by the discovery among the drawings attri-buted to Cherubino Alberti in the Uffizi of a study for three of the angels which seems certainly to be by Taddeo (80. Pl. 169).[1]

The altarpiece of the *Assumption*, in its eventual form a characteristic late work by Federico, includes some vestiges of Taddeo's design. Most of the surviving studies for the chapel are connected with this composition, and from them it is possible to reconstruct Taddeo's intentions and see how far Federico departed from them. Of the four such drawings attributable to Taddeo himself, three are studies for the Apostles in the lower part of the composition, the earliest probably being a sheet of studies for the whole group which appeared on the art-market in London some twenty years ago, and which is known to me only from a small photograph in the British Museum (123). This kind of drawing is difficult to judge from a photograph, but in spite of the inscription *Federico Zuccaro* and the accompanying sketch of Federico's device of a sugar-loaf ('zucchero') stuck with lilies, it seems on the whole more likely, in view of its apparent position in the whole sequence of studies and of the probable connexion of the drawing on the *verso* with the S. Lorenzo in Damaso altarpiece on which Taddeo was simultaneously engaged, that it is by him and not by Federico. A complete but roughly drawn study for the group of Apostles, on the other side of another study for the S. Lorenzo picture, is in the Uffizi (52). This drawing, or an elaborated version now lost, served as the basis of an engraving by Aliprando Caprioli, dated 1577 and inscribed *Tadeus Zuccarus inventor*. In the fresco the figures immediately sur-rounding the sarcophagus in the centre of the group correspond with this drawing, but only that much of Taddeo's design is preserved: studies by Federico for the figures on the outside of the group show that these represent his modifications. Taddeo's version of the kneeling Apostle in the left foreground survived to a very late stage, for he and not the final figure appears in a large squared *modello* in the Louvre by Federico, which otherwise corresponds exactly with the lower part of the composition as executed (173).

[1] Anne Blake Smith has pointed out that the composition is inspired by Dürer's woodcut of the *Trinity*, dated 1511 (see *Visions and Revisions*, Rhode Island School of Design, Providence, 1968, no. xxiii); but in the light of the Uffizi study for the angels and of Federico's habit of making copies after other masters, I find less convincing her contention that the free copy of the Dürer composition by Federico which she discovered and identified in the Boston Museum (64.2180) is a preliminary study for the S. Trinità painting. The principal group in the latter is in fact derived from Michelangelo (see p. 77, note 3).

With one exception, all the known drawings for the upper part of the *Assumption* with the Virgin on clouds surrounded by child-angels are by Federico. In the exception, a sheet of studies in the Louvre (209. Pl. 172), which is certainly by Taddeo, the main study shows the Virgin with her arms extended more or less as in the fresco, but in a smaller subsidiary sketch at the top of the sheet she is looking upwards to the right with her hands joined in adoration. She appears in exactly the same pose in a drawing of the whole composition on a sheet in the Uffizi, on which are also two sketches of *Augustus and the Sibyl* (78). The lower part of the *Assumption* here corresponds, not with the fresco, but with Taddeo's study for the group of Apostles, the only difference being the shifting of the sarcophagus slightly to the left so that it comes exactly in the centre; an alteration which gave the draughtsman some extra space on the right which, to judge from the *pentimenti* there, he was undecided how best to use. The composition differs from the painting in the upper part and also in the skilful integration of this with the lower part, which suggests intelligent study of Daniele da Volterra's *Assumption* in the Della Rovere Chapel in the same church; and significantly enough, the curving wall behind the group of Apostles, which serves both to define the space which they occupy and also to link the two halves of the composition by echoing the shape of the ring of angels supporting the Virgin, was used by Taddeo for exactly the same purpose in the sketch for the S. Lorenzo in Damaso altarpiece on the *recto* (52. Pl. 175) of his study for the group of Apostles. The Uffizi drawing of the whole composition is difficult to accept as being by Taddeo's own hand, but everything about it suggests that it is a *ricordo* of his design, made by Federico. It may not necessarily represent his final solution, however. What is evidently a study for one of the Apostles peering down into the empty sarcophagus in an *Assumption* is in the Ashmolean Museum (157. Pl. 170). No such figure occurs either in the fresco or in the Uffizi drawings, but that it must be a study for this particular composition, on which, according to Vasari, Taddeo was working up to the very end, is established beyond any reasonable doubt by an inscription in Federico's hand identifying it as the last drawing ever made by his brother. Since this can only mean exactly what it says, it is possible that Taddeo died before the composition had attained its definitive form in his mind.

The S. Lorenzo in Damaso altarpiece is less well documented, but the commission can be dated in the last years of Taddeo's life by the presence of two studies for it on the other side of two studies for the Pucci Chapel. Vasari merely alludes to it in passing as a work by Federico which at the time of writing (that is, immediately after Taddeo's death) was in process of execution;[1] but against this

[1] Mr Partridge has kindly told me of a document in the Parma archives which establishes that the altarpiece was well under way by the beginning of 1568 and confirms that it was commissioned by Cardinal

Federico has noted *con ordine di Tadeo*, and in his *Idea della Pittura* of 1605 he refers to this picture as one of Taddeo's outstanding works. Like the Pucci *Assumption*, the S. Lorenzo picture, as executed, is so characteristic of Federico that were it not for his own testimony, unassailable on such a point, and that of the related drawings, it would not occur to one to connect Taddeo's name with it. As with the *Assumption*, however, the drawings enable us to reconstruct Taddeo's intentions and see how radically these were transformed and misunderstood by Federico. The Coronation of the Virgin with angels fills the upper part of this monumental altarpiece. Below, on either side of the foreground, are pairs of colossal figures: St Lawrence kneeling and St Paul standing on one side, balanced by a kneeling St Damasus and a standing St Peter. In the background, visible between these pairs of figures and on a much smaller scale, is a crowded scene of the martyrdom of St Lawrence. This overloaded and confused composition, confused above all because the main focus of interest is undefined, is in fact a conflation by Federico of the two alternative – and, one would have thought, irreconcilable – solutions sketched by Taddeo on either side of a sheet in the Ashmolean Museum (158. Pls. 173, 174). The ultimate form of one, the *Martyrdom of St Lawrence*, is preserved in a large *modello* by Federico in the Uffizi (58); the sketch on the other side of the Ashmolean sheet, of the *Virgin and Child adored by St Lawrence and St Damasus*, was developed by Taddeo in two further drawings, one in the Uffizi on the other side of the study for the lower part of the Pucci Chapel *Assumption* (52. Pl. 175), the second also in the Ashmolean Museum (159. Pl. 176). These alternatives are combined by Federico in a *modello* in a private collection in London which agrees in all essentials with the altarpiece except for the eventual substitution in the latter of the Coronation of the Virgin for the simpler motif of the Virgin and Child. To judge from its resemblance in general lay-out to the corresponding part of this *modello*, the second of the two studies in the Ashmolean Museum must come very close to the final stage of Taddeo's design for that solution.

Though the S. Lorenzo altarpiece and the Pucci Chapel *Assumption* both embody elements derived from Taddeo's designs, these designs were so much altered by Federico that the paintings themselves must be counted as part of his *oeuvre*; to credit Taddeo with either would be to give a totally misleading impression of the direction in which he was developing in his last years. His development falls into

Alessandro Farnese (cf. *B. Mag.*, cviii (1966), p. 342): a letter dated 3 April 1568 from Messer Titio to the Cardinal, then in Sicily, informing him that 'la Tribuna di San Lorenzo corre avanti in vero. Federico se porta beniss.o, unum est, che alla tornata sua la trovera finita, una opera tanto bella che in Roma, non visarra simile; il campanile sabbato S.to sonara ala gloria alegramente' (Archivio di Stato, Parma. Epistolario scelto, Busta 24, Architetti: Giacinto Vignola).

three distinct phases. As a youth in Rome in the late 1540's, he begins by modelling himself on the Roman masters of the previous generation, above all on Polidoro da Caravaggio, who was of particular interest to him as an aspiring façade-decorator, and on Perino del Vaga. But his formation was not exclusively Roman, for thanks to the previous association of his early master, Daniele Porri da Parma, with Correggio and Parmigianino, it was unexpectedly complicated by an Emilian cross-current. To judge from the few drawings assignable in varying degrees of certainty to the period between 1551 and 1553 which he spent in North Italy and the Marches, his absence from Rome seems not to have produced any noticeable modification of the style which he had already formed; but the frescoes in the Mattei Chapel in S. Maria della Consolazione, which occupied much of the four years immediately following his return in 1553 reflect a phase of attraction into the stylistic orbit of Francesco Salviati and Tibaldi. This phase was short-lived, for even before the chapel was completed in 1556 Taddeo's style had undergone a further change. The antithesis 'Classical-Mannerist' is an over-simplified formula for expressing a complex transition, but in whatever terms the contrast between the *Ecce Homo* on one side-wall of the chapel and the *Flagellation* opposite is defined, this contrast is one that reflects a fundamental shift in style and artistic intention. Armenini, writing towards the end of the century, represents Taddeo as having from the very beginning of his career consciously set out to restore and 'purify' the art of painting from the decline which had followed the death of Raphael, but for theoretical writers it is almost an occupational temptation to impose an unduly tidy pattern on the haphazard sequence of events. Though Taddeo certainly modelled his style on an unusually wide range of earlier masters, this is not necessarily to be accounted for by a theory of deliberate eclecticism. It can equally well be explained by the circumstances of his early life and the unsatisfactory nature of his training; and it might also be argued that his 'classicism' was less a deliberate, and isolated, reaction against the current of contemporary taste than the emergence of a latent aspect of his personality at a moment when the climate of taste was propitious. If the *Flagellation* was the last fresco to be executed in the Mattei Chapel, this would enable the change of style to be dated around 1555–56; and that the mid-1550's did mark a general stylistic turning-point in Rome is suggested by the fact that both Salviati and Tibaldi, the chief exponents there of the extreme Mannerist style of which the Mattei Chapel frescoes are also an example, should both have chosen to leave Rome at just that moment. Tibaldi never returned, though he lived on for another forty years. Salviati, it is true, came back after about two years and lived on until 1563, but the failure of all his subsequent efforts to secure a major commission in Rome suggests, even when every allowance is made for his notoriously difficult tempera-

ment, that the more decorous Tridentine atmosphere which he found on his return was uncongenial. Taddeo, on the other hand, clearly had no difficulty in adapting himself to it, and Armenini is right to this extent, that his later style reveals an increasing tendency to hark back to the High Renaissance, and in particular to Raphael. In the early design for the Frangipani Chapel *Blinding of Elymas*, at Windsor (257. Pl. 88), a drawing which probably dates from around 1560, he took Raphael's tapestry as his starting point, though in its eventual form the composition is quite different. A few years later, when faced with the problem of representing the council of Trent itself in the Anticamera del Concilio at Caprarola, he produced a deliberate echo of Raphael's *Disputa*. Both alternative designs for the S. Lorenzo in Damaso altarpieces are no less undisguisedly based on High Renaissance prototypes. The *Martyrdom of St Lawrence* (158 recto. Pl. 173) is a free variant of Titian's altarpiece in the Gesuiti, a composition which itself reflects the Venetian artist's response to the Roman High Renaissance;[1] the other solution, in which the Virgin and Child are adored by St Lawrence and St Damasus accompanied respectively by St Peter and St Paul (159. Pl. 176), is a derivation from Raphael's *Madonna di Foligno*, in which the Virgin and Child, on clouds and surrounded by a circular glory as in Taddeo's drawing, are adored by a similarly posed group of four figures, two kneeling and two standing.[2] There are some artists – Federico Zuccaro for one – in whom such direct borrowing would suggest nothing more than poverty of invention; but in one as brilliantly and as copiously inventive as Taddeo, and who at the age of thirty-five was in the full flood of creative energy, it can only reflect a deliberate effort to bridge the gap between the beginning and the middle of the century by proclaiming a return to High Renaissance principles of design. The inscription on the Ashmolean Museum study of an Apostle in an *Assumption* establishes it as the last drawing that Taddeo actually made, but this outline of his development is more fittingly rounded off by using the last plate of all to reproduce the drawing of the Virgin and Child adored by St Lawrence and St Damasus, for this close variation on the theme of one of Raphael's most monumentally classical compositions concisely sums up the implications of his later style.

[1] I have not found an engraving of this composition earlier than the two by Cort, both dated 1571 (BdH 139, 140); but Federico Zuccaro was an inveterate copyist of works by other masters and had been in Venice in 1564.

[2] The *Madonna di Foligno* remained in its original position above the high altar of S. Maria in Aracoeli until May 1565, when it was removed to Foligno by the family of the donor, Sigismondo de'Conti. The loss to Rome of one of Raphael's most important altarpieces may have stimulated interest in it just when Taddeo seems to have been working on his own altarpiece, and was perhaps responsible for his choice of it as a model.

CATALOGUE
OF DRAWINGS

References (in bold type) to reproductions, including Gernsheim's Corpus Photographicum, *are given only for drawings not here reproduced. The catalogue is arranged according to the location of the drawings, in alphabetical order of places. Private collections are listed as follows: Professor J. Q. van Regteren Altena, Amsterdam; Lord Brooke, London; Professor Norman Canedy, Minneapolis; Mr J. A. Gere, London; Dr Pietro del Giudice, London; Dr Detlef Heikamp, Wurzburg; Mrs Richard Krautheimer, New York; Dr Robert Landolt, Chur; Mr Robert Lehman, New York; the Earl of Leicester, Holkham; Herr Herbert List, Munich; Lord Methuen, Corsham; Professor Einar Perman, Stockholm; Mrs Rayner-Wood (formerly), Malvern; Mr David Rust, Washington; Mr Janos Scholz, New York; Count Antoine Seilern, London; Mr Roderic Thesiger, London.*

1 **Amsterdam, Professor J. Q. van Regteren Altena**

THREE *PUTTI* ON CLOUDS (ONE HOLDING A MARTYR'S PALM) IN A LEFT-HAND SPANDREL
Pen and brown wash, heightened with white, on brown-washed paper. 348:245 mm.
Facsimile engraving in reverse by C. M. Metz, when, in the Cosway Collection (Weigel 8698); Lithograph by Jourdy in J. C. Chabert's *Galerie des Peintres,* **Paris, 1822–34.**

Inscr. on *verso: Paolo Farinati* (crossed out) *Frederik Zuccaro,* but correctly attributed to TZ when in the Cosway Collection. Perhaps connected with the decoration of the Frangipani Chapel in S. Marcello al Corso (see p. 81). Other studies for the group are at Berlin (cat. 4 *verso*) and Leiden (cat. 89), and two copies are in the Uffizi (767^S; 793^S, Gernsheim 40386).

Angers, Musée Turpin de Crissé (Recouvreur Cat., no. 151). *See* cat. 179

2 —— **Recouvreur Cat., no. 314** (as Beccafumi)

A STANDING PROPHET IN A NICHE **Plate 106a**
Pen and brown wash, heightened with white. Squared in black chalk. 410:190 mm.
A. Recouvreur, *Musée Turpin de Crissé: Catalogue Guide,* 1933, p. 163, no. 314: Henry

de Morant, *Images des Musées d'Angers: le Dessin*, Angers, 1962, pl. 1; *Le seizième siècle: peintures et dessins dans les collections publiques françaises*, Paris, 1965, no. 328.

TZ's authorship was recognized by Jacob Bean. One of the best of a group of drawings of similar figures (cat. 4, 21, 49, 126 and 134) which are often attributed to Beccafumi (see cat. 134). Their likeness to the Prophets on the pilasters of the Frangipani Chapel suggests a dating at the end of the 1550's or later. A copy is in the Louvre (4405).

Ann Arbor 1966. I 93. *See* cat. 108

3 **Baltimore, Museum of Art 28.1.6**

Recto. A STANDING BEARDED MAN WITH HIS RIGHT ARM RAISED AND A LARGE BOOK UNDER HIS LEFT ARM
Verso. TWO STUDIES FOR THE SAME FIGURE
Pen and brown wash, heightened with white, on blue paper (*recto*); black and white chalk (*verso*). The *recto* squared in black chalk. 195:370 mm.

Inscr.: on *verso* in an old hand: . . . *ro da S^n Agnolo di urbino* and in a more recent hand: *F. Zuccaro.* Konrad Oberhuber kindly brought this drawing to my notice as a possible TZ. The pose, and the arrangement of the drapery, are close to those of the similar figure in red wash at Stockholm (cat. 223). The probability that they are studies for St Paul in one of the Frangipani Chapel frescoes is supported by the indication, on the *recto* of the Baltimore sheet, of a pair of curving steps like those in the *Healing of the Cripple*.

The conception is undoubtedly TZ's, and in theory this sheet, with its rough sketches for the figure on one side, has a strong *a priori* claim to be accepted as an original by him; but (to judge from a photograph) there is a stiffness about the *recto* figure and an unsubstantiality about the larger study on the *verso*, which put it on the borderline. Nevertheless, this drawing deserves the benefit of the doubt. The head of the *recto* figure, for example, and the rapid small-scale jotting of the pose on the *verso*, with alternative positions of the right arm, are compatible with TZ himself.

4 **Berlin–Dahlem, Kupferstichkabinett 2677** (as Tibaldi)

Recto. A STANDING PROPHET IN A NICHE **Plate 106b**
Verso. TWO *PUTTI* ON CLOUDS
Pen and brown wash over black chalk. 424:254 mm.

Formerly attributed to Goltzius. The attribution to Tibaldi was suggested by Bodmer. Dr van Regteren Altena first noticed the connexion between the *verso* and the drawing in his own collection (cat. 1). The *recto*, a study for the Prophet on the left-hand pilaster of the Frangipani Chapel in S. Marcello (see p. 80), is one of a group of drawings of similar standing Prophets. Another study for the same figure is at Munich (cat. 134).

5 —— **15293**

Recto. THE DONATION OF CHARLEMAGNE **Plate 153**
Verso. STUDIES FOR THE SAME
Red chalk. Some of the *verso* studies in pen and ink. A horizontal fold across the centre of the sheet, which is also damp-spotted. The lower corners cut away. 489:405 mm.
Voss, MdSR, p. 448; **Gernsheim 34469** (*verso*)

Inscr.: *di federico zuccaro*. Voss pointed out, however, that the *recto* is a composition-study by TZ for his *soprapporta* fresco in the Sala Regia (first payment 4 May 1564). It represents an early stage in the design, when the format seems still to have been envisaged as upright, with the figures on two levels. See pp. 103 f.

The red chalk studies on the *verso* are for Charlemagne and the kneeling man with a scroll under his arm. Of the two studies in pen and ink, one is for the canopy over Charlemagne's throne, the other a perspective view of the interior of a cupola with a colonnaded tambour.

6 —— 15294

Recto. CHARLEMAGNE AND HIS SECRETARY **Plate 151**
Verso. LOWER HALF OF A COMPOSITION OF ECCLESIASTICS KNEELING BEFORE AN ENTHRONED POPE

Red chalk (*recto*); black chalk over stylus, with pen and brown ink and brown and violet wash on the left-hand figures, and some white heightening (*verso*). 361:258 mm.

Inscr. top left in ink, partly cut away: *di federico Zuccaro*, and at the bottom of the sheet, in chalk: *F. Zuccaro*. The former inscription is in the hand responsible for the one on cat. 5; the other in the hand that attributed cat. 244 to Francesco Allegrini (1587–1663).

In spite of these misleading inscriptions, the drawing is correctly classified as a study by TZ for the principal group in the *Donation of Charlemagne* in the Sala Regia (see p. 103). It shows only the two figures of Charlemagne and the kneeling man with the scroll and differs from cat. 5 recto in that the kneeling man is on Charlemagne's right and is placed lower down so that his head is on a level with the other's knee. This arrangement comes closest to the solution preserved in a studio-copy in the Louvre (cat. 195).

The drawing on the *verso* is the lower part of a large and carefully finished study for *Paul III bestowing the Cardinal's Hat on four future Popes* in the Anticamera del Concilio at Caprarola, differing in many respects from the final result. See p. 115.

7 —— 18031 (as Primaticcio)

DESIGN FOR PART OF A MURAL DECORATION: A FRESCO IN A STUCCO FRAME FLANKED BY TWO FEMALE TERMS

Plate 39

Pen and brown wash. 251:222 mm.

Attributed to TZ by Philip Pouncey. The subject of the central composition is not clear: the principal figure appears to be pulling down a trophy composed of a breast-plate and shield on a pole, while a statue with a square base lies on its back at their feet. The handling, and also the taste of the ornamental surround, suggest a dating at about the period of the Mattei Chapel (*c.* 1553–56).

—— **21914.** *See* cat. 37

8 —— 22162

A SEATED WOMAN

Pen and brown wash on blue-green paper. 271:199 mm.

Her legs are turned slightly to the left, her head is in profile to the left and she is pointing in the same direction with her extended right arm. Traditionally attributed to TZ. Early (*c.* 1550).

9 **Berlin, Bode-Museum, Ruckf ühr 13421**

THE BETRAYAL OF CHRIST **Plate 56**
Pen and brown wash over black chalk. 502:709 mm.
Voss, MdSR, p. 441.

Inscr. by Vasari : *Taddeo Zuccaro da Sant'Angelo in Vado*. Identified by Voss as a study for the fresco on the vault of the Mattei Chapel. See p. 62.

10 **Besançon, Musée des Beaux-Arts 2272** (as 'Zuccaro')

'FAME'
Pen and brown wash. Squared in black chalk. 286:182 mm.
Gernsheim 9861.

A *modello* for one of the two allegorical figures in ovals on the ceiling of the Sala dei Fatti Farnesiani at Caprarola. It belongs to the same group as the other Caprarola *modelli* in the Uffizi and elsewhere (see pp. 112 ff.
An identical drawing, corresponding even to the position of the squaring in relation to the figure, is at Brunswick (cat. 13). A preliminary study, traditionally and correctly attributed to Federico Zuccaro, is at Edinburgh (cat. 32 *verso*). The Besançon and Brunswick *modelli* are both evidently products of the Zuccaro studio.

Boston, Museum of Art 64.2180. *See* p. 125, note 1

11 **Bremen, Kunsthalle 43/20**

A FLYING ANGEL
Pen and brown wash. 176:130 mm. (lower r. corner cut and made up).

Traditional attribution. Inscr. in pen on *verso*: *T.Z.* There seem to be indications of the wings of another angel on the left. An angel in a similar pose is one of a group of four in a drawing in the Uffizi (cat. 61). The two drawings are identical in style and handling and are possibly connected with the same composition, which may have been *The Angel warning St Joseph to fly into Egypt* known from a complete composition-study at Hamburg (cat. 86). Walter Vitzthum kindly told me of this drawing.

12 **Brunswick, Herzog Anton Ulrich-Museum 076**

Recto. A SEATED WOMAN WITH A MIRROR ('PRUDENCE')
AND TWO *PUTTI* GROUPED ROUND A GIGANTIC
CAPITAL 'L' **Plate 24a**
Verso. THREE STANDING FIGURES
Pen and brown wash, heightened with white, on blue paper. 150:187 mm.

The old attribution was to 'Zuccaro'. Voss suggested Trometta, but the drawing seems to me more likely to be by TZ from whom Trometta derived his drawing style. It might be connected with the *facciata alle lettere d'oro* referred to by Mancini (see p. 42). Walter Vitzthum kindly told me of this drawing.

[134]

13 —— 096

'FAME'

Pen and brown wash. Squared in black chalk. 294:184 mm.

Inscr.: *FAMA*. See cat. 10

14 **Budapest, Museum of Fine Arts 1831** (as Cigoli)

THE DESCENT FROM THE CROSS **Plate 74**

Pen and brown wash over red chalk. 278:195 mm.

Traditionally attributed to Francesco Salviati, and later given to Cigoli. Philip Pouncey's attribution to TZ is entirely convincing. The drawing could be as early as the first half of the 1550's and may be a rejected idea for the altarpiece of the Mattei Chapel. A small panel of this composition, apparently from TZ's own hand, is in the Methuen Collection (T. Borenius, *A Catalogue of the Pictures at Corsham Court*, 1939, no. 76 as Daniele da Volterra). See pp. 69 f. An old copy is in the Uffizi (1279F).

—— **1878.** *See cat.* 100

15 —— **1926** (as Pontormo)

Recto. A GROUP OF PROSTRATE FIGURES **Plate 48**

Verso. TWO FIGURES, ONE KNEELING ON TOP OF THE OTHER

Black chalk, with some white heightening, on blue paper. 220:337 mm.

I. Fenyö, *Bulletin du Musée Hongrois des Beaux-Arts*, no. 19 (1961), pp. 61ff. (**verso repr.**).

Traditionally attributed to Michelangelo, and by Benesch to Pontormo. Konrad Oberhuber's suggestion of TZ is certainly correct. The handling resembles that of the chalk studies for the Mattei Chapel (cat. 127, 146, 211 *verso*), and the *recto* figures are evidently soldiers in a *Resurrection*, a subject which was at one stage projected for the lunette above the altar in the chapel (see p. 67).

16 —— **2410** (as Francesco Villamena)

SHEPHERDS DANCING ROUND A BONFIRE **Plate 6**

Pen and light brown wash, heightened with (oxidized) white, over red chalk. 318:466 mm.

Recognized by Philip Pouncey as one of the group of early drawings by TZ. Perhaps a study for part of a façade decoration. See p. 39.

The attribution to Francesco Villamena (1566–1624) was perhaps suggested by the rather similar cloaked figures in his engraving 'Il Bruttobuono', dated 1601.

Cambridge, Fitzwilliam Museum 3115. *See cat.* 142

Cambridge, Mass., Fogg Museum (Mongan–Sachs no. 212) *See cat.* 108

17 **Chatsworth, 191** (as 'attributed to Niccolò dell'Abbate')

THE BIRTH OF THE VIRGIN

Pen and brown wash, heightened with white, on pinkish prepared paper. 300:191 mm.

G. Waagen, *Treasures of Art in Great Britain*, 1854, iii, p. 356; Popham-Wilde, under no. 1078.

Though the drawing appears as 'attributed to Niccolò dell'Abbate' in the typescript catalogue of the Chatsworth drawings (1929), Waagen, when he visited Chatsworth in 1850, noted 'among the numerous drawings [by Taddeo Zuccaro] the birth of the Virgin [which] particularly struck me for the grace of the motives; pen drawing, heightened with white'. No drawing of this subject is among those attributed to TZ in the 1929 catalogue, so it seems likely that the attribution to Niccolò dell'Abbate is of recent date and that the drawing was previously given to TZ.

A weaker version, at Windsor (6020; Popham-Wilde no. 1078), attributed by Bodmer to Federico Zuccaro, was catalogued by Popham at Antal's suggestion as 'after Taddeo Zuccaro' with a reference to the Chatsworth drawing. Antal was no doubt right in attributing the composition to TZ, but it is an insidious fallacy to assume, when considering two or more versions of a drawing one of which is of higher quality than the rest, that this one must necessarily be the original. The Chatsworth drawing seems more likely to be a copy by Federico Zuccaro of a drawing by his brother, which may well have been fairly early in date.

The composition occurs in an elaborated form in an engraving, dated 1568, by Cornelis Cort (BdH 19). Three child-angels have been added to the right foreground and there is a fireplace on the left, in front of which is a woman airing a towel. Bierens de Haan lists several other engravings of the composition, all apparently based on the engraving by Cort.

A circular composition of the same subject, very similar in style, was formerly in the Scholz Collection, New York (repr. in catalogue of *Exhibition of Old Master Drawings presented by Yvonne ffrench at the Alpine Club Gallery, London*, June 1963, no. 7). The traditional attribution was to TZ, but in my opinion this too is by Federico.

18 —— 193

FIGURES ON THE LEFT-HAND SIDE OF AN *ADORATION OF THE MAGI* **Plate 52**

Pen and brown wash, heightened with white. 497:389 mm.
Popham-Wilde, under no. 1071; *Drawings by Old Masters*, R.A., 1953, no. 124.

Attribution to TZ traditional. As A. E. Popham pointed out, the drawing presumably represents the attendants of the Magi approaching from the left with horses and camels. Another, rougher, study for the same group is in the Uffizi (cat. 50). A copy is also in the Uffizi (851⁸). The composition may have been designed for the Mattei Chapel. (See p. 69.)

19 —— 194

THE ADORATION OF THE SHEPHERDS **Plate 50**

Pen and brown wash, heightened with white. 392:512 mm.
Italian Art and Britain, R.A. (1960), no. 597; *Drawings from Chatsworth*, Smithsonian Institution, 1962–3, no. 76; J. A. Gere, *B. Mag.*, cv(1963), p. 364.

Attribution to TZ traditional. A close variant of cat. 57, q.v. The two have in common the kneeling shepherd in the foreground and the figure seated on the cow, but the figures at either side of the composition differ and the Virgin is sitting the other way

round. Cf. also cat. 201 and 227/228. Perhaps connected with the Mattei Chapel. See p. 68.

—— **197.** *See* cat. 97

20 —— **736**

THE MARRIAGE OF ORAZIO FARNESE AND DIANE DE VALOIS
Pen and brown wash, squared in black chalk. 251:181 mm.

This drawing corresponds with the centre portion of the fresco in the Sala dei Fatti Farnesiani at Caprarola in all but small details (e.g. the position of the bridegroom's head, which in the drawing is in profile to left). It belongs to the group of *modelli* discussed on pp. 112 ff., which seem to be studio-products rather than by Taddeo himself. A study for the composition is in the Scholz Collection, New York (cat. 149).

The drawing has probably been trimmed on either side. Old copies of a complete *modello* in which the centre portion differs from the fresco in exactly the same way, and with groups of figures on either side outside the pillars also differing from the fresco, are in the British Museum (5212–37 and 1899–12–30–1) and in the National Gallery of Canada, Ottawa (6319; A. E. Popham and K. M. Fenwick, *Catalogue of European Drawings*, 1965, no. 41, repr.).

21 **Chicago, Art Institute 22.2965** (as Anonymous Italian, XVI century)

A STANDING PROPHET WITH A BOOK
Pen and brown wash over red chalk, squared in black chalk. 263:141 mm.

The same figure occurs on the right-hand side-wall of the *cappella maggiore* of S. Eligio degli Orefici, Rome. On each side-wall of the shallow chapel is a Prophet in a square-headed niche, and above these, on the curving vault, two rectangular frescoes, one representing *Pentecost*, the other a group of Apostles disputing. Unlike the painting of the *Virgin and Child with Saints* on the curved wall behind the high altar and that of *God the Father with the Crucified Christ and Angels* in the semi-dome above, both attributed by Baglione to Matteo da Lecce and consistent in style with others attributed to him elsewhere (e.g. in the Oratorio del Gonfalone), those on the side-walls and vault of the chapel are entirely Zuccaresque in style, the Prophets being in the direct line of descent from those on the pilasters of the Frangipani Chapel in S. Marcello. Vasari's list of miscellaneous works by TZ (vii, p. 131) includes 'una cappella nella chiesa degli orefici in strada Giulia', and in February and June 1569, less than three years after TZ's death, Federico acknowledges the receipt of payments for the decoration of a chapel in the church; but it is not clear from these documents (both repr. in facsimile in *Monatshefte fur Kunstwissenschaft*, i (1908), p. 1100), whether the payments refer to the *cappella maggiore* or to the altar on the right-hand side-wall of the church above which is an *Adoration of the Magi* painted by Romanelli in 1639–40 to replace a fresco of the same subject by Federico which had been damaged by flood in 1594 and which, according to Van Mander, was engraved by Jacob Matham (presumably B. iii, p. 190, 232).

The Chicago drawing is certainly by TZ, and a similar study by him no doubt underlies the corresponding figure on the opposite wall. On the other hand, the fresco of *Pentecost* and its counterpart are not necessarily based on his designs: cf. similar compositions by Federico at Windsor (Popham-Wilde, fig. 195), in the Albertina (cat. iii, no. 268), and at the Escorial (repr. J. Z. Cuevas, *Pintores Italianos . . . en el Escorial*, 1932, between pp. 200 and 201).

[137]

22 —— **28.196**

Recto. STUDY OF A SEATED MAN, SURROUNDED BY SMALLER
SKETCHES OF THE SAME FIGURE AND FIVE COMPOSITION-
STUDIES **Plate 94**
Verso. THREE MEN SUPPORTING THE BODY OF A FOURTH
 Plate 95

The principal figure on the *recto* drawn with the brush in red wash. The rest of the sheet
in pen and brown wash over black chalk. 387:274 mm.

This drawing, which bears Sir T. Lawrence's collector's mark (Lugt 2445) and was
attributed to Michelangelo when it entered the Chicago collection in 1928, is presum-
ably to be identified with one sold as by Michelangelo in the Lawrence-Woodburn
Sale of 4.vi. 1860: 'lot 108. A Sheet of Studies of various Scriptural Subjects — *in pen
and bistre. In the centre, a draped female, in red chalk, of grand character*'. It may, however,
have been correctly attributed earlier in the century. A high proportion of Lawrence's
collection came from his expert adviser, W. Y. Ottley, and this drawing is possibly lot
1492 in the latter's sale of 20.vi.1814: 'Taddeo Zucchero . . . a leaf of various studies, one
in red chalk, stumped, the rest *free pen and wash — very masterly*'. TZ's authorship was
independently recognized by Philip Pouncey.

The principal figure on the *recto* is a study for the enthroned Procurator, Sergius Paulus,
in the Frangipani Chapel *Blinding of Elymas.* The two lower composition-studies are for
the same fresco. The composition-study top right perhaps represents the *Sacrifice at
Lystra.* The *verso* study is probably for the group of figures holding the body of Eutychus
in the fresco of the *Raising of Eutychus* on the vault of the chapel. See pp. 73f.

23 Chur, Dr Robert Landolt

DIANA HOLDING THREE DOGS ON A LEASH **Plate 23**
Pen and brown wash. The smaller study in pen only. 330:192 mm.

Inscr.: *del Tadeo.* The figure is identified as Diana by the crescent on her forehead. Early,
c. 1550.

24 Corsham, Lord Methuen

A SEATED WOMAN HOLDING AN INFANT **Plate 31**
Red chalk (the small study of the baby lower right in pen). 294:230 mm.

Inscr. on *recto,* in black chalk, and on *verso,* in pen: *Taddeo Zuccaro.* In top left corner , in
pen: 89.

In scale, in the fine technique of fine parallel hatching combined with stumping, and in
the treatment of the figure's right hand, this drawing resembles the standing nude on
the *recto* of the sheet in the Metropolitan Museum (cat. 143. Pl. 12). In style it seems rather
earlier than Mrs Krautheimer's study for the Swooning Virgin in the Mattei Chapel
altarpiece (cat. 146. Pl. 47) which cannot be before 1553.

The figure is evidently intended for the foreground of a birth-scene. She does not occur
in the studies for a *Birth of the Virgin* in the Uffizi and the Albertina which are datable
about the same time (cat. 38 and 245. Pls. 28 and 29).

Michael Jaffé kindly told me of this drawing.

25 ——

ST LUKE IN A PENDENTIVE **Plate 60**

Pen and brown wash, heightened with white, on greenish blue paper. Squared in red chalk. Trimmed to the shape of the pendentive. 147 mm. (greatest height): 142 mm. (greatest width).

Inscr. on old mount: *Parmagiano* (crossed out) *Zuccaro*. The drawing was labelled with the name of TZ by the present Lord Methuen.
The style points to a fairly early date, hardly later than the beginning of the 1550's. This is probably a study for one of the pendentives in the Mattei Chapel (see p. 65).

26 Darmstadt, Hessisches Landesmuseum AE 1562 (as Passignano)

SCENE FROM THE EARLY HISTORY OF THE FARNESE FAMILY
Pen and brown wash over red chalk. Squared in black chalk. 181:149 mm.
Uffizi 1966 Exhibition, under no. 54; **Gernsheim 19200.**

In the right foreground, in the gateway of a city, stands a group of figures of whom the foremost, an ecclesiastic, is handing a key to a man in armour. Behind the latter are three more men in armour, and in the left foreground a page whose body is almost wholly concealed by a large shield charged with the Farnese lilies. A study for the scene in the *quadro riportato* above the right-hand window in the Sala dei Fasti Farnesiani in the Palazzo Farnese in Rome. The drawing seems to be by Federico: it is certainly not by TZ. See p. 122 and, for other drawings connected with the *quadri riportati* in this room, cat. 59 and 176.

27 Düsseldorf, Staatliche Kunstakademie F. P. 160 (as Perino del Vaga)

CIRCULAR COMPOSITION OF FIGHTING SEA-MONSTERS, FOR THE DECORATION OF THE BORDER OF A DISH OR SALVER
Pen and brown wash on yellow paper. 310 mm. diam.
Illa Budde, *Beschreibender Katalog der Handzeichnungen in der Staatlichen Kunstakademie,* Düsseldorf, 1930, no. 22 (**repr.**)

One of the pairs of fighting monsters corresponds with a lost drawing by Perino del Vaga known from several copies (e.g. in the British Museum, P. Pouncey and J. A. Gere, *Catalogue of Drawings by Raphael and his Circle,* no. 192). A preliminary sketch for the whole composition occurs, however, on the *verso* of a sheet of studies by TZ for the Mattei Chapel (cat. 211 *recto*. Pl. 44), and in handling the Düsseldorf drawing is characteristic of TZ rather than Perino. It is not surprising to find TZ borrowing motifs from Perino, in view of the powerful influence which the latter's style exercised on him, but the ultimate source of this kind of decorated border was Raphael himself: cf. his design for a salver at Windsor (Popham-Wilde, no. 793 *verso*, fig. 154).

28 Edinburgh, National Gallery of Scotland D. 1540

FLYING ANGELS
Pen and brown wash over black chalk. 150:223 mm.
K. Andrews, *National Gallery of Scotland: Catalogue of Italian Drawings,* Cambridge, 1968 (**repr.**).

Formerly Anonymous. Attributed to TZ by Philip Pouncey.

29 —— D. 1558

A STANDING MAN AND A KNEELING WOMAN (CHRIST AND
THE WOMAN TAKEN IN ADULTERY?)
Pen and brown wash heightened with white. Torn, creased and tattered and made up on
the left-hand side and along the top. 275:270 mm.
K. Andrews, op. cit. (**repr.**).

See cat. 31.

30 —— D. 1561

A BEARDED MAN WITH A BOOK, SITTING AND LOOKING
UPWARDS TO THE LEFT
Pen and brown wash, heightened with white. The sheet, much creased and torn and
made up top right, is composed of two pieces of paper joined vertically near the left-
hand edge. 317:184 mm.
Andrews, op. cit. (**repr.**).

Inscr.: *un dei profetti in SS. Apostoli*, followed by a word which might be *Figino* but
which has been made difficult to read by having *Bagnacavallo* written over it. See cat. 31.

31 —— D. 1562

A GROUP OF THREE FIGURES: TWO MEN DISPUTING AND A
BEARDED MAN WITH A BOOK, SITTING AND LOOKING
UPWARDS TO THE RIGHT
Pen and brown wash, heightened with white. Much tattered and rubbed, and with
several holes. The whole of the lower left-hand part of the sheet, and most of the top,
have been made up. 291:236 mm.
Andrews, op. cit. (**repr.**).

The indications of an architectural setting in these three much damaged drawings
show that they are fragments of the same sheet. They were formerly attributed to
Polidoro until A. E. Popham pointed out that their style is close to TZ. It is difficult
to judge drawings in such bad condition, but there seems no reason to doubt that
they are from TZ's own hand. See p. 70 for a discussion of their subject and possible
purpose.
Two fragments of what may have been a similar composition are in the Kunsthaus at
Zurich (cat. 262, 263).

—— D. 2224. *See cat. 175*

32 —— D. 2894

Recto. 'COURAGE'
Verso. 'FAME'
Black and red chalk. 124:85 mm.
Andrews, op. cit. (**repr.**).

Inscr. in pen: *F. Zuccaro* 3. 1. (i.e. 3/–, a method of pricing used by the seventeenth-
century collector William Gibson, d. 1703: cf. Lugt 2885 and *Supplement*). The drawings

on both sides are studies for the two allegorical figures in ovals in the centre of the two long sides of the ceiling of the Sala dei Fatti Farnesiani. Each corresponds closely with the fresco, except that the *recto* figure is in the reverse direction. The old attribution to Federico seems very convincing; such evidence as there is suggests that he was also responsible for the allegorical figures on the walls of the adjoining Anticamera del Concilio. See pp. 111 f. and cat. 234.

Two *modelli* for the figure of *Fame*, corresponding with each other in every detail, including even the position of the squaring, are at Besançon (cat. 10) and at Brunswick (cat. 13).

33 ——— D. 4836

THE DONATION OF CHARLEMAGNE Plate 152
Black chalk and brown wash. 238:179 mm.
Andrews, op. cit.

Attributed to TZ by Philip Pouncey, when on the London art-market. A study for the fresco in the Sala Regia. See pp. 103 ff.

——— **RSA 183.** *See* cat. 138

34 Florence, Biblioteca Marucelliana E. 94

FEMALE FIGURE HOLDING A STAFF, SEATED ON A RECTANGULAR FRAME
Pen and brown wash, heightened with white, on blue paper. 215:160.
The figure occurs above one of the windows in the Sala dei Fasti Farnesiani in the Palazzo Farnese in Rome. See cat. 96

35 Florence, Uffizi 64°

DESIGN FOR THE DECORATION OF A ROOM: DOORS SURMOUNTED BY ALLEGORICAL FIGURES (ONE OF THEM 'PEACE') ON EITHER SIDE OF A FIREPLACE OVER WHICH IS A REPRESENTATION OF VENUS IN VULCAN'S SMITHY
 Plate 27
Pen and brown wash. 196:235 mm.
G. Milanesi in Vasari, v, p. 598, note 2; G. Poggi, *Bollettino d'arte*, iii (1909), p. 273; D. Redig de Campos, *Notizia su Palazzo Baldassini*, Rome, 1957, p. 12; R. U. Montini and R. Averini, *Palazzo Baldassini e l'arte di Giovanni da Udine*, Rome, 1957, p. 24; B. Davidson, *Art Bulletin*, xli (1959), p. 323, note 42; the same, *Master Drawings*, i, no. 3 (1963), p. 16, note 15; 1966 Exhibition, no. 5.

Formerly attributed to Perino del Vaga. His decorations in the Palazzo Baldassini in Rome included, according to Vasari, 'sopra il camino di pietre, bellissimo, una Pace, la quale abbrugia armi e trofei, che è molto viva'. Milanesi's suggestion that cat. 34 might be a study for this was followed by Poggi and Redig de Campos. Montini and Averini, on the other hand, doubted the identification, observing that in the drawing the figure of *Peace* is not over the fireplace. Miss Davidson, while still accepting Perino's authorship, pointed out (1959) that the inscription on the companion drawing (cat. 36), referring as it does to Guidobaldo della Rovere, Duke of Urbino, who succeeded to the Duchy in 1538, excludes any possibility of a connexion with the Palazzo Baldassini decorations

which are datable between *c.* 1519 and 1523. She subsequently (1963) rejected Perino's authorship of either drawing.

It must be admitted that both drawings are very Perinesque in style. The *trompe l'oeil* figures in the doorways and the complicated *soprapporta* groups at once bring to mind Perino's last work, the decoration of the Sala Paolina in the Castel Sant'Angelo; and the attribution to him would seem to be supported – not to say confirmed – by the fact, which A. E. Popham was the first to notice, that the *sopraccammino* painting in cat. 35 corresponds in essentials with an engraving by Giorgio Ghisi inscribed *PIRINVS IN.* (B., xv, p. 405, 54). On the other hand, TZ in his drawings sometimes shows himself so susceptible to Perino's influence as to become confusable with him, and quite apart from the connexion with Guidobaldo della Rovere (for whom, incidentally, Perino is nowhere recorded as having worked) the loose handling and soft forms and even some of the facial types (e.g. that of Venus over the right-hand doorway in Cat. 36) are characteristic of TZ's style in the early 1550's. See pp. 44 f.

36 —— 67⁰

DESIGN FOR THE DECORATION OF A ROOM: TWO DOORS EACH INSCRIBED ON THE LINTEL GV. VB. DX., AND SURMOUNTED RESPECTIVELY BY A FIGURE OF FAME WITH TWO *PUTTI* AND BY A GROUP OF MERCURY, VENUS AND CUPID, ON EITHER SIDE OF A LEDGE SUPPORTED ON FOUR FLUTED CONSOLES WITH LION-FEET **Plate 26**
Pen and brown wash. 199:255 mm.
1966 Exhibition, no. 6; B. Davidson, *Art Bulletin* and *Master Drawings*, as for cat. 35

Formerly attributed to Perino del Vaga. The inscriptions over the doors, standing for 'Guidobaldo Urbinati Dux', occur in the same form and in the same place in several rooms of the Palazzo Ducale (now del Governo) at Pesaro. The style of this drawing and its companion (cat. 35) suggests a date in the early 1550's. These could be studies for the 'studiolo' which, according to Vasari, Taddeo decorated for Guidobaldo at Pesaro between 1551 and 1553. See cat. 35 and pp. 44 f.

—— **358ˢ**. *See* cat. 100

—— **434ˢ**. *See* p. 63, note 1

—— **435ˢ**. *See* cat. 208

37 —— 486ᶠ (as Perino del Vaga)

A STANDING PROPHET
Pen and brown wash, heightened with white, on blue paper. 414:152 mm.
Gernsheim 10622.

Inscr. on *verso: dell Gio: Porta di Tadeo Zuccaro.* The figure stands facing the front with the upper part of his body turned slightly to the spectator's left and his head turned so that he looks over his left shoulder. His left foot is supported on a block, and he holds a large open book against the upper part of his left leg.

Not by TZ himself but a copy of a lost drawing which would have resembled the similar studies of Prophets at Angers (cat. 2), Munich (cat. 134), Berlin (cat. 4) and Chicago (cat. 21). See also cat. 49 and 126. Another copy of the present figure in Berlin (21914 as Tibaldi), had previously gone under the name of Guglielmo della Porta, an attribution perhaps suggested by the inscription on the *verso* of the Uffizi sheet, though this presumably refers to Giovanni Battista della Porta (*c.* 1542–1597). Yet another copy is in the Louvre (9942).

38 —— **588E**

Recto. THE BIRTH OF THE VIRGIN **Plate 28**
Verso. STUDIES OF A HEAD, AND A PIECE OF DRAPERY
Pen and brown wash, heightened with white, on blue paper (*recto*); black chalk (*verso*).
194:262 mm.
1966 Exhibition, no. 7.

Inscr.: *Pierino del Vaga*, and previously so attributed. Another study for the same composition is in the Albertina (cat. 245). See pp. 47 f.

39 —— **632F**

BATTLE-SCENE **Plate 166**
Pen and brown wash. Somewhat rubbed, especially on the left. 240:413 mm.
1966 Exhibition, no. 23;

Formerly attributed to Vasari. A study for the fresco between the windows of the Sala dei Fasti Farnesiani in the Palazzo Farnese in Rome (Venturi, ix⁶, fig. 112). The composition is more spread out in the painting, the position of the tree-stump in the foreground has been altered, and the city in the background differs in several details. See p. 122.

—— **767S**. *See* cat. 1

40 —— **782S**

A YOUNG MAN HOLDING A MACE, SEEN FROM BEHIND;
STUDIES OF BALUSTERS, HEADS, ETC.
Pen and brown wash. One of the head-studies in red chalk. 285:206 mm.
1966 Exhibition, no. 21 (**repr.**); **Gernsheim 40384.**

Attribution to TZ traditional. Study for the fresco of *Julius III restoring the Duchy of Parma to Ottavio Farnese* in the Sala dei Fatti Farnesiani at Caprarola. The figure of the mace-bearer does not occur in the fresco as executed, but appears in the group in the left foreground of the composition-study in the Scholz Collection (cat. 149 *recto*, Pl. 148), which was eventually omitted.

—— **793S**. *See* cat. 1

—— **805S**. *See* cat. 70

41 —— **809S**

A BIRTH-SCENE

Pen and brown wash, heightened with white, on brown paper. 250:368 mm.
Gernsheim 40367.

In the foreground, from left to right, are two standing women holding large vases on their heads, two women kneeling on the ground with two children and a large basin, a standing woman with her back turned and a woman stooping down towards a cradle. In the background on the extreme left is a large bed with a woman reclining on it; in the centre a doorway through which a figure enters lifting a curtain; and on the extreme right a fireplace and a steep flight of steps.

Traditionally attributed to TZ. The drawing's condition is such as to make it difficult to tell whether it is an original or a copy, but the composition is certainly TZ's and in feeling and general arrangement so closely resembles the similar scenes in the ground-floor rooms at Caprarola, the *Birth of Jupiter* in the Sala di Giove and the *Birth of Bacchus* in the Camerino dell' Autunno, that it probably dates from about the same time, *c.* 1560

42 —— 821S

CHRIST PREACHING, WITH ST JOHN THE BAPTIST AND ST PAUL
Pen and brown wash, heightened with white, on brown-tinted paper. 171:235 mm.
1966 Exhibition, no. 52 (**repr.**); **Gernsheim 40371.**

See cat. 43.

43 —— 822S

THE CYNIC AND PLATONIC PHILOSOPHERS
Pen and brown wash, heightened with white, on brown-tinted paper. 175:240 mm.
1966 Exhibition, no. 53 (**repr.**); **Gernsheim 40370**

The traditional attribution to Federico of this drawing and its companion, cat. 42 above, is certainly correct. For their connexion with the two principal paintings on the ceiling of the Stanza della Solitudine at Caprarola, see pp. 117 f.

44 —— 841S

Recto. A SOLDIER STANDING BY A FALLEN HORSE
Verso. ST MATTHEW
Pen and brown wash (*recto*); pen and brown wash over black chalk on yellow-washed paper (*verso*). 276:197 mm.
Gernsheim 40400 (*recto*), 40401 (*verso*).

Traditionally attributed to TZ. Though too weak to be from his own hand, both sides are evidently copies of drawings by him. The original of the *verso* seems to have been a study for the pendentive with St Matthew in the Mattei Chapel (Pl. 61a). The saint is half-length as in the pendentive itself, but in the latter he is leaning to the right supporting himself on his right forearm which rests on the open book and looking over his right shoulder towards the angel in the left angle of the pendentive, while in the drawing he leans slightly forward towards the front holding the half-open book in his right hand, with the angel immediately over his head. The *recto* drawing probably reproduces a detail from a Polidoresque battle-scene. A weaker version at Rennes (C.44–Z, as Beccafumi), was indicated to me by Walter Vitzthum.

[144]

—— **851**S. *See* cat. 18

45 —— **861**S

A MAN STANDING IN PROFILE TO LEFT
Black chalk, touched with white chalk, on blue paper. 252:186 mm.
1966 Exhibition, no. 14 (**repr.**); **Gernsheim 40397.**

Inscr. by Federico Zuccaro: *schizzo de mano de tadeo in roma.*
Perhaps a study for the standing figure in the group in the right foreground of the
Mattei Chapel *Ecce Homo.* In the lower left-hand corner is a slight pen and ink sketch
of two men, one standing and the other crouching.

—— **964**S. *See* cat. 100

46 —— **1107**S (as Francesco Salviati)
ALLEGORICAL FEMALE FIGURE IN A NICHE
Pen and brown wash. 235:127 mm.

She stands on a rectangular base in a narrow round-headed niche facing the front, with
her head turned in profile to right. Her left arm hangs down by her side with the hand
gathering the drapery at her waist. The other hand, held up at the level of her shoulder,
grasps a thick ring-shaped object like a quoit.
Though the drawing itself is (at most) a weak product of the Zuccaro studio, and though
the pose and arrangement of the drapery are more static and less evolved than those of
the similar figures of which there are drawings by TZ (i.e. cat. 94, 177, 238, 239), this
figure is in some way connected with this group and may thus go back to a design by
TZ. The object in her right hand might be a small wreath, like the one held by the
figure in cat. 238.

47 —— **1137**S
ALLEGORICAL FIGURE OF 'ABUNDANCE' OR 'CHARITY' IN A
SQUARE-HEADED NICHE
Red and black chalk. 250:142 mm.
1966 Exhibition, no. 50; **Gernsheim 40425.**
Formerly attributed to Francesco Salviati but certainly by Federico Zuccaro. A study
for the allegorical figure above the door on the left of the fireplace in the Anticamera
del Concilio at Caprarola. The figure, who holds a cornucopia and is attended by two
putti, is identified in Georg Kaspar Prenner's engravings of the Caprarola frescoes (1748)
as *Caritas.* The Uffizi drawing suggests that Federico rather than TZ may have been
responsible for the design of these subsidiary details of the decoration. Studies for two of
the allegorical figures on the ceiling of the Sala dei Fatti Farnesiani at Edinburgh (cat.
32), likewise in red and black chalk, seem also to be by him rather than TZ as does the
rough pen and ink study for '*Abundance, the Daughter of Peace*', another of the allegorical
figures in the Anticamera, in the Rosenbach Foundation, Philadelphia (cat. 216).

48 —— **1146**S

A WOMAN RUNNING FORWARD **Plate 22**
Pen and brown wash. Red chalk underdrawing and *pentimento* in right arm only.
Irregularly torn along left edge and made up. 333:228 mm.
1966 Exhibition, no. 10.

K [145] G.T.Z.

Formerly attributed to 'School of Francesco Salviati'. The drawing cannot be connected with any known composition but its style suggests a date not later than the early 1550's.

49 —— 1180^S (as Beccafumi)

A STANDING PROPHET HOLDING A BOOK
Pen and brown wash over black chalk. 383:200 mm.
Gernsheim 16171.

The figure is completely Zuccaresque in style and type and may well go back to a design by TZ.

——1205^S. *See* cat. 135

—— 1279^F. *See* cat. 14

50 —— 1731^F

Recto. A GROUP OF FIGURES WITH HORSES
Verso. STUDIES OF A KNEELING FIGURE AND OF DRAPERY
Black chalk and pen and brown wash, heightened with white, on brown paper (*recto*); black chalk, heightened with white (*verso*). 562:435 mm.
1966 Exhibition, no. 11 (***recto* repr.**).
Discovered by Craig Smyth among drawings attributed to Titian. His attribution to TZ (note on the mount) is confirmed by the close connexion with cat. 18, at Chatsworth, traditionally so attributed. The Uffizi drawing is a rougher sketch for the same group, which is evidently for the left-hand side of an *Adoration of the Magi*. See p. 69 for a discussion of their possible connexion with the Mattei Chapel.

51 —— 6397^F

Recto. A GROUP OF WOMEN AND CHILDREN **Plate 10a**
Verso. A GROUP OF FIGURES **Plate 10b**
Pen and brown wash (*recto*); pen and ink (*verso*). 287:270 mm.
1966 Exhibition, no. 2.

Inscr.: *F da Poppi*, and previously so attributed, but Philip Pouncey's suggestion of TZ is entirely convincing. The drawing is early, *c.* 1550. The *recto* resembles the drawing of women and children in the Victoria and Albert Museum (cat. 112) so closely, not only in technique and handling, but also in scale, in the somewhat incoherent grouping of the figures, and in their facial types, that if (as Ottley believed) the Victoria and Albert drawing is part of a design for a frieze, the Uffizi drawing could be a study for a group in another section of the same composition.
The drawing on the *verso* corresponds exactly with a group of figures on the extreme left of a drawing at Windsor (01234; Popham-Wilde, no. 399, Pl. 83, as Pirro Ligorio). See p. 54.

—— 7686^S. *See* cat. 138

—— 9027^S. *See* cat. 98

52 —— 9342^S

Recto. THE VIRGIN AND CHILD ADORED BY ST DAMASUS AND
ST LAWRENCE **Plate 175**
Verso. A GROUP OF APOSTLES ROUND A SARCOPHAGUS
Pen and brown wash, with traces of squaring in red and black chalk (*recto*); with black
chalk and white heightening and pen squaring (*verso*). 413:298 mm.
J. A. Gere, *B. Mag.*, cviii (1966), p. 290 (**verso repr.**), p. 342 (*recto*); 1966 Ex-
hibition, no. 22 (**verso repr.**).

Inscr. *Zuccaro* but formerly as Barocci. Recognized as TZ by Philip Pouncey. The *recto*
is a study for the high altarpiece in S. Lorenzo in Damaso (see p. 127) occupying a place in
its evolution somewhere between the two studies in the Ashmolean Museum (cat. 158
verso and 159. Pls. 174 and 176). The *verso*, which corresponds with an engraving by
Aliprando Caprioli, dated 1577 and inscribed *Tadeus Zuccarus inventor* (repr. *B. Mag.*
ut cit., p. 291, fig. 9), is a study for the lower part of the *Assumption of the Virgin* in the
Pucci Chapel in S. Trinità de Monti, on which Taddeo was working at the time of his
death (see p. 125).
Since the publication of my article on the Pucci Chapel in *The Burlington Magazine*,
Mr Rudolph Joseph of Munich kindly sent me a photograph of a squared drawing in
his own collection which seems to be the missing link between Taddeo's design for the
left-hand side of the lower group and the study by Federico belonging to Mr Albert
Wade (*B. Mag.*, ut. cit., p. 292, fig. 18). The kneeling figure in the centre foreground
and the one stooping over the sarcophagus on the right are in Mr Wade's drawing, but
the four standing figures on the left correspond in essentials with Caprioli's engraving.

53 —— 10995^F

A GROUP OF FIGURES ON THE RIGHT-HAND SIDE OF A
COMPOSITION **Plate 87**
Red chalk and red wash. 397:308 mm.
1966 Exhibition, no. 33.

A variant of the right-hand side of the *Healing of the Cripple*, one of TZ's frescoes in the
Frangipani Chapel. The foreground figures are quite different (the two principal figures
of the group in the drawing are a man in the extreme right foreground seated on the
ground with his right arm extended, looking up towards a man who stands behind him
and gestures in the same direction) but the connexion between drawing and painting is
established by the exact correspondence of the steps in the foreground and the buildings
in the background. The drawing is not by TZ, however, but by Federico (to whom it is
traditionally attributed), and the most likely explanation is that it is a copy by Federico
of a lost study by his brother. See p. 83.

54 —— 10997^F

PAUL III CREATING ORAZIO FARNESE PREFEC T OF ROME
Pen and brown wash. Squared in black chalk. 277:275 mm.
Gernsheim 11599.

A *modello* for the fresco on the right of the oval portrait of Henri II of France above the
fireplace in the end wall of the Sala dei Fatti Farnesiani at Caprarola, differing from it
in many details, particularly in the perspective of the steps which shows that it must at

[147]

one stage have been intended to place this scene on the left-hand side. In the drawing Orazio Farnese is wearing his mitre and the Pope is handing him a staff; in the fresco his mitre is on the floor beside him, and the Pope makes a gesture of benediction. The background figures in the drawing are all ecclesiastics, and in the fresco there is a large vase in the left foreground.

One of the group of *modelli* discussed on pp. 112 ff. which appear to be studio products rather than by TZ himself. Another *modello* corresponding with this one in every detail including the squaring, is also in the Uffizi (cat. 68). It is somewhat inferior in quality and may be by another hand, but must also have been part of the preliminary working material.

—— 11007**F**. *See cat. 244*

55 —— 11028**F** (as Federico Zuccaro)

Recto. A SAINT HOLDING A CROSS
Verso. TWO STUDIES OF A SEATED FIGURE
Pen and brown wash over black chalk on blue paper (*recto*); black chalk (*verso*).
262:352 mm.
1966 Exhibition, no. 17; **Gernsheim 11370 (*verso*)**

Inscr. on *verso*: *pensono (?) essere del Parmigianino*.
Though it would hardly occur to one to doubt the attribution of the *recto* drawing to Federico, the *verso* studies are not only of much higher quality but are for the figure of the enthroned Procurator in the Frangipani Chapel *Blinding of Elymas* (Pl. 89). This may be one of the rare instances of two hands working on the same sheet.

56 —— 11037**F**

Recto. FOUR MEN IN A BOAT **Plate 86**
Verso. STUDY FOR THE SAME GROUP
Pen and brown wash over black chalk (*recto*); over red chalk with some black chalk (*verso*). The *recto* squared in black chalk. 406:280 mm.
1966 Exhibition, no. 19; **Gernsheim 40314 (*verso*).**

Previously attributed to Federico Zuccaro, but Anna Forlani Tempesti's suggestion of TZ is borne out by the fact, revealed by the recent cleaning of the Frangipani Chapel frescoes, that this is a study for the group in the left foreground of the *Shipwreck of St Paul* on the vault (Pl. 90)

57 —— 11040**F** (as Federico Zuccaro)

THE ADORATION OF THE SHEPHERDS
Pen and brown wash, heightened with white, on brown-washed paper. 438:693 mm.
J. A. Gere, *B. Mag.*, cv (1963), p. 364, note 6; **Gernsheim 11457.**

The sheet is so ruined as to be almost impossible to judge, but the composition is certainly TZ's and the little that is left of the drawing itself could well be from his own hand. There is a stuck-on *pentimento* for the right foreground figure. The one underneath is in a more animated pose, running forward with extended arms.
A copy of the left-hand side of the composition is in the Louvre (9974. Repr. *B. Mag.*,

ut cit., p. 365, fig. 31) and a derivation from it, by TZ himself, in which the elements of the composition have been compressed so that the format is upright and not oblong, is at Stockholm (cat. 227/228). A close variant is at Chatsworth (cat. 19). See also cat. 201. The composition may originally have been intended for the Mattei Chapel. See p. 68.

58 —— 11042F

THE MARTYRDOM OF ST LAWRENCE
Pen and brown wash, heightened with white, on brown paper. 527:270 mm.
1966 Exhibition, no. 51; J. A. Gere, *B. Mag.*, cviii (1966), p. 342 (**repr.**); **Gernsheim 11501.**

This *modello*, though traditionally and correctly attributed to Federico Zuccaro, preserves the final form of a composition by TZ for which cat. 158 *recto* is a first sketch, which was an alternative solution for the high altarpiece in S. Lorenzo in Damaso. The composition is repeated in an altarpiece, traditionally attributed to TZ, in the Chiesa dei Cappuccini at Fermo (repr. *Inventario degli oggetti d'arte d'Italia: Provincie di Ancona e Ascoli Piceno*, 1936, p. 264).

59 —— 11103F

AN ENTHRONED POPE HANDING A STAFF TO TWO KNEELING YOUTHS
Black chalk (some touches of red chalk on the faces) on blue paper. 248:183 mm.
1966 Exhibition, no. 54 (**repr.**); **Gernsheim 11420.**

Inscr. in Federico's hand: *de mano de federigo de tadeo i(n)venti*[one]. A study for the group in the background of the *quadro riportato* above the right-hand doorway in the Sala dei Fasti Farnesiani in the Palazzo Farnese in Rome. See p. 122.

—— 11144F. *See cat.* 124

60 —— 11159F

A NUDE MAN SEATED ON THE GROUND
Pen and brown wash over black chalk, heightened with (partly oxidized) white. 141:194 mm.
1966 Exhibition, no. 12 (**repr.**); **Gernsheim 40325.**

Inscr.: *Taddeo Zucch°*. Perhaps connected with the Mattei Chapel *Last Supper*: an early design for this composition, known from a studio copy in the Albertina (cat. 247) and an engraving by Aliprando Caprioli, differs from the fresco in the left foreground group, one of the figures in which is in a pose close to that of the Uffizi study.

61 —— 11160F

A GROUP OF FLYING ANGELS
Pen and brown wash over black chalk, heightened with (partly oxidized) white, on yellowish paper. The corners cut and made up. 180:191 mm.
1966 Exhibition, no. 9; J. A. Gere, *B. Mag.*, cviii (1966), p. 418, note 6; **Gernsheim 40326.**

Attribution to TZ traditional. Perhaps a study for the group of angels in the upper part of the composition of *The Angel warning St Joseph to fly into Egypt*, known from drawings at Hamburg (cat. 86. Pl. 78) and in Mrs Richard Krautheimer's collection (cat. 145. Pl. 81). What may be another study for the group of angels is at Bremen (cat. 11). The style of all four drawings suggests a date in the early 1550's.

62 —— 11168F

A STANDING MAN IN HEAVY DRAPERY, WITH HIS ARMS HELD OUT TO THE LEFT AND HIS HEAD TURNED AWAY TO THE RIGHT

Black and white chalk on blue paper. Squared in red chalk. 287:181 mm.
1966 Exhibition, no. 15 (**repr.**); **Gernsheim 40339.**

Inscr.: *Taddeo Zucchero.*

63 —— 11179F

A GROUP OF STANDING AND KNEELING FIGURES

Pen and brown wash, heightened with white, on brown-washed paper. 249:194 mm.
1966 Exhibition, no. 13 (**repr.**); **Gernsheim 11496.**

Inscr.: *pulidoro*, but correctly attributed to TZ. The style suggests a date not much later than *c.* 1555. These might be figures in an *Adoration of the Shepherds*, or possibly in the foreground of a disputation-scene like those of which cat. 29–31 and 262–263 seem to have been fragments.

64 —— 11180F

THE CORONATION OF PAUL III

Pen and brown wash. Squared in black chalk. Some damage on the left-hand side. 272:271 mm.
1966 Exhibition, no. 25 (**repr.**); **Gernsheim 11497**

A *modello* or compositional draft for the fresco in the centre of the ceiling of the Anti-camera del Concilio at Caprarola. This and cat. 65 and 66 belong to the group discussed on pp. 112 ff. which seem to be products of the studio rather than by Taddeo himself. The principal differences between drawing and fresco are the eventual substitution of a group of three women, one seated holding a child, for the standing old man and the half-length figure of a soldier in the left foreground of the drawing, and the suppression of the two statues of naked men between the pillars on either side of the background.

65 —— 11183F

ALESSANDRO AND OTTAVIANO FARNESE ACCOMPANYING CHARLES V AGAINST THE LUTHERANS

Pen and brown wash. Squared in black chalk. 280:493 mm.
1966 Exhibition, no. 24; **Gernsheim 11498.**

A *modello* or compositional draft, belonging to the same group as cat. 64 (q.v.) etc., for the fresco on the left-hand side of the long wall opposite the windows in the Sala dei Fatti Farnesiani at Caprarola. The correspondence with the fresco is close, but not exact. The group of figures is essentially the same, though there are slight differences in

costume and in the heads. In the fresco the trees on the right-hand side have been more widely spaced, and there are more cannon, together with a pile of cannon-balls, in the right foreground.

66 ——— 11184^F

PIETRO FARNESE ENTERING FLORENCE IN TRIUMPH AFTER DEFEATING THE PISANS
Pen and brown wash. Squared in black chalk. 282:419 mm.
1966 Exhibition, no. 26 (**repr.**); **Gernsheim 11493**

A *modello* or compositional draft for the fresco on the ceiling of the Sala dei Fatti Farnesiani, belonging to the group discussed on pp. 112 ff. It corresponds very closely with the fresco, the principal difference being that the procession of soldiers in the background has been simplified.

67 ——— 11185^F

HEADS OF THREE MEN, AND THE ARM OF A FOURTH
Pen and brown wash, heightened with white. 93 mm. diameter.
1966 Exhibition, no. 8; **Gernsheim 40333.**

A fragment of a larger composition, datable about the period of the Mattei Chapel.

68 ——— 11195^F

PAUL III CREATING ORAZIO FARNESE PREFECT OF ROME
Pen and brown wash. Squared in black chalk. 277:275 mm.
Gernsheim 11596.

A *modello* or compositional draft for the fresco in the Sala dei Fatti Farnesiani at Caprarola. See cat. 54.

69 ——— 11199^F

A SEATED SIBYL HOLDING A TABLET Plate 33
Pen and brown wash over red chalk. 240:180 mm.
1966 Exhibition, no. 3

The style suggests an early date, *c.* 1550. This might be a study for the figure in the right foreground of the composition of the *Assunta* with Prophets and Sibyls for which there is a complete composition-study in the Louvre (cat. 183. Pl. 32). See p. 49 and also p. 41, note 3.

70 ——— 11208^F

THE ADORATION OF THE SHEPHERDS
Pen and brown wash, heightened with white, on brown paper. 413:289 mm.
Gernsheim 11491.

Of the drawings corresponding with this celebrated composition, widely known from a number of engravings all apparently based on one by Cornelis Cort, dated 1567 (BdH 33), this has perhaps the best claim to be considered an original by TZ. A closely similar version from the Mariette Collection, now in the Louvre (4409), which Mariette

believed to be the original (cf. *Abecedario*, ii, p. 16; lot 808 in his sale, 1775) seems inferior in quality and is probably a copy. Other copies are in the Biblioteca Communale in Siena (S. III. 2, fol. 35, as Casolani; Gernsheim 26232), and in the Rosenbach Foundation in Philadelphia (472/22, no. 4). Bierens de Haan cites yet another in the Uffizi (805S).

This drawing corresponds exactly with Cort's engraving and is in the same direction. It should be noted that the engraving illustrated by Bierens de Haan is not Cort's original but a reversed copy of it signed in the lower right corner NBS (i.e. Natale Bonifazio da Sebenico). Bierens de Haan's statement, which seems to provide a *terminus ante quem* for TZ's composition, that these initials are followed, in the first state of the plate, by the date 1560, is almost certainly incorrect: Natale Bonifazio is said to have been born *c.* 1550 and Cort's engraving, which seems undoubtedly to have been the original of his, is dated 1567. No date follows the engraver's monogram in the British Museum impression of the Bonifazio copy, but below the name *Tadeus Zuccarus* in the lower left corner is one which appears to read 1660 (altered to 1690).

The general style of the composition, with its symmetrically placed and deliberately posed figures, suggests a date towards the end of TZ's career.

71 —— 11214F

AN ARMY MARCHING OUT OF A BURNING CITY

Pen and brown wash over black chalk, heightened with white, on blue paper. 422:475 mm.

1966 Exhibition, no. 28 (**repr.**); **Gernsheim 11469.**

Inscr.: *Taddeo Zuccaro* and, in left-hand margin, *No. 14*. A soldier at the head of the column holds aloft an Imperial crown. Behind him walk two prisoners, one wearing a turban. The Imperial eagle appears on a banner held by one of the soldiers, and on the covering of a waggon.

Vasari says that TZ was commissioned to design the temporary decorations for the obsequies in Rome of the Emperor Charles V: 'furono allogate a Taddeo (che il tutto condusse in venticinque [corrected by Federico to *quindici*] giorni) molte storie de'fatti di detto imperatore, e molti trofei ed altri ornamenti, che furono da lui fatti di carta pesta molto magnifici ed onorati' (vii, p. 86). The obsequies were celebrated in S. Giacomo degli Spagnuoli on 4 March, 1559. According to Sir William Stirling's account of the occasion, taken from contemporary documents, the walls of the church were hung with huge paintings of the Emperor's victories (*The Cloister Life of the Emperor Charles V*, 1882, chapter 11). Though this drawing is both too weak in handling and too uninspired in composition to be from TZ's own hand, it seems certainly to be a product of his studio and may have been a design for one of these paintings. The conspicuously displayed insignia and the turban worn by the prisoner identify the subject as an imperial victory over the Turks; TZ designed and executed the entire decoration in a fortnight so that he is likely to have made considerable use of his assistants' services; and the number '14' inscribed on the drawing in a contemporary (?) hand suggests that the composition may have been one of a series.

TZ presumably also designed the catafalque and the painted decorations on it. According to a contemporary description quoted by Olga Paris Berendsen in an unpublished thesis on the Italian XVI and XVII-century Catafalque (1961: deposited in the Library of the Institute of Fine Arts of New York University), the Emperor's catafalque consisted of four units which surmounted one another in diminishing sizes. The coffin

lay on a square base surrounded by twelve doric columns arranged in groups of three at the corners of the base so that there were pairs of columns at either end of each side. These supported an entablature decorated with trophies and heraldic animals from the arms of the Spanish provinces, on which rested a closed square unit on the sides of which were painted pairs of Virtues: *Providentia* and *Abundantia*, *Immortalitas* and *Veritas*, *Aequitas* and another [illegible in the MS source], and *Fides* and *Magnificentia*. On this was another smaller square unit, also decorated with pairs of allegorical figures: *Religio* and *Laetitia*, *Justitia* and *Spes*, *Augusta Felicitas* and *Pax*, and *Pietas Augusta* and *Salus*. The whole was surmounted by a model of a triumphal chariot drawn by four white horses and driven by a figure symbolizing *Victoria* holding a crown and palm-branch.

72 —— 11216^F

STUDIES OF A NUDE MAN WITH A CUTLASS **Plate 15**

Pen and brown wash over black chalk. The paper somewhat stained. 211:288 mm.
1966 Exhibition, no. 4.

Inscr.: *uiene da Taddeo zucchero*. The drawing is not a copy, as the inscription seems to suggest. The three figures, which are not necessarily in any compositional relationship, are probably studies for a façade-decoration. See p. 39.

73 —— 11217^F (as Federico Zuccaro)

A POPE BLESSING A FLEET

Pen and brown wash. 210:441 mm.
Gernsheim 11366.

The Pope, standing on the left under an awning, behind a semi-circular balustrade at the top of a flight of three curving steps, makes a gesture of benediction towards the ships which occupy the right-hand side of the composition. On the sails of three of them are the Imperial Eagle, the Papal Keys and Tiara, and the Lion of St Mark.

This is evidently Paul III blessing the Imperial Fleet on its departure for Tunis, a subject represented in one of the frescoes on the ceiling of the Anticamera del Concilio at Caprarola. Though the two compositions are entirely different and though the drawing is not by Federico (to whom it is traditionally attributed) and is too weak to be by TZ, the group of bystanders in the left foreground is entirely in the latter's manner and it may well be that this is a (?studio) copy of an early idea for the Caprarola fresco. Two other copies are in the Louvre (1451 and 4528).

74 —— 11218^F

THE RAISING OF EUTYCHUS

Pen and brown wash, heightened with white, on dark bluish-green paper. 356:454 mm.
1966 Exhibition, no. 27 (**repr.**); **Gernsheim 11500.**

An old copy of a rejected design for a fresco on the vault of the Frangipani Chapel in S. Marcello al Corso (Pl. 85). See p. 75. Another copy is at Christ Church, Oxford (1823; Gernsheim 44145). The original probably resembled the drawing by TZ himself in the Metropolitan Museum (cat. 142. Pl. 84) which shows a closely related solution and of which there is a similar copy in the Fitzwilliam Museum, Cambridge.

75 —— 13031F (as Federico Zuccaro)

Recto. STUDY FOR A COMPOSITION OF THE VIRGIN WITH GOD
THE FATHER AND THE HOLY GHOST, ADORED BY TWO SAINTS
Verso. THE LOWER PART OF THE *RECTO* SUBJECT AND
STUDIES FOR A COMPOSITION OF THE HEALING OF A
POSSESSED WOMAN

Pen and brown wash, heightened with white on blue paper (*recto*); pen and black chalk
(*verso*). Indecipherable black chalk strokes on both sides of the sheet, unconnected with
the other studies. 406:262 mm.
1966 Exhibition, no. 16 (**both sides repr.**); **Gernsheim 7974 (*recto*), 7975 (*verso*).**

Inscr.: *Zucchero.* The *recto* design is for a composition with an arched top. The Virgin,
standing on a cloud and surrounded by a double *mandorla* of angels' heads, is adored by
a male and a female saint who stand below. Immediately above her head is the Holy
Ghost, and at the top of the composition God the Father, looking down with his right
arm raised in blessing. On the *verso*, drawn with the sheet turned on its side and on a
larger scale, are the two saints and the lower part of the Virgin's body, the rest of which
has been cut away. These figures, lightly sketched in black chalk with the male saint
reinforced in pen and ink, are at right angles to the other studies on the *verso*, which
consist of a series of rapid thumbnail sketches of a composition of two groups of figures
in front of a high archway flanked by pillars. The figures in the left-hand group turn
away from the spectator towards a personage standing on a higher level with his arms
held out in front of him, a gesture directed towards the figures on the right-hand side
of the composition, conspicuous among which is a woman kneeling with outstretched
arms. A small sketch for this right-hand group is on the *verso* of a drawing in the British
Museum (cat. 106. Pl. 105) of a monastic saint healing a possessed woman, and it seems
reasonable to connect the Uffizi sketches with the same composition, which may
represent the well-known miracle of St Philip Benizzi. A possible, though wholly
conjectural, explanation of their purpose is that they were connected with the decoration
of his chapel in S. Marcello al Corso, a church where TZ was working from about 1558
until his death.
This method of continuous, rapid, small-scale notation, is paralleled on the sheet of
studies at Chicago for the Frangipani Chapel in S. Marcello (cat. 22. Pl. 94). The latter
are in pen and wash while those on the Uffizi sheet are in pen alone with the shaded
areas indicated by a scribbly zig-zag hatching which gives a scratchier and more
schematic impression; but the 'touch' and the evidence of rapidity of thought, sometimes
outrunning the hand to produce an indecipherable but significant jumble of strokes,
are both characteristic of TZ. Federico seems not to have composed in this way, but it is
difficult to see any other hand than his in the *recto* composition or in the large-scale related
study on the *verso*. As in the case of cat. 55, we must again reckon with the possibility –
quite probably when two brothers are working in close collaboration – that one of them
may have used a piece of paper on which the other had already drawn.

76 —— 13409F

THE ADORATION OF THE SHEPHERDS **Plate 7**
Pen and brown wash, heightened with white (partially oxidized). Oil-stains and holes
in the middle of the sheet. 256:409 mm.

1966 Exhibition, no. 1.

Formerly attributed to Polidoro da Caravaggio, but, as Philip Pouncey was the first to observe, this drawing belongs to TZ's earliest, Polidoresque, phase. It should be compared with the treatment of the subject by Polidoro himself known from an engraving by Cort dated 1569 (BdH 30): there is a certain similarity between the two in the agitated movements of the figures and the looseness of their grouping and in the construction of the stable round a live tree.

77 —— 13598^F

Recto. A SEATED MAN **Plate 92**
Verso. HEAD AND SHOULDERS OF A BEARDED MAN TURNING TO THE LEFT, WITH A BOOK UNDER HIS LEFT ARM AND HIS RIGHT ARM RAISED
Red chalk, with traces of oxidized white heightening on the *recto* only. 223:164 mm.
1966 Exhibition, no. 18.

Inscr. on *verso*: *Taddeo Zucchero*, but previously attributed to Parmigianino. The sheet was once larger: the *verso* figure has been cut off at the waist. The *recto* study is for the enthroned Procurator in the *Blinding of Elymas* in the Frangipani Chapel in S. Marcello al Corso, (Pl. 89) and the figure on the *verso* part of a study for St Paul in the same composition. See p. 79.

78 —— 13629^F

THE ASSUMPTION OF THE VIRGIN AND AUGUSTUS AND THE SIBYL
Pen and brown wash. 224:127 mm.
J. A. Gere, *B. Mag.*, cviii (1966), p. 290 (**repr.**); 1966 Exhibition, no. 69 (**repr.**).

Formerly attributed to Parmigianino. Transferred to 'Bottega di Federico Zuccaro' at Philip Pouncey's suggestion. The drawing seems to be by Federico himself but to preserve TZ's design for the Pucci Chapel *Assumption* in S. Trinità dei Monti. The lower part of the composition corresponds closely with the study by him in the Uffizi (cat. 52 *verso*) which was engraved by Caprioli. See p. 126 and *B. Mag.*, ut cit.
There are drawings on the *verso* which cannot be made out through the backing. An old copy of the *recto* is in the Wadsworth Athenaeum at Hartford, Conn. (1948. 135: as Venetian School).

79 —— 13891^F

CAESAR DEFEATING THE SWISS ON THE ARAR
Red chalk. 280:287 mm.
J. A. Gere, *B. Mag.*, cv (1963), p. 313 (**repr.**); 1966 Exhibition, no. 20 (**repr.**); **Gernsheim 11477.**

Inscr. on backing: *sono molti anni, che il Morandi lo copiò da un disegno del Cigoli* and, in another hand: *Nè la maniera è del Cigoli, nè il disegno è Copia ma originale, e bello, creduto di Taddeo Zuccheri.* A design for maiolica (see p. 93 and *B. Mag.*, ut cit.). The subject is identified on another study for the same composition at Munich (cat. 133).

—— 14027^F. *See* cat. 194

——14064^F. *See* p. 29, note 2

—— 15212^F. *See* cat. 100

80 —— 92139

STUDIES OF THREE ANGELS **Plate 169**
Black chalk, with slight touches of red chalk on the faces and hands, on light brown
paper. Much stained and discoloured. 294:411 mm.

Formerly attributed to Cherubino Alberti. These studies are for three of the figures in
the fresco of *God the Father supporting the Dead Christ, with Angels holding the Instruments
of the Passion* on the lower part of the right-hand side-wall of the Pucci Chapel in S.
Trinità dei Monti (repr. *B. Mag.*, cviii (1966), p. 287, fig. 4). The studies, from left to
right, are for the Angel holding the Cross in the left foreground, the one holding the
Nails in the right background, and for the one holding the Column in the right
foreground.
The drawing seems to be by TZ rather than by Federico, and tends to confirm the
suggestion already put forward (see *B. Mag.*, ut cit.) that TZ was responsible for the
design of this particular fresco, though not necessarily for its execution.
A drawing in the Louvre (4430) corresponding exactly with the fresco is at most a copy
made in the Zuccaro studio, perhaps – to judge from the indented outlines – in connexion
with an anonymous engraving datable between 1572 and 1585 (cf. *B. Mag.*, ut cit.,
p. 289).

81 —— 93699

A STANDING BEARDED MAN HOLDING A BOOK, WITH HIS
RIGHT ARM OUTSTRETCHED
Pen and brown wash, heightened with white, on brown paper. 348:238 mm.
Gernsheim 40252

Inscr.: *federicus Zuccarus*. An old copy of a study for St Paul in the Frangipani Chapel
Healing of the Cripple.

——105303. *See* cat. 260

82 **Frankfurt, Städelsches Kunstinstitut 15230** (as Anonymous Italian)

Recto. STUDIES OF AN EVANGELIST OR PROPHET, WITH AN
ANGEL HOLDING A TABLET **Plate 35**
Verso. STUDIES OF AN EVANGELIST OR PROPHET WITH A BOOK,
ETC.
Pen and brown wash. 240:191 mm.

Early, *c.* 1550.

83 **Haarlem, Teyler Museum A*44**

TWO FRAGMENTS OF A STUDY FOR THE *DONATION OF CHARLEMAGNE*

Pen and brown wash, heightened with white. Made up of two irregularly shaped pieces of paper fitted together to form a rectangle. 253:231 mm.

In its complete form this drawing seems to have corresponded almost exactly with the study for the same composition in the British Museum (cat. 104. Pl. 154). For some reason the central figures of the composition, Charlemagne and the kneeling man presenting the document, have been cut out in such a way that the two fragments of the sheet on either side could be fitted together. Part of the kneeling man's drapery, and the end of the scroll which he holds under his left arm, are visible on the extreme left of the right-hand fragment.

The only difference is the addition, in the lower right-hand corner of the Haarlem version, of the standing figure originally on the right of the British Museum sheet. He is now placed on a lower level than the others, so that his head is more or less in line with Charlemagne's left foot. See p. 104.

84 —— **A. X. 30** (as Polidoro da Caravaggio)

SCENE FROM ROMAN HISTORY, PERHAPS AN EPISODE IN THE LIFE OF CAMILLUS

Pen and brown wash over black chalk. 274:295 mm.

M. Jaffé, *Master Drawings*, iv (1966), pp. 136 ff., (**repr.**).

Inscr. on old mount: *Polidoor*. The resemblance in the facial types and expressions of some of the figures to the equally Polidoresque *Camillus and Brennus* in the British Museum (cat. 110. Pl. 16), suggests that this may likewise be a composition by the youthful Taddeo, though the drawing itself seems more likely to be an old copy. The finished composition, for which the lost original was a study, is known from two copies: one by Rubens formerly in a Swiss private collection (Jaffé, op. cit. Pl. 10), and another in the Louvre (6250, as 'after Polidoro').

In the Haarlem drawing the composition is slightly wider than high, but in the Rubens copy the elements have been compressed so that it is considerably higher than wide, a format similar to that of the spaces between the windows on the façade of the Palazzo Mattei; this is exactly the kind of Polidoresque composition that Taddeo might have produced for that commission, but the subject cannot be positively identified with any of those described in the inscriptions given by Vasari. See p. 38.

In the Louvre copy the composition is flanked on one side by a larger-scale draped female figure. On the other side of the sheet is a frieze-shaped composition involving a man with a dagger in his hand who is stepping over the body of a reclining river-god (Caesar crossing the Rubicon?), known from many copies including C. M. Metz *Schediasmata Selecta*, 1791, pl. 38 (see p. 41).

—— **K. 101.** *See cat. 90*

85 **Hamburg, Kunsthalle 21058** (as Barocci)

Recto. A SIBYL IN THE LEFT-HAND SIDE OF A LUNETTE **Plate 62**
Verso. FIGURE-STUDIES

Pen and brown wash, heightened with white on blue paper (*recto*); black chalk (*verso*).
356:248 mm.

Gernsheim 16751 (*verso*).

The *recto* is a study for one of the Sibyls in the lunette above the altar in the Mattei Chapel in S. Maria della Consolazione (Pl. 65). See p. 64. The rectangular moulding on which she sits corresponds closely with the top of the stucco frame surrounding the altarpiece. The *verso* studies include another for the same figure, here shown turned so that her shoulders are flat against the wall. Her left elbow appears to be supported on something and her right arm hangs down with the hand holding one end of a scroll There is also a separate study for her left hand and forearm, and studies of a right arm and hand holding something (a cloth?) and of the head and shoulders of a bald, bearded man leaning forward (perhaps one of the Evangelists in the pendentives on the ceiling of the chapel).

—— **21102B.** *See* cat. 100

86 —— **21515** (as Federico Zuccaro)

THE ANGEL WARNING ST JOSEPH TO FLY INTO EGYPT
Plate 78
Pen and brown wash over red and black chalk, heightened with (partly oxidized) white, on blue paper. 480:388 mm.
Italienische Zeichnungen 1500–1800, Hamburg, 1957, no. 102; J. A. Gere, *B. Mag.*, cviii (1966), p. 418.

In spite of the traditional attribution to Federico (maintained in the catalogue of the 1957 Hamburg Exhibition), the drawing is certainly by TZ. Its style is of the early 1550's and the composition is related to Girolamo Muziano's fresco of the same subject, datable between 1550 and 1555, in S. Caterina della Ruota (repr. *B. Mag.*, ut cit., p. 396). A study for the upper part is in the collection of Mrs Richard Krautheimer, New York (cat. 145. Pl. 81), and two other studies of flying angels which may be connected with the same composition are at Bremen (cat. 11) and in the Uffizi (cat. 61). See p. 50.

Hanover, Kestner Museum Hz 805. *See* cat. 96

Hartford, Wadsworth Athenaeum 1948. 135. *See* cat. 78

87 **Holkham, The Earl of Leicester**

CAESAR DESTROYING THE BRIDGE AT GENEVA
Pen and brown wash. 334:340 mm.
A. E. Popham, *Old Master Drawings from the Collection of the Earl of Leicester*, Arts Council Exhibition, 1948, no. 30; J. A. Gere, *B. Mag.*, cv (1963), p. 306 (**repr.**).

Traditionally attributed to Parmigianino but catalogued by A. E. Popham as TZ, with the comment that it is either a late Perino del Vaga or an early Taddeo, more probably the latter. The composition corresponds with the painting on a maiolica dish in the Victoria and Albert Museum inscribed on the underside *Cesar presso a, Genáva rompé il ponto*, which Rackham (Maiolica Catalogue, 1940, no. 843) attributes to the Fontana factory in Urbino and dates 1550–60. In all probability this dish formed part of the service made between 1560 and 1562 for the Duke of Urbino as a present for Philip II of

Spain, for which, according to Vasari, TZ supplied the designs (see p. 92 and *B. Mag.*, ut cit.). An earlier study for the same composition is at Stockholm (cat. 225).

88 Kremsier, Uměleckohistorické Muzeum 11/15

ST LUKE IN A PENDENTIVE **Plate 58**

Pen and brown wash over black chalk, heightened with white, on blue paper. Some smaller sketches in black chalk alone. 360:254 mm.

Inscr., in the 'Lanière italic hand': *Tadeo Zuccaro*. The style suggests a date not later than the mid-1550's, and the drawing is probably an early study for one of the pendentives in the Mattei Chapel. See p. 65. Michael Jaffé kindly told me of this drawing.

89 Leiden, Rijksuniversiteit Prentenkabinet 2393

Recto. TWO CHILD-ANGELS ON CLOUDS, HOLDING A
MARTYR'S PALM **Plate 97**
Verso. TWO CHILD-ANGELS ON CLOUDS **Plate 99a (detail)**

Red chalk (*recto*); pen and brown wash (*verso*). 221:155 mm.

J. J. van Gelder, *Hondert Teekeningen van oude Meesters in het Prentenkabinet der Rijks-Universiteit te Leiden*, Rotterdam, 1920, no. 14.

The original attribution to 'Zuccaro' was rejected by van Gelder in favour of one to Correggio, but van Regteren Altena pointed out the connexion between the *recto* and the drawings by TZ in his own collection (cat. 1) and at Berlin (cat. 4). The *verso* is certainly, and the *recto* probably, connected with the Frangipani Chapel. See p. 81.

Leningrad, Hermitage 6502. *See* cat. 233

90 ——— 6515

ROMAN SOLDIERS WITH BOATS DRAWN BY OXEN, APPRO-
ACHING A RIVER

Pen and brown wash. 186 mm. diameter.

M. Dobroklonsky, Catalogue of XV and XVI century Italian drawings in the Hermitage, 1940, no. 399.

The composition is presumably intended for maiolica. In discussing it (*B. Mag.*, cv (1963), p. 314) apropos of two other versions, one in the Louvre (10597) and the other in the Teyler Museum, Haarlem (K. 101, repr. ibid., fig. 35), I suggested that it was by Federico rather than Taddeo; but the traditional attribution of the Hermitage drawing to TZ may well be correct, to judge from a photograph.

91 ——— 6516

A NAVAL BATTLE

Pen and brown wash. 183 mm. diameter.

Dobroklonsky, op. cit., no. 400.

Evidently a design for maiolica. To judge from the photograph, the drawing could be by TZ himself. See p. 93. A studio version was sold at Sotheby's, 23. v. 1968 (26).

[159]

92 ——— 6519

ROMAN SOLDIERS DIGGING A TRENCH
Pen and brown wash. 185 mm. diameter.
Dobroklonsky, op. cit., no. 403 (**repr.**).

Formerly attributed to Federico Zuccaro, but catalogued by Dobroklonsky as TZ.
The drawing is exactly the same size as, and clearly *en suite* with, circular drawings of
similar subjects at Turin and in the Albertina (cat. 233 and 237). The connexion with
the latter was noted by Dobroklonsky. A copy is in the Louvre (2236[B]; repr. *B. Mag.*,
cv (1963), p. 308, fig. 26).

93 ——— 7086

PAUL III BESTOWING THE CARDINAL'S HAT ON FOUR
FUTURE POPES
Pen and brown wash, heightened with white. 360:250 mm.
Dobroklonsky, op. cit., no. 408.

As Dobroklonsky pointed out, this is a study for the fresco in the Anticamera del
Concilio at Caprarola. It corresponds fairly closely, except that in the fresco the right
foreground is occupied by a table with a large vase standing on it, so that the standing
figure on the right is nearer the throne. The lower part of another study for the same
composition is in Berlin (cat. 6 *verso*). To judge from a photograph, the Hermitage
drawing could be by TZ himself. Copies are in the Louvre (2177) and in the Accademia
at Venice (178) both attributed to Vasari.

94 ——— 20069

A WOMAN WEARING A HELMET, STANDING IN A SQUARE-
HEADED NICHE **Plate 162**
Pen and brown wash, heightened with white, on brown paper. The outlines indented.
250:155 mm.
Dobroklonsky, op. cit., no. 396.

A study, earlier than the one in the Louvre (cat. 177. Pl. 163), for the allegorical figure
above the right-hand doorway in the Sala dei Fasti Farnesiani in the Palazzo Farnese in
Rome. See p. 120.

95 London, British Museum 5211–15

Recto. A PAIR OF SOLDIERS
Verso. STUDY FOR THE UPPERMOST SOLDIER
Pen and brown wash over underdrawing in red and black chalk (*recto*); pen and ink over
red chalk (*verso*). 408:241 mm.

Inscr. on old mount: *Tadeo Zuchero*.
For the same group as cat. 97 (q.v.).

——— 5211–50. *See* cat. 147

[160]

96 —— 5211–54

FEMALE FIGURE HOLDING A STAFF, SEATED ON A RECT-
ANGULAR FRAME
Pen and brown wash, heightened with white, on brown-tinted paper. Squared in black
chalk. 336:255 mm.

For the allegorical figure above the right-hand window in the Sala dei Fasti Farnesiani
in the Palazzo Farnese in Rome (see p. 120). Though the handling seems rather coarse
and over-simplified for TZ, it is not entirely incompatible with him; it certainly does not
seem to be by Federico, who according to Vasari, completed the decoration of the
room after TZ's death. An old copy (studio repetition?) is in the Kestner Museum,
Hanover (Hz 805). Another was formerly in the Wallraf Collection in London.
Variants, both apparently products of the studio, are in the Rosenbach Foundation,
Philadelphia (cat. 214) and the Biblioteca Marucelliana, Florence (cat. 34). The former
corresponds with the British Museum study except for the drapery over the left leg,
which falls so as to cover the foot. In the latter the left knee is not raised and the upper
part of the figure is less abruptly foreshortened.

—— 5212–37. *See* cat. 20

—— 5237–128. *See* cat. 147

97 —— Ff. 1–26

A GROUP OF SOLDIERS **Plate 157**
Pen and brown wash over black chalk and stylus underdrawing. 407:245 mm.

Inscr. on mount by John Barnard (cf. Lugt 1420): *This Picture is painted in Fresco in the
Hall of the Belvidere Palace att Rome. Baglione. The Subject is Moses & Aaron solliciting
Pharoah in behalf of the Israelites; the Figures in this Drawing are the Guards, who stand by
Pharoahs Throne; The Picture is engrav'd by Cornel^s Cort. 1567. J:B.* Barnard's information
is entirely correct. Baglione (1642 ed., p. 121) refers to a series of frescoes of 'storie di
Faraone, e di Moise' painted by Federico in a room (now part of the Museo Etrusco)
in the Vatican Belvedere. The two principal figures in this group appear in the lower
right-hand corner of the fresco of *Moses and Aaron before Pharaoh*, of which there is an
engraving by Cort dated 1567 (BdH 18). The same two figures occupy the same
position in a drawing of the *Adoration of the Magi* at Chatsworth (197), traditionally
attributed to TZ but certainly by Federico and probably an early design for his altar-
piece in the Grimani Chapel in S. Francesco della Vigna in Venice. But though the
figures occur in two compositions by Federico, the quality and handling of the present
drawing and of cat. 95, a less elaborated study for the same group, unmistakably
indicate the hand of TZ. They seem on the whole more likely to be studies for one of his
own compositions which he for some reason discarded and which Federico later
utilized, than drawings made expressly for Federico's benefit. One possible explanation
is that they are studies for the group of figures on the right-hand side of the *Donation of
Charlemagne* in the Sala Regia, made when the composition was still envisaged with
figures on two levels (see pp. 85 and 104).
Payments for Federico's paintings in the Vatican Belvedere are recorded in September
and October 1563. His altarpiece in the Grimani Chapel is dated 1564. TZ received a
first, interim, payment for the Sala Regia *Donation of Charlemagne* in May 1564.

L G.T.Z.

98 —— Pp. 2–127

A SIBYL IN THE
Pen and brown wash, l
figure, top left, in black
C.L. Ragghianti, *Critic*
Il Manierismo e Pellegrin

Inscr. by Sebastiano Re
collection of drawings {
Suppl.) is Pellegrino M
Museum in 1824. Ragg.
by Briganti in favour o
to point out, this is a st
in the Mattei Chapel ir

different, but the architectural moulding indicated in the drawing corresponds with the
top of the stucco frame surrounding the altarpiece.
In the lower right-hand corner is a slight sketch after Correggio's *Antiope*. See p. 64.
A copy is in the Uffizi (9027S, as Raffaellino da Reggio).

99 —— 1859–8–6–78

COPY OF PART OF AN ANTIQUE RELIEF: TWO HORSES, A NUDE
MAN ON HORSEBACK, AND A SWAN **Plate 18**
Pen and brown wash. 248:329 mm.

Attributed to Giulio Romano when acquired. Subsequently classified as 'Anonymous
Italian'. An example of TZ's early manner, rather more broadly handled than usual –
but the head of the rider is characteristic of him, both in facial type and structure –
reproducing a detail of an Antique sarcophagus relief of the *Fall of Phaethon* (C. Robert,
Die Antiken Sarcophag-Reliefs, iii, 3, Berlin, 1919, no. 342; also repr. G. A. Mansuelli,
Galleria degli Uffizi: le sculture, i, 1958, no. 251, and C. de Tolnay, *Michelangelo*, iii,
Princeton, 1948, fig. 294) now in the Uffizi but in Rome in the middle of the XVI
century. Robert quotes a MS by Pirro Ligorio, *De' Luoghi delle Sepulture* (1550–53) which
describes it outside the door of S. Maria in Aracoeli. The connexion between the
drawing and the relief was first noted by Robert, who reproduces the former under the
old attribution to Giulio Romano.
On the *verso* are some slight sketches in pen and ink: figures, a centaur and two horses,
and the head and shoulders of an old man in profile to left.

100 —— 1895–9–15–652

A NAVAL BATTLE
Pen and brown wash. Circular: 327 mm. diameter
J. C. Robinson, Malcolm Collection Catalogue, 1876, no. 211; Popham-Wilde, under
no. 987; J. A. Gere, *B. Mag.*, cv (1963) p. 309 (**repr.**).

As Polidoro da Caravaggio in the Malcolm Collection Catalogue. Transferred by A. E.
Popham to Perino del Vaga. Subsequently identified as a design for the decoration of an
Urbino-ware cistern in the Bargello, Florence (repr. *B. Mag.*, ut cit., fig. 16) which was
presumably part of the service of maiolica for which TZ supplied designs between 1560
and 1562 (see p. 92 and *B. Mag.*, ut cit.). Certain features of the composition (e.g. the

[162]

figures climbing into the boat) suggest knowledge of Polidoro da Caravaggio's frieze of a naval battle on the façade of the Palazzo Gaddi, engraved by Pietro Santi Bartoli.

For some reason, this particular design was exceptionally popular, for though the original drawing is lost at least ten other copies are known in addition to cat. 100. Of thése, Budapest 1878 seems to come closest to TZ himself. The others are: Uffizi 358S (Gernsheim 7556) and 964S (both as Perino) and 15212F (Anonymous); Hamburg 21102B (as Polidoro: Gernsheim 16992); Louvre 11779 (Anonymous) and RF 1870–29497 (as Polidoro: *Master Drawings*, iii (1965), Pl. 15); Stockholm 456/1863 (as TZ: Sirén 389). Another is at Holkham, in Lord Leicester's collection.

101 —— 1895-9-15-655

THE FLIGHT INTO EGYPT
<div align="right">Plate 113</div>

Pen and grey and black ink and brown wash, heightened with white, on brown-washed paper. Some black chalk underdrawing. 394:233 mm.

J. C. Robinson, Malcolm Collection Catalogue, 1876, no. 214; A. Schmarsow, *Federigo Baroccis Zeichnungen*, iii, Leipzig, 1911, p. 22.

As Barocci in the Lawrence-Woodburn Sale (Christie's, 4. vi. 1860, lot 52) and in the Malcolm Collection Catalogue. Schmarsow pointed out the markedly Roman character of the drawing and argued that if by Barocci it would have to belong to the period of his activity in Rome when he was in contact with the Zuccaros; but, though in the handling of the foliage he saw certain parallels to Barocci's later work, he found it impossible to come to any certain conclusion about the authorship of the drawing since (in his opinion) the group of figures in the foreground had been coarsely reworked by another hand. I see no trace of any reworking. The drawing was subsequently transferred to Federico Zuccaro at the (oral) suggestion of Voss, and later to TZ by Philip Pouncey on the strength of the two studies for the same composition discovered by him in the Louvre (cat. 170 *verso* and 180, Pls. 111 and 112), which are certainly by TZ. These three drawings are for the fresco on the right of the high altar in S. Maria dell' Orto (Pl. 117), the one in the British Museum being closest to the final result. See p. 98.

102 —— 1895-9-15-814

Recto. A SOLDIER IN ROMAN ARMOUR DESCENDING A STEP HOLDING A STAFF OR THE SHAFT OF A SPEAR OR BANNER
Verso. A NUDE MAN REACHING UPWARDS

Red chalk (*recto*); pen and brown ink (*verso*). 358:135 mm., including a strip about 6, mm. wide added along lower edge.

J. C. Robinson, Malcolm Collection Catalogue, 1876, no. 367; C. Loeser, *Archivio storico dell'arte*, 2nd ser., iii (1897), p. 354, note 1; P. d'Achiardi, *Sebastiano del Piombo* 1908, p. 322; L. Dussler, *Sebastiano del Piombo*, 1942, p. 181 (***recto* repr.**); R. Pallucchini, *Sebastian Viniziano*, 1944, p. 192.

Inscr. in pencil in a XIX-century hand: *Sebastiano del Piombo*, an attribution accepted wholeheartedly by Loeser and Robinson and with hesitation by d'Achiardi and Dussler. The latter lists the *recto* among drawings doubtfully attributed to Sebastiano but seems on the whole inclined to accept it and to date it at the same period (*c.* 1517) as the studies for the *Raising of Lazarus* in the National Gallery which he believed were by him but

which Wilde has convincingly restored to Michelangelo. Pallucchini was inclined to reject it, with the comment 'piuttosto da espungere'.

No previous attribution is recorded. That to Sebastiano has a flavour of the mid-XIX century: it was perhaps an idea of J. C. Robinson's, prompted by the combination of the *recto* figure's vaguely 'Michelangelesque' character and the then fashionable tendency to see Sebastiano as Michelangelo's *alter ego*. But Sebastiano's drawing-style is now better defined, and it is obvious that this drawing belongs to a later and quite different current. Popham's (oral) suggestion of Federico placed it in the right *milieu* and period but was made when the distinction between the two brothers was still far from clear, and when drawings like cat. 95 and 97 were still believed to be by Federico. The passages of even, tonal hatching in this drawing, the sinuous contour continuously bounding the form, the scribbled indication of the right hand, the stance and facial type of the figure, are all characteristic of TZ. His chalk studies of single figures tend to be more deliberate and highly wrought, but this can be seen as the equivalent in another medium of one of his loose pen and wash drawings.

The style suggests a fairly late date, *c.* 1560 or later. The framing-line along the right-hand edge, together with the direction of the figure's gaze, suggests a study for the extreme right-hand side of some composition. This might perhaps have been the *Donation of Charlemagne* in the Sala Regia (Pl. 155) in which similar figures and steps occur (cf. p. 104).

The figure on the *verso* is posed in a seated position, with his left thigh resting on a support high enough for his right leg to be fully extended. In his left hand he holds what looks like a stone. This could be a drawing from life of a model posed on a high piece of furniture, or alternatively a sketch for part of a decorative complex embodying some architectural feature such as a window-frame or doorway. The outline of the upper part of the support suggests a cornice. D'Achiardi, Dussler and Pallucchini regard the *verso* as by a different hand from the *recto* but TZ's authorship is confirmed by comparison with such a drawing as cat. 95 *verso*.

103 —— 1895-9-15-1043

A PROCESSION OF LICTORS: DESIGN FOR A FRIEZE
Pen and brown wash over black chalk on blue paper. The outlines pricked. Reworked by Rubens in green and white bodycolour. 164:422 mm.

Lawrence Gallery, First [Rubens] *Exhibition*, 1835, no. 12; J. C. Robinson, Malcolm Collection Catalogue, 1876, no. 584; M. Rooses, *L'Oeuvre de P. P. Rubens*, Antwerp, v, 1892, no. 1396; A. M. Hind, *Drawings by Dutch and Flemish Artists in the British Museum*, ii. 1923, p. 20, no. 48; P. Pouncey and J. A. Gere, *Drawings by Raphael and his Circle in the British Museum*, 1962, no. 288 (**repr.**); M. Jaffé, *Master Drawings*, iii (1965), p. 25.

Ottley's attribution (sale, 13. iv. 1804, lot 307) to Perino del Vaga 'touched by Rubens' was replaced, in the Lawrence Gallery Catalogue, by one to Rubens 'in the style of Polidore'. This was repeated by Robinson, Rooses, and Hind. A. E. Popham came independently to the same conclusion as Ottley, that this is a XVI-century Italian drawing reworked by Rubens. He attributed it to the Cavaliere d'Arpino, but it certainly belongs to the Polidoresque group of early drawings by TZ, datable *c.* 1550. It was included in the catalogue of drawings by Raphael and his Circle to illustrate the extent of Polidoro's influence on the younger generation of Roman artists.

[164]

—— **1899–12–30–1.** *See* cat. 20

—— **1946–2–9–32.** *See* p. 105, note 1

104 —— **1946–7–13–108**

THE DONATION OF CHARLEMAGNE **Plate 154**
Pen and two shades of brown ink, and brown wash, over black chalk, heightened with white, on blue paper. 401:537 mm.
A. E. Popham, *Old Master Drawings*, vii (1932/33), p. 42 and Fenwick Collection Catalogue, 1935, p. 114.

Attributed to Federico Zuccaro in the Lawrence-Woodburn Sale (Christie's, 8. vi. 1860, lot 1073) and described as 'King John signing Magna Charta'. Identified by A. E. Popham as a study by TZ for the *soprapporta* in the Sala Regia (first payment, May 1564).
The two figures on the extreme right are the only point of exact correspondence between drawing and fresco. They are drawn on a separate strip of paper and represent an afterthought, for the ends of the scrolls held by the kneeling figure are cut off abruptly in a way that could not have happened if the strip had been added before the drawing was started in order to enlarge the sheet to the necessary size. The ends of the scrolls are visible on the back of the added strip together with the artist's first thought for the right-hand side, a man standing with his body turned to the left and his face to the spectator, and with his left hand resting on his sword-hilt. In order to make the alteration, the strip was simply cut off, turned over, and reattached. The rejected figure appears as an additional element, on a lower level than the rest of the group, in the repetition of the British Museum study by TZ himself of which there are two fragments at Haarlem (cat. 83), See p. 104. A complete copy, not by TZ himself but evidently the work of a studio-assistant, is at Windsor (6849; Popham-Wilde, no. 1070, fig. 202). This might be by the hand responsible for the drawing in the Fogg Museum connected with TZ's other *soprapporta* in the Sala Regia (see cat. 108) and for the copy in the Albertina of a lost study for the Mattei Chapel *Last Supper* (cat. 247).

105 —— **1946–7–13–579**

PROCESSION OF SOLDIERS AND PRISONERS: DESIGN FOR A FRIEZE **Plate 5**
Pen and brown wash. 159:418 mm.

A. E. Popham, Fenwick Collection Catalogue, 1935, p. 105; P. Pouncey and J. A. Gere, *Drawings by Raphael and his Circle in the British Museum*, 1962, no. 287.

Attributed to Perino del Vaga in the Philipe (22. v. 1817, lot 154) and Lawrence-Woodburn (8. vi. 1860, lot 986) Sales, and in the Fenwick Catalogue. On entering the Museum classified as 'attributed to Vasari'. This belongs to the Polidoresque early group of drawings by TZ which are datable *c.* 1550. It was included in the catalogue of drawings by Raphael and his Circle for the same reason as cat. 103.
The attribution to TZ is confirmed by the drawing in the Ambrosiana (cat. 128. Pl. 4), identified by Resta as a study for part of the façade of the Palazzo Mattei. The rhythm of

the figures' movement is very similar in both, and the group immediately to the left of the centre in the Ambrosiana drawing is identical with the central right-hand pair in the other, except that in the latter one of the figures is a prisoner. A copy of the group on the extreme left is on a sheet at Stockholm (781/1863; Sirén, no. 215, as 'Parmigianino?'), which Philip Pouncey has suggested may be by Pompeo da Fano (see p. 28, note 1).

106 —— 1946-7-13-587

Recto. A MONASTIC SAINT HEALING A POSSESSED WOMAN
Verso. A MONUMENTAL WALL-TOMB **Plate 105**

Pen and brown wash over black chalk (*recto*); pen and brown ink (*verso*). 410:277 mm. (size of whole sheet, including backing 420:286).
A. E. Popham, Fenwick Collection Catalogue, p. 115.

Inscribed on *recto*: *Barocco* (twice) and on verso: *Tadeo Zuccaro. 33.* The latter attribution was followed in the Fenwick Catalogue.
A design for a large altarpiece with an arched top. A sheet of studies for the same composition is in the Uffizi (cat. 75). This cannot be connected with any of TZ's known commissions, but a possible explanation of the subject is that it is St Philip Benizzi healing the demoniac girl: what can be made out of the habit of the saint in the drawing is compatible with that of the Servite Order, of which St Philip was the principal saint, and the healing of a demoniac woman was one of his most celebrated miracles. This suggests a possible connexion with the church of S. Marcello al Corso, the Roman headquarters of the Order. Taddeo was working there, in the Frangipani Chapel, at the time when the church was being restored and redecorated, and might well have been asked to make a design for the altarpiece of the chapel dedicated to St Philip. The present chapel of St Philip, the fifth on the left-hand side, adjoining the Frangipani Chapel, is decorated with scenes from his life by Bernardino Gagliardi (1609–1660).
The drawing of a tomb on the *verso*, mostly drawn with ruler and compasses, is TZ's only known excursion into the field of monumental architecture. This was clearly not his *forte*, for this design is noticeably clumsier and less elegant than his project for a small wall-tomb at Montpellier (cat. 131). It is a variation on the type of tomb established in Rome by Andrea Sansovino's Basso and Sforza monuments in S. Maria del Popolo and – significantly, in view of the possible purpose of the *recto* study – by Jacopo Sansovino's tomb of the Cardinal Sant'Angelo in S. Marcello. TZ has retained from these the continuous subsidiary cornice of the main storey, but has made the lateral sections of this storey as high as the arched central section. Above the subsidiary cornice in each lateral section is a square-headed niche containing a seated figure, and below it a somewhat higher arched niche with a standing figure. The centre section is enclosed by a pair of Corinthian columns instead of by pairs of superimposed pilasters as in the three Sansovino tombs. The whole is crowned by a heavy entablature which breaks forward above the centre section and supports standing figures on either side of a rectangular tablet. The tablet is surmounted by a pediment on the apex of which is an oval escutcheon supported by *putti*. Over this is drawn, freehand, an alternative for the uppermost storey: a larger pediment, as wide as the centre section of the entablature and resting directly upon it, with the escutcheon roughly indicated on top. The continuous order, the aedicule-like finial and the superimposed niches in the lateral sections also suggest knowledge of Peruzzi's tomb of Adrian VI in S. Maria dell'Anima.

[166]

107 —— 1946–7–13–627

Recto. A STANDING MAN LOOKING TO HIS LEFT Plate 93a
Verso. A STANDING MAN LEANING FORWARD WITH HIS HAND
OVER HIS EYES Plate 93b
Red chalk. 330:155 mm.
A. E. Popham, Fenwick Collection Catalogue, 1935, p. 84; Janet Cox Rearick, *The Drawings of Pontormo*, 1964, p. 395, no. A.209.

In the Fenwick Collection catalogue attributed to Pontormo, and on entering the Museum classified as 'anonymous Florentine'. Later placed with drawings by the Cavaliere d'Arpino, but in fact a characteristic example of TZ's red chalk style of the late 1550's. The combination of the gesture and the quasi-oriental costume of the *verso* figure suggests that this may be a study for the blinded sorcerer Elymas in the Frangipane Chapel fresco (Pl. 89); the *recto* figure could be St Paul in the same composition. See p. 80. Mrs Rearick includes the drawing in her list of rejected attributions.

—— 1946–7–13–1537. *See* p. 124, note 1

108 —— 1947–4–12–154

Recto. THE FOUNDATION OF ORBETELLO Plate 160
Verso. TWO FEMALE FIGURES SEATED ON A PEDIMENT: STUDY
FOR A *SOPRAPPORTA* Plate 158
Pen and brown wash. Stylus underdrawing on *verso*. The three separate studies for the right-hand figure on the *verso*, and part of the underdrawing of this figure in the study for the complete *soprapporta*, in red chalk. 271:424 mm.

Inscr. on *verso*, in the 'Lanière italic hand': *Tadeo Zuccaro*. The *recto* is an early sketch for the feigned tapestry which with its border occupies the width of the space between the two doors in the entrance wall of the Sala dei Fasti Farnesiani in the Palazzo Farnese in Rome (Pl. 167). Voss identifies the subject as 'The Entry of Charles V', but the fresco represents the foundation of the city of Orbetello by Pietro Farnese in A.D. 1100 (see *Enciclopedeia italiana*, s.v. 'Farnese'). The peninsula of Orbetello can be seen in the left background of the fresco. In front of it, in the middle distance, are two oxen approaching an altar inscribed, in another study for the composition in the Scholz Collection, New York (cat. 150, Pl. 161), with the words *COL[ONIA] VRBETELLI*.
In the fresco the composition is reversed so that Pietro Farnese advances with his retinue from the right-hand side, and is elaborated by the addition of groups of onlookers on either side of the foreground. Two intermediate stages in this evolution are preserved in the drawing in the Scholz Collection and another formerly in the Berlin Museum which I know from a photograph taken *c.* 1920 given me by Hermann Voss. The inventory number of the latter is not recorded, and the drawing cannot now be traced. Mr Scholz's drawing is in the same direction as the fresco. The figures in the foreground have not yet been added, but in general disposition the main group comes close to the fresco, for it is enlarged by the addition of two figures on foot leading the procession immediately in front of Pietro Farnese and a group of horsemen following him. The Berlin drawing resembles the final result except for the two standing men on the right of the group in the right foreground. In the fresco the right-hand figure stands with his back turned, extending his left arm so as to obscure all but the head and left hand of his

companion; in the drawing he leans on a spear facing the spectator, while his companion, who is moving to the left, turns back to address him. See p. 121.

The *verso* studies are for the *soprapporta* on the end wall of the Sala Regia, above the entrance to the Cappella Paolina (Pl. 159) for which TZ received an interim payment in December 1564. See p. 105. This rough sketch can be elucidated with the help of a carefully finished drawing in the Fogg Museum, Harvard (Mongan-Sachs, fig. 116; also repr. '*Pontormo to Greco*', Indianapolis, 1954, no. 40) which corresponds with it in every detail and is evidently a product of TZ's studio, perhaps by the hand responsible for the comparable drawing of the *Donation of Charlemagne* at Windsor (see cat. 104) which is likewise a fair copy in pen and wash of an intermediate design for another *soprapporta* in the same room. In the British Museum and Fogg drawings the figures are sitting directly on the pediment, symmetrically posed in almost identical attitudes, the main difference being in the placing of the right and left arms of the left and right-hand figures. The tablet in the centre is supported by *putti*, and on either side, behind the two seated figures, is an elaborate arrangement of weapons, shields, armour etc. grouped round trophies to which naked captives are manacled. In the fresco the composition has been simplified, no doubt for the reason which dictated the eventual simplification of the *Donation of Charlemagne* (see p. 105). The figures are no longer sitting right on the pediment, for it must have been realised that the projection of the latter would obscure them; they are larger in scale and are pushed further apart by the enlargement of the central tablet; their pose is less formalized and their draperies fuller and more elaborate; and while there are still trophies in the background these are less conspicuous, and the subsidiary *putti* and captives have disappeared altogether.

A version of the Fogg drawing is at Turin (16037; Bertini cat., no. 449, repr.). Another, inscribed in an old hand *Pellegrino Tibaldi Bolognese*, was lot 57 in Sothebys' sale of 25 March, 1965 (*Drawings of Five Centuries . . . presented by Peter Claas at the Alpine Gallery*, London, June, 1965, no. 68, Pl. x) and is now at Ann Arbor (1966.I 93).

109 ⸺ 1949-8-12-9

THE DEATH OF THE VIRGIN
Pen and brown wash, heightened with white, on brown-tinted paper. Squared in black chalk. 350:272 mm.
J. A. Gere, *B. Mag.*, cviii (1966), p. 289, note 7 (**repr.**).

Inscr.: *Taddeo Zucchero*. The drawing corresponds almost exactly – the only difference being in the head of the standing Apostle holding a book – with the fresco on the left-hand side-wall of the Pucci Chapel in S. Trinità dei Monti (*B. Mag.*, ut cit., p. 287, fig. 2), the decoration of which Taddeo agreed to complete for the Archbishop of Corfu by a contract dated 8 June, 1563. The chapel was not finally completed until 1589, but Vasari in 1568 describes this particular fresco as having been finished by TZ before his death. The British Museum drawing, which must be a preliminary study, has thus a strong claim to be accepted as by TZ himself, but the case has to be put in these negative terms for if the drawing is by him it shows his draughtsmanship in an unusually dull and laboured aspect. But see p. 124, note 1.

110 ⸺ 1952-1-21-73

BRENNUS THROWING HIS SWORD INTO THE SCALES Plate 16
Pen and brown wash. 232:208 mm.

J. A. Gere, *B. Mag.*, xcix (1957), p. 162

Inscr. on the old mount, in an XVIII-century hand: *Polidoro*. The attribution to TZ was first suggested by K. T. Parker's attribution to him of a drawing in the Ashmolean Museum (cat. 160. Pl. 13), likewise believed to be by Polidoro in the XVIII century. The style of both drawings is characteristic of TZ's earliest, Polidoresque phase, and both are probably studies for façade-decorations. See p. 38.

—— **1969–10–11–1.** *See cat. 240*

III **London, Courtauld Institute, Witt Collection 2704** (as Schidone)

THE VIRGIN AND CHILD WITH ST ELIZABETH AND THE INFANT BAPTIST
Pen and brown wash. 258:205 mm.

Independently attributed to TZ by A. E. Popham and Philip Pouncey.

112 **London, Victoria and Albert Museum C.A.I. 257** (as 'Anonymous Italian')

WOMEN AND CHILDREN WITH WINE-JARS, VASES, ETC.
Pen and brown wash. Some outlines indented. Much rubbed and faded. 273:434 mm.
W. Y. Ottley, *The Italian School of Design*, 1823, p. 57, with facsimile engraving by F. Lewis (Weigel 6058); perhaps no. 46 in The Lawrence Gallery, 7th Exhibition [Polidoro], 1836; J. A. Gere, *B. Mag.*, cvii (1965), p. 201.

The drawing is so ruined that it is more easily studied in Lewis's admirable facsimile engraving in the *Italian School of Design* (**repr. B. Mag., ut cit., p. 204, fig. 47**). Attributed by Ottley to Polidoro da Caravaggio, and in the handlist of the Ionides Bequest (1904) described as 'Anonymous Italian, XVII Century'. A characteristic example of TZ's early Polidoresque manner. Ottley suggests that it was part of a design for a façade decoration. See p. 39.

113 —— **D. 758–1886** (as Parmigianino)

TWO SECTIONS OF A FRIEZE
Pen and brown wash, with traces of underdrawing in black chalk. Somewhat damaged by spotting. 218:311 mm. (corners cut).

Recognized by Philip Pouncey as an early drawing by TZ.
The upper frieze is bounded on the left by a trophy of a helmet and breastplate on a square base, between two Caryatid *putti*. The rest of the frieze consists of sea-monsters, some blowing conches while others drag along a naked woman (Galatea?) and a winged *putto* on a shell. The lower frieze is part of a sacrificial procession, consisting of women with baskets of fruit on their heads and men and children leading a goat and an ox.

114 —— **8091–1**

BRIZIO
Pen and brown wash, heightened with white. 205 mm. diameter.
See cat. 115.

115 —— **8091–2**

HARPOCRATES
Pen and brown wash, heightened with white. 205 mm. diameter.

Cat. 114 and 115 were attributed by Sebastiano Resta (nos. *h. 37* and *h. 36* in the MS inventory of the collection formed by him and bought by Lord Somers: see Lugt 2981 and *Suppl.*) to TZ and correctly connected with the frescoes in the Stanza di Aurora at Caprarola. They seem, in fact, to be by Federico. For their subject-matter (Brizio 'Dea de'Vaticinj' and Harpocrates 'Dio del Silenzio') see Annibale Caro's letter of 21 November 1562 dictating the iconographic scheme for the room (Vasari, vii, pp. 126 ff).

116 London, Lord Brooke

THE INFANT BACCHUS KILLED BY THE TITANS AND RESTORED TO LIFE BY RHEA
Plate 132

Pen and brown wash. 255:225 mm. (diameter of circle enclosing the composition, 285 mm.)

Inscr. in ink: *Zuccaro*, interpreted by John Skippe as TZ, but by A. E. Popham (Skippe Sale Catalogue, Christie's, 21.xi.1958, lot 232ª) as more probably indicating Federico. Skippe was no doubt right, for the drawing is a careful study for one of the circular compositions of the story of Bacchus in the Camerino di Autunno on the ground floor of Caprarola (Pl. 133). See pp. 109 f.

117 London, Mr H. M. Calmann

THE AGONY IN THE GARDEN

Pen and brown wash over black chalk. Irregularly cut on top and made up. 225:192 mm. (including made-up portion).
J. A. Gere, *B. Mag.*, cv (1963). p. 393 (**repr.**).

Attributed by the writer to TZ and identified as a study for a small panel, previously attributed at various times to Correggio, Lotto and Orsi, in the Strossmayer Gallery in Zagreb (Pl. 67; see *B. Mag.*, ut cit.). A study by TZ for the group of sleeping Disciples in the right foreground of this composition is at Windsor (cat. 259. Pl. 68) and another study by him for the whole composition is at Montpellier (cat. 132).
Three other drawings, none of them by TZ but all independent versions of the composition, differing from it and from one another, perhaps represent some form of exercise by TZ's pupils (see *B. Mag.*, ut cit.). A fourth, in the Hermitage (4820; Dobroklonsky cat., no. 177, pl. xxxvii), seems, like the one in the Albertina (1513) repr. *B. Mag.*, p. 392, fig. 12, to be by TZ's close follower Niccolò Trometta (see *Master Drawings*, i (1963), no. 4, pp. 15 and 18).

118 ──

TWO HALBERDIERS OR STANDARD-BEARERS

Black chalk. 169:125 mm.

Previously unattributed. The convincing suggestion of TZ is due to Philip Pouncey. The spindly elongation of the legs and the suggestion of the weight and mass of the body of the left-hand figure are both characteristic. Similar figures occur in some of the frescoes at Caprarola (cf. for example those in the study in the Scholz Collection for *Paul III creating Pierluigi Farnese Captain-General of the Church*, cat. 149 *verso*, pl. 146).

119 London, Mr J. A. Gere

DESIGN FOR PART OF A FRIEZE, WITH A PROCESSION OF
SOLDIERS CARRYING A MODEL OF A CITY Plate 2

Pen and brown wash, heightened with white, on faded blue paper. 159:275 mm.
Lawrence Gallery, 7th Exhibition [Polidoro], 1836, no. 38.

Attributed to Polidoro in the Lawrence Gallery Catalogue, and to Federico Zuccaro in
Sotheby's sale of 12.iii.1963 (lot 23). The drawing is certainly by TZ and belongs to his
early Polidoresque group of frieze-designs. It may be connected with the decoration
of the Palazzo Mattei. See p. 37.

120 ——

JOSEPH AND POTIPHAR'S WIFE Plate 34

Pen and brown wash. The outlines traced through with the stylus and the *verso*
blackened for transfer. In some places (e.g. the woman's foot) the drawing is in stylus
only. The horizontal strokes close to the right-hand edge are studies of legs drawn in
pen on the *verso*, and showing through the paper. 178:140 mm.

This drawing corresponds, in reverse and with some differences of detail, with an
etching by Bartolommeo Passarotti (B. xviii, p. 2, no. 1). In the etching the woman is
not bare-headed but wears a close-fitting headdress, the arrangement of the drapery
on the bed is more elaborate. Joseph wears a kind of loose kilt tied with a sash round the
lower part of his body; and while in the drawing he seems to be sitting in a not very
well realised pose on the very edge of the bed, in the etching he is standing, as if poised
to run, with his weight on his left foot (right foot in the drawing) and with his other leg
stretched out behind him with only the toe touching the ground.
Bartsch attributes the composition to Parmigianino; but this drawing, which in its
very incoherence has all the marks of a preparatory study in which the artist is still
groping his way towards the final solution, is stylistically inseparable from the rest of
the early TZ group.
A related drawing, showing only the two figures on the same scale and in the same
direction, was exhibited under its old attribution to Parmigianino in the exhibition *Italian
Art and Britain* at Burlington House in 1960 (no. 477). This more carefully worked out study,
in pen and wash heightened with white on blue paper, comes between the drawing here
reproduced and the final version as etched by Passarotti: the woman's drapery is as in the
first drawing, and she is still bare-headed, but Joseph's stance and costume are as in the
etching. In my opinion, this intermediate study is stylistically inseparable from the group
of early drawings by TZ. It finds its closest analogy with the drawing of three standing
figures in the Ashmolean Museum (cat. 160. Pl. 13), in which, significantly, Parker
noted the distant influence of Parmigianino: in both there is the same elegant convention
for indicating legs and feet, the same loose hatching with widely spaced strokes of white
bodycolour, the same sharp folds of drapery with the light catching their edges, and the
same curly heads. A. E. Popham, who was responsible for cataloguing the section of
drawings in the Burlington House exhibition and thus for endorsing the attribution to
Parmigianino, permits me to say that after careful reconsideration he now regards
Parmigianino's authorship as out of the question and is in full agreement with the
attribution to TZ. Unfortunately it has not been possible to illustrate this beautiful, and
unpublished, drawing in the present volume.

[171]

The related drawing is inscribed *Parmesan* in an XVIII-century hand and was so attributed in the Lawrence Collection (Lawrence Gallery, 4th exhibition, 1836, no. 10) and in various subsequent sales. The attribution no doubt derives from the inscription *F. parmensie f.* on a second etching of the composition, of the type of those made in about 1636 by Lucas Vorsterman and Hendrik van der Borcht after drawings in the Arundel Collection and thus datable about 100 years after Parmigianino's death. It has been assumed that the second drawing was the original of this etching and that it must therefore have belonged to Lord Arundel; and since Lord Arundel is known to have had access to a particularly good source of genuine drawings by Parmigianino, the 'argument from provenance' has been put forward in support of the traditional attribution. But comparison of the four versions of the composition shows that the 'Vorsterman-van der Borcht' etching was not based on either of the drawings but that it corresponds with Passarotti's etching in every particular, including those details of the woman's headdress and drapery in which this etching differs from both drawings. It might still be argued that Lord Arundel's group of Parmigianino drawings included the lost final version which was used by Passarotti, were it not that the 'Vorsterman-van der Borcht' etching is in the same direction as the two drawings and in reverse to the Passarotti etching. The final version would presumably have been in the same direction as the preliminary studies, and since the 'Vorsterman-van der Borcht' etched copies are invariably in reverse to the original drawings, it would seem likely that the second etching was either made directly from Passarotti's etching or from a drawing after it. Neither source need be taken seriously in support of the attribution to Parmigianino. See p. 50.

121 ——

DESIGN FOR THE SIDE-WALL AND ALTAR-WALL OF A CHAPEL WITH *THE ADORATION OF THE MAGI, THE ADORATION OF THE SHEPHERDS* AND *THE RESURRECTION* **Plate 43**
Pen and brown wash. 276:403 mm.

Inscr.: *Lorenzetto da Bologna* (i.e. Lorenzo Sabbatini) and so attributed in Sotheby's sale of 27.ii.1963 (lot 1) and in Messrs. Colnaghi's exhibition of old master drawings in the following July (no. 12). In the exhibition-catalogue James Byam Shaw observed that the drawing showed the influence of TZ. In fact, it is a preliminary design by TZ himself for the decoration of the Mattei Chapel. See p. 62.

122 London, Dr Pietro del Giudice

THE CONVERSION OF ST PAUL
Pen and brown wash, heightened with white. The outlines indented. 306:394 mm.

In the Skippe Collection ascribed to Bertoja, but A. E. Popham pointed out in the catalogue of the sale (Christie's, 21.xi.1958, lot 234) that it corresponds with the lower part of the altarpiece in the Frangipani Chapel (Pl. 104). See pp. 82 f.
The correspondence is very close, the principal differences being in such small details as the angle at which the figure in the left foreground holds his weapon and the position of his left hand. Though the drawing has none of the marks of a preliminary study, it seems intelligent and vigorous enough to be by TZ himself. Popham suggested that it might have been made in connexion with the small version of the painting in the Doria Gallery (Pl. 104).

123 London, Dr Alfred Scharf (formerly)

Recto. STUDIES OF A GROUP OF APOSTLES ROUND A
SARCOPHAGUS
Verso. A GROUP OF ANGELS ON CLOUDS
Pen and wash. Measurements unknown.
J. A. Gere, *B. Mag.*, cviii (1966), p. 290 (***recto* repr.**), p. 342 (***verso* repr.**).

Inscr. on *recto*: *Federico Zuccaro*, with a sketch of Federico's device of a sugar-loaf
('*zucchero*') stuck with lilies; but to judge from a photograph, the drawing is more
likely to be by TZ. The *recto* is a study for the lower part of the *Assumption of the Virgin*
in the Pucci Chapel in S. Trinità dei Monti; the *verso*, for the upper part of the
altarpiece of the *Virgin and Child adored by St Lawrence and St Damasus* intended for S.
Lorenzo in Damaso. TZ was working on both commissions at the very end of his life,
and they were completed after his death by Federico. See p. 125 and *B. Mag.* ut cit.
Another sheet with studies for them both is in the Uffizi (cat. 52, one side repr. pl. 175).
This drawing was in the possession of the late Dr Scharf in about 1940 and is said to have
come from an album formerly in the Borghese and Holland-Hibbert Collections.

124 London, Count Antoine Seilern

Recto. TWO *PUTTI* ON CLOUDS, IN THE RIGHT-HAND SIDE OF
A LUNETTE **Plate 99b**
Verso. STUDIES FOR THE DECORATION OF A LUNETTE
 Plate 99c
Red chalk (*recto*); pen and wash and red chalk (*verso*). 270:152 mm.

Inscr. on *verso*: *Tad° Zuccaro 1–3* (i.e. 5/–, a method of pricing used by the XVII-
century collector William Gibson, d. 1703: cf. Lugt 2885 and *Supplement*). The draw-
ings on both sides are studies for the decoration of the lunette above the altarpiece in the
Frangipani Chapel (Pl. 98). On the verso are six sketches for the right-hand side and
one for the left-hand side. Some of these, as well as the two large figures in red chalk on
the *verso* and the putti on the *recto*, are close to the final solution, but one of the small
sketches looks like the *Conversion of St Paul* (ultimately the subject of the altarpiece)
while others seem to represent the *Agony in the Garden*.
Count Seilern pointed out to me that a drawing in black and red chalk related to the
recto study is in the Uffizi (11144^F, as Federico Zuccaro; Gernsheim 11403). It is not by
TZ himself, but is either an old copy or a studio product.

124* London, Mr Roderic Thesiger
AN ANGEL SITTING ON A CLOUD
Pen and brown wash, heightened with white, over black chalk on blue paper. 173:120
mm. (including two strips of paper about 10 mm. wide added on either side).
Inscr.: *cher albert* (i.e. Cherubino Alberti). Attributed to TZ by James Byam Shaw.

Lulworth, Colonel Joseph Weld. *See* cat. 254

125 Maidenhead, Mr John Carter Jonas

A SIBYL IN THE RIGHT-HAND SIDE OF A LUNETTE **Plate 63**
Pen and brown wash, heightened with white, on blue paper. 192:162 mm.

Inscr. in pencil, in handwriting like that found on drawings which passed through the hands of Samuel Woodburn (d. 1853): *Zucchero*. Recognized as TZ by James Byam Shaw, who kindly brought it to my attention. A study for the sibyl on the right of the lunette on the altar-wall of the Mattei Chapel in S. Maria della Consolazione (see p. 64).

126 Malvern, Mrs Rayner–Wood (formerly)

A STANDING PROPHET
Pen and brown wash, heightened with white, on brown paper. 410:176 mm.

As Lorenzo Costa in the Skippe Collection. The attribution to TZ, first put forward by A. E. Popham in the Skippe Sale Catalogue (Christie's, 21.xi.1958, lot 235a), is confirmed by the correspondence between the drawing and the Prophet on the right-hand entrance-pilaster of the Frangipani Chapel (Pl. 107a). Close though the correspondence is, the relationship of the drawing to the fresco does not seem to be that of a copy, and in handling, though somewhat disappointing when compared with the study of a similar figure at Angers (cat. 2. Pl. 106a), it comes very close to TZ.

127 Milan, Biblioteca Ambrosiana Cod. F. 255 inf. no. 2013 (as Anonymous XVII-century)

CHRIST ON THE CROSS **Plate 45**
Black chalk. The sheet badly stained. 318:223 mm.

In style and handling this drawing is close to the chalk studies for the Mattei Chapel in Mrs Krautheimer's collection (cat. 146. Pl. 47) and in the Rosenbach Foundation (cat. 211 *verso*. Pl. 46). It may be a study for the figure in the altarpiece of the chapel.

128 ——Cod. F. 261 inf., no. 127

FRIEZE WITH A PROCESSION OF ROMAN SOLDIERS **Plate 4**
Pen and brown wash, heightened with white. 216:576 mm.

Inscr. by Sebastiano Resta: *Taddeo Zuccaro figlio d'Ottaviano nell'istoria di Furio Camillo a Mattei. Va per bocca di Pittori non volgari, che Mich. Ang° Buonaroto prendesse apprensione dal valore di Taddeo, che vidde spiccare in questa opera, che fu tra le sue p[rim]e. Ma che quando vidde Taddeo cingere spada con piuma bizzarra al Cappello, disse ridendo: Da che Taddeo cinge spada non mi fa più d'i suoi pennelli.* This drawing is in the Resta Codex, but was not included in the selection of 100 drawings from the Codex published in facsimile in 1955. See pp. 35 f.

129 Milan, Castello Sforzesco, Raccolta Achille Berterelli, C. 945

A SEATED NUDE YOUTH **Plate 96**
Black chalk, with touches of red chalk on the face, on blue paper. Squared in black chalk. 300:248 mm.

Attributed to TZ and correctly identified as a study for the angel on the left of the upper part of the *Conversion of St Paul* in the Frangipani Chapel (Pl. 104). See p. 82.

130 Minneapolis, Mr Norman Canedy

A BEARDED MAN STANDING WITH HIS BACK TURNED, HOLDING A STAFF IN HIS OUTSTRETCHED RIGHT HAND

Pen and brown wash over black chalk. Cut to an irregular shape. 325 mm. high.

Attributed to TZ by Philip Pouncey when on the London art-market. In an old pen and wash copy of this figure which was part of lot 1 in Sotheby's sale of 9 July 1968, the right hand is held open and what might be the upper part of a crooked staff is indicated behind the left shoulder.

131 **Montpellier, Musée Fabre 837–1–239** (as Camillo Procaccini)

DESIGN FOR AN ECCLESIASTIC'S WALL-TOMB
Pen and brown wash. 245:170 mm.
Gernsheim 5837.

Inscr. on *recto*: *Camillo Procaccino*. The monument is in the form of a sarcophagus protruding from the wall, on which sit two female figures each with one elbow supported on an urn which stands on the sarcophagus. Behind them is a round-headed niche, in the upper part of which is an ecclesiastical hat with two tassels.
I only know the drawing from a photograph; and while the design seems undoubtedly to be TZ's, it is impossible, without seeing the original, to be certain whether this is from his own hand or is merely a faithful old copy.

132 —— **864–2–616** (as Luca Cambiaso)

THE AGONY IN THE GARDEN
Pen and brown wash over black chalk. 320:250 mm.

Michael Hirst kindly told me of this drawing, pointing out that it must form part of the series connected with the painting in the Strossmayer Gallery in Zagreb (Pl. 67). See cat. 117.

Munich, Staatliche Graphische Sammlung 2262. *See* cat. 229.

133 —— **2525** (as Anonymous Italian)

CAESAR DEFEATING THE SWISS ON THE ARAR
Pen and brown wash. Somewhat damaged. 354 mm. diameter.
J. A. Gere, *B. Mag.*, cv (1963), p. 313.

Inscr.: *Cesare abbatte svizzari alla sona* and on *verso*: *Pierino del Vago*. The former inscription is in the same handwriting as the similarly worded one on a drawing at Stockholm (cat. 225), likewise circular in composition, which identifies its subject as another episode from Caesar's campaign against the Helvetii. His battle with them on the Arar (Saône) is described in *De Bello Gallico*, i, 12.
A red chalk drawing of the composition, also by TZ, is in the Uffizi (cat. 79). These two drawings, like the drawing at Stockholm and the more carefully finished version of it at Holkham (cat. 87) are designs for the service of maiolica decorated with episodes from the history of Julius Caesar, presented to Philip II of Spain by the Duke of Urbino. See p. 93.

—— **8635.** *See* cat. 181

134 —— **37815** (as Beccafumi)

A PROPHET STANDING IN A SQUARE-HEADED NICHE, HOLDING A BOOK
Pen and brown wash. 356:135 mm.

A study for the figure on the left-hand entrance-pilaster of the Frangipani Chapel in S. Marcello al Corso (Pl. 107b). A copy in the Metropolitan Museum (57–32–2) was attributed by Sebastiano Resta (*k. 180* in the MS inventory of the collection of drawings formed by him and bought by Lord Somers: see Lugt *Suppl.* 2981) to Beccafumi. It later belonged to William Roscoe (lot 92 in his sale, Liverpool, 23. ix. 1816) who defended the attribution to Beccafumi in an inscription on the back: *Vasari mentions two Apostles engraved in chiaroscuro by Domenico Beccafumi, one of which was in his own collection. Bottari assures us that there are at least six, and perhaps on the whole twelve. Giunti, Vasari, 2, 56. I have two of the prints which were in Mr Barnard's Coll*ⁿ. *This drawing is the design for a third, but I have never seen an engraving of it. W.R.*
The same figure, transformed into a Sibyl by the removal of the beard, appears in the chapel of the Villa d'Este at Tivoli, decorated on Federico Zuccaro's designs in 1572 see p. 80, note 1).

135 **Munich, Herr Herbert List**

THE MARRIAGE OF ALEXANDER AND ROXANA
Pen and brown wash. Somewhat creased and rubbed. 274:403 mm.
Engraved in facsimile in reverse by C. M. Metz when in the collection of E. Knight (Weigel 7057).

The attribution to Raphael under which the drawing was engraved by Metz can be explained by the fact that this is a variant of a well-known composition by him. A. E. Popham's suggestion, made apropos of a version of the Raphael composition at Windsor (Popham-Wilde, no. 809), that the original of the Metz engraving was an adaptation by TZ, is confirmed by the fact that the drawing is a study for one of the frescoes in the Palazzo Caetani (Pl. 126b). See p. 96. The central group of Alexander and Roxana and their immediate attendants is the same in both, but the groups of *putti* to either side are different.
Another version of the Raphael composition is the fresco by Sodoma in the Farnesina. Sodoma's Farnesina frescoes seem certainly to have influenced the young TZ (see pp. 52f.), but the present drawing is derived from the Raphael composition and not from Sodoma's derivation from it. A copy is in the Uffizi (1205ˢ, as Cherubino Alberti).

136* ——

ALEXANDER CUTTING THE GORDIAN KNOT Plate 128a
Pen and brown ink and brown and red wash. 224:396 (size of whole sheet: size of oval composition 215:385).
Formerly attributed to Perino del Vaga. Identified by Philip Pouncey as a study for the fresco in the Palazzo Caetani (Pl. 128b). See p. 97/1.

137 **Naples, Museo di Capodimonte, Gabinetto Stampe e Disegni 139**

DESIGN FOR A CEILING
Pen and brown wash, with some red chalk. 410:271 mm.

Inscr. on *verso*: *Io l'hebbi con certe cose di Gio. de Vecchi venute da Ancona il dì dell'entrata*

in Roma di Card. Millini. Questo è disegno che Taddeo Zuccaro diede per li ripartim[en]ti del Palazzo di Caprarola all'Antinoro Pittor de ripartim[en]ti . . . Nota che Taddeo teneva vuoto le molte pitture in quell opera.

A design with alternatives and showing only two of the three longitudinal sections, for an oblong ceiling with blank spaces for paintings surrounded by an elaborate framework of grotesque-decoration and *stucchi*. The space in the centre of the ceiling is oval and there is an oblong space of the same height on either side. These three spaces are common to both alternatives. One alternative involves five paintings arranged in the form of a cross, those at either end of the ceiling being higher than wide, their width being that of the centre oval, and having their upper corners cut away to allow for the placing of large ornamental bosses at the intersection of the ribs enclosing the centre oval. The spaces in the four corners of the ceiling are occupied by square panels with the arms (presumably to be executed in stucco) of a Farnese Cardinal. In the second alternative, all three spaces at either end of the ceiling contain paintings, oblong in shape and with their long sides parallel with the end of the ceiling.

It is only the inscription that makes it necessary to take this drawing seriously as a possible original by TZ. Nothing else at all comparable by him is known; in handling and general appearance it resembles the group of grotesque-designs at Windsor and elsewhere which are attributable to the studio of Perino del Vaga, and may likewise be the work of some specialist in grotesque decoration in TZ's studio. 'Antinoro' was the author of a design for the stucco surround of the ceiling of the chapel at Caprarola which he sent to Federico Zuccaro with a letter dated 20 September 1566, now in the Rosenbach Foundation, Philadelphia (472/22, no. 34b).

If this drawing was made for Caprarola – as seems very likely in view of the inscription and the heraldry as well as the general taste of the design – then the almost square proportion of the whole design suggests that it was designed for the Anticamera del Concilio. There is, however, no resemblance between it and the ceiling of this room as executed.

138 Newcastle upon Tyne, Mr Ralph Holland

THE FEEDING OF THE FIVE THOUSAND
Pen and brown wash over black chalk. 275:184 mm.

Inscr.: *H. Goltzio.*

An upright composition on two levels, with Christ and the Disciples on the summit of a hill, top right. He is seated in a pose similar, but in reverse, to that of the Procurator in the Frangipani Chapel *Blinding of Elymas*, and is blessing a basket of loaves held by one of the Disciples. The crowd is mostly on the left-hand side of the composition, grouped round the foot of the hill. The heads of the figures in the centre are visible over the top of another rise in the ground which forms the immediate foreground, on the left-hand side of which is the conspicuous seated figure of an almost nude man turning towards Christ.

Philip Pouncey's suggestion that this is a copy of a drawing by TZ is borne out by the inscription *Taddeo Zuccarus inventor* on an engraving of a close variant, in the opposite direction but otherwise agreeing in essentials, formerly attributed to Cort, but according to Bierens de Haan by Aliprando Caprioli (BdH, p. 79). Copies of the engraved composition are at Edinburgh (RSA 183: repr. K. Andrews, *National Gallery of Scotland: Catalogue of Italian Drawings*, Cambridge, 1968) and in the Uffizi (7686S, as Muziano).

M [177] G.T.Z.

A weak variant, with an arched top and with the foreground occupied by large half-length figures of St Paul and a Pope, is in the Louvre (5123, as Muziano).

139 New York, Cooper–Hewitt Museum 1901–39–108 (as 'Anonymous Italian')

TWO ANGELS Plate 80
Black chalk on blue paper. 241;383 mm.

The positions of both figures, and the indication of curving lines below the one at the top of the sheet, suggest that these are designs for the decoration of a left and right-hand spandrel. The style suggests a fairly early date, not much later than the mid-1550's.

140 —— 1938–88–4496 (as 'Anonymous Italian')

A SOLDIER RUNNING Plate 54
Pen and brown wash, heightened with white, on faded blue paper. Holes in the middle of the sheet, and other damage. 369:215 mm.

A study for the figure in the left foreground of the *Betrayal of Christ* in the Mattei Chapel (Pl. 57). See p. 63.

141 New York, Metropolitan Museum 56.219.3

Recto and *verso*. STUDIES FOR A CIRCULAR COMPOSITION OF
DIANA AND HER NYMPHS BATHING **Plate 121 (*recto*)**
Pen and brown wash. 273 : 203 mm.
Drawings from New York Collections I: The Italian Renaissance, 1965, no. 134 (**verso repr.**).

Inscr. on *recto* in black chalk: *École Italienne, 16ᵉ siècle* and classified as 'Anonymous Italian' until TZ's authorship was recognized by Jacob Bean. It is possible, however, that this drawing is one attributed to TZ when in the Ottley and Lawrence Collections at the beginning of the XIX century (see New York Exhibition catalogue and p. 201).
The subject is established by the dog which forms part of the rough sketch for the central group in the lower right-hand corner of the *recto*. The final form of the composition is preserved in a large *modello* in the Louvre, traditionally attributed to Orazio Sammacchini (cat. 187), which corresponds closely with the *recto* study. The main differences are that the group in the left foreground, to which a third standing figure has been added, is partly cut by the circumference of the circle and is balanced in the right foreground by a seated women with a child. The central group of Diana and her attendants, enlarged by a figure standing behind and to the right holding up a towel, is posed round the base of a fountain the upper part of which is composed of four *putti* (only three of them visible) supporting a shallow basin into which water spouts from the mouths of a cluster of children's heads.
A drawing for the group in the right background is in the Perman Collection, Stockholm (cat. 232). A sheet of studies in red chalk of a seated woman drying herself with a towel, in the Louvre (cat. 205. Pl. 168), may also be connected with this composition. The style of these and of the New York drawing itself suggests a late dating, not much before 1560.
The purpose of this composition is unknown. Though the shape suggests maiolica, for which TZ was making designs in the early 1560's, the only recorded series of maiolica designs represented episodes from the life of Julius Caesar. In style the Louvre *modello*

[178]

is not inconsistent with the traditional attribution to Sammacchini, who must have been in contact with TZ when both were working in the Sala Regia from 1563/4 onwards.

—— **57–32–2.** *See* cat. 134

142 —— **67.188**

THE RAISING OF EUTYCHUS **Plate 84**
Pen and brown wash, heightened with white, on blue paper. 336:460 mm.

Identified by the writer, when in a Swedish private collection, as a study by TZ for the fresco on the vault of the Frangipani Chapel in S. Marcello (Pl. 85). See pp. 74 ff.
A copy is in the Fitzwilliam Museum, Cambridge (3115).

143 —— **68.113**

Recto. A STANDING NUDE MAN **Plate 12**
Verso. THREE STUDIES OF SOLDIERS **Plate 14**
Red chalk, with some white heightening. 422:285 mm.

Inscr. on *verso*: *Maturino*. The old attribution to this shadowy assistant of Polidoro da Caravaggio, who is known only from references in literature, was repeated in the catalogue of Sotheby's sale, 11.iii.1964 (141). It underlines the drawing's Polidoresque character, but TZ's authorship, initially suggested by the scribbly handling of the *verso* and by the facial type and the indication of the right arm of the right-hand figure, was confirmed by the subsequent observation that the *recto* figure, though on a scale and of a degree of finish almost unparalleled among TZ's known drawings of this period, is a study for the soldier holding the bridle of the horse in the centre of the Polidoresque composition-study belonging to Mr David Rust (cat. 250. Pl. 9).

—— **80.3.4.** *See* cat. 229

New York, Pierpont Morgan Library I.23. *See* cat. 208

144 ——**IV. 71B**

ST PETER
Pen and brown wash, heightened with white, on pale brown paper. 252:139 mm.

Inscr. on old mount: *inconnu*. Classified as 'Anonymous Venetian' until placed, at the writer's suggestion, with TZ. The drawing corresponds, in reverse and with a different position for one of the arms, with an etching by Bartolommeo Passarotti (B. xviii, p. 5, 7). See p. 50.

145 New York, Mrs Richard Krautheimer

A GROUP OF ANGELS **Plate 81**
Pen and brown wash over black chalk, heightened with white, on blue paper. 220:283 mm.
Drawings from New York Collections I: The Italian Renaissance, 1965, no. 133; J. A. Gere, *B. Mag.*, cviii (1966), p. 418.

The attribution to TZ, first suggested by the writer, was confirmed by the subsequent observation that this is a study for the upper part of the composition of *The Angel*

warning St Joseph to fly into Egypt of which there is a drawing at Hamburg (cat. 86. Pl. 78). See also cat. 11 and 61.

146 ——

Recto. THE SWOONING VIRGIN, SUPPORTED BY ONE OF THE HOLY WOMEN; SEPARATE STUDIES OF THE VIRGIN'S HANDS AND OF HER HEAD **Plate 47**
Verso. DRAPERY OF A STANDING FIGURE LEANING OVER TO THE LEFT
Black chalk (*recto*); red chalk (*verso*). 170:248 mm.

Inscr. on *verso*, by Federico: *schizo de mano de Tadeo . . . uento.* The *recto* studies are for the fresco of the *Crucified Christ with the Virgin and the Holy Women* above the altar in the Mattei Chapel in S. Maria della Consolazione (Pl. 75) .The study on the *verso* is for a figure in the right background of the *Washing of the Feet* on the vault of the chapel (Pl. 70). See p. 65.

147 New York, Mr Robert Lehman

THE MARTYRDOM OF ST PAUL **Plate 82**
Pen and brown wash, heightened with white. 485:376 mm.
Drawings from New York Collections I: the Italian Renaissance, 1965, no. 135.

A study for the fresco in the centre of the vault of the Frangipani Chapel in S. Marcello al Corso (Pl. 83). See pp. 74 f. Copies are in the British Museum (5211–50 and 5237–128) and the Louvre (11558).

148 New York, Mr Janos Scholz

A GROUP OF WOMEN ADVANCING TOWARDS A MOUND ON WHICH STANDS A SMALL IMAGE OF A COW
Pen and brown wash. 268:388 mm.

Exh. Indianapolis, 1954, '*Pontormo to Greco*', no. 21 (**repr.**).
As Naldini in the catalogue of the Indianapolis exhibition. TZ's authorship was recognised by Philip Pouncey. The subject is obscure. In the Indianapolis exhibition it was described as a scene from the story of Judith of Bethulia, but E. Panofsky (orally) doubted this interpretation and suggested that the drawing might represent Iphigenia saved from being sacrificed by the miraculous substitution of an animal which, according to one version of the legend, was a heifer.

149 ——

Recto. JULIUS III RESTORING THE DUCHY OF PARMA TO OTTAVIO FARNESE **Plate 148**
Verso. THE MARRIAGE OF ORAZIO FARNESE AND DIANE DE VALOIS; PAUL III CREATING PIERLUIGI FARNESE CAPTAIN-GENERAL OF THE CHURCH

Plate 146 (detail)
Pen and brown wash over stylus underdrawing. Some red chalk underdrawing on *verso*. 354:556 mm.
Drawings from New York Collections I: The Italian Renaissance, 1965, no. 136.

[180]

All three studies on the sheet are for frescoes in the Sala dei Fatti Farnesiani at Caprarola. The two large ones on the *verso* correspond in essentials with the paintings, but the composition on the *recto* differs in being larger and more elaborate. The figures in the fresco are relatively larger in scale, and the composition has been reduced by the omission of the group of standing figures on the extreme left, so that it is now enclosed on either side by the candelabra in the immediate foreground. The seated onlookers on the left and the principal figures on the dais are run together to form one continuous group and the altar which appears beside the window in the drawing has disappeared altogether.

That the composition was envisaged in this larger form until a late stage is shown by the squared *modello* in the Louvre (cat. 208) which belongs to the same group as those in the Uffizi and elsewhere (see p. 112) and which corresponds not with the fresco as executed but with Mr Scholz's sketch. A sheet of studies for the mace-bearer in the eventually omitted left-hand group and for details of the balustrade, etc. is in the Uffizi (cat. 40).

150 ——

THE FOUNDATION OF ORBETELLO Plate 161
Pen and brown wash. Squared in black chalk. 264:391 mm.
Exh. Indianopolis, 1954, '*Pontormo to Greco*', no. 41; Hamburg, 1963, '*Italienische Meisterzeichnungeu . . . Die Sammlung Janos Scholz, New York*', no. 179.

A study for the fresco in the Palazzo Farnese, Rome (Pl. 167), See cat. 108 and p. 121.).

151 ——

A GROUP OF FIGURES Plate 164
Pen and brown wash. Squared in red chalk. 221:161 mm.

A study for the group in the left foreground of the *Foundation of Orbetello* in the Sala dei Fasti Farnesiani in the Palazzo Farnese in Rome (Pl. 167). See pp. 121 f.

152 ——

Recto. THE BAPTIST PREACHING Plate 165
Verso. A KNEELING DRAPED FIGURE
Pen and brown wash, heightened with white on blue paper (*recto*); black chalk (*verso*). 337:235 mm.
Exh. Indianapolis, 1954, '*Pontormo to Greco*', no. 42 (**verso** repr.); Hamburg, 1963, '*Italienische Meisterzeichnungen . . . Die Sammlung Janos Scholz, New York*', no. 180 (**verso** repr.).

Inscr. in a cartouche on the old mount: *TADDEO ZUCHERO DA S. AGNOLO. PITTORE*. The wording and appearance of the inscription suggest that this sheet may have formed part of Vasari's *Libro*. If so, the *recto* drawing provides a useful criterion for applying to a certain type of finished, late, drawing which sometimes hangs in the balance between TZ and Federico. The Indianapolis catalogue points out that the *verso* study anticipates the work of later draughtsmen like Francesco Vanni.

Ottawa, National Gallery of Canada 6319 (Popham–Fenwick, no. 41). *See* cat. 20

153 ——— 6896

ALLEGORICAL FIGURE OF 'TEMPERANCE'

Pen and brown wash, heightened with white, on blue-grey paper. 226:101 mm.
A. E. Popham and K. M. Fenwick, *European Drawings in the Collection of the National Gallery of Canada*, 1965, no. 40 (**repr.**).

Inscr.: *Barocj*. The attribution to TZ is due to A. E. Popham. An old copy is at Windsor (4788; Popham–Wilde, no. 754 as 'attributed to Giuseppe Porta' following H. Tietze and E. Tietze-Conrat, *The Drawings of the Venetian Painters*, no. 1396; repr. *Arte Veneta*, xvii (1963), p. 164).

154 ——— 15,276

CHRIST SHOWN TO THE PEOPLE ('*ECCE HOMO*')

Pen and brown wash over black chalk. 277:369 mm.

Inscr.: *Piren del Vago*. The drawing corresponds with the fresco on the right-hand side-wall of the Mattei Chapel (Pl. 72) except that the two half-length figures to right of centre in the immediate foreground are absent, the man reclining in the extreme right foreground holds his arm at a different angle, and his counterpart on the left is not a youth but a bearded man whose head and body are turned so that that they are seen in profile. These differences suggest that the drawing is either a preparatory study or a copy of one: in my opinion it is the latter, since I cannot see Taddeo's own hand in it.
A more detailed copy of the left-hand side of the composition, corresponding exactly with this drawing, is in the Bibliothèque Nationale, Paris, attributed to Martin Fréminet (62 D 5646; repr. L. Fröhlich-Bum, *Parmigianino und der Manierismus*, 1921, fig. 158). It shows the two small figures whose heads and shoulders can be seen about half way up the left-hand edge of the composition as women, whereas in the fresco they are men.

155 Oxford, Ashmolean Museum P. II 464 (as Peruzzi)

DESIGN FOR A RECTANGULAR DECORATIVE PANEL CONTAINING AN ESCUTCHEON SUPPORTED BY ALLEGORICAL FIGURES OF *PEACE* AND *STRENGTH*

Plate 17

Pen and brown wash. 303:253 mm.
Parker, *Ashmolean Cat.*, ii. no. 464; J. A. Gere, *B. Mag.*, xcix (1957), p. 161; L. Frommel, *Baldassare Peruzzi als Maler und Zeichner: Beiheft zum Römischen Jahrbuch für Kunstgeschichte*, xi (1967/68), p. 166.

There is no traditional basis for the attribution to Peruzzi, and in a review of the Ashmolean Catalogue (*B. Mag.*, ut cit.) I argued that the drawing was, rather, the work of a 'fully developed Mannerist in whose style can be detected elements deriving from Salviati and Niccolò dell'Abbate', with the suggestion that it might prove to be by the same hand as a drawing at Windsor catalogued, on Antal's suggestion, as Pirro Ligorio (Popham–Wilde, no. 399, pl. 83). The latter is certainly connected in some way with TZ (see p. 54) though it does not seem necessarily to be by him. The convincing attribution of the Ashmolean drawing to TZ was suggested by Philip Pouncey on the strength of a comparison with the British Museum drawing of Camillus and Brennus

(cat. 110, Pl. 16). The style suggests a dating around 1550. The drawing is perhaps a design for a detail of decoration in one of the palaces of the Duke of Urbino (see p. 46). Frommel includes the drawing in his list of rejected attributions to Peruzzi.

—— **P. II 752.** *See* p. 37, note 1

156 —— **P. II 761**

HEAD AND SHOULDERS OF A MAN LOOKING UPWARDS TO THE RIGHT

Black and white chalk. The sheet is made up of several pieces of brownish paper. 652:573 mm.

J. C. Robinson, *A Critical Account of the Drawings by Michel Angelo and Raffaello in the University Galleries, Oxford*, Oxford, 1870, no. 59; B. Berenson, *The Drawings of the Florentine Painters*, no. 1568B (**repr. 1938 ed.**); L, Goldscheider, *Michelangelo Drawings*, 1951, fig. 169 (**repr.** with corresponding detail of painting); Parker, Ashmolean Cat., ii, no. 761.

This cartoon fragment formed part of Lawrence's Michelangelo series, and both Robinson and Berenson accepted the attribution. They considered the drawing entirely worthy of Michelangelo, and each notes the similarity in pose and type between this figure and those in the lower part of the *Last Judgement*; but they were puzzled by the fact that though this is part of a cartoon and thus must belong to a composition of which the design had reached the ultimate stage, no such figure occurs in the *Last Judgement* or in any other of Michelangelo's known works. The problem was settled by Victor Bloch's observation that the figure is that of the cripple in TZ's fresco of the *Healing of the Cripple* in the Frangipani Chapel. Berenson nevertheless retains the drawing under the name of Michelangelo in his 1961 (Italian) edition and refers to the connexion with the Frangipani fresco in such a way as to imply that TZ may have worked a fragment by Michelangelo into his own composition (see *Master Drawings*, ii (1964), p. 280).

157 —— **P. II 763**

A STANDING FIGURE IN HEAVY DRAPERY, SEEN FROM BEHIND, LEANING ON THE EDGE OF A SARCOPHAGUS

Plate 170

Pen and brown wash over black chalk, heightened with white, on paper thinly washed with yellow bodycolour. The upper outline of the figure has been roughly silhouetted and the sheet made up. 378:262 mm. (size of whole sheet).

Parker, Ashmolean Cat., ii, no. 763; J. A. Gere, *B. Mag.*, cviii (1966), p. 293.

Inscr. by Federico Zuccaro: *lultimo disegno di ma dla Bta Anima di mio fratello Tadeo B.M. lano 1566.* Parker convincingly suggested that this must be a study for an Apostle in the *Assumption* in the Pucci Chapel in S. Trinità dei Monti on which Taddeo was working at the time of his death; but though he is right in saying that no such figure occurs in this composition, it should be noted, as a particularly flagrant instance of the unreliability of engravings as evidence, that the Apostles in the lower part of the *Assumption* engraved by Jacob Matham with the inscription *Taddeo Zucchero Inventor Roma* (B. iii, p.192, 239), cited by Parker in justification of his statement, in fact corresponds in reverse with a painting of the subject by Francesco Bassano the younger (cf. W. Arslan, *I Bassano*, Bologna, 1931, Pl. lxviii and E. Arslan, *I Bassano*, Milan, 1960,

fig. 256). The upper part of the engraving, on the other hand, is not derived from the Bassano composition: the pairs of flying angels on either side of the Virgin correspond in reverse with those in the same position in the Pucci Chapel *Assumption*, and the figure of the Virgin herself, though not corresponding with the painting, is clearly of Zuccaresque derivation.

A copy by Federico in red and black chalk is in the Louvre (9061; 1969 Exh., no. 59).

158 —— P. II 764

Recto. THE MARTYRDOM OF ST LAWRENCE Plate 173
Verso. THE VIRGIN AND CHILD IN GLORY, ADORED BY
ST LAWRENCE AND ST DAMASUS Plate 174
Pen and brown wash. Some red chalk underdrawing on *verso*. 248:206 mm.
Parker, Ashmolean Cat. ii, no. 764; J. A. Gere, *B. Mag.*, cviii (1966), p. 342.

Inscr.: *Antonio Viviani il Sordo* and attributed to this minor follower of Barocci in the Roscoe Sale Catalogue (Liverpool, 24. ix. 1816, lot 199). TZ's authorship was pointed out by A. E. Popham. The drawings are sketches of alternative solutions for the high altarpiece in S. Lorenzo in Damaso, which was executed with considerable modifications by Federico after TZ's death. Later stages of the *verso* solution are preserved in drawings by TZ in the Uffizi (cat. 52 *recto*. Pl. 175) and in the Ashmolean Museum (cat. 159. Pl. 176); what appears to be the ultimate form of the other is known from a finished *modello* by Federico in the Uffizi (cat. 58) and a painting in the Chiesa dei Cappucini at Fermo. See p. 127 and *B. Mag.*, ut cit.

159 —— P. II 765

THE VIRGIN AND CHILD IN GLORY ADORED BY ST LAWRENCE
AND ST DAMASUS WITH ST PETER AND ST PAUL

 Plate 176

Pen and brown wash, over black chalk and stylus. 540:360 mm.
Parker, Ashmolean Cat. ii, no. 765; J. A. Gere, *B. Mag.*, cviii (1966), p. 342.

As TZ in the Sir George Clausen Sale (Sotheby's, 2.vi.1943, lot 82). Parker pointed out that this must be connected with the same composition as No. 158 *verso* (Pl. 174). Both in fact are studies for the S. Lorenzo in Damaso altarpiece (see p. 127 and *B. Mag.*, ut cit.).

160 —— P. II 766

A GROUP OF STANDING FIGURES Plate 13
Pen and brown wash, heightened with white, on brown-washed paper. 272:198 mm.
Lawrence Gallery, 7th Exhibition [Polidoro], 1836, no. 36; Parker, Ashmolean Cat. ii, no. 766.

As Polidoro in the Lawrence Collection, but Parker's attribution to TZ is confirmed by the fact that this is a study for the group of figures in the right foreground of a composition of an Antique Sacrifice, probably intended for part of the decoration of a façade, which is known in its complete form from a drawing in the École des Beaux-Arts, Paris (cat. 168. Pl. 11).

161 Oxford, Christ Church 0146 (Bell D.34, as Polidoro da Caravaggio)

THE VIRGIN AND CHILD

Pen and brown wash. 120:109 mm.

Gernsheim 41298.

Philip Pouncey's suggestion that this is an early drawing by TZ seems convincing.

162 —— **0177 (Bell E.25)**

Recto. ALEXANDER THE GREAT AND BUCEPHALUS **Plate 41**
Verso. STUDIES FOR A STUCCO *BASAMENTO* **Plate 42**
Pen and brown wash. Stylus underdrawing on *recto*. 376:429 mm.

Inscr. on *verso*, in ink: *di Tadeo. Taddeo Zucchero.* One of TZ's frescoes in the Palazzo Caetani is of Alexander subduing Bucephalus (Pl. 127b) and the horse also appears in *Alexander in his Tent with Roxana* at Bracciano (Pl. 123b), but both sets of frescoes date from around 1559–60 whereas the style of the drawing suggests a date in the early 1550's. TZ also painted six scenes from the life of Alexander on the façade of a house near S. Lucia della Tinta. No trace of these remains; but in the engraving in Metz's *Schediasmata Selecta* which may reproduce part of this decoration (see p. 42) Alexander is shown standing holding Bucephalus by the bridle.
The *verso* studies are perhaps connected with the ornate *basamento* which was at one stage intended for the side-walls of the Mattei Chapel in S. Maria della Consolazione (see p. 71).

163 —— **0241 (Bell G. 21, as 'attributed to Tempesta')**

TRIPTOLEMUS TEACHING MANKIND THE ARTS OF
CULTIVATION **Plate 137**
Pen and two shades of brown ink and brown wash, heightened with white, on blue paper. Red chalk underdrawing in the figure of Triptolemus, the chariot and the dragons. 249:316 mm.

Inscr. on the XVIII-century mount, in pencil, in an old hand: *antonio Tempesta.* A study for the fresco on the ceiling of the Camerino dell'Estate at Caprarola (see p. 110). The landscape background is not indicated in the drawing; the figures correspond almost exactly with those in the fresco, but their relative position is slightly different.

164 —— **0349 (Bell K. 24, as 'attributed to Muziano')**

THE MEETING OF JANUS AND SATURN
Pen and brown wash. 269:410 mm.
J. A. Gere, *Master Drawings*, vi (1968), p. 249 (**repr.**); **Gernsheim 41505.**

Inscr.: *RVrb*, and in ink on the old mount, in an old hand: *Mutiano*. A copy of the fresco by Polidoro da Caravaggio, one of four scenes from legendary Roman history formerly in the Villa Lante and now in the Palazzo Zuccari. The style and handling of this copy suggest that it is by TZ in the late 1540's.

165 —— **0651 (Bell T.7, as 'anciently attributed to Raphael')**

A YOUTHFUL SATYR **Plate 119**
Black chalk on pale brown paper. 276:205 mm.

Inscr.: in the 'deceptive hand' (see Popham-Wilde, *Windsor*, p. 379): *Rafael d'Urbino.*

[185]

Such a drawing is not easy to date, but I would be inclined to place it towards the end of the 1550's, or even later.

166 —— **0773 (Bell X. 3,** as 'Anonymous Italian')

THE SIEGE OF TUNIS **Plate 156**

Pen and brown wash, heightened with (partly oxidized) white. 318:187 mm.

A study for the fresco on the left of the entrance to the Cappella Paolina in the centre of one end wall of the Sala Regia (Pl. 159). A payment to TZ for the decoration of this wall is recorded on 22 December 1564, and he had completed the painting on the left of the door and above it when Pius IV died in December 1565. Though carefully finished and without *pentimenti* this drawing is not the final design, for though it corresponds with the fresco in general arrangement the figures differ in detail and in the drawing the view of Tunis in the background continues over the doorway into the space eventually occupied by the allegorical figures of women with trophies (cf. cat. 108). The figures in the drawing are also smaller in scale, in relation to the picture area, than those in the fresco.

167 —— **1420**

STUDY FOR THE LEFT-HAND PART OF AN *ADORATION OF THE SHEPHERDS* **Plate 51**

Pen and brown wash, heightened with white, on four conjoined pieces of paper washed with yellow bodycolour. 437:672 mm.

Inscr. on the mount: *Taddeo Zucchero*. In a study for a group of shepherds on the right-hand side of an *Adoration*, at Windsor (cat. 258), the figures are on roughly the same scale and are drawn on the same yellow ground. The two drawings so closely resemble each other in handling and general style of composition that they could be connected with the same project. When they are placed side-by-side in what would, if this were so, be the correct relation to one another, the gaze of the shepherds seems to converge on the same spot.

The excited movement of the figures, and the way in which they are piled up one above the other, suggest a dating about the period of the Mattei Chapel, 1553–56. See p. 68.

—— **1823.** *See* cat. 74

—— **1921.** *See* cat. 186

Paris, Bibliothèque Nationale 62 D 5646. *See* cat. 154

168 Paris, École des Beaux–Arts 349

AN ANTIQUE SACRIFICE **Plate 11**

Pen and brown wash, heightened with white. 273:417 mm.
1969 [Louvre] Exhibition, no. 8.

Formerly attributed to Francesco Salviati. Evidently a design for a Polidoresque façade-decoration. The style indicates a date at the very beginning of TZ's career, when he was influenced by Polidoro da Caravaggio and also by Parmigianino. A study for the

group of figures on the extreme right of the composition is in the Ashmolean Museum (cat. 160. Pl. 13). See pp. 38 and 40

Paris, Louvre 1451. *See* cat. 73

—— **2177.** *See* cat. 93

—— **2236^A.** *See* cat. 233

—— **2236^B.** *See* cat. 92

169 —— **2750**

ST PAUL
Brush drawing in brown wash. Squared in black chalk. 362:218 mm.
1969 Exhibition, no. 17.

An old attribution to Sebastiano del Piombo is inscribed on the mount. Discovered by Philip Pouncey among the Anonymous Florentine drawings and identified by him as a study by TZ for the figure of St Paul in the *Healing of the Cripple* in the Frangipani Chapel in S. Marcello al Corso (Pl. 91), with which it agrees very closely, the principal difference being in the gesture of the right arm and hand.

—— **2811.** *See* cat. 179.

170 —— **2816**

Recto. A GROUP OF FOUR MUSES **Plate 110**
Verso. THE FLIGHT INTO EGYPT **Plate 111**
Black chalk and brown wash (*recto*); black chalk (*verso*). 401:233 mm.
Le seizième siècle européen: dessins du Louvre, 1965, no. 128; 1969 Exhibition, no. 19.

Formerly attributed to Daniele da Volterra. Later classified as 'Anonymous Florentine'.
· The attribution to TZ was made by Philip Pouncey. The *recto* is a study for the group in the left foreground of the fresco of 'the Muses round the Castalian Spring' (Pl. 109) which TZ painted for Stefano Bufalo 'in his garden near the Fontana di Trevi' (cf. Vasari, vii. p. 86). According to Gaspare Celio (*Il Vasari*, viii (1936–7), p. 113) this fresco, in colour, was on the vault of the loggietta of the garden-house, the façade of which had been decorated by Polidoro da Caravaggio in the 1520's with a series of paintings in grisaille which included one of the same subject. In 1885, when the Palazzo Bufalo was demolished, six of Polidoro's frescoes (including his *Parnassus*) were detached and transferred to canvas, and are now in the Museo di Roma (cf. *Le case romane con facciate graffite e dipinte*, exh. Rome, 1960, p. 20). TZ's *Parnassus*, also transferred to canvas, was retained by the last surviving member of the Bufalo family, Countess Cordelli, and remained in the Palazzo Cordelli until 1925, when it was acquired by the present owner, Comm. Avv. Ilo Nuñes (information kindly communicated by the owner). A copy of a lost study for the same group is also in the Louvre (cat. 199).
Vasari mentions the Bufalo commission immediately after his reference to TZ's activity at Bracciano, which can be dated *c.* 1559–60 (cf. p. 94). That the *Parnassus* must date from about the same period is further suggested by the classical, symmetrical style of the composition as well as by the drawing on the *verso* of the present sheet. This is a

study for one of the frescoes (Pl. 117) flanking the high altar of S. Maria dell' Orto which were carried out jointly by TZ and his brother Federico (cf. pp. 97 f). Vasari's statement that this was among Federico's very first commissions enables it to be dated at the end of the 1550's, when he would have been aged about 18 or 19.

171 —— 2892

THE ADORATION OF THE SHEPHERDS
Pen and brown ink. 280:271 mm.
J. A. Gere, *B. Mag.*, cv (1963), p. 364, note 6 (**repr.**).

Formerly attributed to Barocci. An old facsimile of a drawing by TZ, which might have been a study for the fresco in S. Maria dell'Orto (see *B. Mag.*, ut cit.).

—— **4400.** *See* cat. 195

172 —— 4403

THE BLINDING OF ELYMAS
Pen and brown wash, heightened with white, over black chalk. The outlines indented.
436:550 mm.
1969 Exhibition, no. 16.

Traditionally attributed to TZ. Though this seems at first sight to be nothing more than an old facsimile of the study at Windsor (cat. 257. Pl. 88) the black chalk underdrawing is free and intelligent and there are differences in detail which seem too trifling and at the same time too intelligent to be modifications introduced by a copyist. This could be a somewhat damaged original by TZ himself.

—— **4405.** *See* cat 2

—— **4409.** *See* cat. 70

—— **4430.** *See* cat. 80

173 —— 4432

A GROUP OF APOSTLES ROUND A SARCOPHAGUS
Pen and brown wash over black chalk, heightened with white, on brown paper. Squared in black chalk. 537:793 mm.
J. A. Gere, *B. Mag.*, cviii (1966), p. 293 (**repr.**); 1969 Exhibition, no. 58.

Inscr.: *TADEO.ZVCCA[RO]*. Except for the position of the Apostle kneeling in the left foreground, the drawing corresponds exactly with the lower part of the *Assumption of the Virgin* above the altar of the Pucci Chapel in S. Trinità dei Monti (*B. Mag.*, ut. cit., fig. 1). TZ was working on the design of this composition at the time of his death, and it was completed 23 years later by Federico. In spite of the old inscription attributing it to TZ, both the handling of the drawing and its apparent place in the sequence of studies for the composition suggest that it is by Federico. See p. 125 and *B. Mag.*, ut. cit.

174 ——— 4451

CHARLES V DOING HOMAGE TO PAUL III ON HIS RETURN FROM TUNIS

Pen and brown wash, heightened with white. Some black chalk underdrawing in the group of figures and horses in the left foreground. 316:480 mm.
1969 Exhibition, no. 33.

Inscr.: *Thadeo da Vrbino*. A study for the fresco in the Anticamera del Concilio at Caprarola, differing from it in the more extended spacing of the groups of figures and the consequently wider format. The group of horses and figures in the left foreground is the same as in the fresco, but in the drawing the steps of the throne are greater in number and more prominent, and neither the bearded man with his back turned who stands slightly left of centre in the immediate foreground of the fresco nor the man in a heavy cloak in the extreme right foreground have yet made their appearance. But though these differences establish the drawing as part of the preliminary working material, it can hardly be by TZ himself: the position of the horses' legs in the left-hand group and the structure of the Pope's throne and of the canopy above it in the right background are both misunderstood in a way that would be impossible if the draughtsman had himself excogitated the composition. This must be the work of a studio-assistant copying something which he does not properly understand.

——— **4452.** *See* p. 105, note 1

175 ——— 4460

THE MARRIAGE OF OTTAVIO FARNESE AND MARGARET OF AUSTRIA

Pen and brown wash. Squared in black chalk. Much rubbed and damaged. 250:271 mm.
1969 Exhibition. no. 34.

A *modello* for the fresco in the Sala dei Fatti Farnesiani at Caprarola which differs from it in certain details: notably the introduction of a small boy standing by the left-hand pillar and the substitution of an ecclesiastic for the bearded man in a short cloak on the extreme right. This drawing belongs to the same group of *modelli* as cat. 64–66 etc. which seem to be products of TZ's studio. See pp. 112 ff.
A copy is at Edinburgh (D. 2224: repr. K. Andrews, *National Gallery of Scotland: Catalogue of Italian Drawings*, Cambridge, 1968).

176 ——— 4462

SCENE FROM THE EARLY HISTORY OF THE FARNESE FAMILY

Pen and brown wash. Squared in black chalk. 235:178 mm.
Uffizi 1966 Exhibition, under no. 54; 1969 Exhibition, no. 36 (**repr.**).

A man on a throne in the centre is seated with his body turned to the right, holding a sceptre. In front of him, in the left foreground, stands a man with his back to the spectator, and in the right foreground one in a long robe reading from a document. The heads of spectators appear in the right background. All the figures are in mediaeval dress, Inscr.: *Sodoma*, but attributed in the Louvre to TZ. A study for the *quadro riportato*

[189]

above the left-hand doorway in the Sala dei Fasti Farnesiani in the Palazzo Farnese in Rome. The drawing is not by TZ, nor by Federico who seems to have been responsible for the only other known studies for the *quadri riportati* in this room (cat. 26 and 59); it seems to be the work of an as yet unidentified studio-assistant. See p. 122.

177 —— 4473

A WOMAN WEARING A HELMET, STANDING IN A NICHE

Plate 163

Pen and brown wash, heightened with white, on brown-washed paper. Squared in black chalk. 328:169 mm.
1969 Exhibition, no. 28.

Traditionally attributed to TZ. A study for the allegorical figure above the right-hand doorway in the wall opposite the windows in the Sala dei Fasti Farnesiani in the Palazzo Farnese in Rome (Pl. 167).
There are slight differences in the arrangement of the drapery and in the fresco the head is seen less sharply foreshortened. An earlier study for the same figure is in the Hermitage (cat. 94. Pl. 162). See p. 120.

178 —— 4504

ST JOHN THE EVANGELIST

Plate 103

Brush drawing in red wash. The outline of the figure has been roughly silhouetted. 242:135 mm. (size of whole sheet).
Facsimile engraving in reverse by Caylus, when in the Cabinet du Roi (Weigel 8697); 1969 Exhibition, no. 18.

Inscr.: *thadeo Zuchero F.* The figure stands holding the book under his left arm and pointing downwards with his right hand. The book suggests that he is an Apostle; his youthful face, that he is St John. In Raphael's tapestry of the *Healing of the Lame Man at the Beautiful Gate*, which must have been known to TZ (see p. 73), St John stands beside St Peter and points down towards the lame man with a rather similar gesture. Other studies of single figures in this style and technique are for the Frangipani Chapel (see pp. 77 f.).

—— **4517.** *See* p. 93, note 2

179 —— 4519

CIRCULAR COMPOSITION OF A CHARIOT-RACE

Pen and brown wash. 266:325 mm. (part of the circle cut off at the bottom).
J. A. Gere, *B. Mag.*, cv (1963), p. 310 (**repr.**)

Inscr. by Sebastiano Resta (Lugt 2992): *Lo hebbi da Cavl Antᵒ Gabbiani è di p[rima] maniera di Taddeo Zuccaro. Feste Saturnali dipinte da Polidoro e Maturino in Campo Martio ora p[er]dute affatto ad imitatione delle q[uel]li sono queste di Taddeo Zuccaro giovine venuto a Roma. ditorno a gli Obelisc[hi] giravano le bigh[e] e quadrighe. Adesso la gloria de'giovani sta in guidar calessi per le strade . . . era manten . . . qu . . . di fresc . . . cerca a . . . è venuto . . . ma restan . . . alquanto nel. . . .*
An old copy of what must have been a design for a piece of the 'Spanish Service' of

maiolica (see pp. 91 ff. and *B. Mag.*, ut cit.). Two other versions are also in the Louvre (4533 and 2811) and a fourth is in the Museum at Angers (Recouvreur Catalogue, no.151, as Perino del Vaga).

—— **4521.** *See* cat. 213

—— **4528.** *See* cat. 73

—— **4533.** *See* cat. 179

—— **4534.** *See* p. 124, note 1

180 —— **5091**

THE FLIGHT INTO EGYPT Plate 112
Pen and brown wash, heightened with white, over black chalk. 573:351 mm.
Le seizième siècle Européen: dessins du Louvre, 1965, no. 195; 1969 Exhibition, no. 20.

As TZ in the MS inventory of the Jabach Collection (in the Cabinet des Dessins) but attributed to Muziano when TZ's authorship was recognized by Philip Pouncey. A study for the fresco to the right of the High Altar in S. Maria dell' Orto, Rome (Pl. 117). Cat. 101 and 170 *verso* are studies for the same composition. See pp. 97 f.

—— **5123.** *See* cat. 138

181 —— **6112**

THE ROMAN MATRONS GIVING THEIR JEWELS FOR AN
OFFERING TO APOLLO Plate 3
Pen and brown wash, heightened with white, on brown paper. 364:559 mm.
1969 Exhibition, no. 7.

Formerly classified as 'attributed to Polidoro da Caravaggio' but certainly by TZ and in all probability a study for one of the paintings on the façade of the Palazzo Mattei in Rome, the decoration of which was completed in 1548 and was his first independent work (see p. 37). The drawing goes well in style with the others which might be connected with the same commission (cat. 105, 119 and 128. Pls. 5, 2 and 4). A copy is at Munich (8635).

182 —— **6220**

SCENE FROM ROMAN HISTORY: A SUPPLIANT PLEADING
WITH A GENERAL ON HORSEBACK Plate 1
Pen and brown wash, heightened with white. 268:221 mm.
1969 Exhibition, no. 10.

Formerly classified as 'after Polidoro', this is in fact one of the early, Polidoresque, group of drawings by TZ. The faces of the soldiers in the top left corner and the two heads closest to the right-hand edge are unmistakably characteristic. The drawing is probably a design for a façade painting. The composition suggests knowledge of the Antique relief of *Barbarians submitting to Marcus Aurelius* (Palazzo dei Conservatori).
On the *verso*, partly cut away, is a slight pen sketch of a standing man holding a shield.

—— **6250.** *See* cat. 84

183 —— **6341**

THE *ASSUNTA*, WITH GOD THE FATHER, PROPHETS AND SIBYLS Plate 32

Pen and greyish-brown ink and wash. 266:202 mm. (upper corners cut).
Le Dessin à Naples du XVI^e siècle au XVIII^e siècle, (Louvre exhibition), Paris, 1967, no. 6; 1969 Exhibition, no. 12.

The traditional attribution to Lanfranco, whose name is inscribed on the back of the old mount in an XVIII-century hand, was rejected in the catalogue of the 1967 exhibition. It was pointed out that the drawing is earlier in style and still wholly Mannerist, but the suggested attribution to Francesco Curia (1538–*c.* 1610), based on comparison with a group of drawings certainly by him at Stockholm, is not convincing: the 'handwriting' in the Stockholm drawings is more staccato and more agitated in rhythm, and is obviously closely dependent on the later drawings of Polidoro da Caravaggio. Miss Gael Hayter was the first to suggest the name of TZ, and the drawing is indeed a characteristic example of his early style of around 1550. See pp. 48 f.

184 —— **6612**

A STANDING WOMAN

Black chalk on brown paper. Some oil-stains and damage lower right. 423:261 mm.
1969 Exhibition, no. 27.

Inscr. on back of mount, in a hand like Sebastiano Resta's (Lugt 2992a): *PARMEG-GIANO nella Steccata di Parma Vergine.*
Formerly attributed to Parmigianino, but transferred to TZ at Philip Pouncey's suggestion. The figure stands facing the spectator, looking over her left shoulder. Her right arm is raised and the other hangs loosely down by her side and in the crook of the wrist supports a staff, one end of which rests on the ground. The indications of drapery on the arms and the summary treatment of the rest of the body and the legs show that this is not a nude study but the beginning of a drawing of a draped figure with the legs drawn first to establish the stance. A finished study for the same figure is in the Albertina (cat. 238).

185 —— **6676**

CIRCULAR COMPOSITION OF A BANQUET IN A PIAZZA
 Plate 120
Brush drawing in red wash, with a few touches of white heightening. 320 mm. diameter.
J. A. Gere, *B. Mag.*, cv (1963), p. 309; *Le seizième siècle Européen: dessins du Louvre*, 1965, no. 249; 1969 Exhibition, no. 21.

The previous old attribution to Raffaellino da Reggio goes back at least to the time of Mariette, and seems never to have been challenged. It is true that this artist, though some twenty years TZ's junior, sometimes comes confusingly close to him, especially in his drawings; but the technique of brush and red wash is one which seems to have been

peculiar to TZ, and there can be no doubt that this drawing is by him and it is one of his maiolica designs (see p. 92).

In the Mariette Sale Catalogue (Paris, 1775, lot 532) the subject is given as the *Marriage at Cana*; but like all the other known maiolica designs it is a scene from Roman history. The inner part of the composition covers the whole interior of a maiolica bowl in the Louvre (1720) inscribed underneath POP LO ROMA CONVITO. This piece, though classified as 'Urbino-ware, mid-XVI-century', is unlikely to have formed part of the original service since the composition appears in an incomplete form and it lacks the border of grotesque decoration which is a feature of all the pieces which seem to have formed part of the service; but the inscription probably repeats that on the original piece. A copy is in the Louvre (6680).

—— **6680.** *See* cat. 185

186 —— **6745**

THE BETRAYAL OF CHRIST Plate 55

Pen and brown wash, heightened with (partly oxidized)white. 320:258 mm.
1969 Exhibition, no. 14.

Formerly attributed to Giulio Cesare Proccaccini. Philip Pouncey was the first to point out that this is a study by TZ for the group in the background of the fresco in the Mattei Chapel (Pl. 57). See p. 63. A copy is in one of the Ridolfi Albums at Christ Church, Oxford (1921).

187 —— **9030**

THE BATH OF DIANA

Pen and brown wash with touches of red chalk, heightened with white. 402 mm. diameter.
1969 Exhibition, no. 41.

Traditionally, and no doubt correctly, attributed to Orazio Sammacchini, this drawing represents the finished state of a composition by TZ for which there are two complete studies on either side of a sheet in the Metropolitan Museum (cat. 141. Pl. 121).

—— **9061.** *See* cat. 157

—— **9942.** *See* cat. 37

—— **9974.** *See* cat. 57

188 —— **10007**

THE HOLY FAMILY WITH GOD THE FATHER ABOVE

Pen and black ink and brown wash, heightened with white, on brown paper. 355:248 mm.

Inscr.: *Perino del Vaga*. Formerly classified as Anonymous. Philip Pouncey first pointed out that this must be a copy of a lost drawing by TZ.

N [193] G.T.Z.

—— **10308.** *See* cat. 208

189 —— 10322

JULIUS III OPENING THE PORTA SANTA Plate 8
Pen and brown wash, heightened with white. 136 mm. diameter.
1969 Exhibition, no. 11.

Formerly classified as Anonymous, and first attributed to TZ by Philip Pouncey. An important fixed point in the development of TZ's style, being one of the very few drawings of the period before 1553 which can be precisely dated. This ceremony takes place only in a Jubilee Year, and the only Jubilee celebrated in TZ's lifetime was in 1550. The drawing is presumably a design for the reverse of a commemorative medal which was never struck (the Porta Santa appears on the reverse of three of the medals struck by Julius III to commemorate the Jubilee of 1550, but in each case without figures: C. du Molinet, *Historia Summorum Pontificum a Martino V ad Innocentium XI per eorum Numismata*, Paris, 1679. Pl. 16, nos. I to III). TZ made some of the temporary decorations for Julius's coronation in February 1550, and is recorded as working for the Pope himself in the following year (cf. *B. Mag.*, cvii (1965), p. 201).

190 —— 10347

AUGUSTUS AND THE SIBYL Plate 171
Pen and brown wash, heightened with white, on blue paper. 255:178 mm.
J. A. Gere, *B. Mag.*, cviii (1966), p. 289; 1969 Exhibition, no. 31.

Formerly classified as Anonymous Florentine; attributed to TZ by Philip Pouncey. In handling this drawing comes close to the study of an Apostle in an *Assumption* in the Ashmolean Museum (cat. 157, Pl. 170) which must be connected with the *Assumption* in the Pucci Chapel in S. Trinità dei Monti, the decoration of which was TZ's last work. This is no doubt a study for the fresco of *Augustus and the Sibyl* (a subject which he also contracted to paint) on the upper part of the right-hand side-wall (repr. *B. Mag.*, ut cit., fig. 3). The arrangement of the figures in the drawing shows knowledge of the chiaroscuro woodcut by Antonio da Trento after Parmigianino (B. xii, p. 90, 7); the fresco is entirely different in composition and seems to have been not only executed but also designed by Federico.

191 —— 10364

VULCAN GIVING JUPITER A SHIELD MADE FROM THE SKIN OF AMALTHEA Plate 130
Pen and brown wash over black chalk. 242:429 mm.
1969 Exhibition, no. 22.

Formerly classified as Anonymous. Philip Pouncey had suggested an attribution to Federico Zuccaro, without reference to the fact, first observed by Loren Partridge, that this is a study for one of the small frescoes on the vault of the Sala di Giove at Caprarola (Pl. 131). See p. 110.

[194]

192 —— 10428

HERCULES AND IOLE FINDING THE MUREX ON THE
SEA-SHORE Plate 134
Pen and brown wash. 173:242 mm.
1969 Exhibition, no. 26.

Formerly classified as Anonymous. A study for the fresco on the vault of the Stanza dei
Lanefici at Caprarola, agreeing with it in all essentials except shape, that of the fresco
being an elongated octagon. Like cat. 193, with which it is *en suite* (the two were mounted
together in the XVIII century) it was attributed to Federico by Philip Pouncey, without
reference to the connexion with the Caprarola fresco. In my opinion, both drawings
are more likely to be by TZ. See p. 116.

193 —— 10429

HERCULES GIVING IOLE A GARMENT DYED WITH MUREX
 Plate 135
Pen and brown wash. 171:244 mm.
1969 Exhibition, no. 25.

Formerly classified as Anonymous. Attributed to Federico by Philip Pouncey. The
connexion with the fresco on the vault of the Stanza dei Lanefici at Caprarola was first
noticed by Loren Partridge. See cat. 192 and p. 116.

194 —— 10481

THE HOUSE OF SLEEP Plate 140
Pen and brown wash. 265 mm. diameter.
Le seizième siècle Européen: dessins du Louvre, 1965, no. 129; 1969 Exhibition, no. 23.

Formerly classified as Anonymous, in spite of being correctly attributed to TZ in the
MS inventory of the Jabach Collection. A study for the circular fresco of Somnus with
Phantasos, Morpheus and Icelos in one of the ceiling pendentives of the Stanza di
Aurora at Caprarola (Pl. 141). The two correspond very closely, but there are enough
differences in detail (e.g. the right-hand doorway is further to the right in the fresco and
the bed less abruptly foreshortened, while the love-making couple top centre has dis-
appeared altogether) to show that the drawing is not simply a copy of the fresco. This is
the kind of careful drawing that sometimes hovers on the borderline between TZ and
Federico, but this particular example is too intelligent, too efficient and – in such
passages as the head of Morpheus – too sensitive, to be by anyone but TZ himself. The
composition follows the detailed programme for the room laid down by Annibale Caro
in his letter of 21 November 1562 (Vasari, vii, pp. 115 f.; see also Ovid, *Metamorphoses*,
xi, 592 etc, for the source of Caro's imagery). A copy of the drawing is in the Uffizi
(14027F; Gernsheim 40257).

195 —— 10594

THE DONATION OF CHARLEMAGNE
Pen and brown wash. 439:368 mm.

Formerly classified as Anonymous. Though this drawing is clearly not by TZ himself,
its condition makes it impossible to be certain whether it is a damaged drawing by a

[195]

studio-assistant or an old copy of a lost drawing. It preserves an otherwise unrecorded stage in the evolution of the *soprapporta* in the Sala Regia (see pp. 103 ff.). Charlemagne's throne is set obliquely but he himself is sitting with his shoulders parallel with the picture-plane. The right foreground is occupied by a soldier standing with his back to the spectator and his head turned to the left. Balancing him in the left foreground is the figure, holding scrolls and kneeling on one knee before Charlemagne, who appears in all the known studies for the composition but is omitted from the fresco itself. He kneels on the same level as the soldier, and behind him and slightly to the left is a standing man with one hand on his hip who looks straight out of the picture. The composition seems to be complete and the figures on either side are symmetrically balanced and seem intended to frame the composition. The difference of shape between this drawing and the fresco itself (see p. 103), suggests that TZ was considering the possibility of narrowing the painted area in some way.

A study by TZ himself of Charlemagne and the kneeling man, at Berlin (cat. 6. Pl. 151), comes close to the group in this drawing. The complete composition occurs, with slight modifications of detail and the addition of two figures, in the background of a large drawing in the Albertina (15463; S.N. 214) representing the decapitation of a male saint, which seems to be an essay in original composition by one of TZ's less inspired followers.

A copy of cat. 195 is in the Louvre (4400).

196 —— 10595

CIRCULAR COMPOSITION OF GLADIATORS FIGHTING
Pen and brown wash over black chalk, with some brown and some violet wash. 342:334 mm. (diameter of composition: 327 mm.).

Formerly classified as Anonymous. An old inscription, faintly visible through the backing, seems to read: *Spettacolo . . . Antichi*. The drawing is an old copy of one of TZ's maiolica designs (cf. p. 92). The composition occurs on a large wine-cistern in the Stockholm Museum and on a dish formerly in the Fountaine Collection at Narford Hall (*B. Mag.*, cv (1963), p. 307, fig. 21).

—— **10597.** *See* cat. 90

197 —— 10880

THREE TRUMPETERS IN A PROCESSION
Pen and brown wash, heightened with white. 190:182 mm.
1969 Exhibition, no. 9 (**repr.**).

Inscr. on old mount: *Carache Ecole Lombarde*, and until recently classified as Anonymous. The pointed, slant-eyed mask of the right-hand figure is characteristic of TZ's early style, and the loose handling and wiry contours may be compared with those in cat. 105 (Pl. 5). This drawing must similarly be part of an early design for a frieze in a façade-decoration.

—— **11558.** *See* cat. 147

198 —— **11578**

THE EXCOMMUNICATION OF HENRY VIII **Plate 142**
Pen and brown wash. Traces of underdrawing in black chalk, 220:343 mm.
1969 Exhibition, no. 24.

Inscr. in pen: *Cesare Nebbia. École Venetienne.* Formerly classified as Anonymous.
Attributed by Philip Pouncey, without reference to its connexion with the fresco in the
Anticamera del Concilio at Caprarola, to Federico Zuccaro. It is improbable, however,
that anyone but TZ himself would have been responsible for a rough preliminary
sketch of this sort; and though the clumsy way in which the architectural setting is
indicated makes an unsatisfactory impression, the drawing of the figures seems fully
compatible with him. See p. 111.

199 —— **11724**

A GROUP OF FIVE MUSES
Pen and brown wash. 275:212 mm.
1969 Exhibition, no. 39.

One Muse sits with her body and legs turned to the right and her head and shoulders
twisted round to the left in sharp *contrapposto*. She looks over her left shoulder towards
another who stands on the left-hand edge of the group in profile to right. The heads and
shoulders of two standing Muses appear behind the seated figure. The fifth stands to
her right, turned towards the spectator and looking to the right.
Philip Pouncey was the first to point out that this drawing, which he found among
those classified as Anonymous, must be a copy of a lost drawing by TZ. The original
was a study for the group in the left foreground of the *Parnassus* formerly in the Casino
del Bufalo (see cat. 170).

200 —— **11762**

ALEXANDER THE GREAT REFUSING THE WATER OFFERED
TO HIM
Pen and brown wash. 230:335 mm.
1969 Exhibition, no. 44.

Formerly classified as Anonymous. A weaker version at Windsor (5066; Popham-
Wilde, no. 1074) was catalogued as a copy after TZ at the suggestion of Antal, who had
pointed out its resemblance to the study for *The Family of Darius before Alexander* at
Bracciano, in the Albertina (cat. 248). Both his attribution and the comparison, as well
as A. E. Popham's suggestion that the subject represented may likewise be some
incident in the story of Alexander, are borne out by the drawing's connexion with a
fresco in the Palazzo Caetani (Pl. 124b) which dates from the same period as the
Bracciano paintings (see p. 94) and represents an episode described in Plutarch's life of
Alexander. 'Some Macedonians who were fetching water from a river, seeing that
Alexander was faint with thirst, filled a helmet and gave it to him to drink. Alexander,
seeing that those round him were eagerly watching him and coveting the water, gave
it back without tasting it, saying "If I alone drink, my soldiers will be discontented".'
The main difference between fresco and drawing is the introduction of a horse in the
right foreground of the latter. Of the two versions, the one in the Louvre is of better

quality, but Philip Pouncey is no doubt right in describing it, in a note on the mount, as a copy after TZ by Federico.

—— **11779.** *See* cat. 100

201 —— **11816**

THE ADORATION OF THE SHEPHERDS Plate 49
Pen and brown wash, heightened with white, over black chalk. 270:419 mm.
1969 Exhibition, no. 15.

Inscr. very faintly in pen, in the 'Lanière italic hand': *Zuccaro*. Formerly classified as Anonymous, and attributed to TZ by Philip Pouncey. The drawing is an example of his Correggiesque manner at its loosest and most extreme and can probably be dated in the early 1550's. A man reclining on the back of an ox and adoring the Infant Christ is a prominent feature of the *Adoration of the Shepherds* for which there are studies at Chatsworth (cat. 19. Pl. 50) and in the Uffizi (cat. 57). The Louvre drawing could be a study for the same composition. See p. 68.

202 —— **11897**

ST JOHN THE EVANGELIST IN A PENDENTIVE Plate 59
Pen and brown ink and red chalk over black chalk underdrawing. Squared in black chalk. 345:261 mm.
1969 Exhibition, no. 13.

Inscr.: *TADEO.ZVCCARO.* The shape of the pendentive and the direction of the perspective of the feigned reveal of the opening show that this is a study for the pendentive on the left of the altar-wall in the Mattei Chapel (see p. 65). The object in the left-hand angle is not easy to make out, but it must be a bird with its body on the left, with one small wing visible and claws underneath, extending a small head on the end of a long neck in the direction of the figure. If it does not immediately suggest St John's attribute of an eagle, still less can it be interpreted as an angel, a lion, or an ox, the symbols of the other Evangelists. The identification of the figure as St John is further supported by his youthful appearance, and by the fact that the Evangelist in the corresponding pendentive in the chapel (Pl. 65), though represented half-length and with his attribute no longer visible, is a young man and must therefore be St John.

203 —— **12070**

DESIGN FOR PART OF A FRIEZE: A PANEL OF *PUTTI* AND SWAGS FLANKED BY CARYATIDS Plate 108
Pen and brown wash, heightened with white. Traces of underdrawing in black chalk. 260:320 mm.
1969 Exhibition, no. 29.

In spite of the old inscription *Tadeo Zucharo*, the drawing was formerly classified as Anonymous Florentine. Its purpose is unknown. The style suggests a date towards the end of the 1550's or later.

204 —— **12812**

A GROUP OF FIGURES, INCLUDING A MAN ON HORSEBACK
Pen and brown wash, heightened with white. 184:221 mm.

Formerly classified as Anonymous. The group occurs on a maiolica dish in the Bargello, Florence, inscribed on the underside *Cesare conserva il cittadino*, which was evidently part of the service for which TZ made designs between 1560 and 1562 (*B. Mag.*, cv (1963), p. 308, fig. 25). The Louvre drawing is perhaps a copy of a lost drawing. See p. 93.

205 —— 12886

STUDIES OF A SEATED WOMAN DRYING HERSELF　　Plate 168
Red chalk. 190:240 mm.
1969 Exhibition, no. 30.

Formerly classified as Anonymous XVII-century. The attribution to TZ is supported by comparison with the similar lightly drawn figures in red chalk in the lower part of the study in Berlin for the Sala Regia *Donation of Charlemagne* (cat. 5 *recto*. Pl. 153). These studies are perhaps connected with the composition of the *Bath of Diana* (see cat. 141 *recto*. Pl. 121): a figure in much the same pose, but seen from a different angle, is in the left foreground of the complete composition-study on cat. 141 *verso*. The pose seems to have been inspired by the Raphaelesque motif of Venus pulling a thorn from her foot (cf. engraving by Marco Dente, B. xiv, p. 241, 321).

206 —— 12959

STANDING BEARDED MAN HOLDING AN OPEN BOOK
Black chalk. 281:188 mm.

Formerly classified as Anonymous. Philip Pouncey pointed out that this is a copy, by Federico, of the figure of St Paul in the *Raising of Eutychus* on the vault of the Frangipani Chapel (Pl. 85).

207 —— 35300

THE APOTHEOSIS OF AMALTHEA
Pen and brown wash. 283:252 mm.

Formerly classified as Anonymous. The connexion with the fresco on the vault of the Sala di Giove at Caprarola was pointed out by Loren Partridge. The fresco composition is slightly wider than high, that of the drawing slightly higher than wide, with the figures set more closely together. The drawing also differs from the fresco in the pose of the right-hand nymph of the three in the foreground, and in the drapery and position of the left arm of the nymph in the centre. In spite of these differences, the drawing cannot be by TZ himself: it must be an old copy of a lost study by him. See also cat. 220.

208 —— RF 1870–73

JULIUS III RESTORING THE DUCHY OF PARMA TO OTTAVIO FARNESE
Pen and brown wash. Squared in black chalk. 338:454 mm.
1969 Exhibition, no. 35.

A *modello* for the fresco in the Sala dei Fatti Farnesiani at Caprarola, corresponding not with the fresco as executed but with the study in the Scholz Collection, New York (cat. 149 *recto*. Pl. 149). It belongs to the same group as those in the Uffizi and elsewhere

(see pp. 112 ff.). Copies are in the Louvre (10308), the Uffizi (435S) and the Pierpont Morgan Library, New York (I. 23; repr. *A Selection from the Collection of Drawings by the Old Masters formed by C. Fairfax Murray*, London, 1904, pl. 23).

209 —— RF 1870–29242

STUDIES OF THE VIRGIN SURROUNDED BY ANGELS, FOR THE UPPER PART OF AN *ASSUMPTION* **Plate 172**

Pen and brown wash. 261:191 mm.
1969 Exhibition, no. 32.

Formerly classified as Anonymous Venetian, XVIII-century. Independently recognised as TZ by Konrad Oberhuber. A study for the upper part of the *Assumption of the Virgin* in the Pucci Chapel in S. Trinità dei Monti. See p. 126.

—— RF 1870–29497. *See* cat. 100

210 Philadelphia, Museum of Art, Academy Collection (as Sebastiano del Piombo)

A POPE PRESENTING A STANDARD TO A KNEELING MAN IN ARMOUR **Plate 144**

Pen and brown wash over black chalk. 284:224 mm.

Two similar compositions are in the Sala dei Fatti Farnesiani at Caprarola, *Eugenius IV creating Ranuccio Farnese Captain-General of the Church* (Pl. 145b) and *Paul III creating Pierluigi Farnese Captain-General of the Church* (Pl. 145a). The drawing is closer to the former in such details as the shape of the Pope's throne, the window, and the group of ecclesiastics in the background, but there is no exact correspondence, and the composition differs from both frescoes in being upright.

Philadelphia, Philip and A. S. W. Rosenbach Foundation 472/22, no. 4.[1]
See cat. 70.

[1] The Rosenbach Foundation possesses the greater part of the drawings attributed to Taddeo and Federico Zuccaro in the collection of Sir Thomas Lawrence. After Lawrence's death in 1830 his collection of drawings became the property of his principal creditor, the art-dealer Samuel Woodburn, who tried to dispose of it by a series of exhibitions of the best drawings under the collective title 'The Lawrence Gallery'. The seventh exhibition, in July 1836, consisted of 'One hundred original drawings by Zucchero, Andrea del Sarto, Polidoro da Caravaggio, and Fra Bartolomeo'. 25 Zuccaro drawings were exhibited, nos. 1 to 20 being the series by Federico illustrating Taddeo's early life (see pp. 28 f.) and nos. 21 to 25 single drawings attributed to Taddeo. A note adds that 'the drawings by the two Zuccheros consist of eighty in number and will be sold entire for £400'. They did not find a purchaser, for when the bulk of the Lawrence Collection was finally disposed of at auction some years after Woodburn's death (Christie's, 4.vi.1860, etc.) it still included 74 drawings attributed to the Zuccaros: lot 1073, 'Zucchero (F.) – King John signing Magna Charta' and lot 1074, 'Zucchero (F. and T.) – a most interesting Series of 20 Drawings representing incidents in the life of Taddeo Zuccaro, drawn by his brother Frederick; followed by 53 Specimens of their Works, in Bistre, Chalk, &c., consisting of Original Designs and Studies for some of their principal Pictures. Handsomely bound in red morocco. A superb and highly important Collection'. Both lots were bought by Sir Thomas Phillipps, for 17/– and £63 respectively. The single drawing sold in lot 1073, which is in fact a study by Taddeo for the *Donation of Charlemagne* in the Sala Regia (cat. 104), passed to the British Museum in 1946 with the bulk of the Phillipps Collection but the album (Phillipps MS 15135) had already been sold in 1930 to the American bookseller Dr. A. S. W. Rosenbach, who sold six drawings from it, three by Taddeo (cat. 149, 150 and 151) and three by Federico, to Mr Janos Scholz. Those now in the

211 —— 472/22, no. 17

Recto. CIRCULAR COMPOSITION OF FIGHTING SEA-MONSTERS,
FOR THE DECORATION OF THE BORDER OF A DISH OR
SALVER **Plate 44**
Verso. STUDIES OF FIGURES, A HEAD, ETC. **Plate 46**

Pen and brown wash over stylus underdrawing (*recto*); red chalk and black chalk
(*verso*). 265:352 mm. Traces of red chalk off-setting on the *recto*.

Attributed to TZ in the W. Y. Ottley sale catalogue (6.vi.1814, etc., lot 1490). The
studies on the *verso*, for the Mattei Chapel (see pp. 64 f.), resemble in technique and
handling those on the sheet in Mrs Krautheimer's collection (cat. 146). The traces of
offsetting suggest that the Rosenbach sheet, at any rate, may have formed part of a
sketchbook; but it should be noted that the watermark is a pair of crossed arrows

Rosenbach Foundation in Philadelphia number 67 (counting as two the drawings on either side of a leaf
from one of Sebastiano Resta's albums) of which 5 are catalogued here as by Taddeo himself and 3 as after
him. Of the remainder, 35 are by Federico (including the series of 20 illustrating Taddeo's early life) and
4 probably from the Zuccaro studio, leaving 11 by or after a miscellaneous assortment of other masters
including Belisario Corenzio, Vasari, Tiburzio Passarotti, Orazio Sammacchini, Raffaellino da Reggio and
Palma Giovane, and 9 for which no satisfactory attribution has yet been suggested.

It must be emphasised that though the album contained all but two of the 25 drawings by the two
Zuccaros exhibited in the Lawrence Gallery in 1836, it was not put together by Lawrence and its contents
do not reflect his connoisseurship. There is no reference to any such volume in the MS inventory of his
collection made soon after his death in 1830; the Lawrence Gallery catalogue refers to a total of 80
drawings, whereas the album contained only 73; and the binder's stamp inside the cover is datable not
earlier than 1834. By no means all the drawings by Taddeo in the Lawrence Collection were included in it.
The British Museum study for the *Donation of Charlemagne* was only omitted because of its exceptional
size, but in other cases Taddeo's authorship passed unrecognised. For example, of the 25 items which
appeared under the name of Polidoro da Caravaggio in the same Lawrence Gallery exhibition, three
(nos. 26, 36 and 38) and possibly a fourth (no. 46) are identifiable with drawings by Taddeo (cat. 250, 160,
119 and 112 respectively), and other drawings by him were attributed when in the Lawrence
Collection to Michelangelo (cat. 22), Barocci (cat. 101), Rubens (cat. 103) and Perino del Vaga
(cat. 105).

Of the two drawings in the Lawrence Gallery catalogue still unaccounted for, no. 24 is described
as 'A Female Figure holding a sword, probably allegorical of Justice; signed by the artist; pen and India'
ink on a grey ground. Capital. Size, 15½ inches by 9½ inches. From the Collection of W. Y. Ottley, Esq.
(in the latter's 1814 sale catalogue, lot 1493, the figure is said to be standing in a niche and the signature is
transcribed as *Thadeo Zuccaro F.*). This description does not apply to no. 3 in the Rosenbach Album.
Though the subject is an allegorical figure of *Justice* holding a pair of scales, neither the medium (oil on
paper, varnished) nor the measurements (15½ × 6¾ inches) agree with the description in the Lawrence
Gallery catalogue, the figure is not holding a sword, and there is no trace of the inscription. The drawing
has no connexion with the Zuccaros and is clearly later in date, perhaps even as late as the XVIII century.
One can only suppose that when Woodburn was making up the album he put this drawing in by mistake,
misled by its superficial likeness to the description in the Lawrence Gallery catalogue. No. 23 in the
Lawrence Gallery catalogue, 'The Bath of Diana – an elegant sheet of studies; pen lightly washed with
bistre. 11 inches by 9¼. From the Collection of W. Y. Ottley, Esq.' (presumably lot 1491 in the latter's
1814 sale, attributed to Taddeo: 'a leaf of poetical designs of Venus bathing, *on both sides* – free pen and
wash'), seems never to have been in the album. Were it not for the absence of Lawrence's collector's mark
and the difference in size (10⅜ by 8 inches) it would be tempting to identify it with the double-sided sheet
of studies in pen and brown wash for a circular composition of Diana bathing with her Nymphs (cat.
141), which the Metropolitan Museum acquired in 1956.

while that of Mrs Krautheimer's drawing is the Piccolomini arms in an oval. A more highly finished version of the *recto* composition is at Düsseldorf (cat. 27).

212 —— 472/22, no. 20

A RIVER-GOD **Plate 19**
Pen and brown wash, heightened with white, over black chalk on blue paper. 202:286 mm.

Inscr.: *Agostino Carracci*. The presence of the drawing in the Phillipps-Rosenbach album shows that Woodburn, in spite of this inscription, believed the drawing to be by one or other of the Zuccaros. It seems certainly to be by TZ and to date from not later than the early 1550's. Whether Woodburn was following some earlier opinion, either Lawrence's or his expert adviser Ottley's, is impossible to say. I could find no reference to this drawing in the MS inventory of the Lawrence Collection (copy in BM. Printroom Library) or in any of the Lawrence Gallery exhibition catalogues, but the fact that it did not pass to the Earl of Ellesmere with the rest of Lawrence's Carracci drawings in 1837 (see P. A. Tomory, *The Ellesmere Collection of Old Master Drawings*, Leicester, 1954, pp. 5 f.) suggests that the attribution to Agostino was abandoned before then. See p. 31.

213 —— 472/22, nos. 24 and 25

THE MARRIAGE OF THE VIRGIN
Pen and brown wash. 275:746 mm. The sheet has been divided vertically down the middle and the two halves are now mounted separately.

Inscr. on each half of the sheet: *Federico Zuccaro*. A drawing corresponding exactly with the centre part of this composition, retouched by Rubens, in the Louvre (4521; 1969 Exh., no. 40; repr. *Master Drawings*, iii (1965), pl. 11), is inscribed *f zuccaro* in an old hand. See p. 99.

214 —— 472/22, no. 32

FEMALE FIGURE HOLDING A STAFF, SEATED ON A RECTANGULAR FRAME
Pen and brown wash, heightened with white, on brown paper. 275:211 mm.

The figure occurs above one of the windows in the Sala dei Fasti Farnesiani in the Palazzo Farnese, Rome. See cat. 96.

215 —— 427/22, no. 34a

THE BATTLE OF COSA **Plate 147**
Pen and brown ink and grey wash over black chalk. Some outlines (e.g. of the dead man in the foreground) reinforced in brown wash. 429:320 mm.

Inscr. by Sebastiano Resta (Lugt 2981: *l. 51 b*): *di Taddeo è per la Sala del Palazzo Farnese, ma federico che terminò la pittura lasciata abozzata la variò in dipingerla*. The reference is presumably to the battle-scene between the windows in the Sala dei Fasti Farnesiani in the Palazzo Farnese in Rome (see cat. 39), the decoration of which was completed by Federico after Taddeo's death (see p. 122). The drawing is in fact a study for the fresco, inscribed *Petrus Farnesius hostibus S. Romanae Ecclesiae fusis et profligatis in vestigiis Cosae Vulcentium, Orbitellum victoriae monumentum condidit Anno Sal. M.C.*, on the ceiling of

the Sala dei Fatti Farnesiani in the Palazzo Farnese at Caprarola (*B. Mag.*, cv (1963), p. 311, fig. 31). It corresponds closely with the fresco, except that the latter is circular.

216 —— **472/22, no. 39**

ALLEGORICAL FIGURE OF 'ABUNDANCE, THE DAUGHTER OF PEACE'
Pen and brown wash. 280:132 mm.

This study for one of the allegorical figures in the Anticamera del Concilio is attributable to Federico on grounds of style and handling. Another study by him for one of the companion figures, *Abundance* or *Charity*, is in the Uffizi (cat. 47). The engraving of the present figure in Georg Kaspar Prenner's publication *Illustri Fatti Farnesiani coloriti nel Real Palazzo di Caprarola*, Rome, 1748, is entitled *Abundantia Pacis Filia*. An elaborated variant in reverse exists in several versions, all by Federico, as Philip Pouncey was the first to point out (e.g. Windsor 4786: Popham-Wilde, no. 50, fig. 18, as Niccolò dell' Abbate). These cannot be studies for the fresco since the figure and her attributes are too widely spread out to fit into the niche, but must be derivations from it.

217 —— **472/22, no. 41**

THE TRIUMPH OF BACCHUS **Plate 138**
Pen and brown wash over black chalk. Squared in black chalk. 157:420 mm.

Inscr. on back of mount: *Federigo Zuccaro in Caprarola vicino a Roma J R.* The drawing seems to be by Taddeo, however, and is possibly the one referred to by the younger Jonathan Richardson as a study for the '*Bacchanale*' in the Stanza dell' Autunno at Caprarola (*An Account of some of the Statues, Bas-Reliefs, Drawings and Pictures in Italy . . .* London, 1722, p. 291). See p. 109.
The composition is inspired by an Antique relief (cf. e.g. the sarcophagus front now at Woburn Abbey: Reinach, *Répertoire de reliefs*, Paris, 1909–12, ii, p. 538).

218 Princeton, University Art Museum 53–38

Recto. A KNEELING NUDE MAN AND OTHER STUDIES
Verso. A GROUP OF WOMEN AND CHILDREN AND OTHER STUDIES, INCLUDING ONE FOR A *LAMENTATION*
Pen and brown ink. Black chalk underdrawing in the large study on the *recto*. 279:297 mm.
J. Scholz, *B. Mag.*, cix (1967), p. 294 (**both sides repr.**).

Inscr. on old mount: *Leonardo da Vinci.* A later owner suggested that the drawing might be by Fuseli. Winslow Ames noted that the drawing was 'Zuccaroid' and Philip Pouncey later pointed out that the large study on the *recto* is for the cripple in the Frangipani Chapel *Healing of the Cripple* (Pl. 91). The group of women and children on the *verso* could be a study for the onlookers at the miracle. See pp. 73 f.

Rennes, Museum C.44–Z. *See cat. 44*

219 Rome, Gabinetto Nazionale Delle Stampe 750, formerly 125685 (as 'School of Correggio')

Recto. A GROUP OF KNEELING WOMEN **Plate 53**

[203]

Verso. THE ADORATION OF THE MAGI

Pen and brown wash, heightened with white, on brown-washed paper (*recto*); black chalk and pen and brown wash, heightened with white (*verso*). 358:268 mm.

Attributed to TZ by Konrad Oberhuber. The *recto* could be a study for part of the right-hand side of an *Adoration*. The partly cut away figure in the lower right-hand corner shows that the drawing was originally larger. The Parmigianinesque style (particularly obvious in this fragmentary figure) suggests a fairly early date, and it seems reasonable to place this drawing in the same period as studies for similar compositions datable in the early 1550's. See p. 69. The *verso* drawing must always have been very sketchy and is now so stained and damaged that it is difficult to make out; but what can be seen of the composition resembles, in essentials, Federico Zuccaro's altarpiece of 1564 in the Grimani Chapel in S. Francesco della Vigna, Venice.

220 —— F.C.125532

THE APOTHEOSIS OF AMALTHEA

Pen and brown wash. 186:180 mm.

Identified by Loren Partridge as a copy of a lost preliminary study for the fresco on the vault of the Sala di Giove at Caprarola, closely related to the one of which there is a copy in the Louvre (cat. 207). In format the two studies differ from the fresco in the same way, but whereas in the Louvre drawing two of the three nymphs in the foreground correspond with those in the painting in position and in pose, in the other the central figure in the fresco appears in reverse on the left of the group while the central figure is in a pose close to that of the left-hand figure in the fresco.

221 Rotterdam, Boymans–Van Beuningen Museum I. 116 (as 'Anonymous Italian')

STANDING MAN HOLDING A BATON **Plate 21**

Pen and brown wash, heightened with white, on blue paper. 284:155 mm.

The left arm is a *pentimento*, drawn on a separate piece of paper which has been stuck onto the drawing. The letters 'A', 'G', 'V' indicate the colours of the drapery (*azzurro, giallo, verde*). I cannot connect this study with any known composition by TZ, but the style suggests a date not much later than the mid-1550's. The pose of the right leg, with the foot raised and turned outwards so as to show part of the sole, is a motif which seems to have been inspired by Parmigianino (cf. A. E. Popham, *The Drawings of Parmigianino*, London, 1953, Pl. XLIII and p. 35).

Siena, Biblioteca Communale S. III. 2, fol. 35. *See* cat. 70

222 Stockholm, Nationalmuseum 305/1863

THE BLINDING OF ELYMAS

Pen and brown wash heightened with white oil-colour. 354:498 mm.
M. Jaffé, *Master Drawings* iii (1965), p. 22 (**repr.**).

Inscr.: *Raphael*, an attribution evidently suggested by the subject-matter. A copy by Rubens of a lost study by TZ for the fresco in the Frangipani Chapel (see p. 73). On the *verso* (repr. *Master Drawings* ut cit., fig. 1) are various figure-studies, including a river-god and another seated figure which might be a river-god or a captive, which do not seem necessarily to have any connexion with TZ.

223 —— 452/1863

Recto. A STANDING BEARDED MAN, HOLDING A BOOK IN HIS LEFT HAND AND WITH HIS RIGHT ARM RAISED, APPARENTLY SUPPORTING A CROSS (ST PAUL OR ST ANDREW) **Plate 100**
Verso. DESIGN FOR THE STUCCO DECORATION OF A CEILING
Brush drawing in red wash and white bodycolour, with traces of underdrawing in black chalk; the book outlined in pen (*recto*); pen and brown ink (*verso*). 287:176 mm.
Sirén, no. 385.

Traditionally attributed to TZ. In its technique, and in the placing of the figure in isolation on the page, the *recto* drawing resembles other studies of single figures, some of which are connected with the Frangipani Chapel (see p. 77). Sirén's identification of the figure as St Andrew is natural in view of the cross which he appears to be holding, but the relation of the cross to the arm and hand is ill-defined and unconvincing, and the gesture of the arm itself and the way the book is held are precisely what we find in the studies for St Paul in the Frangipani Chapel miracles. It seems more likely that the figure was originally St Paul and that TZ himself later transformed it into St Andrew by adding the cross.
The drawing on the *verso*, a schematic diagram of the stucco decoration of a ceiling with four elongated oval spaces surrounding a central rectangular space, could equally well be connected with the Camera di Isabella at Bracciano or with one of the two rooms in the Palazzo Caetani (see p. 96). Both schemes of decoration must date from about the same time, *c.* 1559–60.

—— 456/1863 (**Sirén, no. 389**). *See* cat. 100

224 —— 458/1863

A MAN IN A PLUMED HAT SITTING AT A TABLE **Plate 118**
Black chalk. The lips of the figure in red chalk (the Schönbrunner-Meder facsimile reproduces the drawing as if wholly in black chalk). 254:171 mm., including a strip 9 mm. wide added to the top edge.
J. Schönbrunner and J. Meder, *Handzeichnungen alter Meister aus der Albertina und anderen Sammlungen*, Vienna, 1896–1908, no. 1312; Sirén, no. 391.

Inscr. in black chalk near the right-hand edge, possibly by the artist himself: *31*, and in pen, in Federico's hand: *schizzo de mano de Tadeo*. A later hand has added *Zuccaro*.
Were it not for the old inscription, one might have been tempted by the directness of observation and the psychological realism of this somewhat grotesque but at the same time moving portrait to begin looking for its author in the circle of the Carracci towards the end of the century.
On the *verso* are two drawings by Federico of a monster in red and black chalk.

225 —— 479/1863

Recto. CAESAR DESTROYING THE BRIDGE AT GENEVA
Verso. FIGURE-STUDIES
Pen and brown wash, with underdrawing in stylus and black chalk (*recto*); black chalk (*verso*). 260:325 mm.
Sirén, no. 403; J. A. Gere, *B. Mag.*, cv (1963), p. 306 (**recto repr.**).

[205]

Inscr.: *Cesare presso a gienova rompe il ponte*, and on the mount: *Federico Zuccaro*. Sirén accepts this attribution, but there can be no doubt that the drawing is by TZ: not only is it a study for the maiolica design known in its finished form in the drawing in Lord Leicester's collection (cat. 87), but the black chalk studies on the *verso*, some of which are for figures on the *recto*, are in TZ's freest and most masterly style, comparable with that of the studies for the Mattei Chapel (cat. 127, 146, 211 *verso*).

The style of the inscription is identical with that on the underside of the dish in the Victoria and Albert Museum for which Lord Leicester's drawing served as the design, and is in the same hand as that on another drawing of a circular composition also representing an episode from Caesar's *De Bello Gallico* (cat. 133), of which a more finished version likewise exists.

—— 781/1863 (Sirén, no. 215). *See* cat. 105

226 —— 1313/1863 (as 'Anonymous Italian')

DESIGN FOR AN APSIDAL CHAPEL DEDICATED TO ST JOHN THE EVANGELIST, WITH SCENES OF THE SAINT PREACHING AND HIS MARTYRDOM **Plate 38**

The paintings, including the figures in the spandrels, in pen and black ink and grey wash on separate pieces of paper stuck on to the drawing of the architectural framework; the latter mostly drawn with ruler and compasses in pen and brown wash. 301:210 mm.

The style of the drawing suggests a date not later than the mid-1550's. No such commission is recorded, but the fifth chapel on the left in S. Spirito in Sassia, dedicated to St John the Evangelist, is identical in shape and proportion, with similar figures holding tablets in the spandrels above the entrance arch. The whole chapel is reproduced in P. de Angelis, *Chiesa di Santo Spirito in Santa Maria in Sassia*, Rome, 1952, p. 19, but not clearly enough for any details of the decoration to be made out. The decoration consists of five small frescoes illustrating episodes in the life of the saint, including his preaching and his Martyrdom, attributed by Gaspare Celio (*Memorie . . . delli nomi degli artefici delle pitture che sono in . . . Roma*, Naples, 1638, p. 93) to Perino del Vaga and G. F. Penni, and by Baglione (*Vite*, 1642, p. 20) to Marcello Venusti under Perino's direction. The Martyrdom, on the wall to the right of the altar, is reminiscent of the principal group in the same scene in the drawing, and the enthroned tyrant in the drawing resembles the same figure in the circular fresco of the saint's condemnation in the semi-dome. The suggestion seems at least worth putting forward, therefore, in however tentative a form, that TZ may have made a design for this chapel which served as the point of departure for the decoration eventually carried out. It is true that the greater part of the decoration of the church dates from the 1570's, but the building was completely reconstructed between 1538 and 1544, and since at least one chapel (the third on the left) was decorated *c.* 1550 (cf. de Angelis, op. cit. p. 18), the decoration of others could also have been under consideration then. There seems to be no reason for associating Venusti with these paintings; but their style can be defined in terms of Perino.

227 —— 1360-61/1863

Recto. THE VIRGIN AND ST JOSEPH AND OTHER FIGURES ON THE RIGHT OF AN *ADORATION OF THE MAGI* **Plate 77**

Verso. THE VIRGIN AND OTHER FIGURES ON THE RIGHT OF AN *ADORATION OF THE SHEPHERDS*

Black chalk, on the *recto* touched in places with white chalk. The sheet is made up of four pieces of paper, the horizontal join being just above the Virgin's elbow on the *recto*, and the vertical join close to the left-hand edge. 658:410 mm.
J. A. Gere, *B. Mag.*, cv (1963), p. 364 (**both sides repr.**).

See cat. 228.

228 —— 1362/1863

Recto. SHEPHERDS AND THE INFANT CHRIST ON THE LEFT-HAND SIDE OF AN *ADORATION OF THE SHEPHERDS*
Verso. FIGURES AND PART OF THE STABLE ON THE LEFT-HAND SIDE OF AN *ADORATION OF THE MAGI*
Black chalk. The sheet is made up of two pieces of paper, the join being about 105 mm. from the top of the *recto*. 656:368 mm.
J. A. Gere, *B. Mag.*, cv (1963), p. 364 (**both sides repr.**).

Inscr. on *recto*: *Mucian*. Nils Lindhagen was the first to observe that this drawing and cat. 227 are fragments of the same sheet, and to recognize in them the hand of TZ. Both sides of the two fragments are reproduced in the correct relation to each other, as established by the position of the joins in the paper, in *B. Mag.*, ut cit., figs 28 and 29.
Cat. 227 *recto* and cat. 228 *verso* are fragments of a study – or, to judge from its scale, an unfinished cartoon – for the panel painting of the *Adoration of the Magi* in the Fitzwilliam Museum, Cambridge, previously attributed to Battista Naldini and to Lelio Orsi (Pl. 79). Philip Pouncey's attribution of this picture to TZ is confirmed by the fact that the *Adoration of the Shepherds* of which cat. 227 *verso* and cat. 228 *recto* form part is a close variant of the drawings at Chatsworth (cat. 19. Pl. 50) and in the Uffizi (cat. 57) which are unquestionably by him and which may be rejected designs for the Mattei Chapel (see p. 68).
In the Stockholm *Adoration of the Shepherds* the elements of the Uffizi drawing are compressed laterally so that the composition is higher than wide. The presence of this drawing on the *verso* of a study for the Fitzwilliam painting suggests that it may have been adapted from the Uffizi drawing as an alternative for the picture.
Miss Renée M. Arb of Radcliffe College pointed out (letter in Fitzwilliam Museum) that the composition of the Fitzwilliam picture shows knowledge of Correggio's drawing in the Metropolitan Museum (A. E. Popham, *Correggio's Drawings*, 1957, Pl. vi).

229 —— 1387–88/1863

Recto. THE ARMISTICE BETWEEN CHARLES V AND FRANCIS I AT NICE **Plate 149**
Verso. STUDIES FOR THE *DONATION OF CHARLEMAGNE*, AND OF A MOUNTED MAN IN ARMOUR, ETC. **Plate 150**
Pen and brown wash. Some black chalk underdrawing on *recto*. 232:326 mm., upper corners cut.

[207]

Formerly attributed to Titian, and later to Cigoli. The attribution to TZ, and the identification of the studies as for Caprarola and the Sala Regia, are due to Nils Lindhagen. So far as it goes, the *recto* corresponds closely with the fresco in the Anticamera del Concilio at Caprarola. The irregularly shaped outline close to the right-hand edge of the *recto* is part of the contour of the body and neck of the horse which occupies the extreme right foreground of the fresco, and it is clear from the *verso* that the sheet has been trimmed on all four sides.

The studies of a group of figures on the *verso* are for the *Donation of Charlemagne* in the Sala Regia (first payment, 4 May, 1564). The other studies on the *verso*, of horses etc., are presumably connected with Caprarola. I can find nothing exactly corresponding with them, but similar motifs occur in several of the historical scenes in the Sala dei Fatti Farnesiani and the Anticamera del Concilio.

A free copy of the *recto* drawing, in its untrimmed state, is at Munich (2262, as Francesco Salviati). This shows the horse in the extreme right foreground in a less stolid pose than in the fresco.

A drawing in the Metropolitan Museum (80.3.4) corresponds, with certain differences of detail, with the left-hand side of the Caprarola painting and seems from its style to be a product of the studio. This fragment is enclosed by framing-lines in the same ink as the rest of the drawing, which suggest that it was intended to be complete in itself. If so, it is likely to be a later derivation, perhaps made — as the differences from the painting seem to suggest — on the basis of a preparatory drawing.

230 —— 1762 (as 'Anonymous')

A GROUP OF TEN FIGURES

Pen and black ink and grey wash, heightened with white, on pink-washed paper. 366:264 mm.

The right-hand part of a larger composition. In the extreme right foreground a woman stands, with her back to the spectator, holding a child on her left arm. To her left is a youth holding a book, seated on the edge of a wide flight of steps which apparently formed the centre of the composition. Behind him, to the left, is a seated woman looking to the left, and there are other figures in the background.

If the original of this obvious copy ever turns up, it may well prove to be a very early Polidoresque drawing by TZ of around 1548, of the period of the Louvre drawing of *Camillus and the Roman Matrons* (cat. 181. Pl. 3). But see also p. 54, note 1.

231 **Stockholm, Professor Einar Perman**

Recto. UNIDENTIFIED SUBJECT **Plate 40**
Verso. STUDIES OF *PUTTI*, ETC.
Pen and brown wash. 179:227 mm.

Previously attributed, tentatively, to Aliense. In addition to the groups of *putti* on the *verso*, there is a sketch of a figure on a bed with others standing on either side and an unidentifiable form in the air overhead. This might, for example, be the *Dream of Constantine*, but the *recto* does not seem to represent any episode in the story of Constantine or of his mother, S. Helena. The identification of the *recto* as an early sketch for the *Raising of Eutychus* in the Frangipani Chapel is also open to objection. See p. 75, note 1.

232 ——

A GROUP OF NUDE WOMEN
Pen and brown wash, with some black chalk. 122:123 mm.

Inscr. in ink, in an old hand: *Tadeo Zucharo*. A study for the group of figures in the right background of the *Bath of Diana*, a sheet of composition-studies for which is in the Metropolitan Museum (cat. 141. Pl. 121).

233 Turin, Biblioteca Reale 15800 (as 'Follower of Perino del Vaga')

A ROMAN ARMY FORDING A RIVER
Pen and brown wash. Circular: 185 mm. diameter.
A. Bertini, *I disegni italiani della Biblioteca Reale di Torino*, 1958, no. 328 **(repr.)**; J. A. Gere, *B. Mag.*, cv (1963), p. 310 **(repr.)**.

Traditionally attributed to Perino del Vaga. Bertini pointed out that it is by the same hand as a companion drawing in the Albertina (No. 237), there catalogued as by a follower of Perino: an attribution which so far as it goes is correct. Both are certainly by TZ and are evidently designs for maiolica (cf. p. 93 and *B. Mag.*, ut cit.).
Copies are in the Louvre (2236A as Vasari) and in the Hermitage (6502, as TZ: Dobroklonsky, Catalogue of XV–XVI century Italian drawings, 1940, no. 404).

234 —— **15857** (as Cavaliere d'Arpino)

'SOVEREIGNTY'
Black and red chalk. 140:99 mm.
Bertini, op. cit., no. 117 **(repr.)**.

The connexion with the figure on the vault of the Sala dei Fatti Farnesiani at Caprarola was first noted by Philip Pouncey. Loren Partridge pointed out that this drawing is *en suite* with the studies for *Courage* and *Fame* on the same ceiling, on the *recto* and *verso* of a sheet in the National Gallery of Scotland (cat. 32). All three studies are in the same technique and both sheets were in the Lely Collection in the late XVII century. The Edinburgh drawing has an old, and correct, attribution to Federico. See pp. 111 f.

—— **16037 (Bertini, no. 449)**. *See* cat. 108.

Urbania, Biblioteca Comunale 88, I. *See* cat. 239.

Venice, Accademia 178. *See* cat. 93

235 —— **917** (as Andrea del Sarto)

AN OLD MAN WEARING A CLOAK AND HAT; TWO STUDIES FOR HIS HEAD **Plate 102**
Brush drawing in red wash. The head-studies in red chalk. 352:234 mm.

Attributed to TZ by Philip Pouncey. The technique is exactly like that of other studies of single figures some of which are connected with the Frangipani Chapel (see pp. 77 f.). This could be a discarded study for one of the onlookers in the *Raising of Eutychus*.

o

G.T.Z.

236 **Vienna, Albertina** 449 (as 'Follower of Perino del Vaga')

ALEXANDER THE GREAT AND TIMOCLEA
Pen and brown wash over black chalk, heightened with white, on blue paper. 244:378 mm.
Wickhoff S. R. 538; Albertina Cat., iii, 1932, no. 19 (**repr.**); **engraved in facsimile, in reverse, by Caylus and Le Sueur (Weigel 5918).**

When in the Crozat Collection attributed to Perino del Vaga (inscr. on engraving) and in the Albertina Catalogue to a follower. The attribution to TZ, suggested independently by Philip Pouncey and Konrad Oberhuber, is confirmed by the connexion with one of the frescoes in the Palazzo Caetani (see p. 96). The drawing corresponds with the fresco in all but small details.

237 —— 452 (as 'Follower of Perino del Vaga')

ROMAN SOLDIERS DIGGING A CANAL
Pen and brown wash. Circular, 187 mm. diameter.
Wickhoff S. R. 541; Albertina Cat., iii, 1932, no. 198 (**repr.**); J. A. Gere, *B. Mag.*, cv (1963), p. 310 (**repr.**).

The traditional attribution to Perino del Vaga was accepted without comment by Wickhoff. In the Albertina catalogue the drawing is attributed to a follower of Perino. It is certainly by TZ, as Philip Pouncey was the first to recognise. Wickhoff describes the subject as 'Hannibal digging a Canal', but this must be one of the series of scenes from the life of Julius Caesar which TZ made between 1560 and 1562 as designs for maiolica (see p. 93 and *B. Mag.*, ut cit.).

238 —— 494 (as Francesco Salviati)

A WOMAN STANDING IN A ROUND-HEADED NICHE, HOLDING A WREATH AND A STAFF
Pen and brown wash, heightened with white, on brown-tinted paper. Squared in black chalk. 387:213 mm.
Wickhoff S.R. 587; Albertina Cat., iii, no. 231 (**repr.**)

Inscr.: . . .*lviati.* See cat. 239.

239 —— 495 (as Francesco Salviati)

A WOMAN STANDING IN A ROUND-HEADED NICHE, HOLDING A GLOBE AND A RUDDER
Pen and brown wash, heightened with white, on brown-tinted paper. 387:213 mm.
Wickhoff S.R. 588; Albertina Cat., iii, no 232 (**repr.**).

Wickhoff seems to have accepted *faute de mieux* the attribution to Francesco Salviati suggested by the partial inscription on one drawing: he omits the 'eigenhändig' which he adds when he found a traditional attribution convincing. He was followed by Stix and Fröhlich-Bum in the Albertina catalogue, but Konrad Oberhuber's observation that these figures are Zuccaresque in character is borne out by the existence of a preparatory study by TZ for one of them (cat. 184). It is not always easy to decide whether drawings of this carefully finished type are by TZ or his brother, but in handling these

are compatible with others which do seem to be by TZ himself: e.g. cat. 252 and 177, for the allegorical figures in the Palazzo Farnese in Rome. In any case, the preparatory study for one of them establishes TZ's responsibility for their design.

The approximate date of these figures is suggested by their general resemblance to the pair in the Palazzo Farnese (1563/4–1565): the position of the head and right arm of cat. 238 is identical with that of the male figure in the Palazzo Farnese, and that of her left arm and staff with that of the female. Their purpose was no doubt the same: to balance each other on either side of some decorative complex. A Sibyl based on cat. 238 does in fact occur on the right of the end-wall of the chapel of the Villa d'Este at Tivoli decorated on Federico's designs in 1572; her counterpart on the left, however, is not based on cat. 239 but is one of the Prophets from the Pilasters of the Frangipani Chapel transformed into a female by the removal of his beard (see p. 80, note 1).

A weaker version of cat. 238, also squared and presumably a product of the Zuccaro studio, is in the Biblioteca Communale at Urbania (88. I.; L. Bianchi, *Cento disegni della Biblioteca Communale di Urbania*, exh. Rome-Urbino, 1958–59, no. 84, Pl. 97; Gernsheim 31339). This bears no attribution, but Luigi Grassi is credited with the acute observation that the figure resembles a drawing of *Abundance* at Windsor (4786; Popham-Wilde, no. 50, fig. 18, as Niccolò dell' Abbate) which is a derivation by Federico Zuccaro of one of the allegorical figures in the Anticamera del Concilio at Caprarola.

240 —— 576

THE CULTIVATION OF SILKWORMS Plate 136
Pen and brown wash. 184:242 mm.
Wickhoff S. R. 674; Albertina Cat., iii, 1932, no. 250.

The traditional attribution to TZ was accepted by Wickhoff and in the Albertina Catalogue without reference to the connexion with the fresco in the Stanza dei Lanefici at Caprarola. The doubts expressed on p. 116 were confirmed by the appearance, only after the printing of this book was completed, of a better version, identical in handling to other studies for the same room (cat. 192 and 193) and likewise attributable to TZ himself. The drawing (**Pl. 136**) is in pen and brown wash and measures 170 × 247 mm. It was no. 35 in W. A. Martin and Brian Sewell's exhibition of Old Master Drawings (1969) as 'Ottaviano Cane', and has been acquired by the British Museum (1969-10-11-1).

241 —— 625 (as Federico Zuccaro)

A STANDING BEARDED MAN (ST PAUL) WITH HIS RIGHT ARM RAISED AND A BOOK UNDER HIS LEFT ARM
Pen and brown wash. 327:198 mm.
Wickhoff, S. R. 727; Albertina Cat., iii, no. 257 (**repr.**); W. R. Rearick, 'Battista Franco and the Grimani Chapel' in *Saggi e memorie di storia dell'arte*, 2, Venice, 1959, p. 131, note 105.

Inscr.: *T. Zucharo*. The attribution to Federico, put forward by Wickhoff and accepted in the Albertina catalogue and by Rearick, is evidently due to a misreading of the initial. Rearick, who regarded this drawing as a study for Christ in Federico's *Raising of Lazarus* in the Grimani Chapel, describes it as 'an adaptation of the figure of S. Paul of the S. Marcello type'; but in fact it is a study by TZ himself for the group of St Paul and the figures immediately surrounding him in one of the frescoes of miracles in the Frangipani Chapel in S. Marcello. On either side of St Paul are two very roughly sketched figures:

one on the right kneeling and looking up at him, balanced on the other side by another who seems to be peering round underneath the saint's raised arm. Along the lower edge of the sheet are three small sketches of groups of figures which resemble the similar sketches on the Chicago sheet of studies for the Frangipani Chapel (cat. 22, Pl. 94).

242 —— 643

CARDINAL ALESSANDRO FARNESE ENTERING PARIS WITH CHARLES V AND FRANCIS I
Pen and brown wash. Squared in black chalk. 313:445 mm.
Wickhoff S. R. 745; Albertina Cat., iii, no. 265 (**repr.**); L. Collobi, *Critica d'arte*, iii (1938), pp. 73 f. (**repr.**).

The drawing corresponds in all essentials with the fresco in the Sala dei Fatti Farnesiani at Caprarola, but there are numerous differences of detail and in its final form the composition has been extended lengthways by increasing the space between the canopy and the trees on the left. This is one of the group of *modelli* for the paintings in the Sala and the Anticamera discussed on pp. 112 ff.

243 —— 644 (as Federico Zuccaro)

GLADIATORS FIGHTING: DESIGN FOR A MAIOLICA DISH
Pen and brown wash. 284:227 mm.
Wickhoff S. R. 746 (**repr.**); Albertina Cat., iii, no. 275 (**repr.**)

Though the attribution to Federico was accepted by Wickhoff with the comment 'eigenhändig', the drawing is not by him. The composition is certainly Taddeo's. It is very close in general style to another circular composition of the same subject which occurs on at least two pieces of maiolica and in an old copy in the Louvre (cat. 196). In both of these, as in TZ's circular composition of a chariot race (see cat. 179), the foreground plane is delimited by a fence or barrier in the background which forms a horizontal line dividing the composition about a third of the way from the top. The drawing itself does not seem to be from Taddeo's own hand, but might be a product of his studio. Part of the decorative border of the dish is also shown in the drawing.

244 —— 861 (as Allegrini)

A STANDING BEARDED MAN (ST PAUL) WITH HIS RIGHT ARM RAISED AND A BOOK UNDER HIS LEFT ARM **Plate 101**
Brush drawing in grey wash. The background washed with pale brown. 418:251 mm.
Wickhoff, S. R. 966.

Inscr.: *Allegrini*. This attribution was accepted by Wickhoff without comment, but, as Konrad Oberhuber pointed out, the drawing is by TZ. To judge from the technique, which is exactly like that of the drawings in red wash connected with the Frangipani Chapel (see pp. 77 f.), and the pose and type of the figure, this is probably a study for St Paul in one of the Frangipani miracles. A close variant in black chalk, too weak to be by TZ himself, is in the Uffizi (11007F, as Federico Zuccaro; Gernsheim 40260).

245 —— 1623 (as Paolo Farinati)

THE BIRTH OF THE VIRGIN **Plate 29**
Pen and brown wash. 252:316 mm.

Wickhoff, S. V. 209; Albertina Cat., i, no. 173; Uffizi 1966 Exhibition, under no. 7.

Inscr. on mount: *attribué à Paul Véronese*. Wickhoff's comment that the drawing is by a follower of Francesco Salviati, which at least placed it in the right *milieu*, was disregarded by the authors of the Albertina catalogue who catalogued it – presumably on the strength of the inscription on the mount – under the name of Paolo Farinati. This is certainly an early drawing by TZ of around 1550. Another study for the same composition, previously attributed to Perino del Vaga, is in the Uffizi (cat. 38. Pl. 28). See p. 48.

246 —— **1711** (as Alessandro Turchi)

TWO WOMEN WITH AN INFANT **Plate 30**

Pen and brown wash over red chalk. Some of the contours gone over and emphasised in black chalk, by the artist. The pounced-through lines on the right of the sheet have no connexion with the drawing. 304:233 mm.

Wickhoff, S. V. 301; J. Schönbrunner and J. Meder, *Handzeichnungen alter Meister aus der Albertina und anderen Sammlungen*, Vienna, 1896–1908, no. 1273; Albertina Cat., i, no. 222; T. Pignatti, *Disegni Veneti del Seicento* (estratto dal catalogo della mostra 'la pittura del Seicento a Venezia'), 1959, no. 19.

Inscr. on the mount: *Alexandre Turchi, dit l'Orbetto Véronèse*, an attribution accepted by Wickhoff, in the Albertina Catalogue, and by Pignatti. I cannot follow Pignatti in seeing any resemblance between the facial types, drapery, etc. in this drawing and those in paintings by Turchi. The drawing is certainly not by the hand responsible for the one in the National Gallery of Scotland (RSA 165; repr. K. Andrews, *Catalogue of Italian Drawings*, 1968) identified by Philip Pouncey as a study for Turchi's painting of the *Triumph of Cupid* in the Rijksmuseum. The handling of the wash, the continuous, irregular, thick line emphasizing the contour of the back and shoulders of the foremost figure, the superimposition of wash over the hatching in the shaded areas, the shape of the hands with widely spaced pointed fingers, and the drawing of the ear, the hair and the nape of the neck of the foremost woman as well as her facial type — she might be twin sister to the youthful king in the foreground of the Fitzwilliam Museum *Adoration of the Magi* (Pl. 79) — are all characteristic of TZ.

The drawing is evidently a study for a group in the foreground of a *Birth of the Virgin* or a *Birth of the Baptist*. The two related composition-studies for a *Birth of the Virgin*, in the Uffizi (cat. 38. Pl. 28) and the Albertina (cat. 245. Pl. 29) and Lord Methuen's red chalk drawing of a seated woman holding an infant (cat. 24. Pl. 31), can hardly date from much after *c.* 1550, but the present drawing might be later.

247 —— **8208**

THE LAST SUPPER

Pen and brown wash over black chalk on brown-washed paper. The outlines indented. Extensively reworked by Rubens in white and brown oil-colour. 330:375 mm.

O. Benesch, *Kunstchronik*, vii (1954), p. 201; idem, *Jahrbuch der Kunsthistorischen Sammlungen in Wien*, liii (1957), p. 25 (**repr.**); M. Jaffé, *Master Drawings*, iii (1965), p. 22 (**repr.**).

The drawing corresponds exactly with an engraving by Aliprando Caprioli, dated 1575 (Le Blanc 3). The composition is a variant of TZ's fresco on the vault of the Mattei Chapel in S. Maria della Consolazione (Pl. 71): the shape has been made up to a rectangle and the group in the left foreground is completely different from the fresco. What can

be seen of the original drawing – most clearly discernible in the group of Christ and the Disciples in the background – suggests that this was a product of the Zuccaro studio, perhaps by the same hand as the fair copy of the study for the *Donation of Charlemagne* at Windsor, (see cat. 104), probably made on purpose for the engraving on the basis of a drawing by TZ. The difference of shape makes it improbable that this particular drawing was part of the preliminary material for the fresco itself.

A study by TZ of a man seated on the ground in very much the same pose as the figure in the group in the left foreground, is in the Uffizi (cat. 60).

248 —— 14213

THE FAMILY OF DARIUS BEFORE ALEXANDER THE GREAT
Pen and brown wash over black chalk, heightened with white, on blue paper. 398:540 mm.
Wickhoff S. R. 671; Albertina Cat., iii, 1932, no. 249 (**repr.**);
Körte, p. 71.

Inscr.: *Thadeo Zuccaro F.* Körte (oral opinion quoted in Albertina Catalogue) pointed out that this is a study for the fresco in the Sala di Alessandro at Bracciano. The two differ in certain details, notably in the position of the horse's legs and the head-dress of Darius's wife. See pp. 95 f.

—— 15463 (S. N. 214). *See* cat. 195

249 **Warsaw, National Museum 211**

Recto. CARDINAL FARNESE ENTERING PARIS WITH CHARLES V AND FRANCIS I
Verso. CARDINAL FARNESE AND CHARLES V AT WORMS
Pen and brown wash. 270:400 mm.
Muzeum Narodowe w Warszawie, Sztuka Czazow Michata Aniola, Exhibition, 1963/64, no. 108 (**both sides repr.**); Uffizi 1966 Exhibition, under no. 26

Both drawings correspond closely but not exactly with the frescoes in the Sala dei Fatti Farnesiani at Caprarola. The *recto* drawing differs from the painting and agrees with the *modello* in the Albertina (cat. 242) in certain details, especially in representing the canopy-bearer in the centre of the composition as a young man, in the poses of the left-hand canopy-bearer and of the horse immediately to the right of the tree on the left, and in the narrowing of the whole composition by reducing the interval between the canopy and the tree. See p. 112, note 1.

250 **Washington, Mr David Rust**

GROUP OF ROMAN SOLDIERS WITH HORSES **Plate 9**
Pen and brown wash over black chalk, heightened with white, on blue paper. An irregular piece torn out and made up on the left-hand side. 257:282 mm.
Lawrence Gallery, 7th Exhibition [Polidoro], 1836, no. 26.

Attributed to Polidoro da Caravaggio in the Lawrence Gallery and to Federico Zuccaro in Sotheby's sale of 12.iii.1963, lot 22. The drawing is certainly by TZ, however, and belongs to the early Polidoresque group of designs for façade-decorations.

[214]

A nude study in red chalk for the figure holding the horse's bridle in the centre of the composition is in the Metropolitan Museum (cat. 143 *recto*. Pl. 12).

251 ——

GROUP OF FOUR STANDING WOMEN **Plate 20**
Pen and brown wash. 204:124 mm.

Early, *c.* 1550.

252 **Weimar, Goethe–Nationalmuseum**

A STANDING NUDE MAN IN A NICHE, HOLDING A STAFF IN HIS RIGHT HAND AND A CORNUCOPIA IN HIS LEFT
Pen and brown wash, heightened with white. Traces of squaring in chalk. 265:180 mm.
Voss, ZdISR, p. 46, no. 16 (**repr.**).

Formerly attributed to Ligozzi. Voss's attribution to TZ is confirmed by the fact that the drawing is a study for the allegorical figure above the left-hand doorway in the Sala dei Fasti Farnesiani in the Palazzo Farnese in Rome (Pl. 167). A similar study for its female counterpart above the right-hand door is in the Louvre (cat. 177. Pl. 163).

Windsor, Royal Library 01234 (Popham–Wilde, no. 399). *See* cat. 51 and p. 54, note 1.

253 —— **01240**

THE BLINDING OF ELYMAS
Red chalk. Squared in black chalk. 395:546 mm.
Popham-Wilde, no. 1068 (**repr.**).

Attributed to TZ by A. E. Popham, and connected with the fresco in the Frangipani Chapel. In spite of its suspiciously exact correspondence with the fresco, the drawing is certainly by TZ himself: it must be the *modello* from which the full-size cartoon was enlarged.

—— **4786 (Popham–Wilde, no. 50).** *See* cat. 216

—— **4788 (Popham–Wilde, no. 754).** *See* cat. 153

—— **5066 (Popham–Wilde, no. 1074).** *See* cat. 200

254 —— **5201** (as 'Anonymous Italian')

ALEXANDER AND BUCEPHALUS
Brush drawing in red wash. 208:344 mm.

Attributions ranging from Niccolò dell'Abbate to Stradanus have been put forward at various times, but Philip Pouncey's suggestion that this is an old facsimile of a drawing by TZ is confirmed by its connexion with one of the frescoes in the Palazzo Caetani (see pp. 94 f.). The principal difference between drawing and fresco is that in the latter the group on the left has been enlarged from three figures to six. The copyist has even preserved the characteristic technique which TZ used from the late 1550's onwards.
After this book had gone to press, the original drawing in red wash and measuring 216 × 353 mm., came to light in the Weld (formerly Weld-Blundell) Collection, previously at Ince Blundell Hall and now at Lulworth (**Pl. 127a**).

[215]

255 —— 5471 (as 'after Perino del Vaga')

A NAVAL BATTLE
Pen and brown wash. Diameter of centre 342 mm. (281:350 size of whole sheet).
Popham-Wilde, no. 987; J. A. Gere, *B. Mag.*, cv (1963), p. 313 (**repr.**).

Inscr.: *Polidoro*. Catalogued by A. E. Popham as a copy after Perino del Vaga on the strength of its resemblance in composition to another *Naval Battle* which he then believed to be by Perino (cf. cat. 100). As Popham points out, both designs are for maiolica (the Windsor drawing includes the decorated border, and the composition, in an oval form, occurs inside a cistern dated 1574 in the Wallace Collection, repr. *Apollo* (1945), p. 300); but whereas the composition of the other *Naval Battle* seems undoubtedly by TZ himself and to have been designed for the 'Spanish Service' of maiolica completed by September 1562 (see *B. Mag.*, ut cit. and pp. 91 ff.), the Windsor design is derived from the background of the *Siege of Tunis* in the Sala Regia which cannot have been begun, or even contemplated, before the middle of 1564. It seems likely, therefore, that the Windsor design is a pastiche evolved in the Zuccaro studio, probably after TZ's death.

—— 5990 (**Popham-Wilde, no. 1066**). *See* p. 34

—— 6010 (**Popham-Wilde, no. 416**). *See* p. 82, note 3

256 —— 6011

Recto. A BEARDED MAN (ST PAUL) STANDING WITH HIS RIGHT ARM EXTENDED AND HOLDING A BOOK IN HIS LEFT HAND
Verso. DRAPERY OF A STANDING FIGURE AND A SMALL COMPOSITION-STUDY
Brush drawing in red wash (*recto*); the drapery on the *verso* in black chalk and the composition-study in pen and ink. 373:222 mm.
Popham-Wilde no. 1069 (***recto* repr.**).

Inscr.: *zuccaro*. Popham's specific attribution to TZ is convincing, as is his identification of this drawing as a study for St Paul in the Frangipani Chapel *Healing of the Cripple* (Pl. 91). The stance of the two figures is closely similar and, as Popham points out, a fold of drapery on the right hangs over a step in exactly the same way in both.
The drapery-study on the *verso*, with faint indications of the head and shoulders and right arm, is for the same figure. The small sketch of a composition, which resembles those on the Chicago sheet of studies for the Frangipani Chapel, shows an enthroned potentate on a dais at the foot of which are a kneeling man looking towards him with arms outstretched, and a group of two standing men apparently supporting a third.

257 —— 6016

THE BLINDING OF ELYMAS **Plate 88**
Pen and brown wash over black chalk, heightened with white, on blue paper. 392:530 mm.
Popham-Wilde, no. 1067.

Inscr. in the 'Lanière italic hand': *Taddeo* (almost entirely cut away) *Zuccaro*. Popham's suggestion that this is an early sketch for the Frangipani Chapel fresco (Pl. 89) is convincing. The symmetrical arrangement of the composition shows knowledge of Raphael's tapestry. See p. 73. A version, probably also by TZ himself, is in the Louvre (cat. 172).

258 —— 6019

A GROUP OF SHEPHERDS ON THE RIGHT OF AN *ADORATION*
Pen and brown wash on yellow-washed paper. Some outlines indented. The sheet is made up of two pieces joined horizontally. 500:418 mm.
Popham-Wilde, no. 1071 (**repr.**).

Inscr.: on the mount: *Zuccaro*. Popham's more specific attribution to TZ is certainly correct. A similar study at Christ Church, for a group of shepherds on the left of an *Adoration* (cat. 167), might be for the same composition. They belong to a group of studies for *Adorations*, some of which may be connected with the Mattei Chapel (see pp. 68 f.): certainly their style suggests a dating at about that period.

—— 6020 (Popham–Wilde, no. 1078). *See* cat. 17

259 —— 6024 (as Francesco Salviati)

TWO SLEEPING DISCIPLES Plate 68
Black chalk and brown wash. 257:391 mm.
Popham-Wilde, no. 887; J. A. Gere, *B. Mag.*, cv (1963), p. 393.

An inscription *ZUCCARO* in pencil on the old mount is mostly cut away, but enough remains to show that it was in the hand, apparently of the XVIII century, which inscribed similar attributions on other drawings in the Royal Collection (e.g. No. 256 above).
The drawing was catalogued as Francesco Salviati at Antal's suggestion, but even apart from the old inscription there can be no doubt that it is by TZ. It is a study for a group of two sleeping Disciples in the right foreground of a composition of the *Agony in the Garden* known from a small panel in the Strossmayer Gallery in Zagreb (Pl. 67) and a drawing in the possession of Mr H. M. Calmann (cat. 117 q.v.). The resemblance between these figures and those in the Mattei Chapel *Agony in the Garden* suggests a dating at about the same period. See p. 66.

—— 6849 (Popham–Wilde, no. 1070). *See* cat. 104

260 Wurzburg, Dr Detlef Heikamp (formerly)

THE COUNCIL OF TRENT
Brush drawing in red wash, with a few touches of white heightening. Squared in black chalk. Mounted on canvas and extensively rubbed, damaged, tattered and water-stained. 350:508 mm.

The drawing, which is certainly from the hand of TZ himself, corresponds except for a few minor differences with the fresco in the Anticamera del Concilio at Caprarola. It is evidently the final *modello*, made immediately before the full-scale cartoon. A com-

parable *modello* in red chalk, for the Frangipani Chapel *Blinding of Elymas*, is at Windsor (cat. 253). See p. 79.

After this book was in the hands of the printer Dr Heikamp presented the drawing to the Uffizi (105303).

261 Zürich, Kunsthaus 1943/24 (as 'Anonymous Italian')

TWO SLEEPING DISCIPLES IN AN *AGONY IN THE GARDEN*

Plate 66

Pen and brown wash over black chalk, heightened with white, on blue paper. 365:275 mm.

Inscr. on *verso*: *Tadeo Zuccaro*. Keith Andrews, who kindly drew my attention to this and to two other drawings by TZ in the Kunsthaus, recognised its resemblance to the group of studies for an *Agony in the Garden* published B. *Mag.*, cv (1963), pp. 390 ff. Some of these are by TZ himself but others are evidently the work of close followers or pupils. This one is certainly by TZ, and is probably a study for the fresco in the Mattei Chapel (Pl. 69). See p. 66.

262 —— Alter Bestand (as 'Anonymous Italian')

A HALF-NAKED OLD MAN SEATED ON THE GROUND, LOOKING UPWARDS TO THE RIGHT

Pen and brown wash, heightened with white. Somewhat rubbed and damaged. The upper corners cut. 169:169 mm.

Inscr. in lower left-hand corner: *21*. See cat. 263.

263 —— Alter Bestand (as 'Anonymous Italian')

THREE FIGURES: FRAGMENT OF A LARGER COMPOSITION

Pen and brown wash, heightened with white. Somewhat rubbed and damaged. Both right-hand corners cut. 212:135 mm.

Inscr. in lower left-hand corner: *20*. The principal figure in the group is an old bearded man holding a large book open in front of him, which is supported from below by a youthful figure seen from the back. The old man is being vehemently addressed by a younger man, whose head, in profile, and outstretched left arm pointing upwards and to the right appear in the upper left-hand corner of the fragment.

The connexion of this drawing and its companion (cat. 262) with TZ was recognised by Keith Andrews. Both in style and handling and in the types and psychology of the figures, they resemble not only each other but also the three similar fragments of a larger composition, probably *Christ and the Woman taken in Adultery*, at Edinburgh (cat. 29, 30, 31). It is impossible to fit either of the Zürich fragments into this composition, but the larger one seems to be part of a similar disputation-scene and it is possible that they came from a companion drawing or drawings.

264 Whereabouts unknown

AN ALLEGORICAL FEMALE FIGURE IN AN OCTAGON

Facsimile engraving by J. A. Schweickart in Monaldini's *Scuola Italiana*, 1787

(**Weigel 8700**). The original drawing seems to have been in pen and wash heightened with white. In the engraving the octagon measures 159:159 mm.

The engraving, inscr.: *Taddeo Zuccheri inv.*, represents a winged female figure seated on clouds, seen in foreshortening from below. Rays of light come from her head and she holds both arms extended with a wreath in either hand. This design, evidently for an octagonal painting in the centre of a ceiling, was probably made for Julius III (1550–55). Wreaths were among the charges on his coat-of-arms and often appear in decorations executed for him (see p. 75, note 1), and the style of the original (so far as this can be judged from the engraving) seems compatible with a dating in the early 1550's.

INDEX OF RELATED WORKS

References are to numbers in the Catalogue

INDEX OF SUBJECTS

References are to numbers in the Catalogue

INDEX OF PREVIOUS
ATTRIBUTIONS

References are to numbers in the Catalogue

INDEX OF PERSONS
REFERRED TO

References are to page numbers

PHOTOGRAPHIC SOURCES

Unless otherwise stated, photographs have been supplied by their owners or by the Museums, etc. in question

Agraci, Paris 11, 49, 103
Alinari–Anderson, Rome 104, 155, 159, 167
Alpenland, Vienna 30
Ashmolean Museum, Oxford 41, 42, 51
British Museum 12, 14
A. and C. Buscaglia, Milan 96
A. C. Cooper, London 20, 23, 40, 132
Michael R. Dudley, Great Milton 137
V. Edelmann, Frankfurt-a-M 35
J. Evers, Angers 106 a
John Freeman, London 31, 43, 56, 63, 82, 99 a and b (copyright Count A. Seilern), 152
A. Fréquin, The Hague 21 (copyright Boymans-van Beuningen Museum, Rotterdam)
Gabinetto Nazionale Fotografico, Rome 36, 37, 83, 85, 89, 90, 91, 98, 107 a and b, 124 a and b, 125 a and b, 126 a and b, 127 b, 128b, 129 a and b, 131, 133, 139, 141, 145 a and b.
Walter Gernsheim, Florence (*Corpus Photographicum*) 62
Kleinhempel Fotowerkstätten, Hamburg 78
Ernest Nash, Rome 114, 115
Philadelphia Museum of Art, A. J. Wyatt, Staff Photographer 144
Photo-Studios, London 2, 50 (copyright Royal Academy), 52 (copyright Royal Academy)
Donato Sanminiatelli, Rome 122 a and b, 123 a and b
Oscar Savio, Rome 53
Giovanni Scichilone, Rome 116, 117
Service de Documentation des Musées Nationaux, Paris 1, 3, 8, 32, 55, 59, 108, 110, 111, 112, 113, 120, 142, 163, 168, 171, 172
Služea, Zagreb 67
Soprintendenza ai Monumenti del Lazio, Rome, Archivio Fotografico 57, 61 a and b, 65, 69, 70, 71, 72, 73, 75, 76 a and b
Messrs. Sotheby, London 127a, 136
Stockholm, Nationalmuseum 84
R. F. Wills, Bristol 60

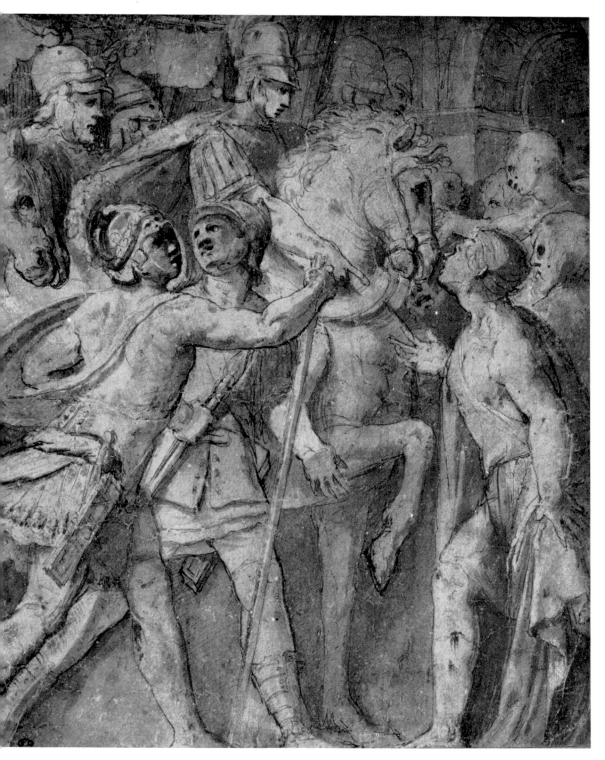

1 (cat. 182). Scene from Roman History
Louvre

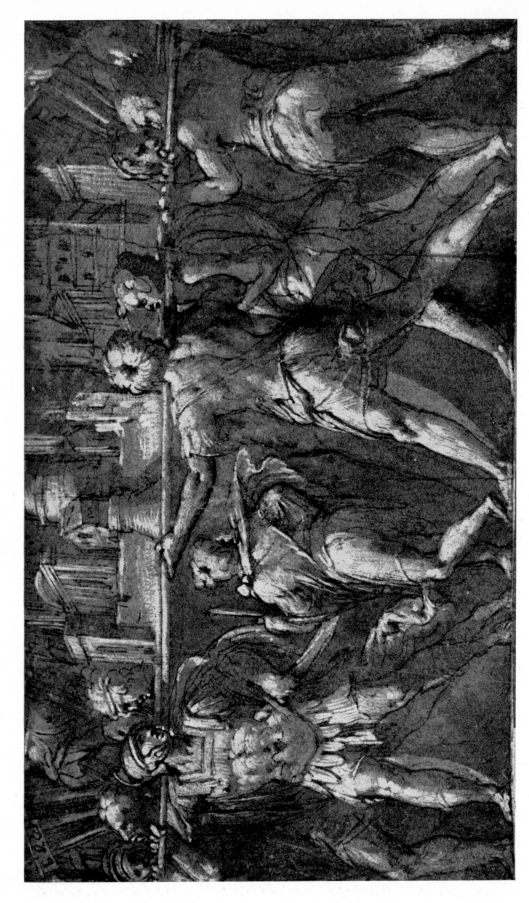

2 (cat. 119). Triumphal Procession of Roman Soldiers carrying a Model of a City

Mr. J. A. Gere

3 (cat. 181). The Roman Matrons giving their Jewels for an Offering to Apollo

Louvre

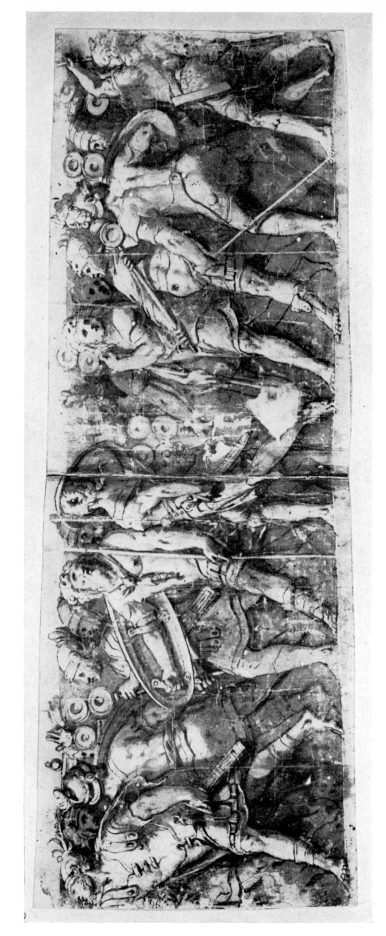

4 (cat. 128). Triumphal Procession of Roman Soldiers
Ambrosiana

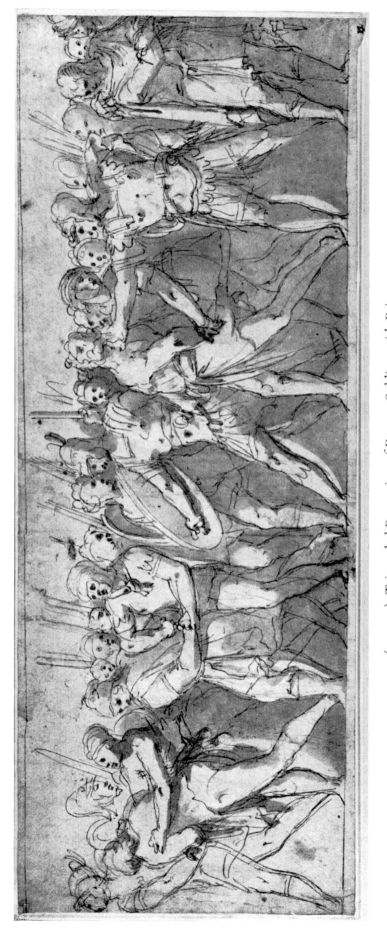

5 (cat. 105). Triumphal Procession of Roman Soldiers with Prisoners

British Museum

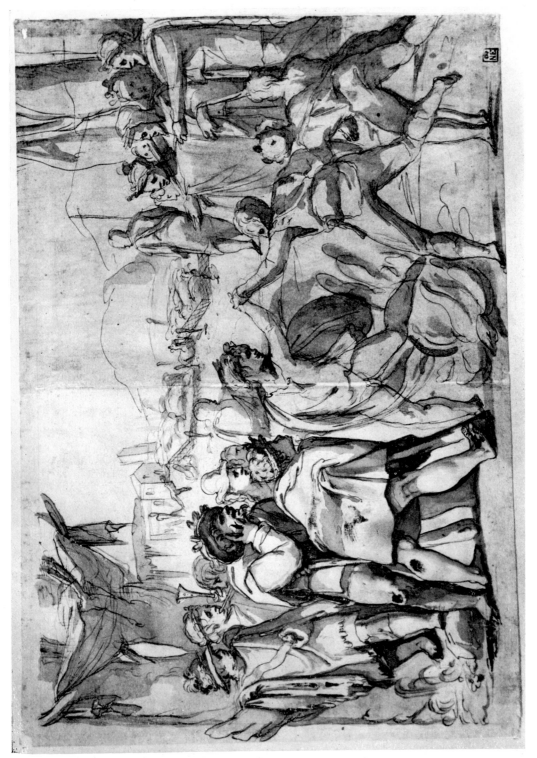

6 (cat. 16). Shepherds dancing round a Bonfire
Budapest

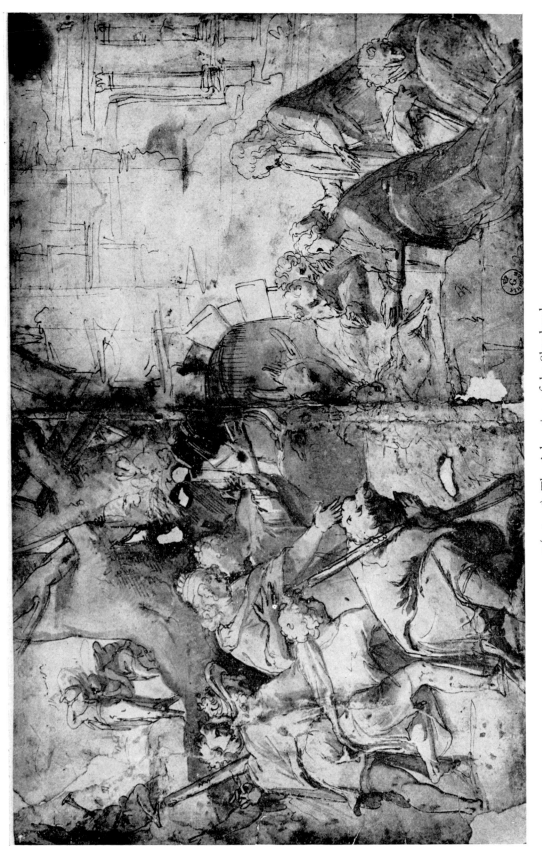

7 (cat. 76). The Adoration of the Shepherds

Uffizi

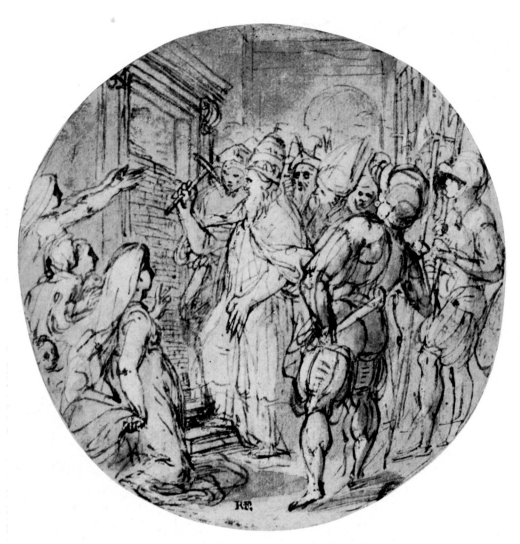

8 (cat. 189). Julius III opening the Porta Santa
Louvre

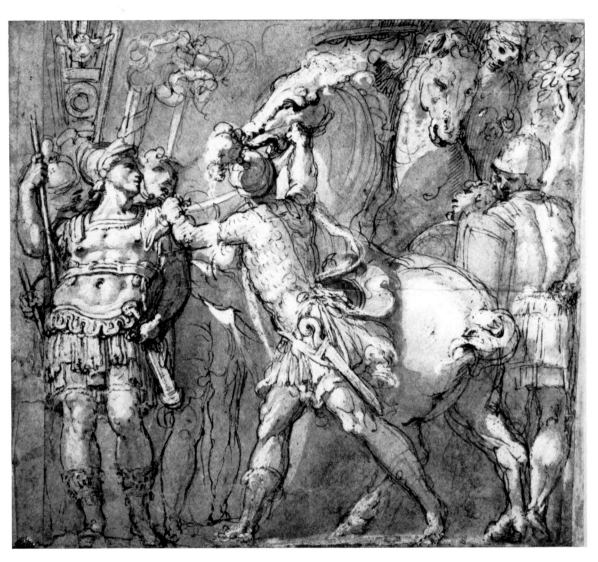

9 (cat. 250). Roman Soldiers with Horses
Mr. David Rust

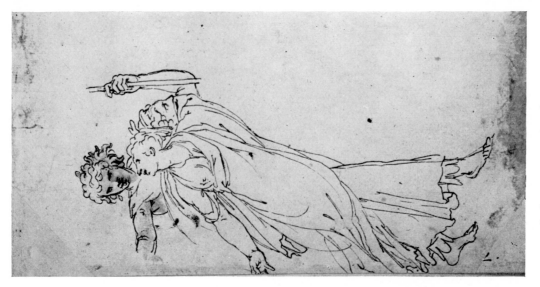

10b (cat. 51 *recto* detail). Figures

Uffizi

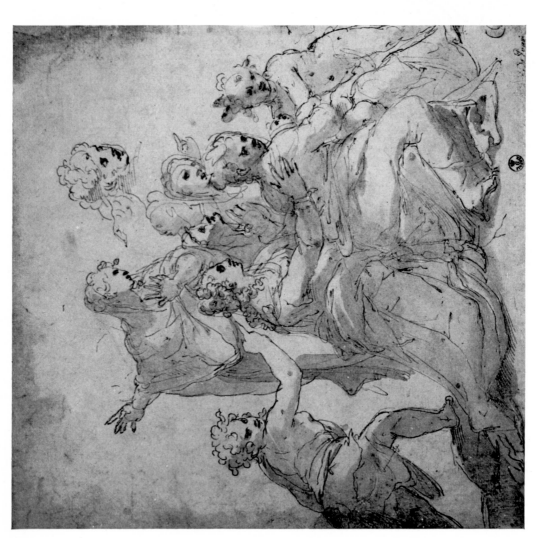

10a (cat. 51 *recto*). Group of Women and Children

Uffizi

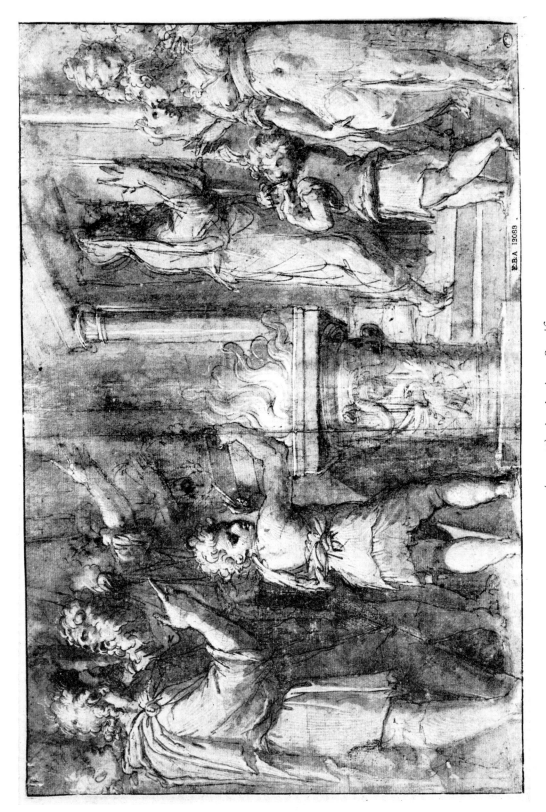

II (cat. 168). An Antique Sacrifice
École des Beaux-Arts, Paris

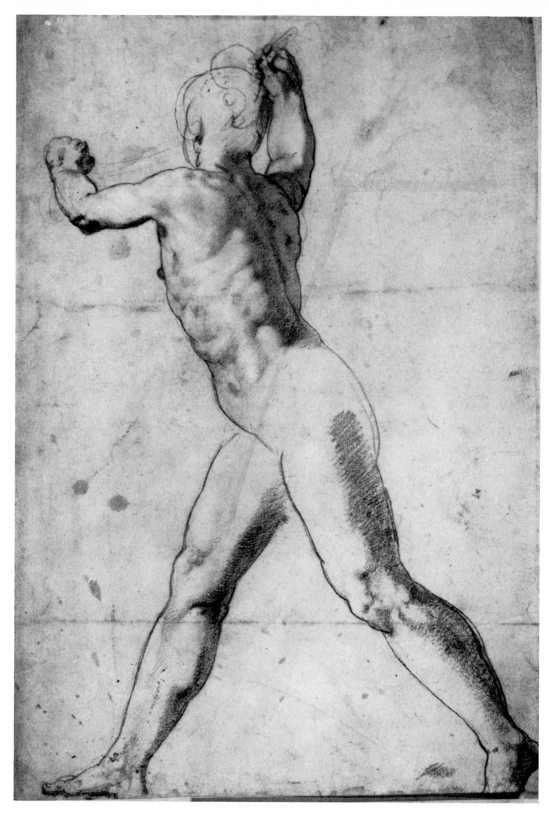

12 (cat. 143 *recto*). Study of a nude Man
Metropolitan Museum

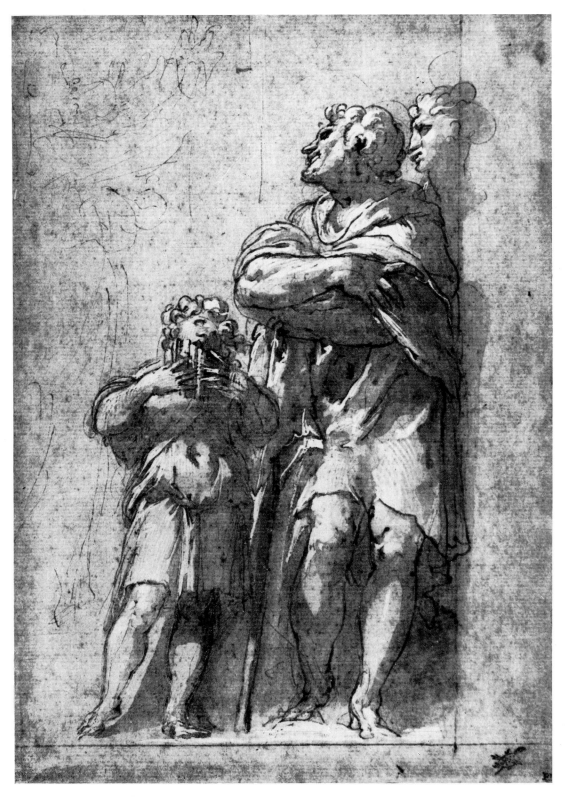

13 (cat. 160). Group of Figures
Ashmolean Museum

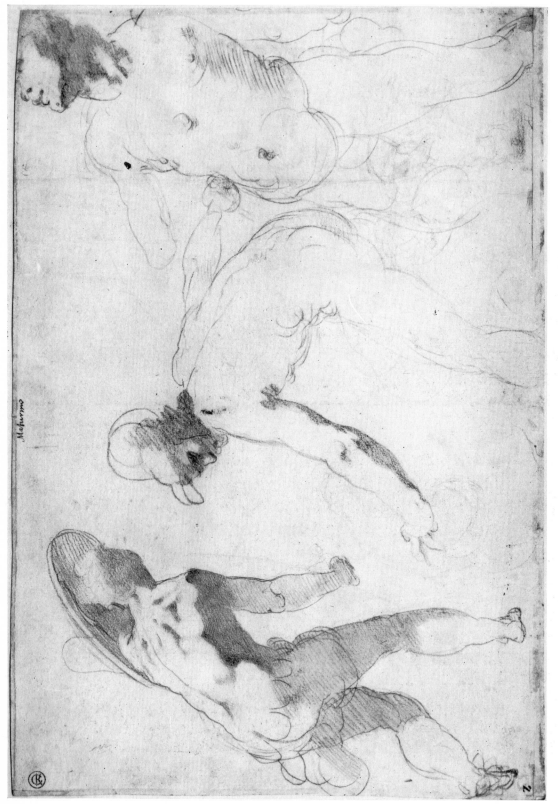

14 (cat. 143 *verso*). Studies of Soldiers

Metropolitan Museum

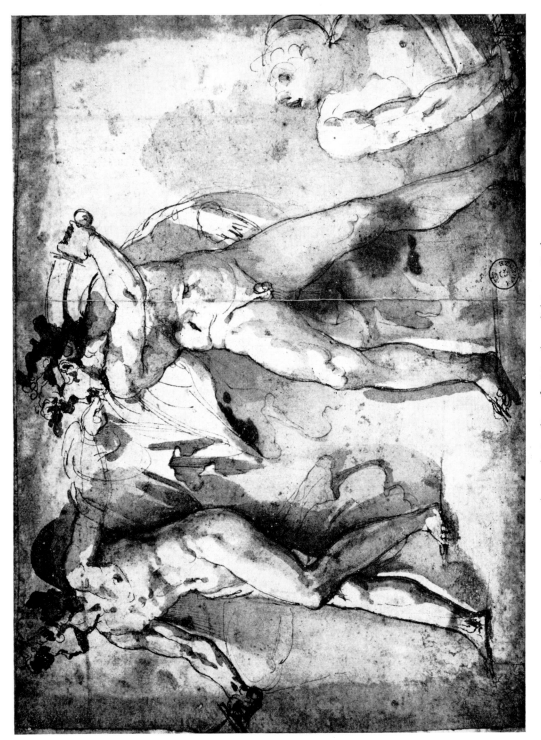

15 (cat. 72). Studies of a Man brandishing a Cutlass
Uffizi

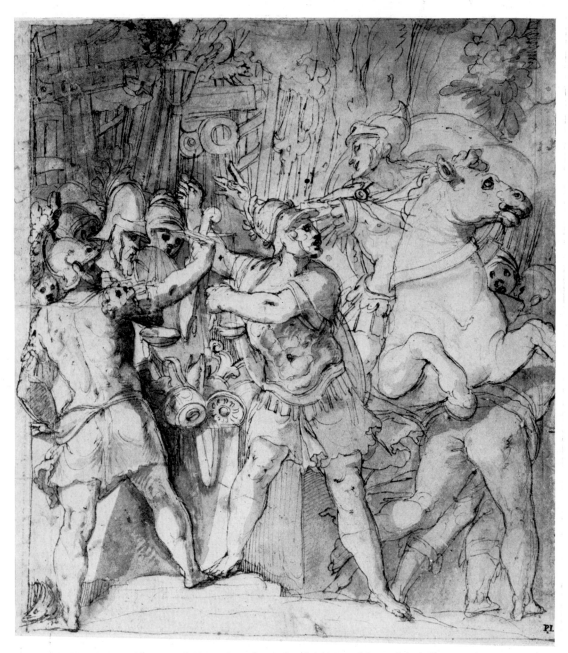

16 (cat. 110). Brennus throwing his Sword into the Scales

British Museum

17 (cat. 155). A Decorative Panel containing an Escutcheon supported by
Peace and *Strength*

Ashmolean Museum

18 (cat. 99). Fighting Horses: Copy of Part of an Antique Relief of the *Fall of Phaethon*
British Museum

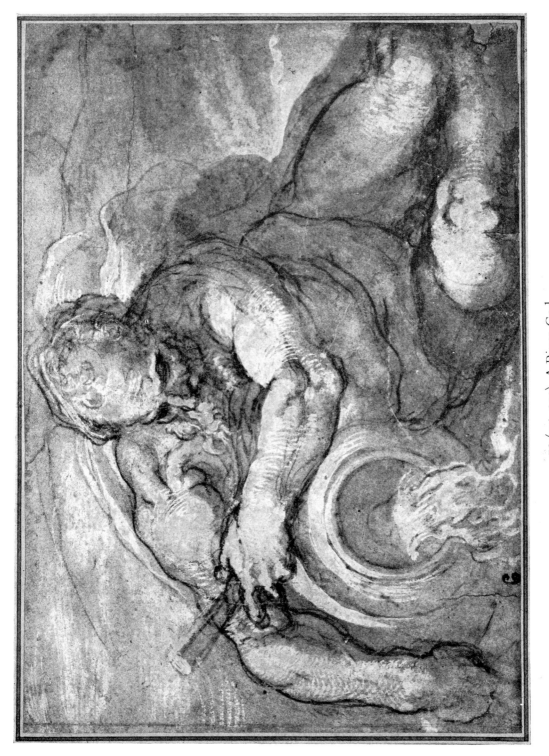

19 (cat. 212). A River-God

Philip H. and A. S. W. Rosenbach Foundation, Philadelphia

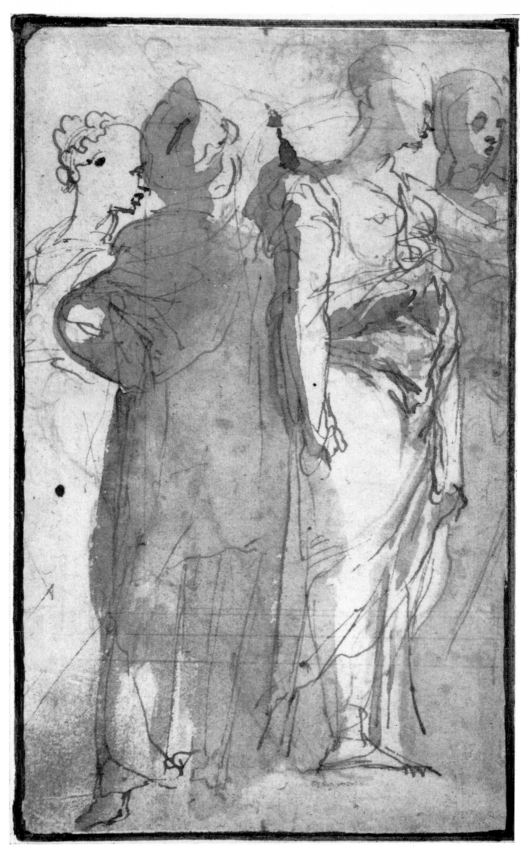

20 (cat. 251). Group of four standing Women
Mr. David Rust

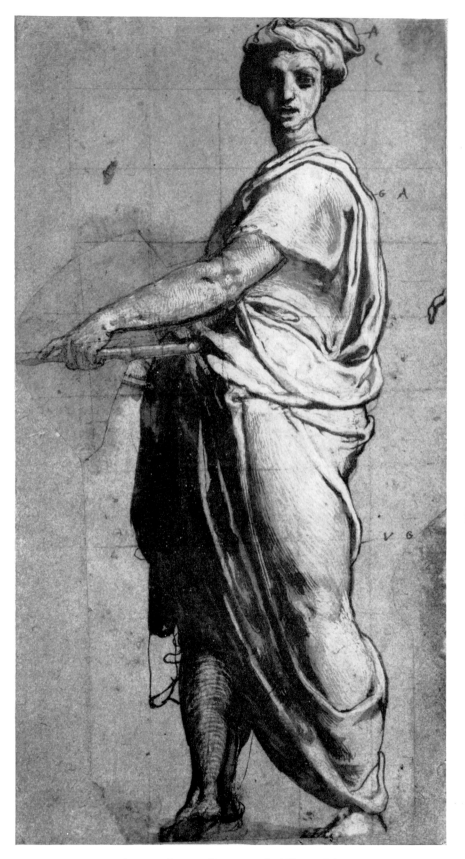

21 (cat. 221). Standing Man holding a Bâton
Boymans-van Beuningen Museum, Rotterdam

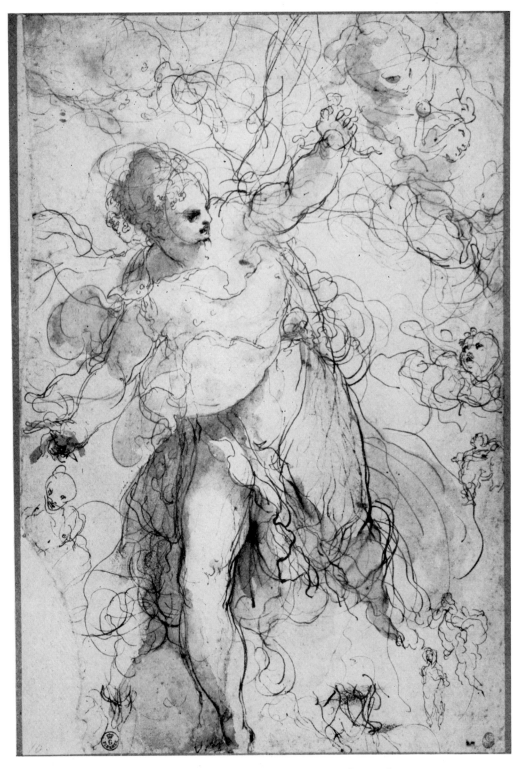

22 (cat. 48). Studies of a Woman running forward, etc.
Uffizi

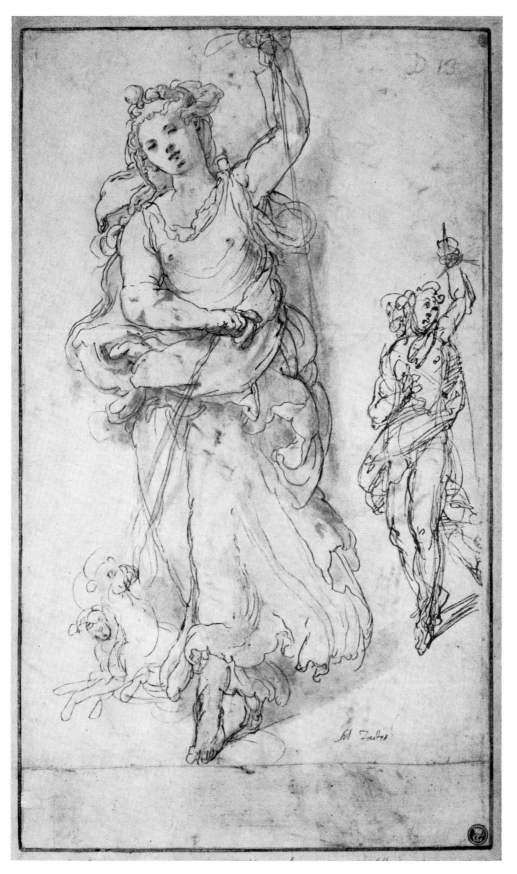

23 (cat. 23). Diana
Dr Robert Landolt

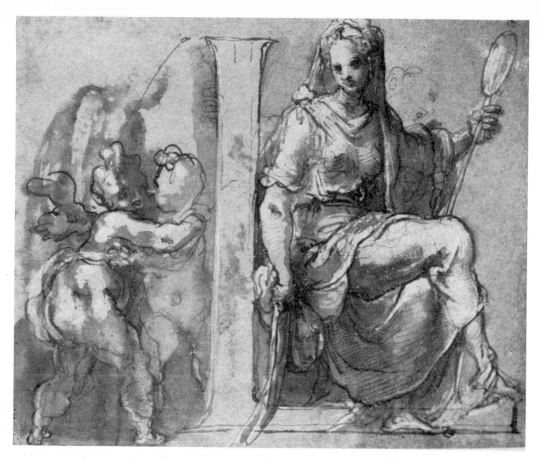

24a (cat. 12). A capital 'L' with *Prudence* and two *Putti*
Herzog Anton Ulrich-Museum, Brunswick

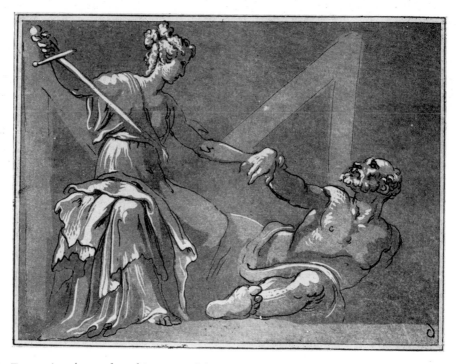

24b. Engraving (reproduced in reverse) by C. M. Metz, from *Schediasmata Selecta*, 1791

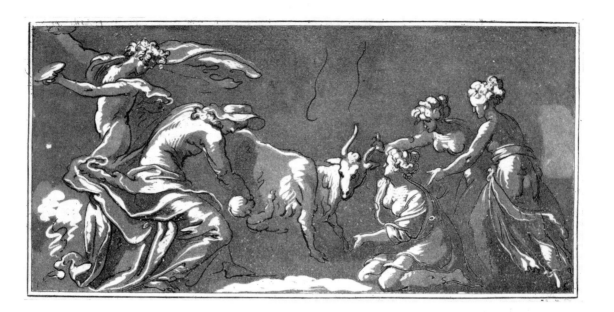

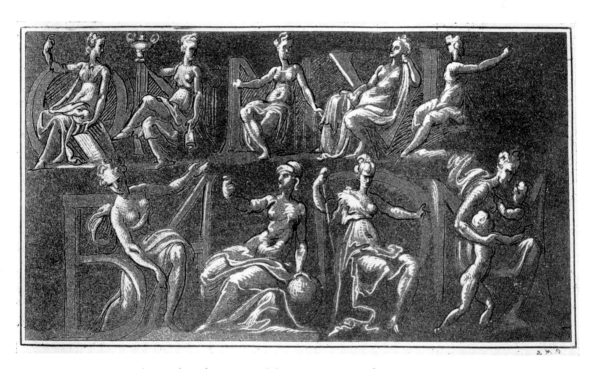

25. Engravings (reproduced in reverse) by C. M. Metz, from *Schediasmata Selecta*, 1791

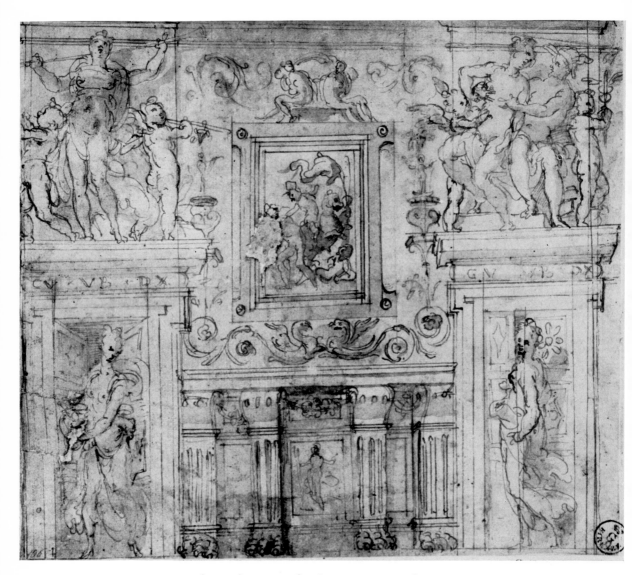

26 (cat. 36). Design for the Decoration of a Room
Uffizi

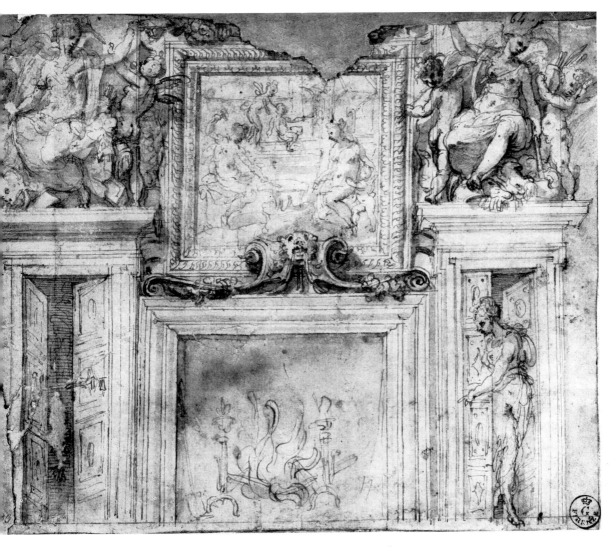

27 (cat. 35). Design for the Decoration of a Room
Uffizi

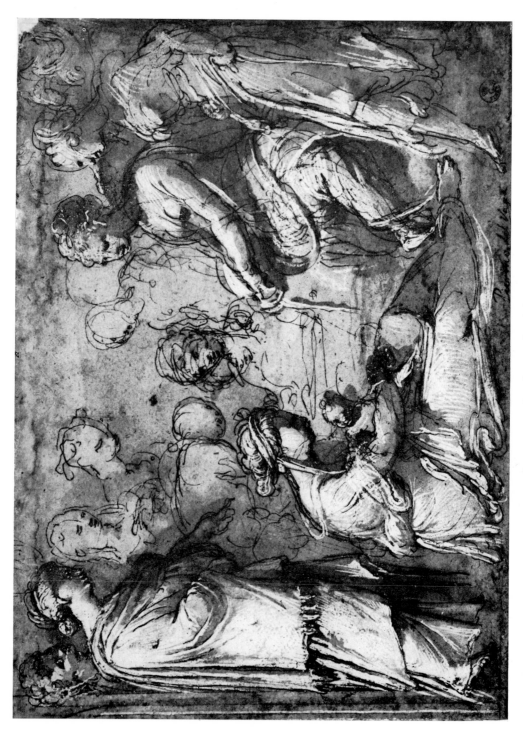

28 (cat. 38 *recto*). The Birth of the Virgin
Uffizi

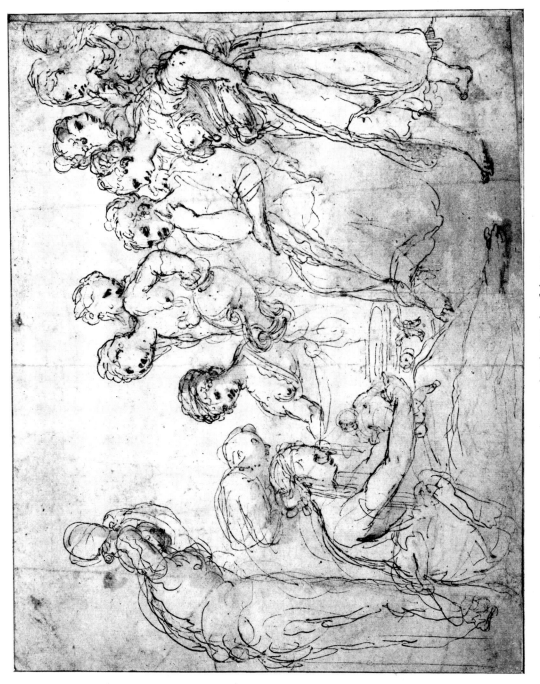

29 (cat. 245). The Birth of the Virgin
Albertina

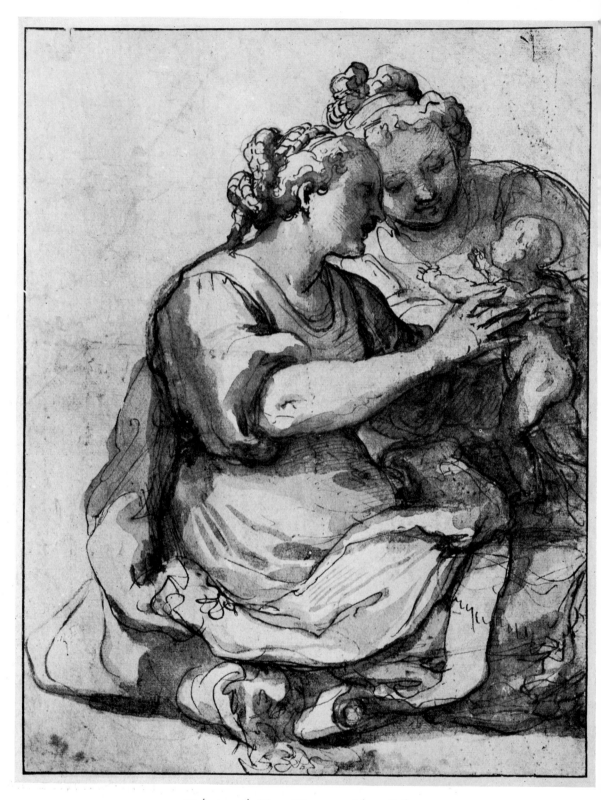

30 (cat. 246). Two Women with an Infant
Albertina

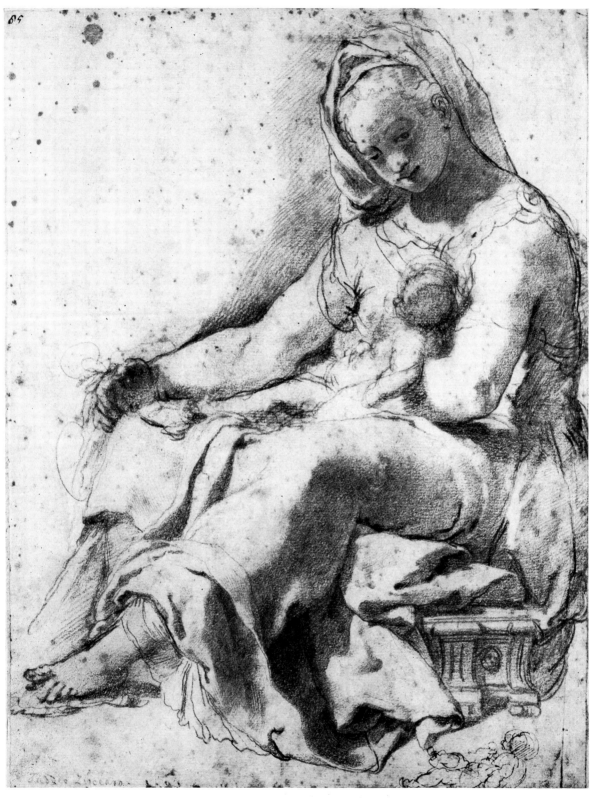

31 (cat. 24). Woman with an Infant
Lord Methuen

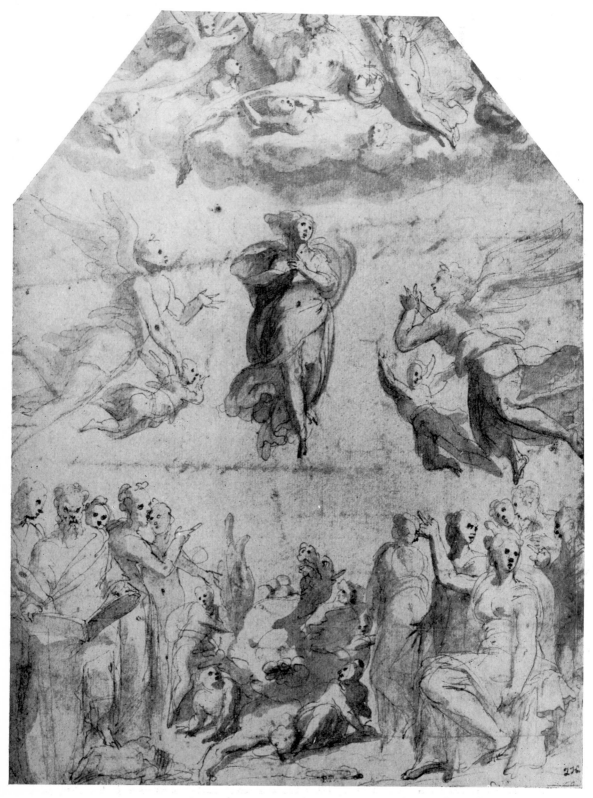

32 (cat. 183). The *Assunta* with God the Father, Prophets and Sibyls

Louvre

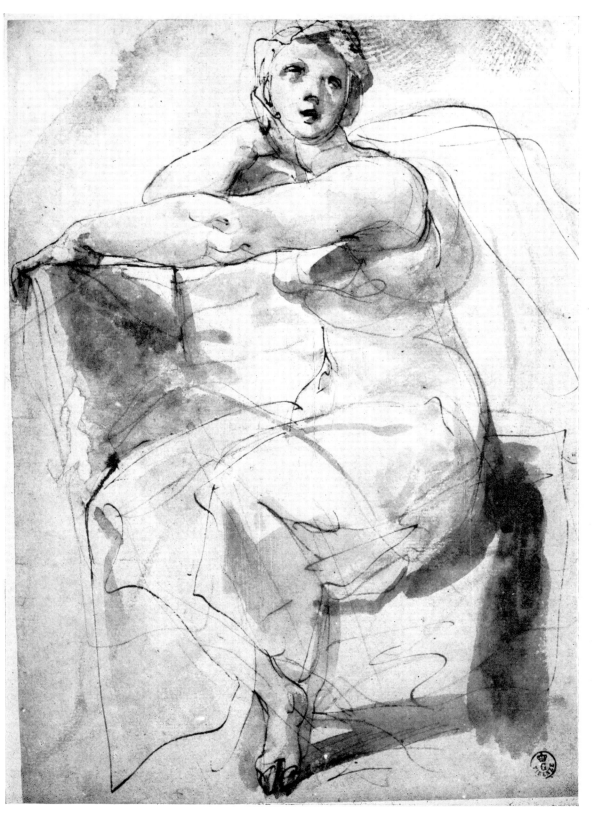

33 (cat. 69). A Sibyl
Uffizi

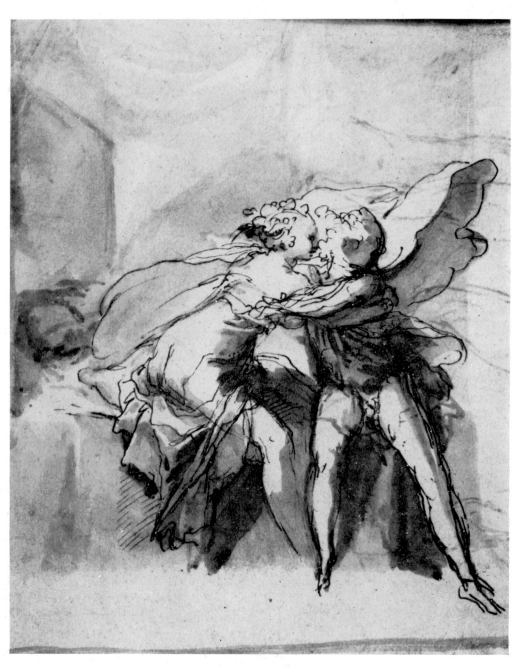

34 (cat. 120). Joseph and Potiphar's Wife

Mr. J. A. Gere

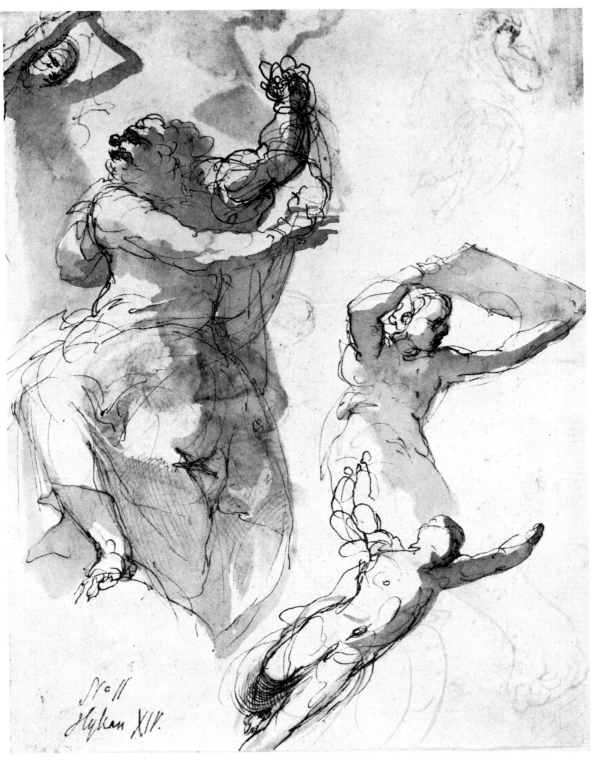

35 (cat. 82 *recto*). Studies of an Evangelist or Prophet and an Angel holding a Tablet

Staedel Institute, Frankfurt

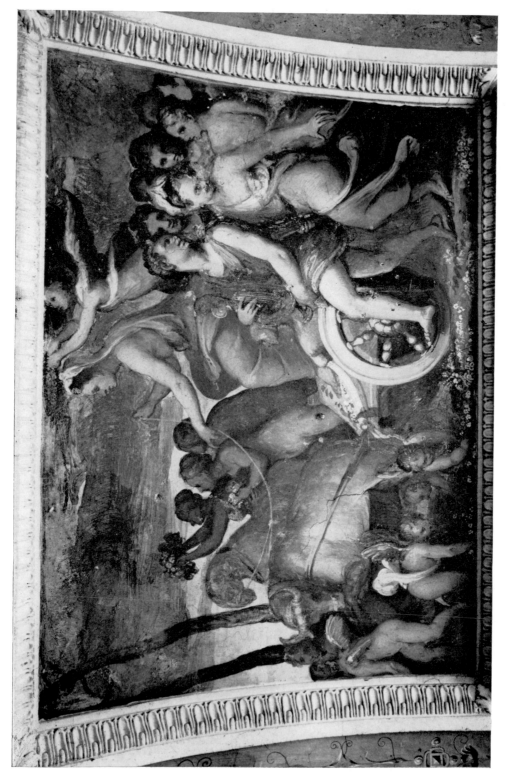

36. Spring: the Triumph of Flora
Fresco: Rome, Villa Giulia

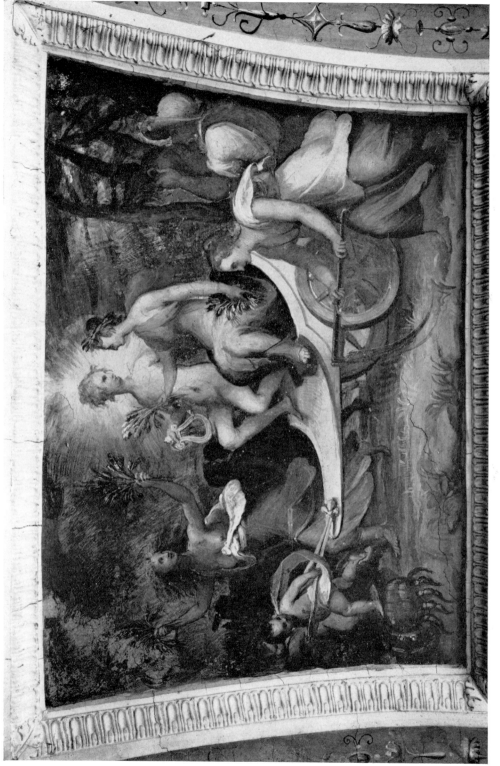

37. Summer: The Triumph of Apollo and Ceres

Fresco: Rome, Villa Giulia

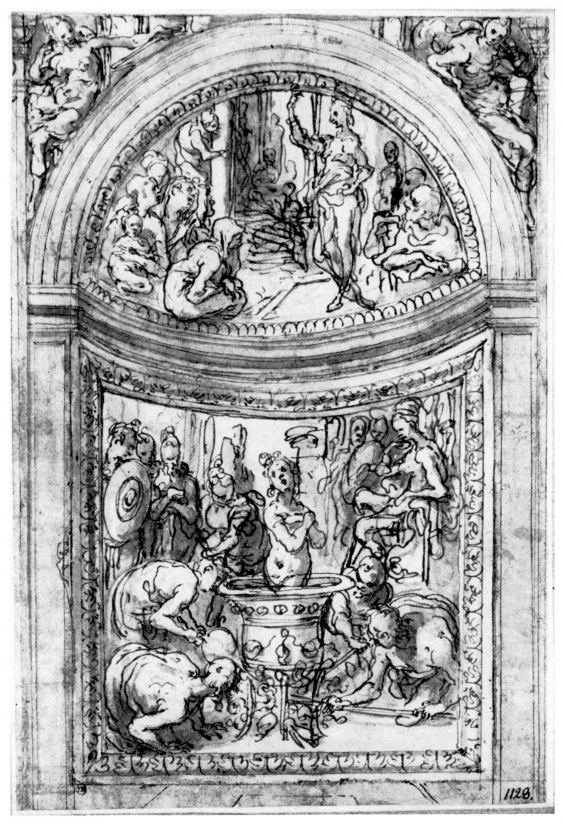

38 (cat. 226). Design for the decoration of a Chapel dedicated to St John the Evangelist
Stockholm

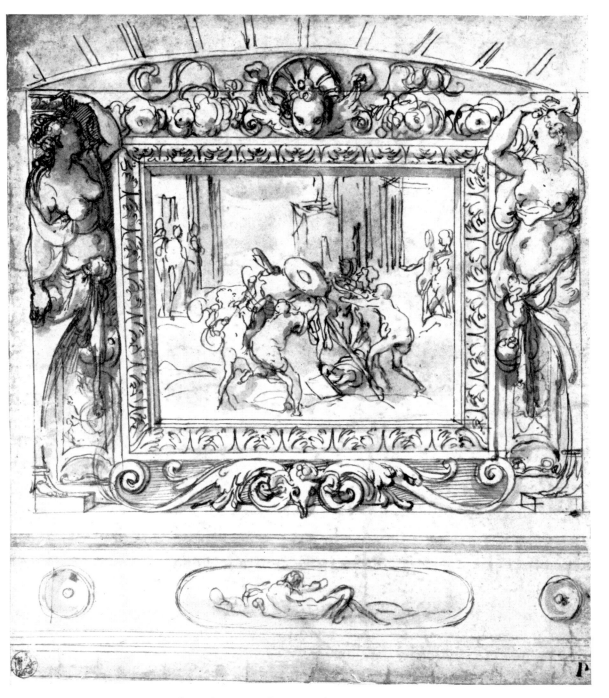

39 (cat. 7). Design for part of a Mural Decoration
Berlin

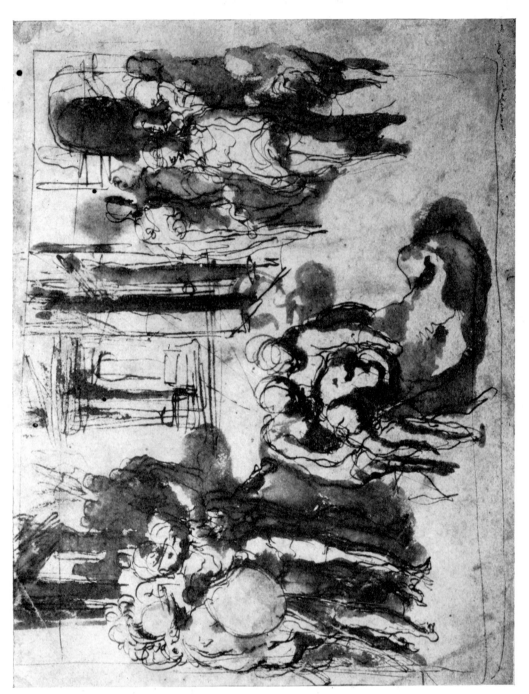

40 (cat. 231). Unidentified Subject
Professor Einar Perman

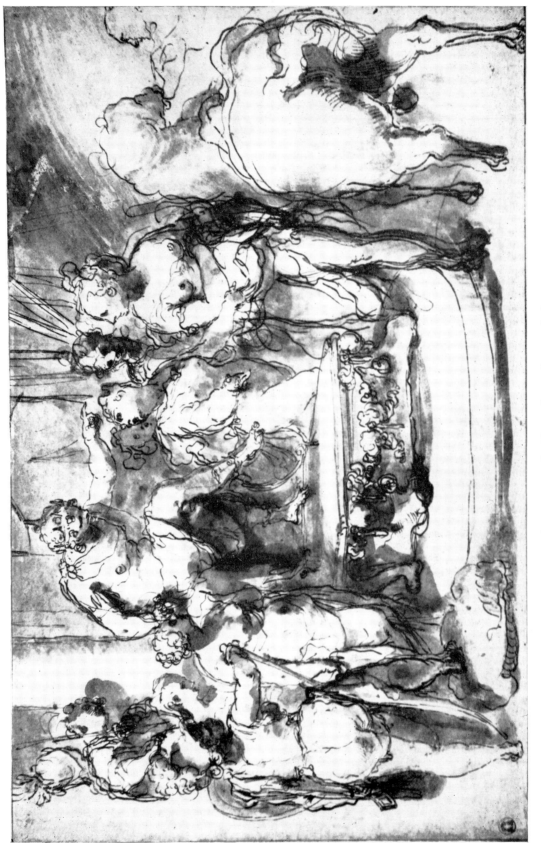

41 (cat. 162 *recto*). Alexander and Bucephalus

Christ Church

42 (cat. 162 *verso*). Designs for a Stucco *Basamento*
Christ Church

43 (cat. 121). Design for the decoration of the left-hand Side–Wall and Altar–Wall of a Chapel

Mr. J. A. Gere

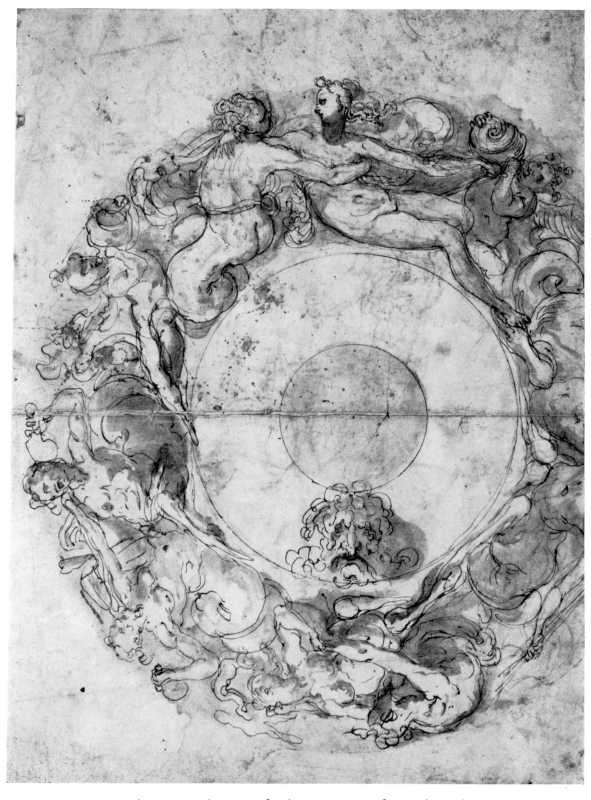

44 (cat. 211 *recto*). Design for the Decoration of a circular Dish

Philip H. and A. S. W. Rosenbach Foundation, Philadelphia

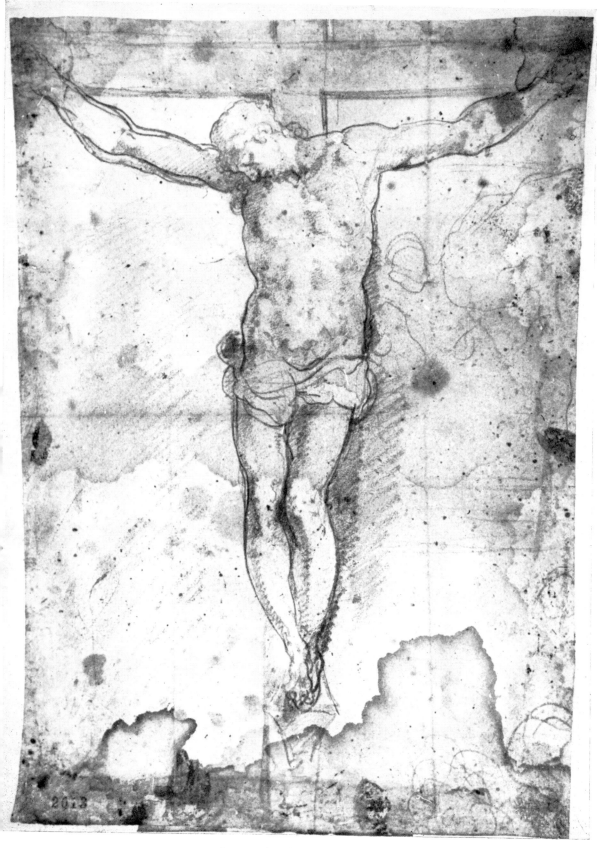

45 (cat. 127). Christ on the Cross
Ambrosiana

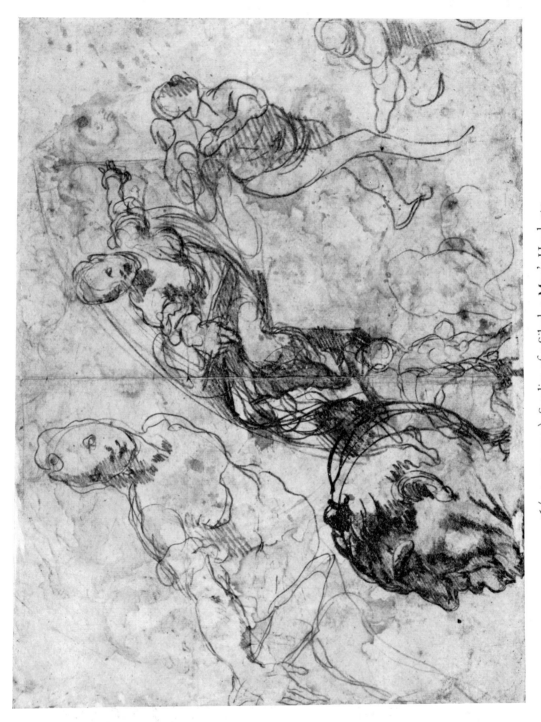

46 (cat. 211 *verso*). Studies of a Sibyl, a Man's Head, etc.
Philip H. and A. S. W. Rosenbach Foundation, Philadelphia

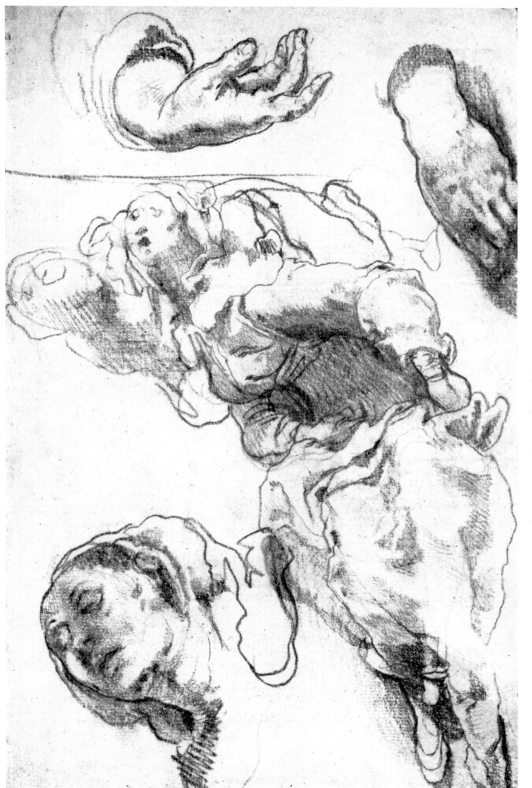

47 (cat. 146 *recto*). Studies of the Swooning Virgin
Mrs. Richard Krautheimer

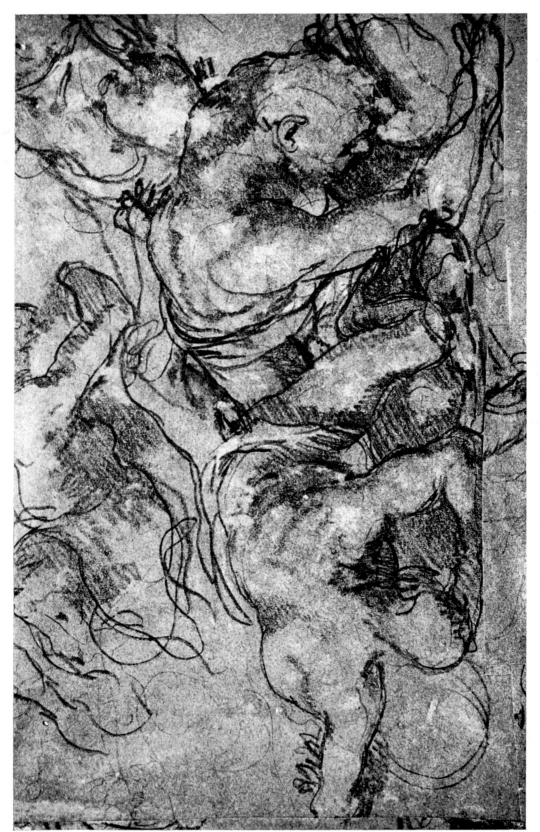

48 (cat. 15 *recto*). Soldiers in a *Resurrection*
Budapest

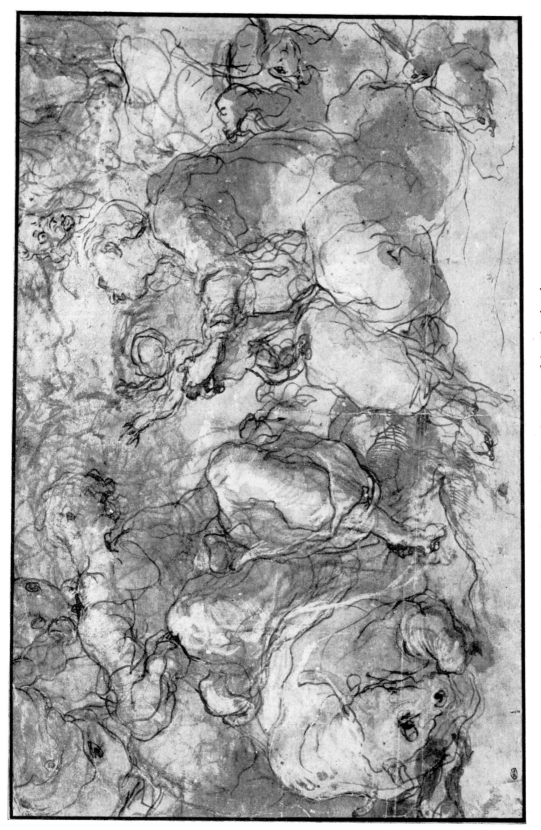

49 (cat. 201). The Adoration of the Shepherds

Louvre

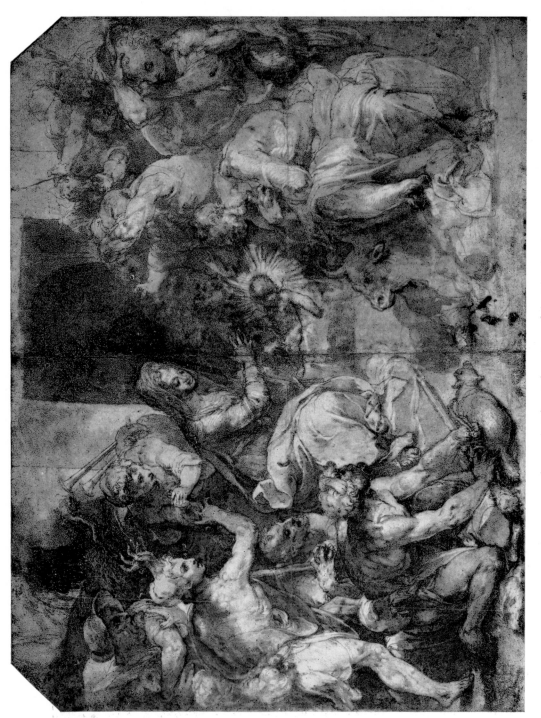

50 (cat. 19). The Adoration of the Shepherds *Chatsworth*

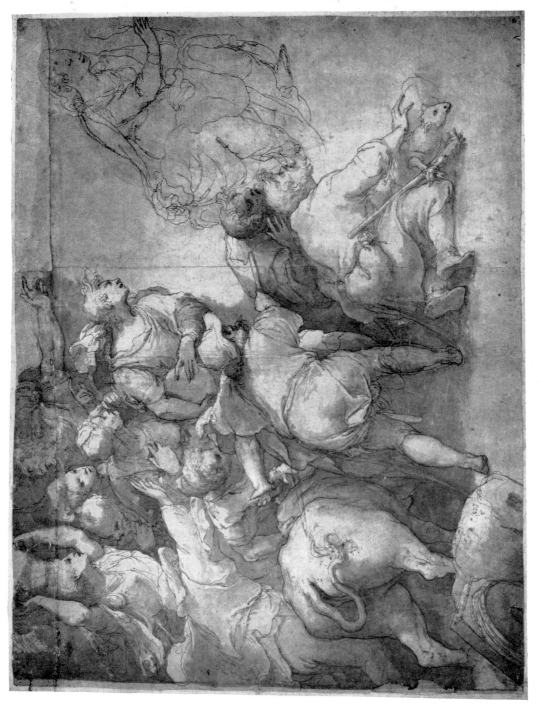

51 (cat. 167). Shepherds in an *Adoration*
Christ Church

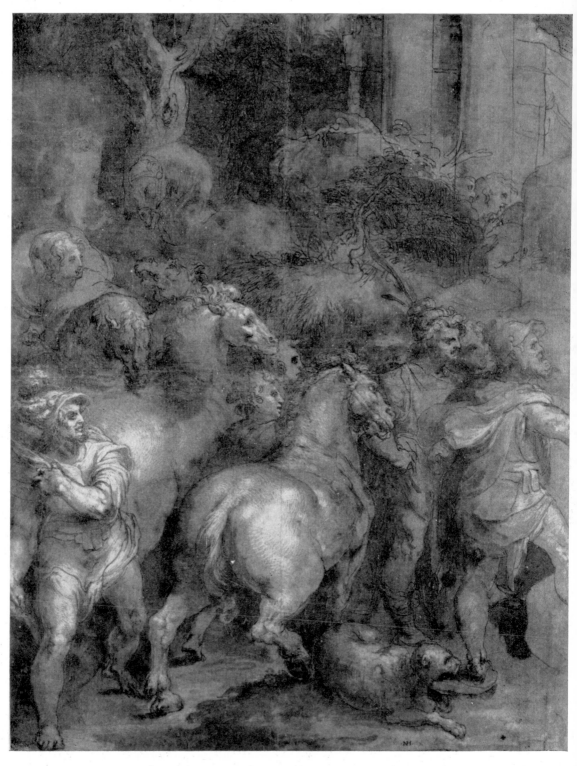

52 (cat. 18). Men and Horses in an *Adoration of the Magi*
Chatsworth

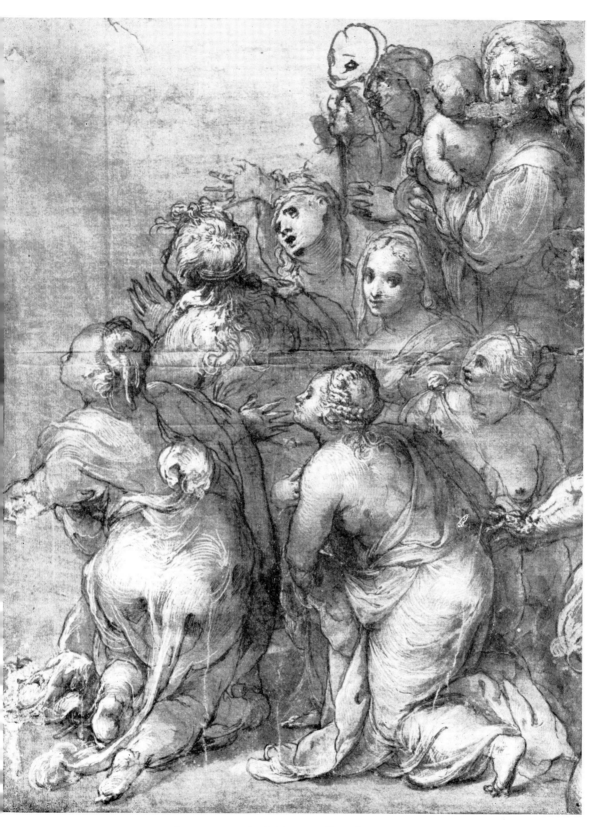

53 (cat. 219 *recto*). A Group of kneeling Women
Rome

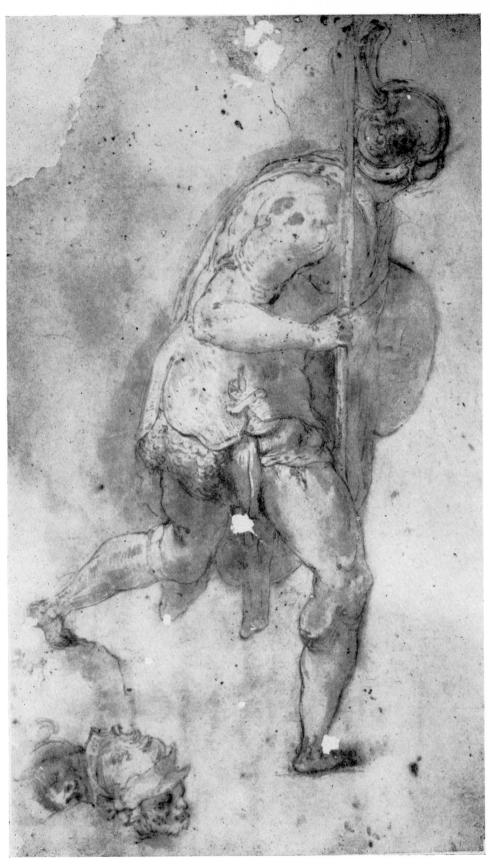

54 (cat. 140). A running Soldier
Cooper-Hewitt Museum, New York

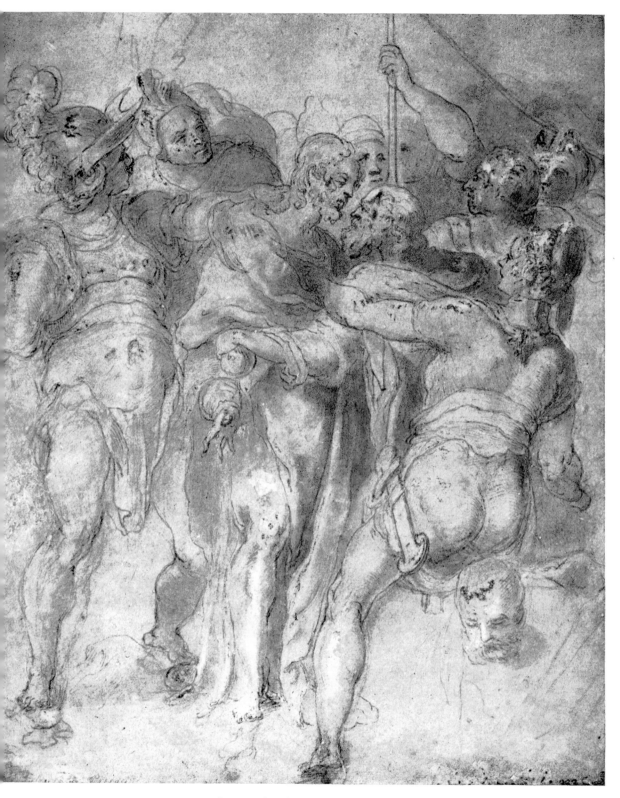

55 (cat. 186). The Betrayal of Christ
Louvre

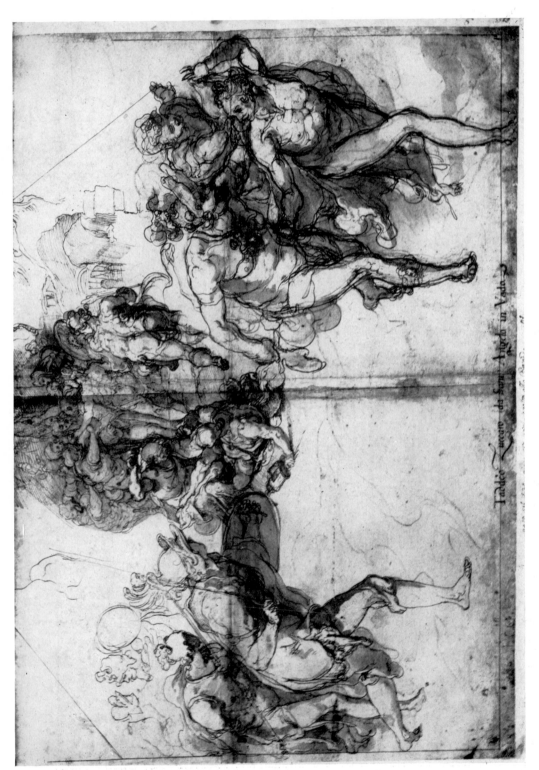

56 (cat. 9). The Betrayal of Christ
Berlin

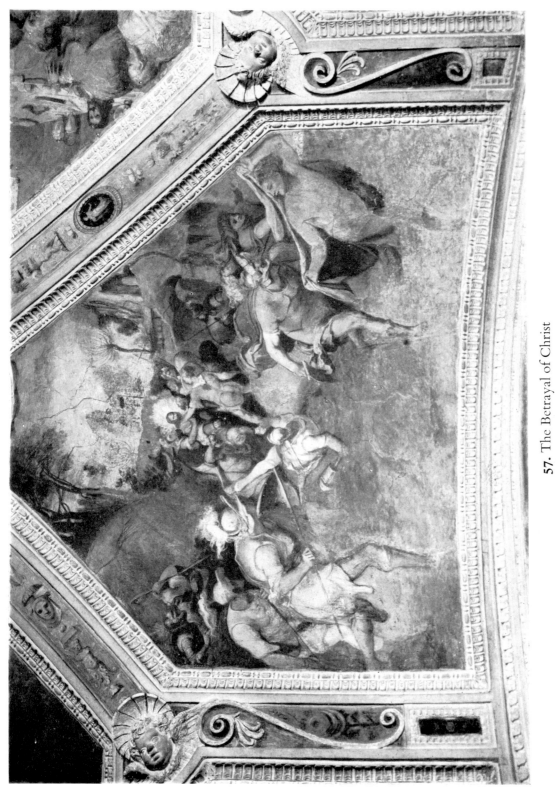

57. The Betrayal of Christ

Fresco: Rome, S. Maria della Consolazione

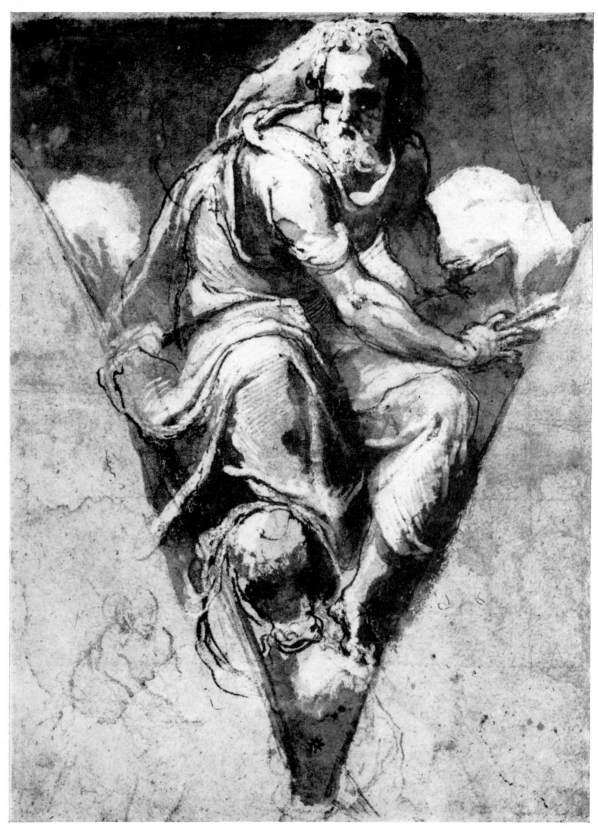

58 (cat. 88). St Luke in a Pendentive
Museum of the History of Art, Kremsier

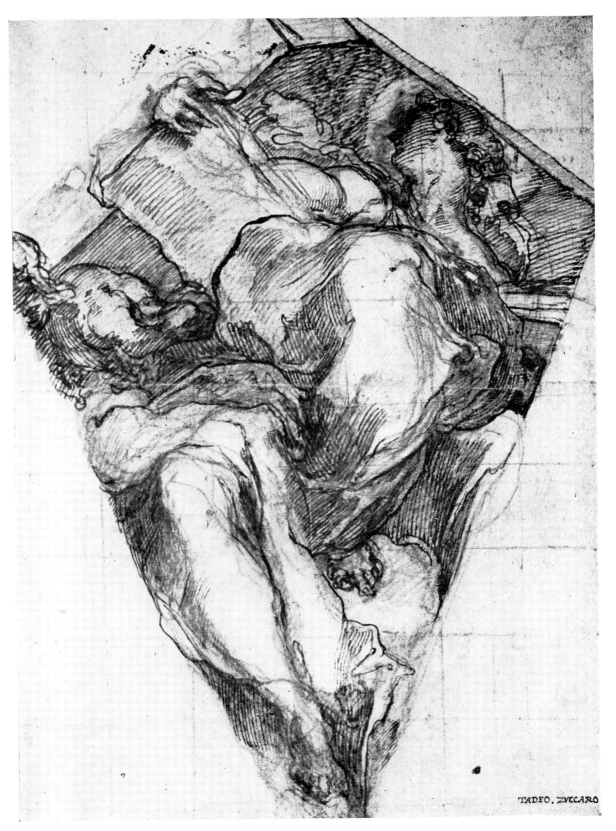

59 (cat. 202). St John the Evangelist in a Pendentive

Louvre

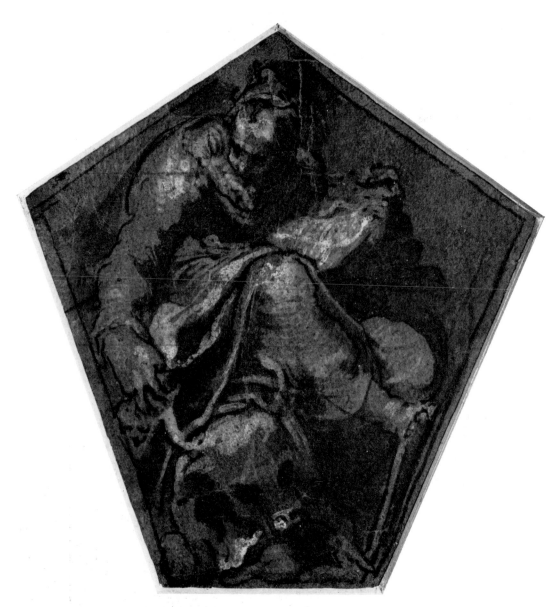

60 (cat. 25). St Luke in a Pendentive
Lord Methuen

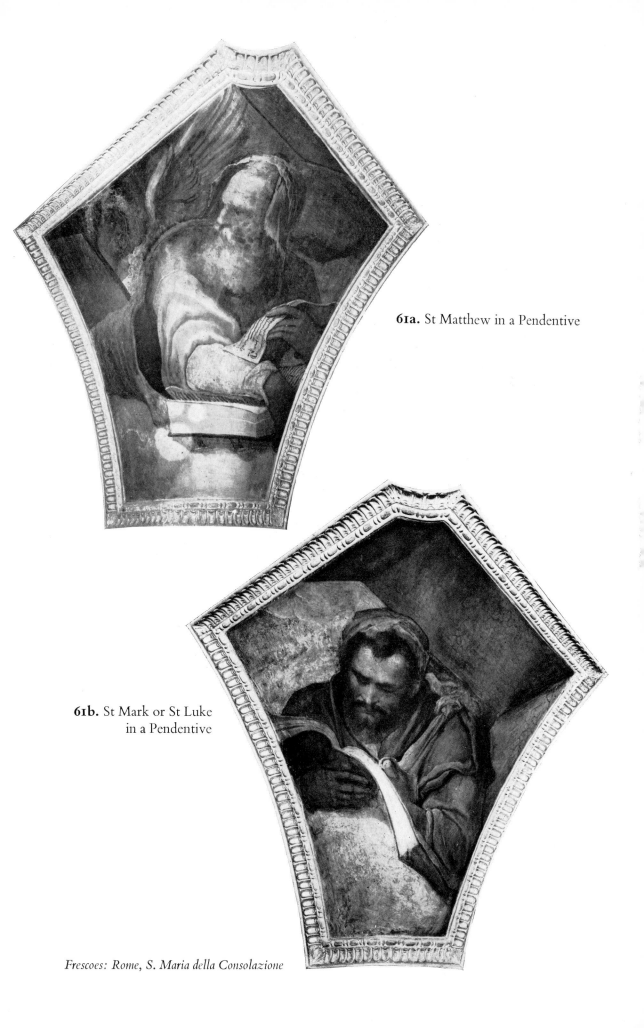

61a. St Matthew in a Pendentive

61b. St Mark or St Luke
in a Pendentive

Frescoes: Rome, S. Maria della Consolazione

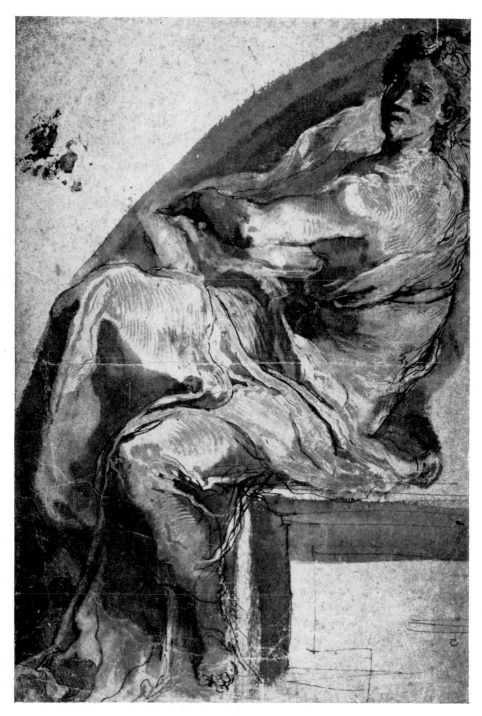

62 (cat. 85 *recto*). A Sibyl in a Lunette
Hamburg

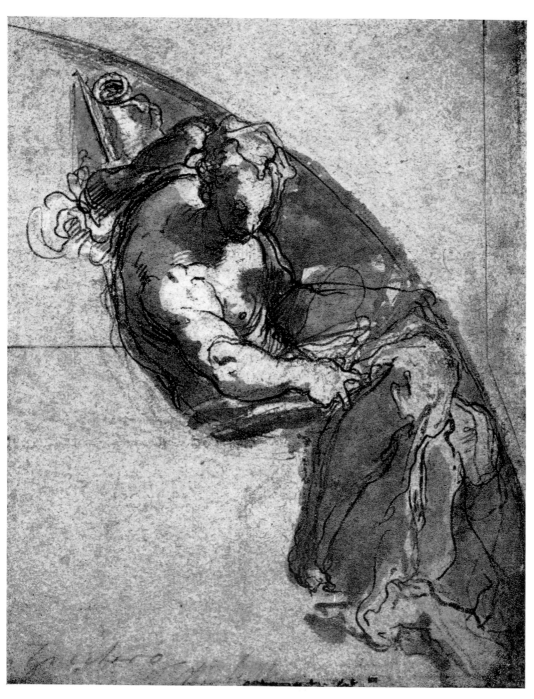

63 (cat. 125). A Sibyl in a Lunette
Mr. John Carter Jonas

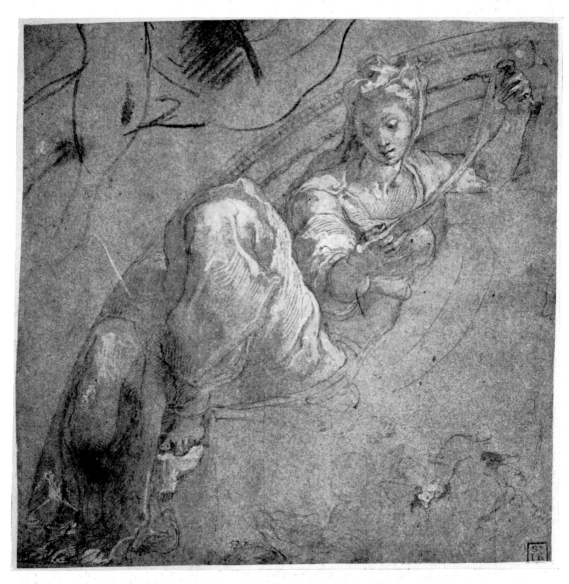

64 (cat. 98). A Sibyl in a Lunette
British Museum

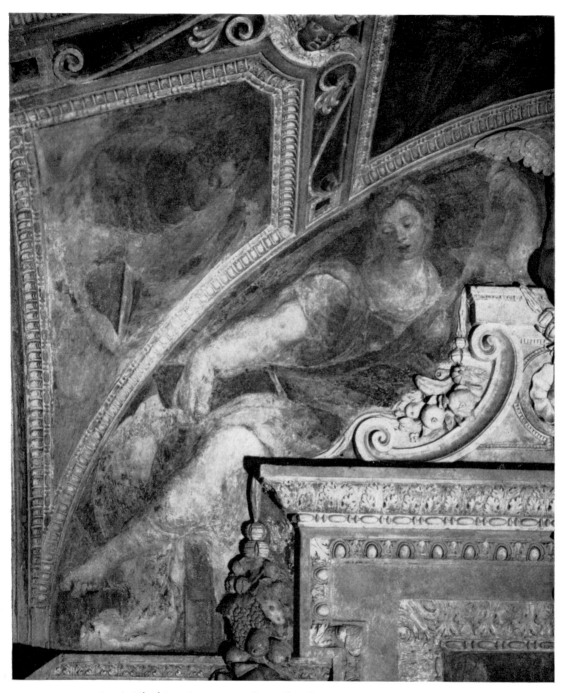

65. A Sibyl in a Lunette and St John the Evangelist in a Pendentive

Fresco: Rome, S. Maria della Consolazione

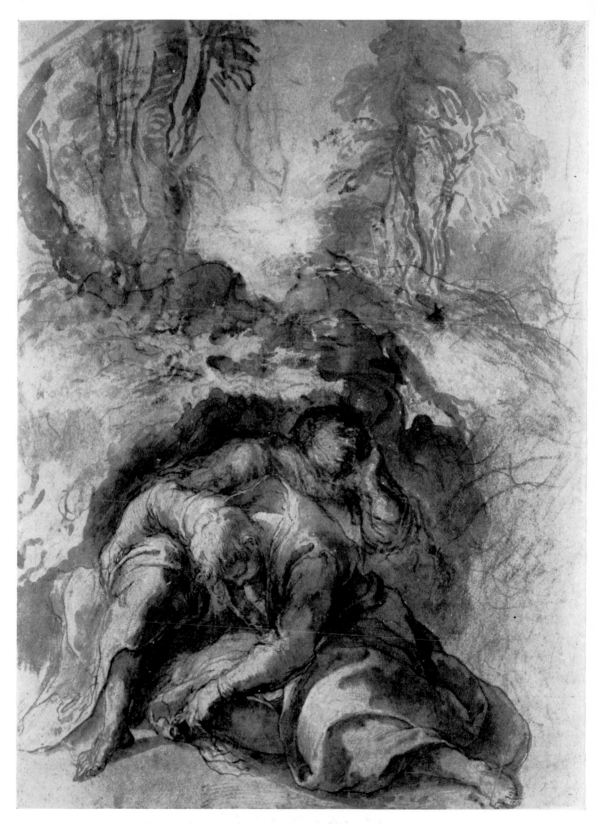

66 (cat. 261). Two sleeping Disciples in an *Agony in the Garden*
Kunsthaus, Zürich

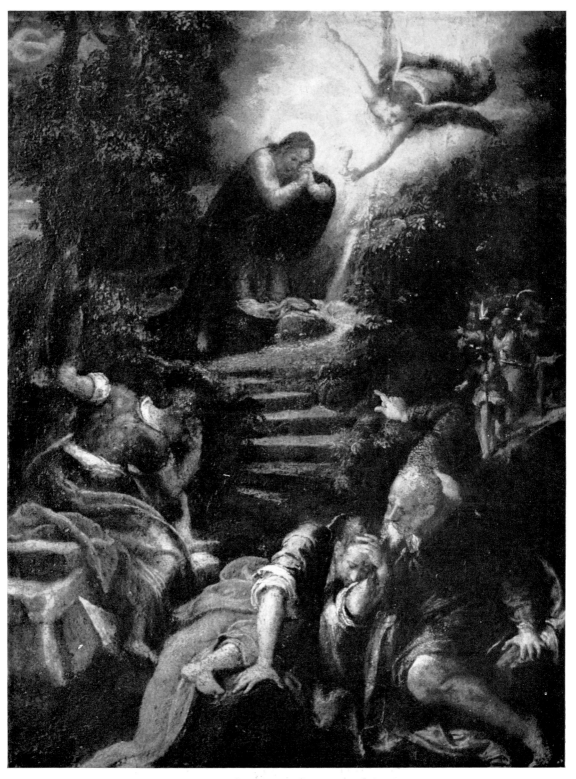

67. The Agony in the Garden
Panel: Zagreb, Strossmayer Gallery

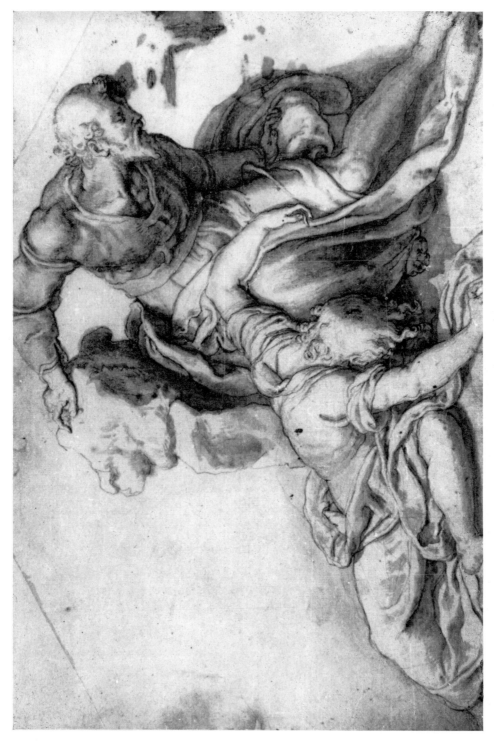

68 (cat. 259). Two sleeping Disciples in an *Agony in the Garden*

Windsor

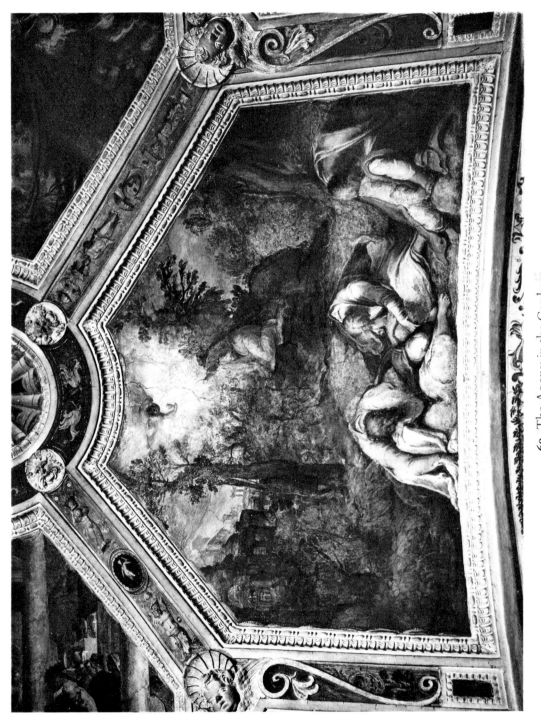

69. The Agony in the Garden

Fresco: Rome, S. Maria della Consolazione

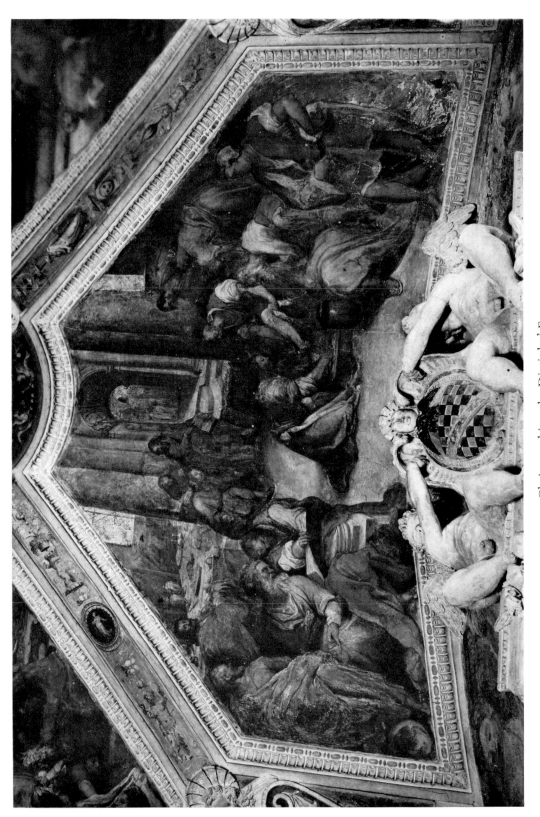

70. Christ washing the Disciples' Feet
Fresco: Rome, S. Maria della Consolazione

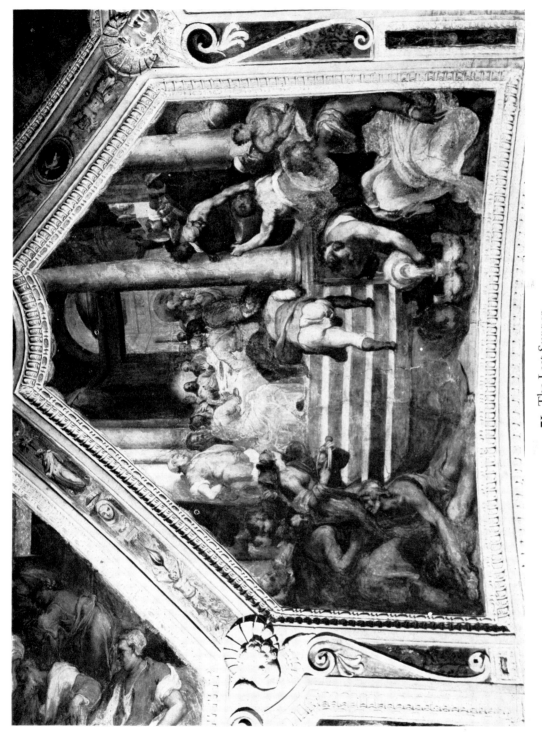

71. The Last Supper

Fresco: Rome, S. Maria della Consolazione

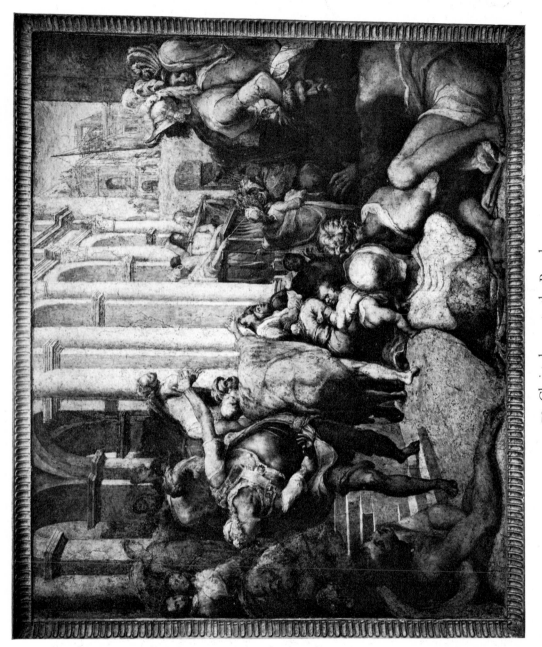

72. Christ shown to the People
Fresco: Rome, S. Maria della Consolazione

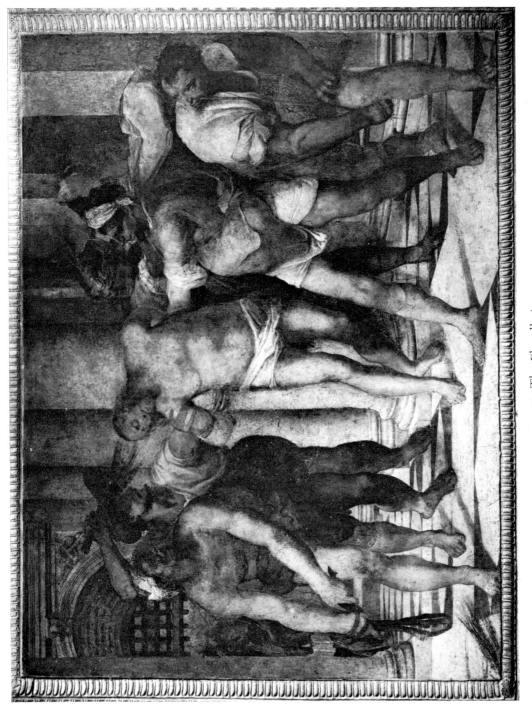

73. The Flagellation

Fresco: Rome, S. Maria della Consolazione

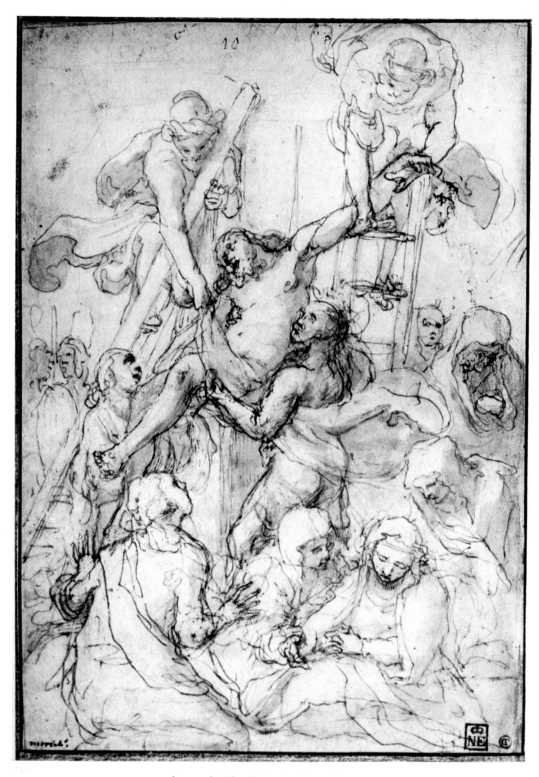

74 (cat. 14). The Descent from the Cross
Budapest

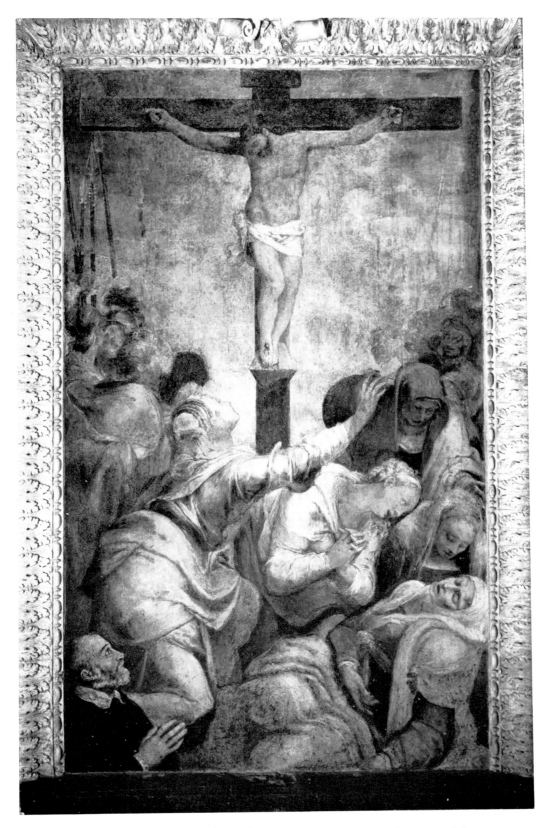

75. The Virgin, attended by the Holy Women, swooning at the Foot of the Cross

Fresco: Rome, S. Maria della Consolazione

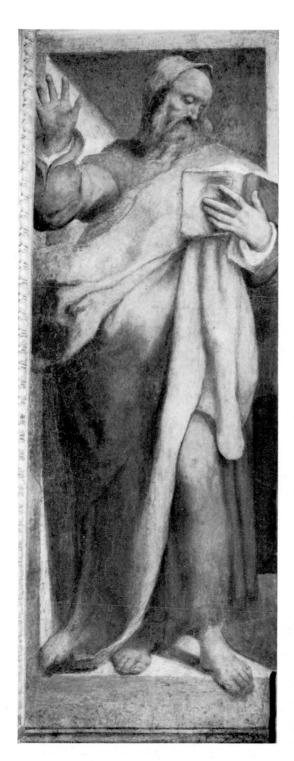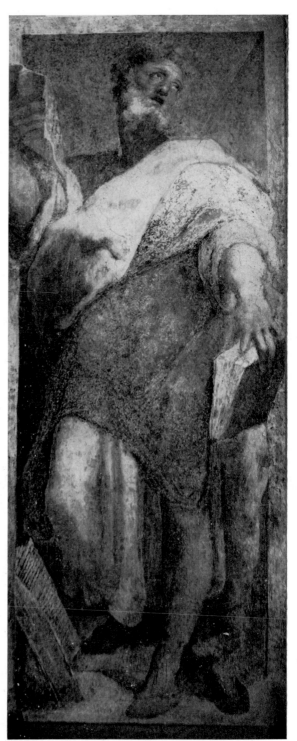

76. Prophets

Frescoes: Rome, S. Maria della Consolazione

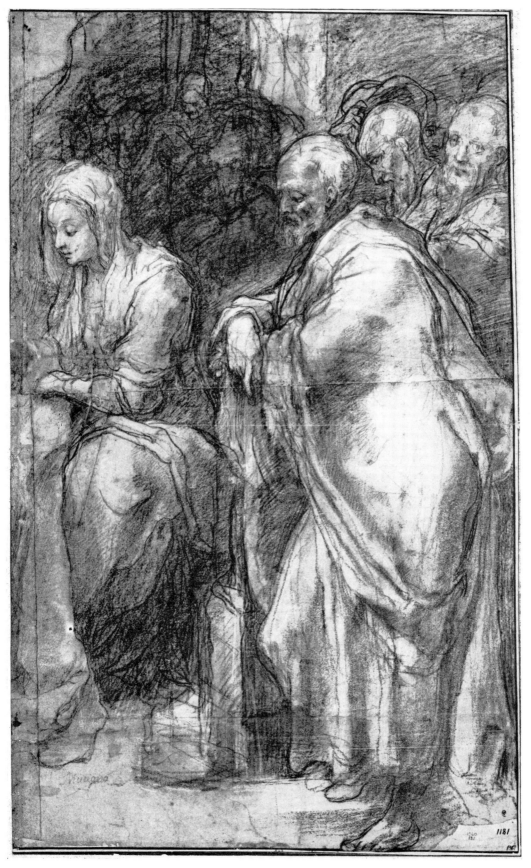

77 (cat. 227 *recto*). The Virgin and St Joseph in an *Adoration of the Magi*
Stockholm

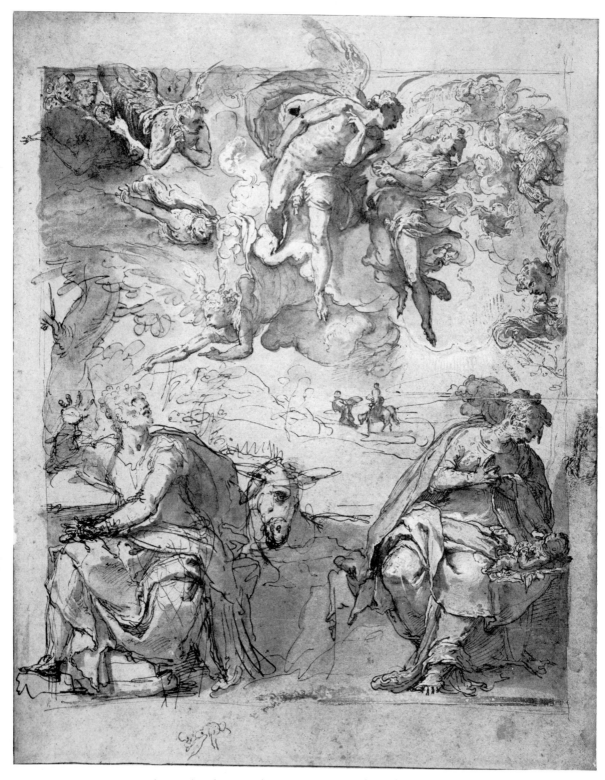

78 (cat. 86). The Angel warning St Joseph to fly into Egypt
Hamburg

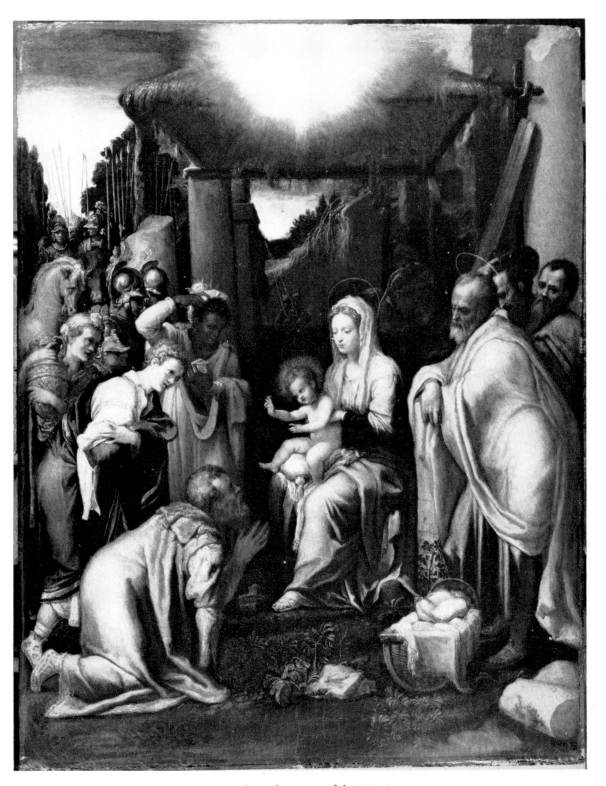

79. The Adoration of the Magi
Panel: Cambridge, Fitzwilliam Museum

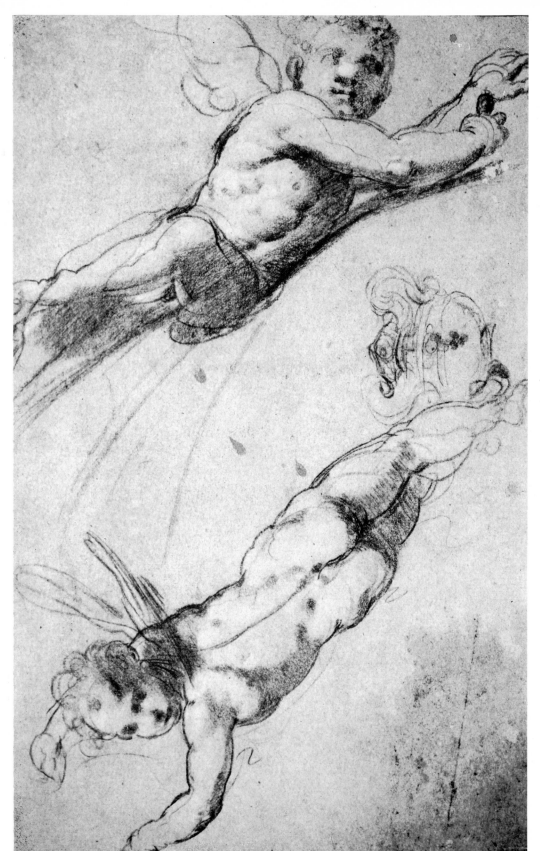

80 (cat. 139). Two Angels
Cooper–Hewitt Museum, New York

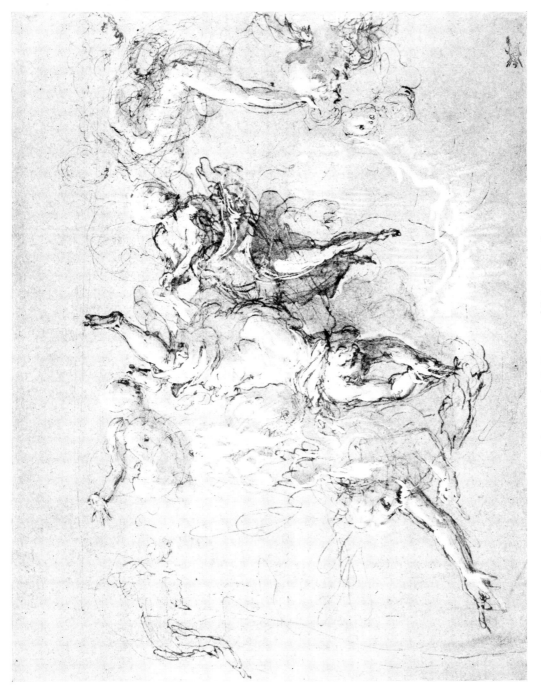

81 (cat. 145). A Group of flying Angels
Mrs. Richard Krautheimer

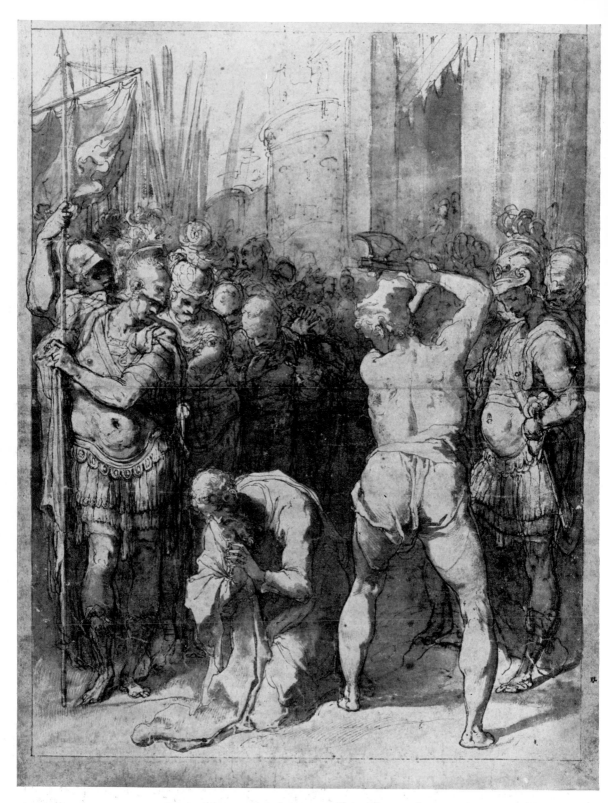

82 (cat. 147). The Martyrdom of St Paul
Mr. Robert Lehman

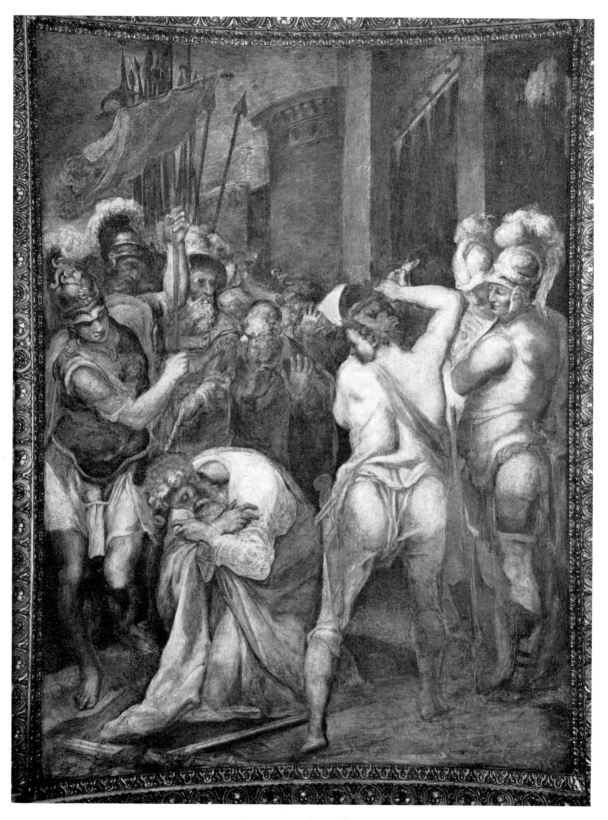

83. The Martyrdom of St Paul
Fresco: Rome, S. Marcello al Corso

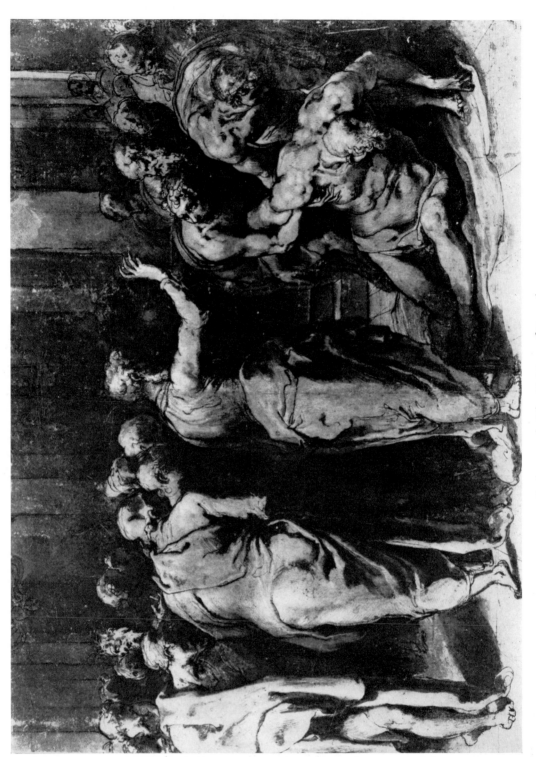

84 (cat. 142). The Raising of Eutychus
Metropolitan Museum

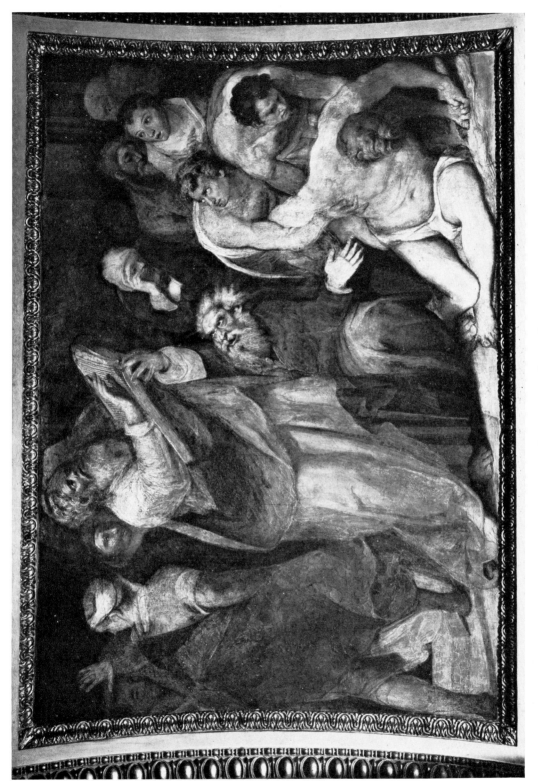

85. The Raising of Eutychus
Fresco: Rome, S. Marcello al Corso

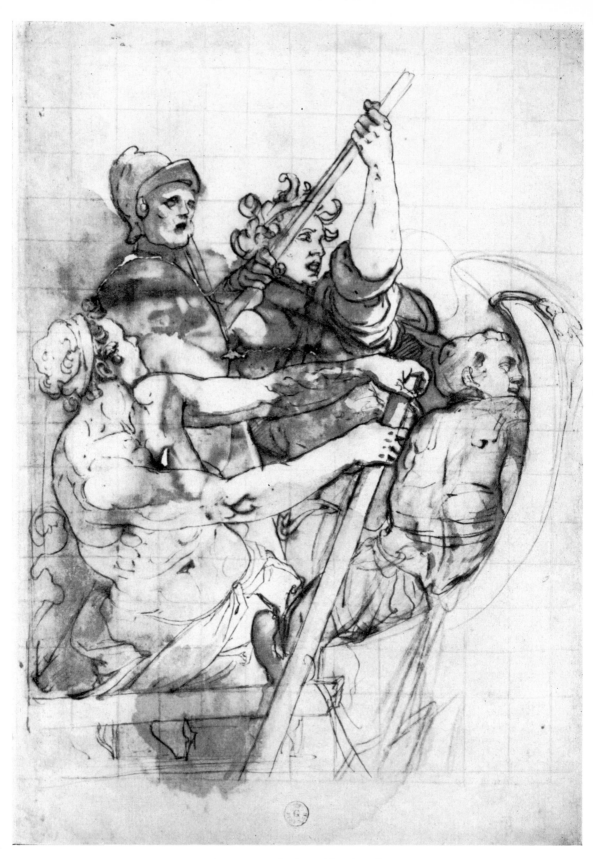

86 (cat. *56 recto*). Four Men in a Boat
Uffizi

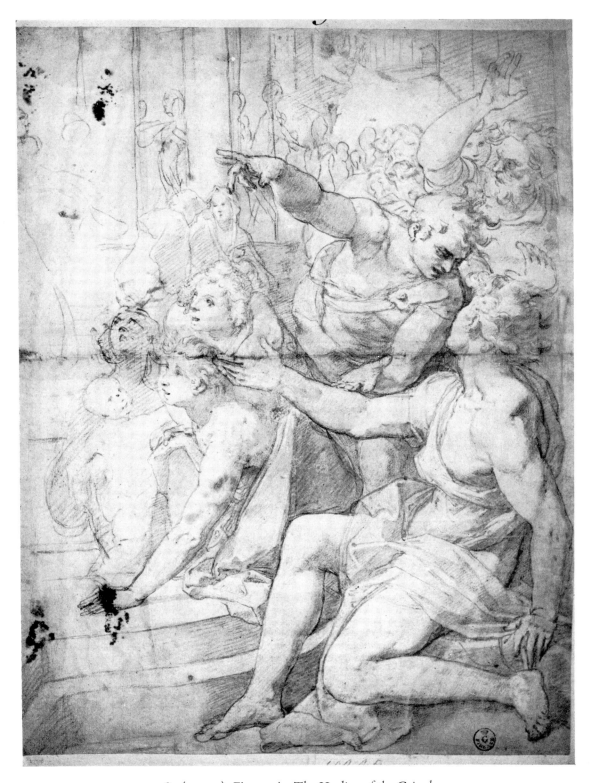

87 (cat. 53). Figures in *The Healing of the Cripple*
(here attributed to Federico Zuccaro after Taddeo Zuccaro)
Uffizi

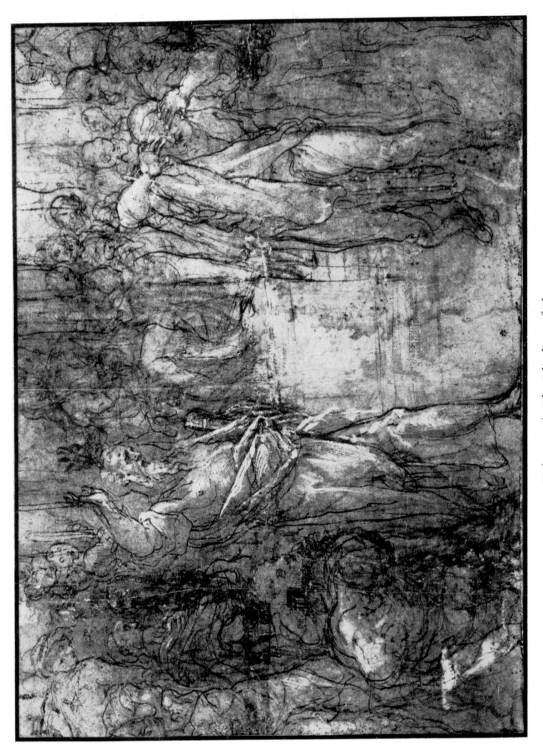

88 (cat. 257). The Blinding of Elymas

Windsor

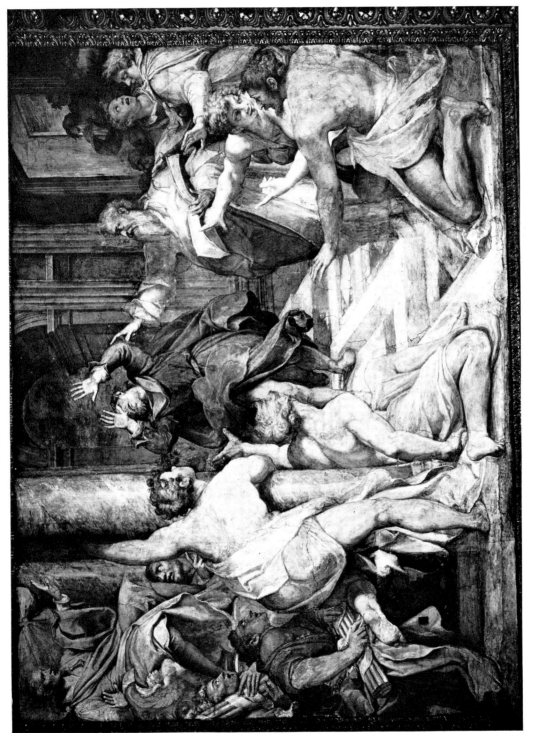

89. The Blinding of Elymas
Fresco: Rome, S. Marcello al Corso

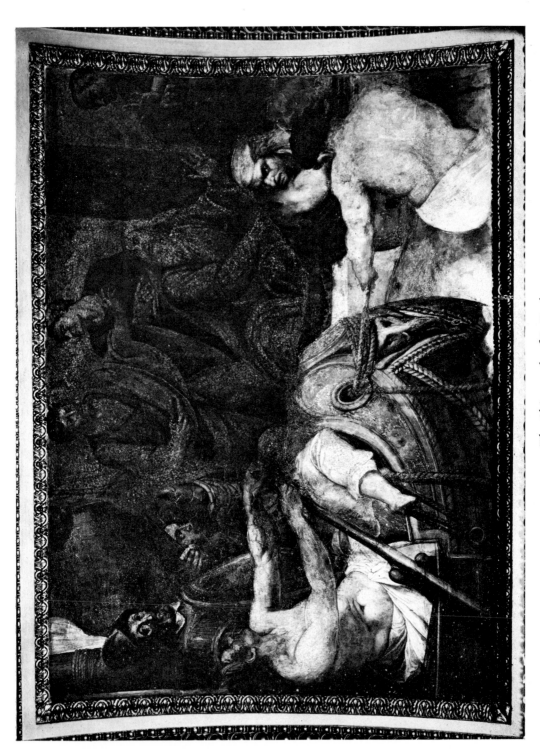

90. The Shipwreck of St Paul
Fresco: Rome, S. Marcello al Corso

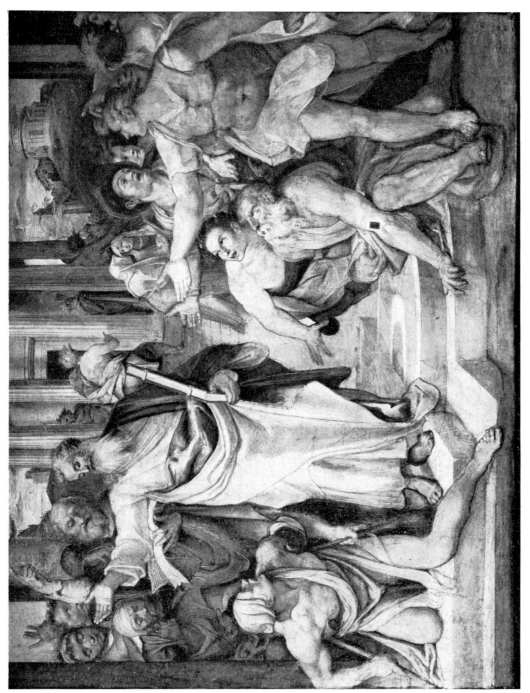

91. St Paul healing the Cripple
Fresco: Rome, S. Marcello al Corso

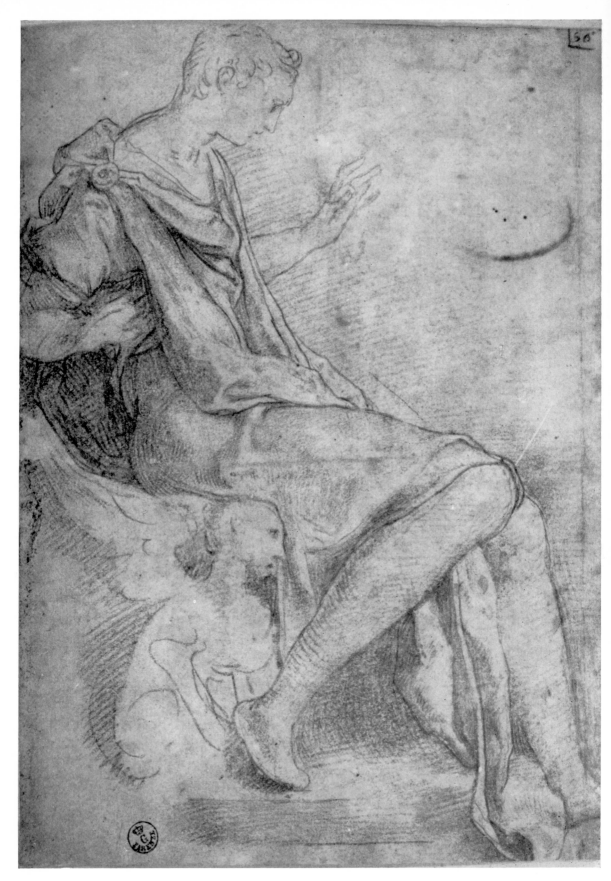

92 (cat. 77 *recto*). A seated Man
Uffizi

(a) St Paul

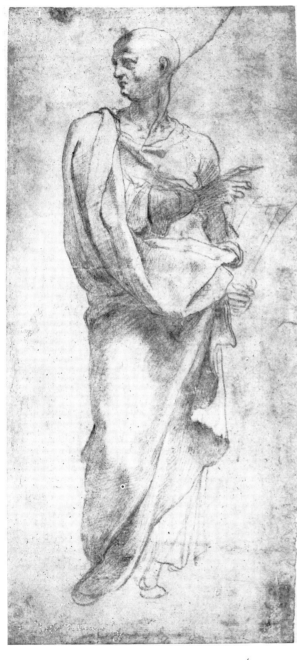

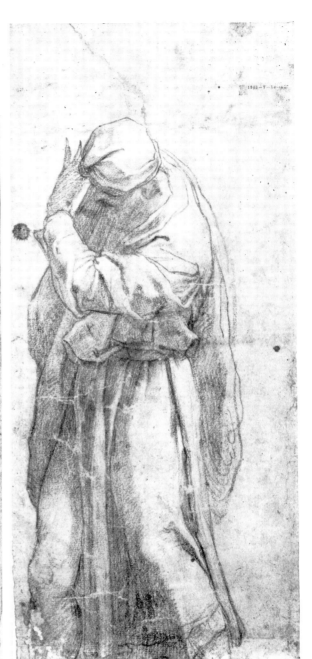

(b) Elymas

93 (cat. 107 *recto* and *verso*).
British Museum

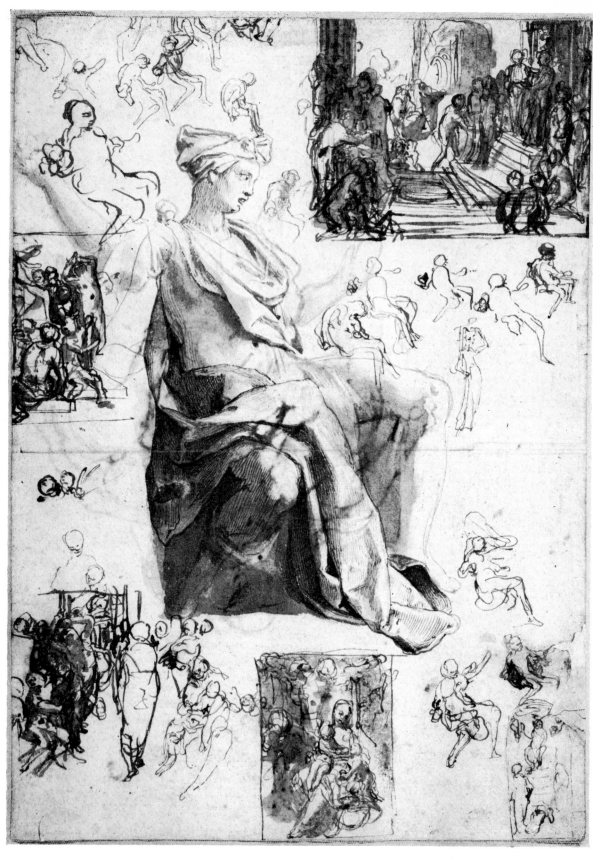

94 (cat. *22 recto*). Studies of a seated Man and five Composition-Studies

Art Institute of Chicago

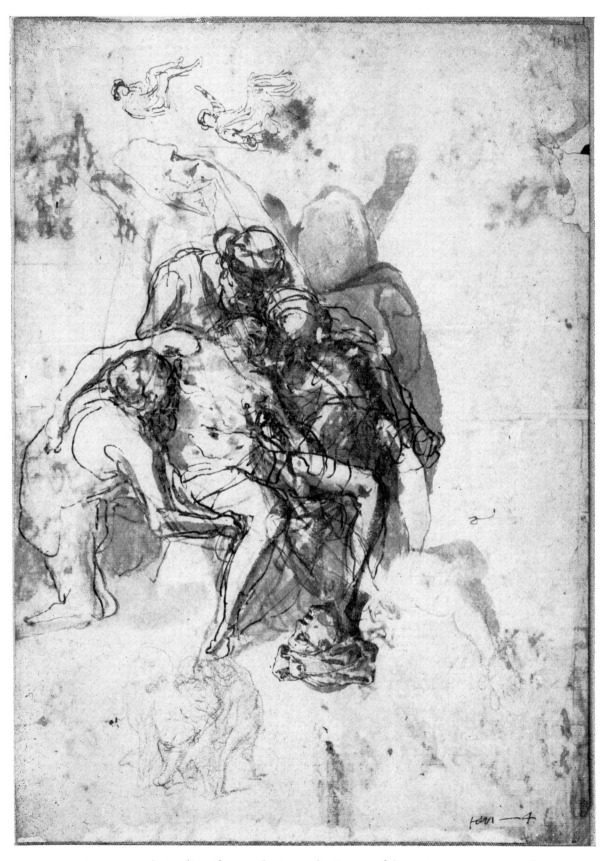

95 (cat. 22 *verso*). Studies of a seated Man and a Group of three Figures supporting the
Body of a fourth

Art Institute of Chicago

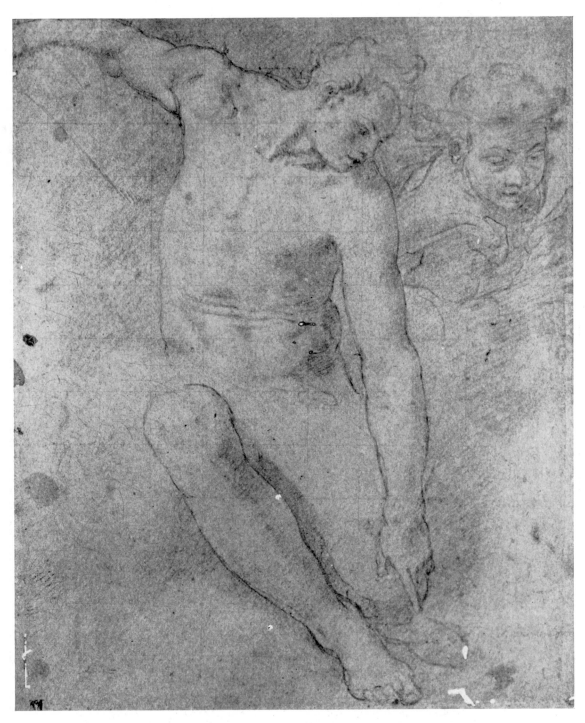

96 (cat. 129). A seated nude Youth

Castello Sforzesco, Milan

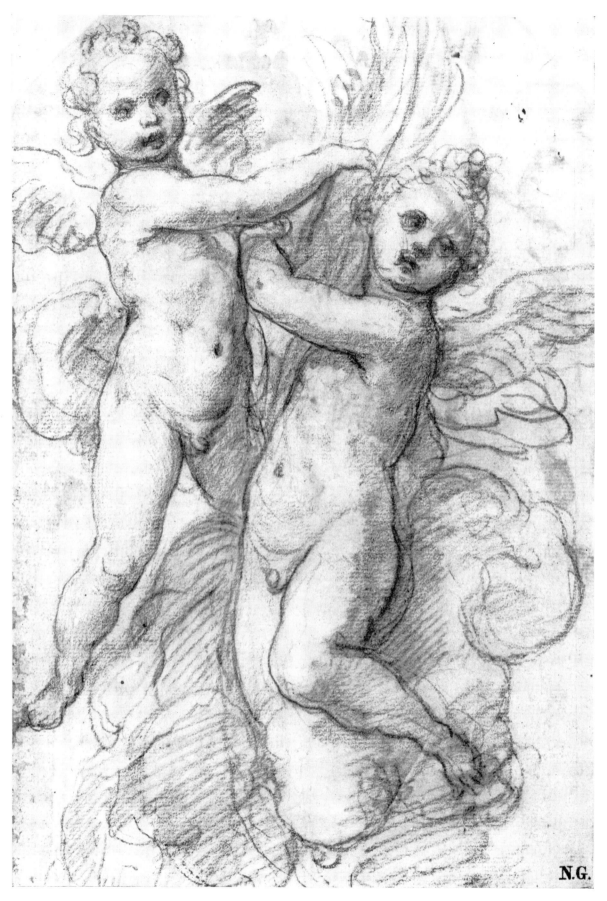

97 (cat. 89 *recto*). Two Child Angels holding a Martyr's Palm
Leiden University Printroom

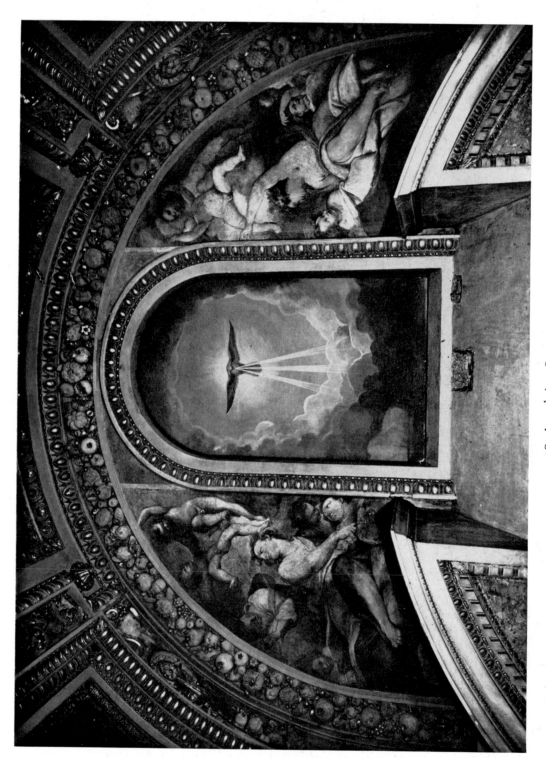

98. Angels in a Lunette
Fresco: Rome, S. Marcello al Corso

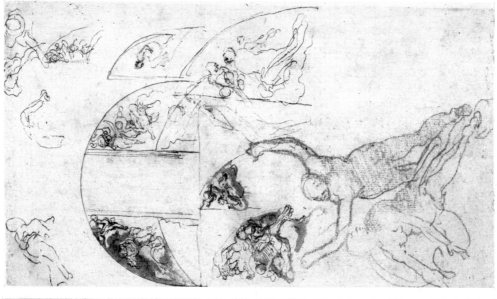

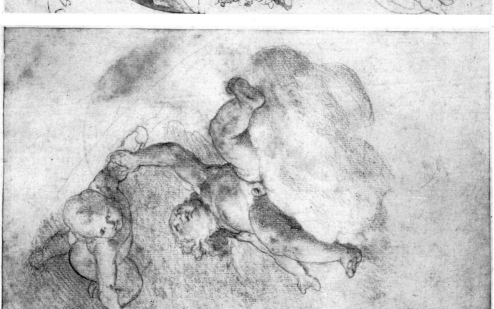

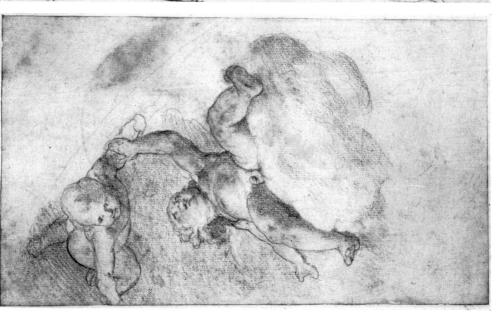

99b and **c** (cat. 124 *recto* and *verso*). Child-Angels in a Lunette; Studies for the Decoration of a Lunette

Count Antoine Seilern

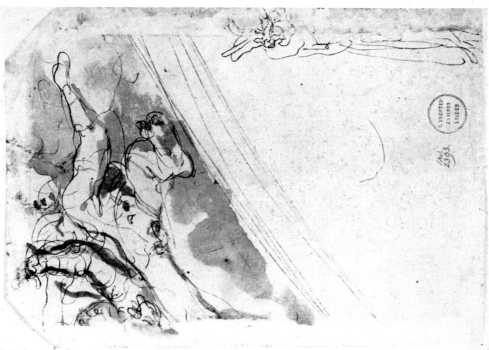

99a (detail of cat. 89 *verso*). Two Child-Angels

Leiden University Printroom

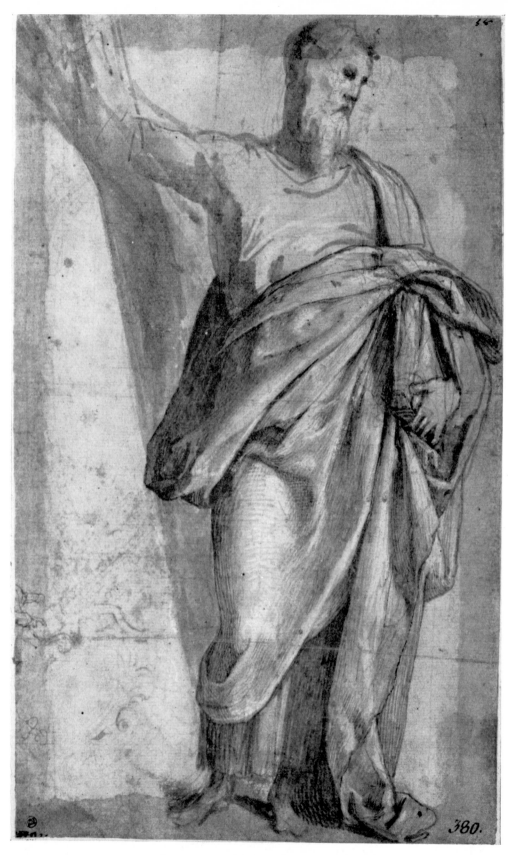

100 (cat. 223 *recto*). St Paul or St Andrew
Stockholm

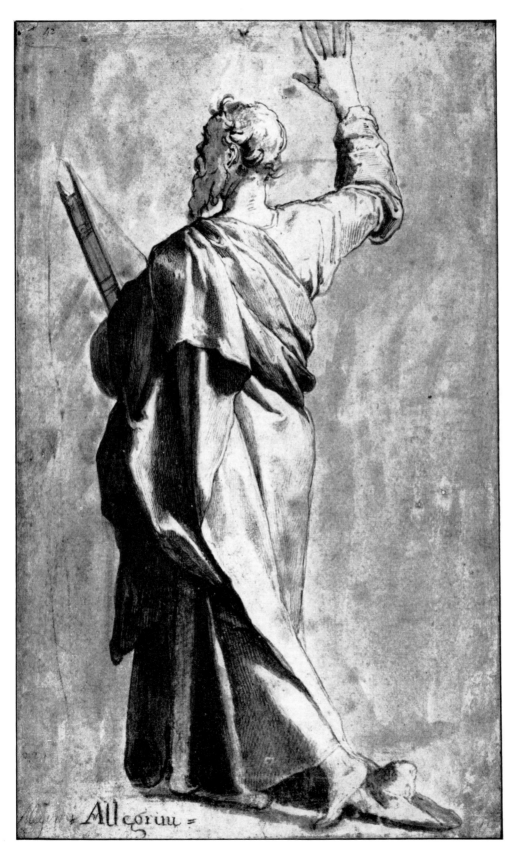

101 (cat. 244). St Paul
Albertina

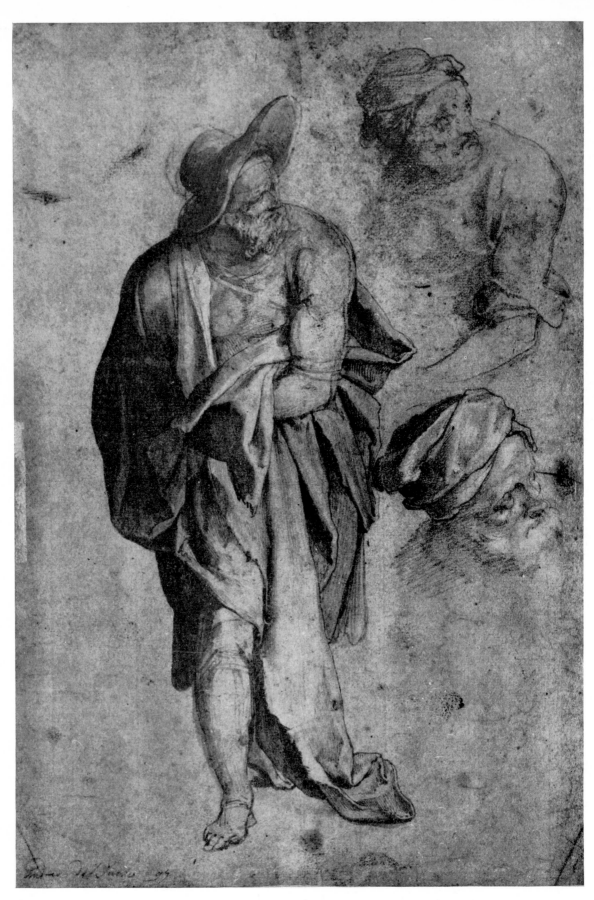

102 (cat. 235). Studies of an old Man in a Cloak
Accademia, Venice

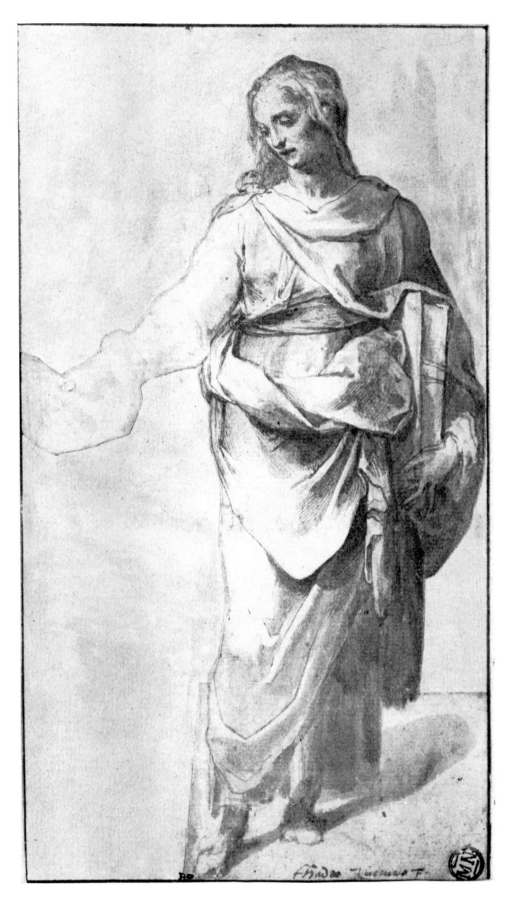

103 (cat. 178). St John the Evangelist
Louvre

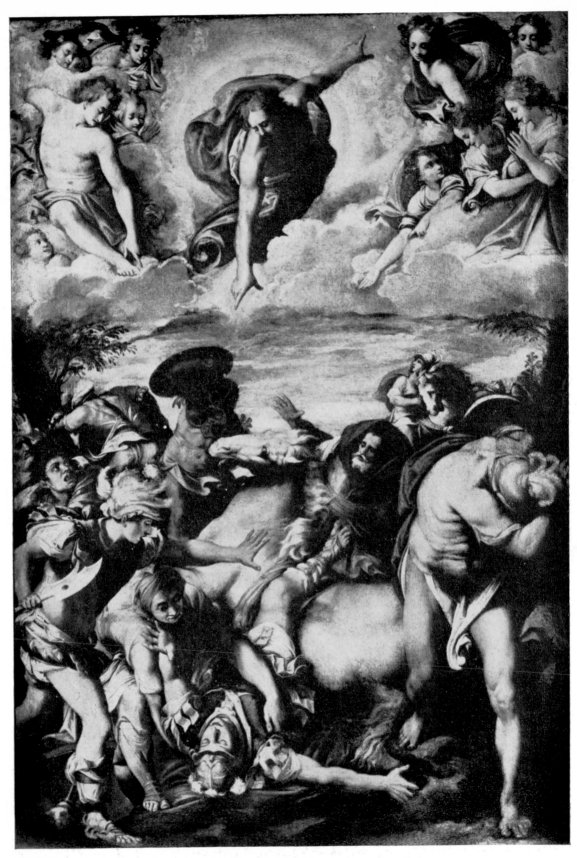

104. The Conversion of St Paul (reduced replica of altarpiece
in S. Marcello al Corso)

Copper: Rome, Palazzo Doria-Pamphili

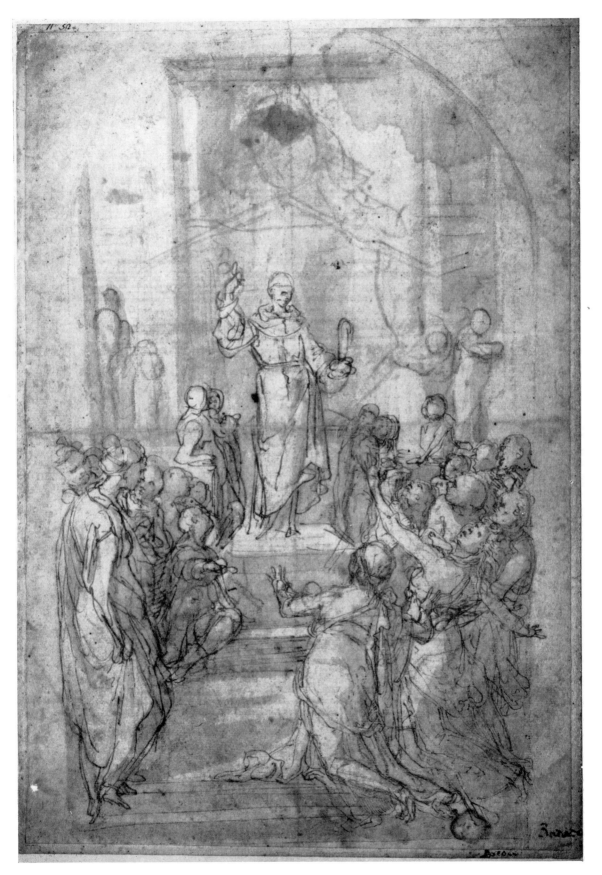

105 (cat. 106 *recto*). St Philip Benizzi(?) healing a possessed Woman
British Museum

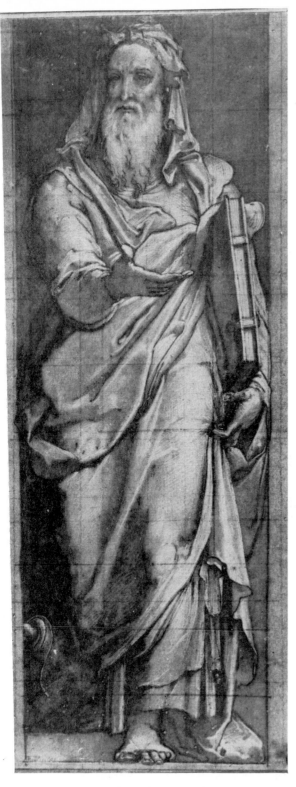

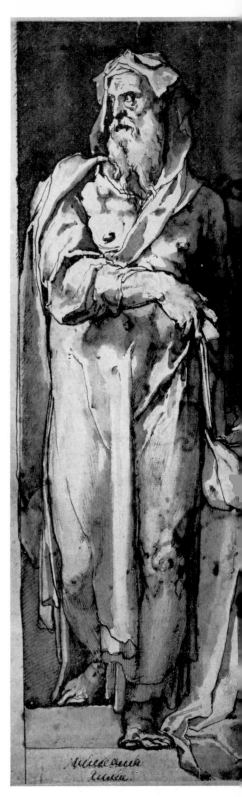

106a (cat. 2). A Prophet
Musée Turpin de Crissé, Angers

106b (cat. 4). A Prophet
Berlin

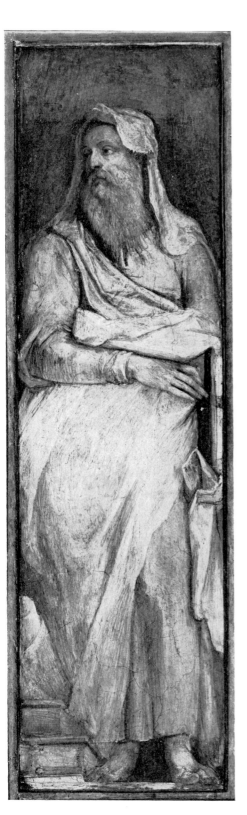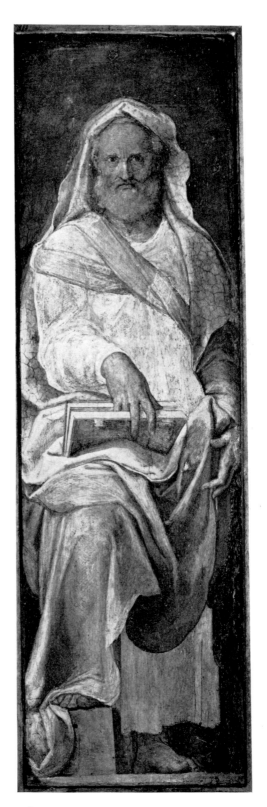

107. Two Prophets
Frescoes: Rome, S. Marcello al Corso

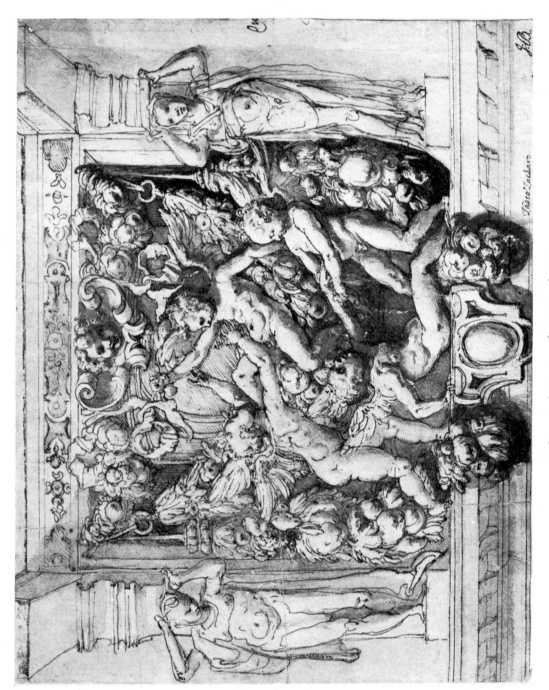

108 (cat. 203). Design for Part of a Frieze

Louvre

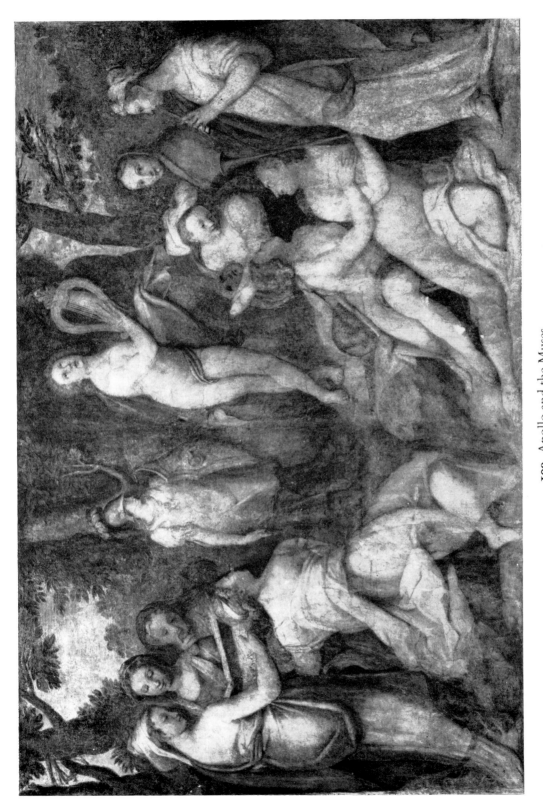

I09. Apollo and the Muses

Fresco, transferred to canvas: Rome, formerly in Casino dei Bufalo,
now coll. Comm. Avv. Ilo Nunès

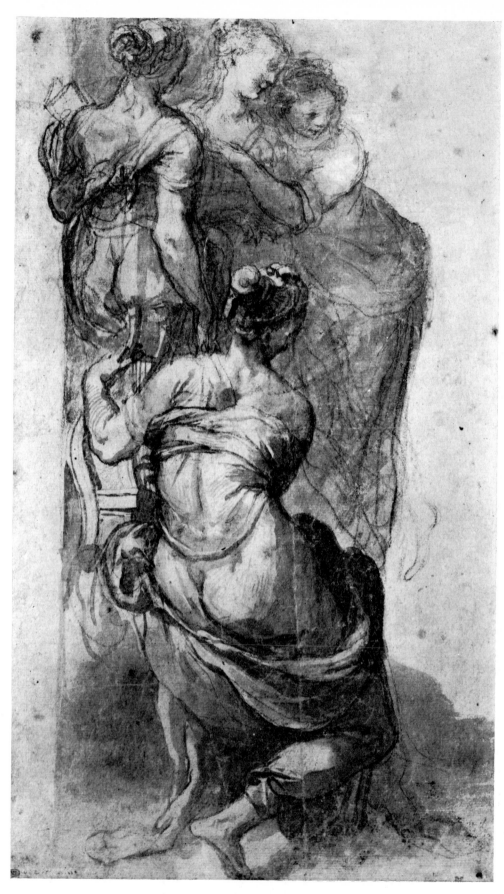

110 (cat. 170 *recto*). Group of four Muses
Louvre

III (cat. 170 *verso*). The Flight into Egypt
Louvre

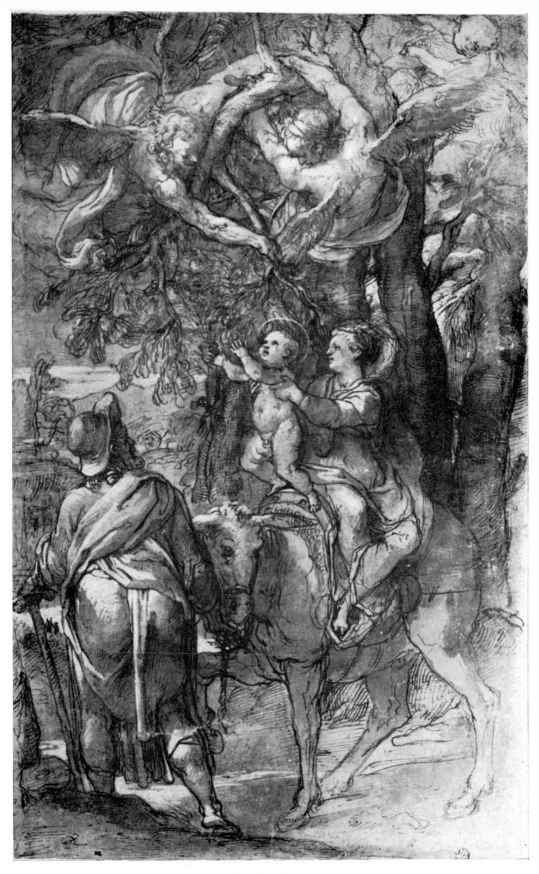

112 (cat. 180). The Flight into Egypt
Louvre

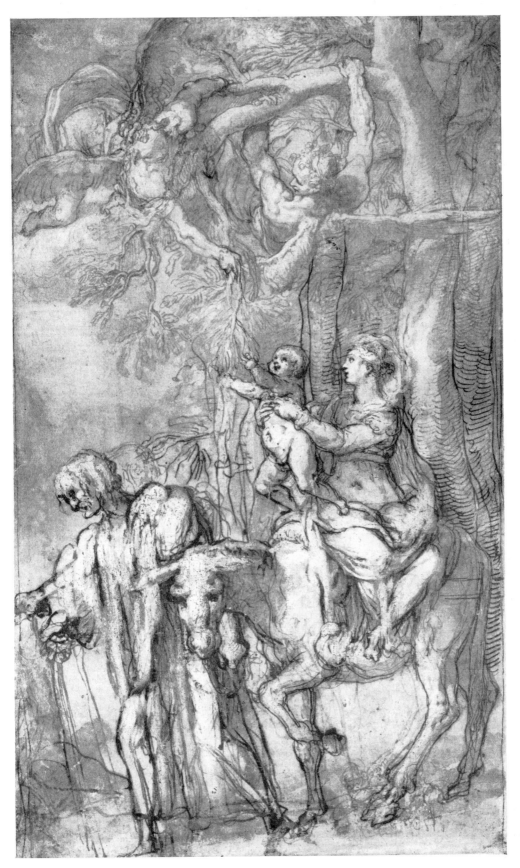

113 (cat. 101). The Flight into Egypt
British Museum

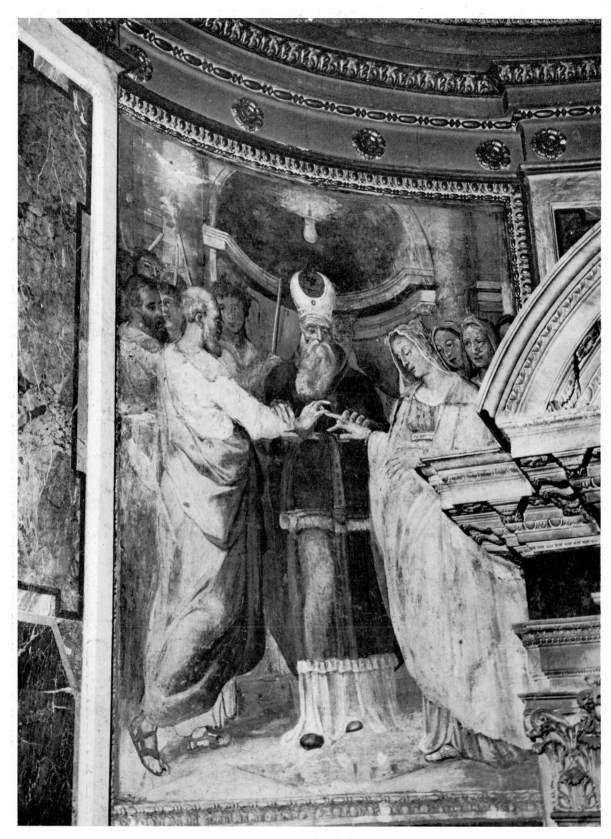

114. The Marriage of the Virgin
Fresco: Rome, S. Maria dell' Orto

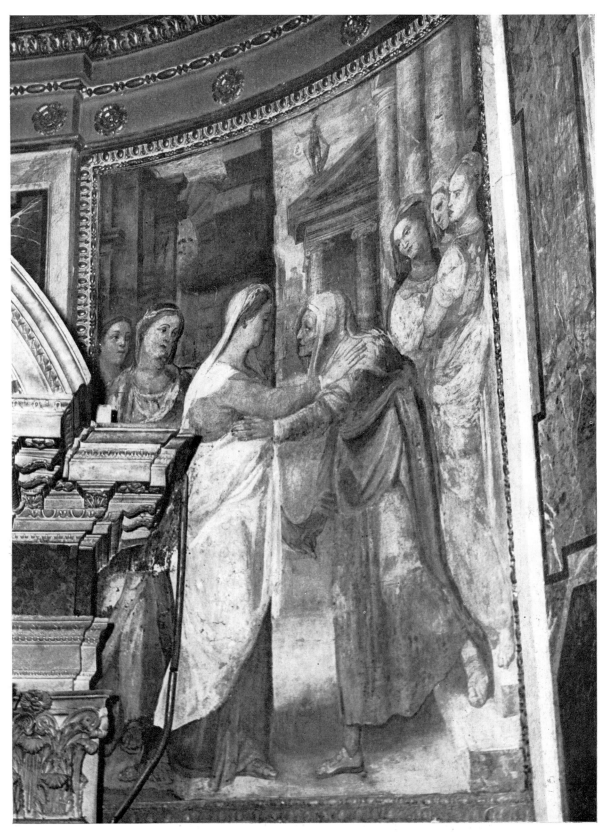

115. The Visitation
Fresco: Rome, S. Maria dell' Orto

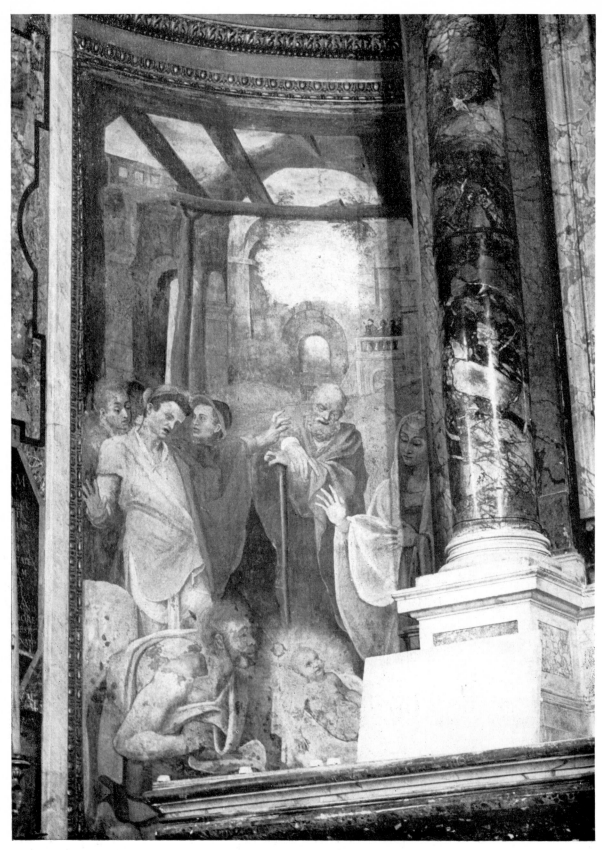

116. The Adoration of the Shepherds

Fresco: Rome, S. Maria dell' Orto

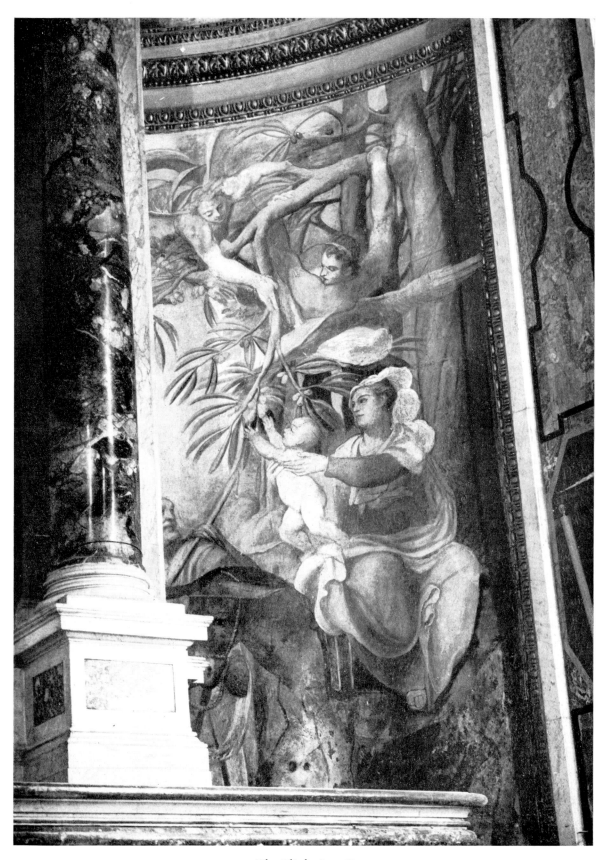

117. The Flight into Egypt

Fresco: Rome, S. Maria dell' Orto

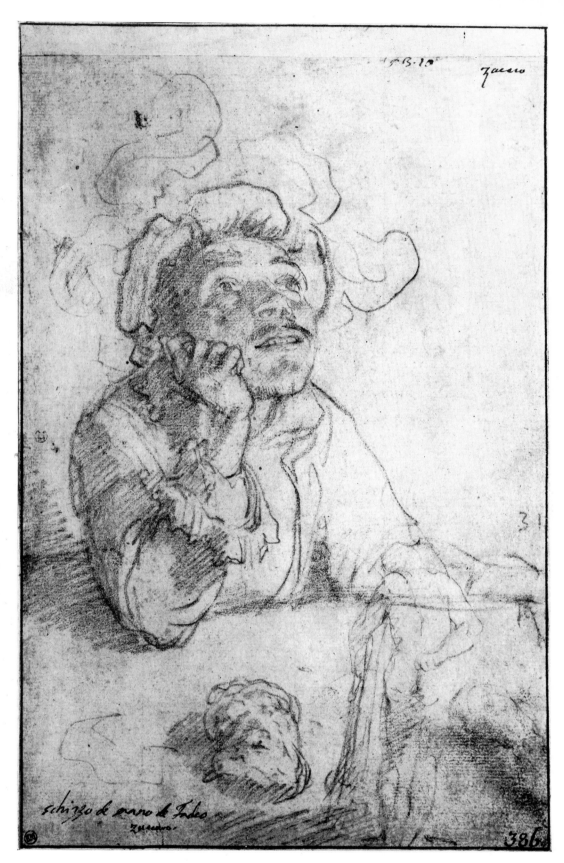

118 (cat. 224). A Man sitting at a Table
Stockholm

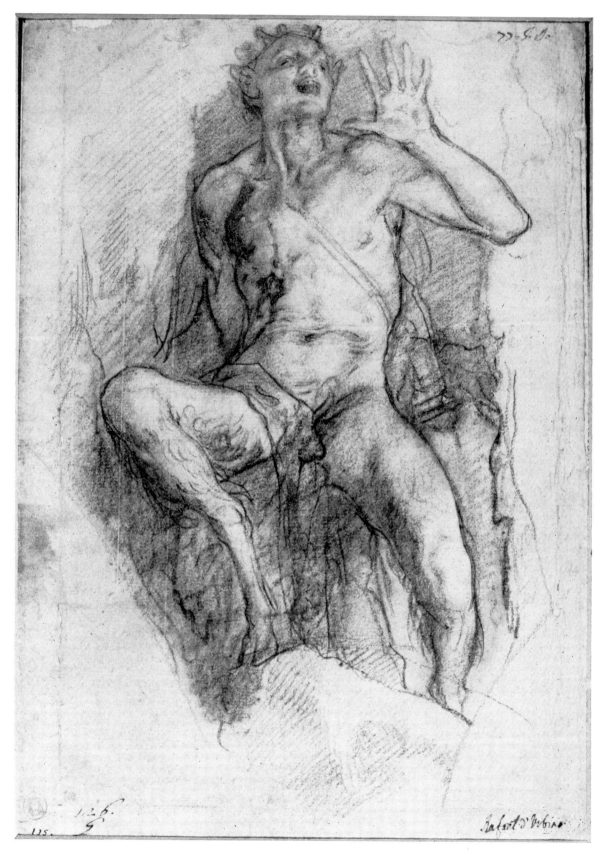

119 (cat. 165). A youthful Satyr
Christ Church

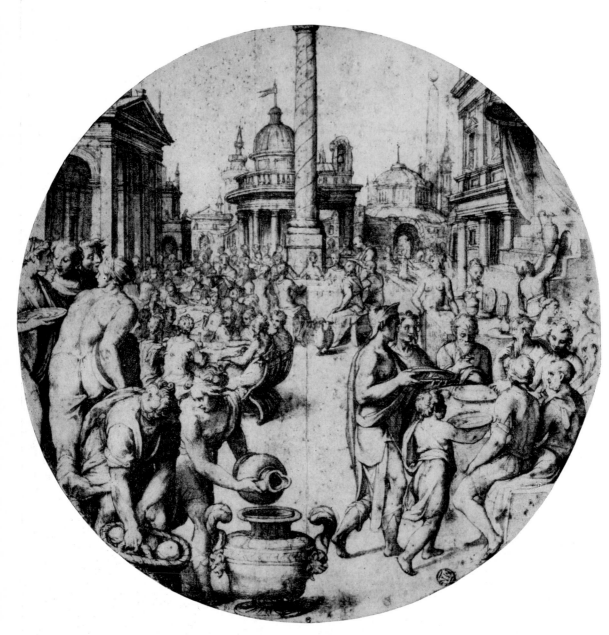

120 (cat. 185). A Banquet in a Piazza
Louvre

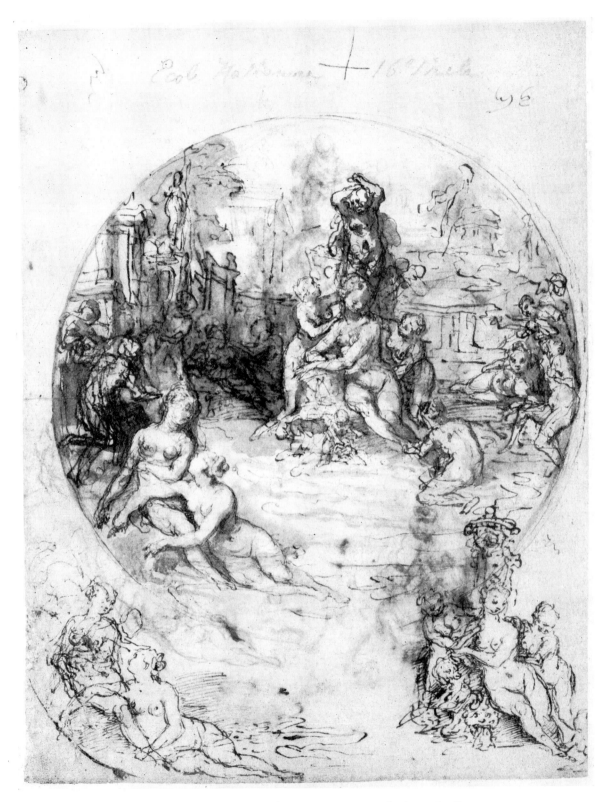

121 (cat. 141 *recto*). Studies for a composition of *The Bath of Diana*
Metropolitan Museum

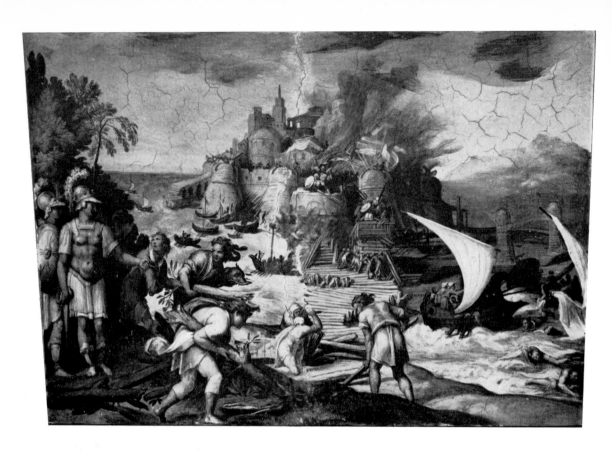

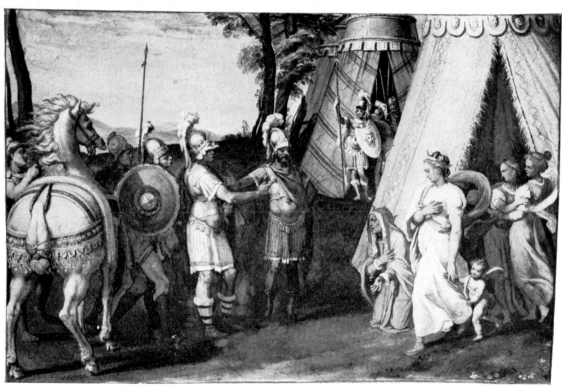

122a. Alexander directing the Siege of Tyre(?)
122b. Alexander and the Family of Darius
Frescoes: Bracciano, Castello Odescalchi

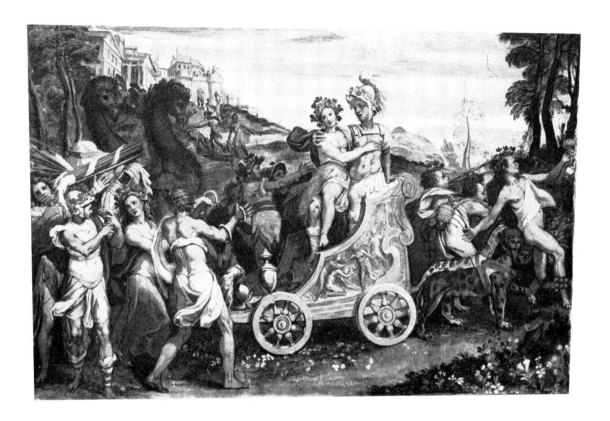

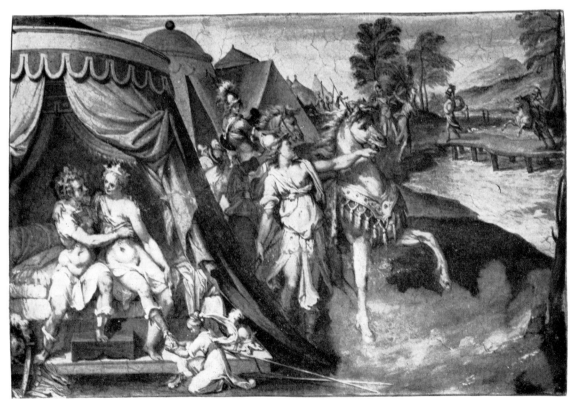

123a. Triumph of Alexander and Thais
123b. Alexander in his Tent with Roxana
Frescoes: Bracciano, Castello Odescalchi

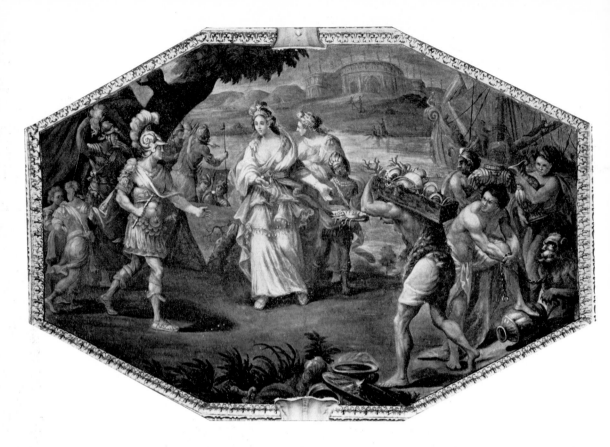

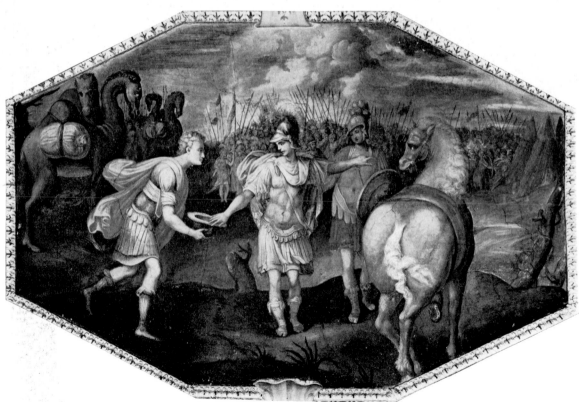

124a. Alexander and the Family of Darius
124b. Alexander refusing the Water offered him by the Macedonians
Frescoes: Rome, Palazzo Caetani

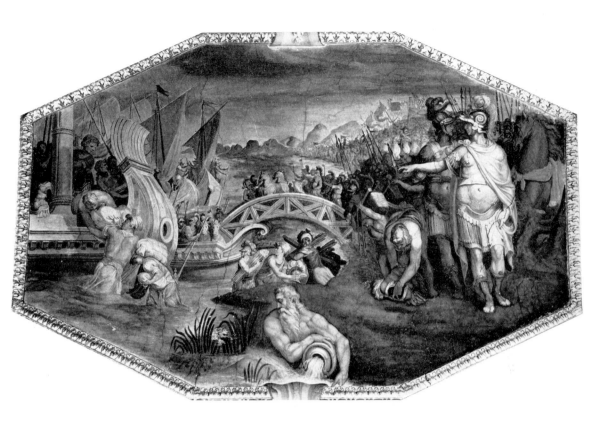

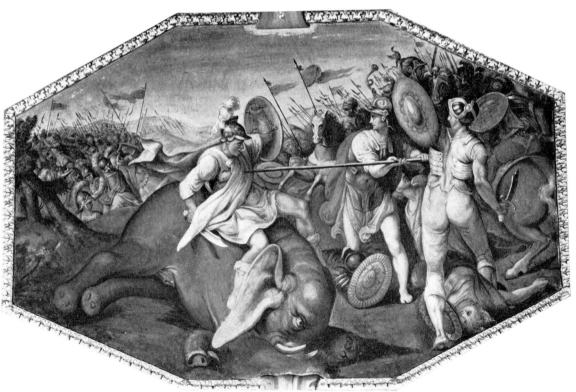

125a. Alexander and his Army crossing the River Hydaspes
125b. Alexander defeating Porus
Frescoes: Rome, Palazzo Caetani

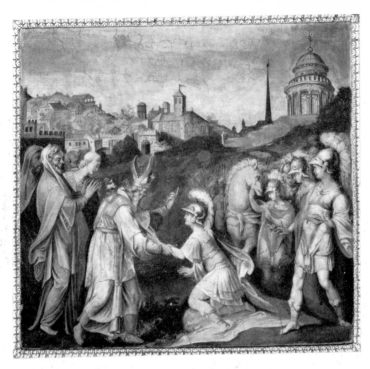

126a. Alexander and the Priest of Ammon

Fresco: Rome, Palazzo Caetani

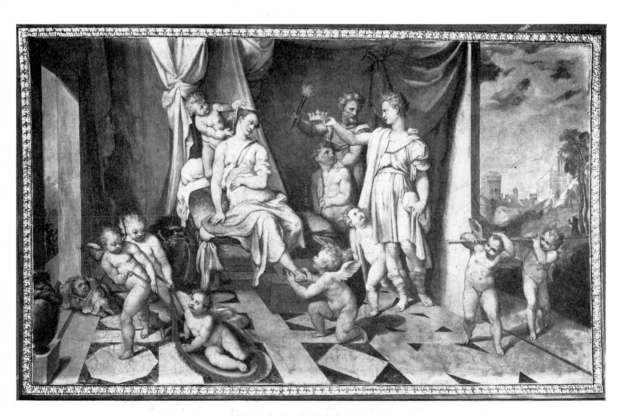

126b. The Marriage of Alexander and Roxana

Fresco: Rome, Palazzo Caetani

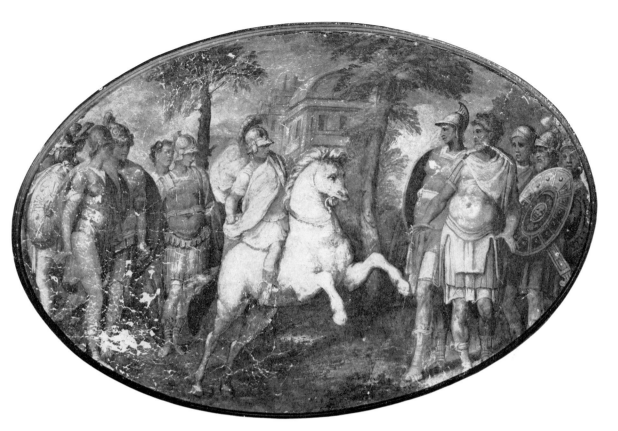

127a Alexander and Bucephalus
Fresco: Rome, Palazzo Caetani

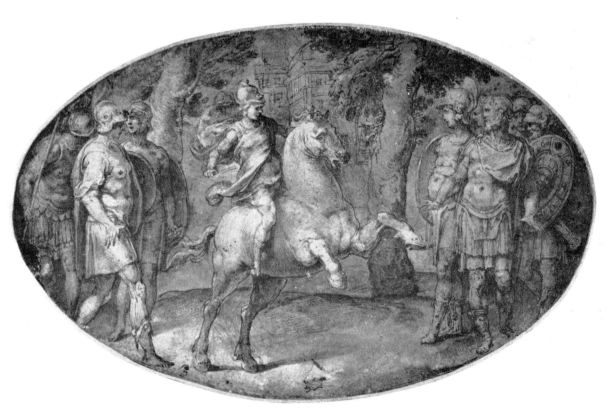

127b. (under cat. 254). Alexander and Bucephalus
Colonel Joseph Weld

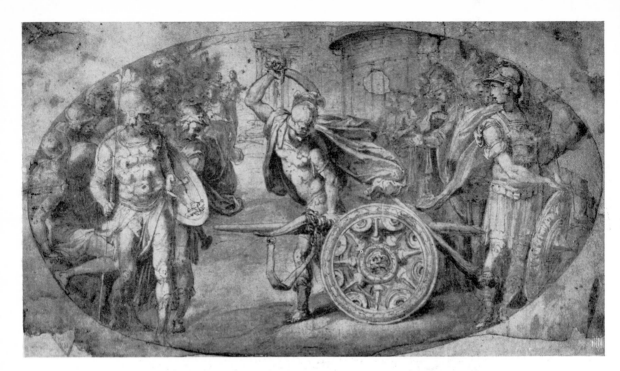

128a (cat. 136). Alexander cutting the Gordian Knot
Herr Herbert List

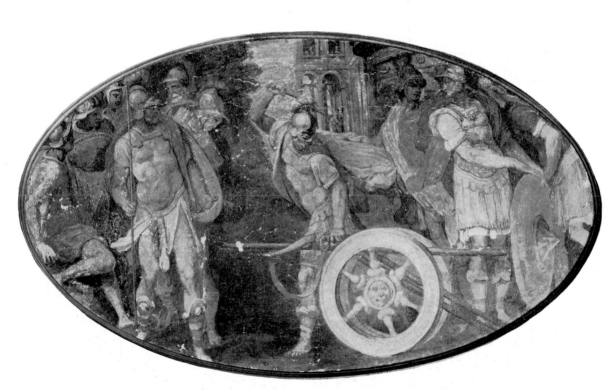

128b. Alexander cutting the Gordian Knot
Fresco: Rome, Palazzo Caetani

129a. Alexander and Diogenes
Fresco: Rome, Palazzo Caetani

129b. Alexander and Timoclea
Fresco: Rome, Palazzo Caetani

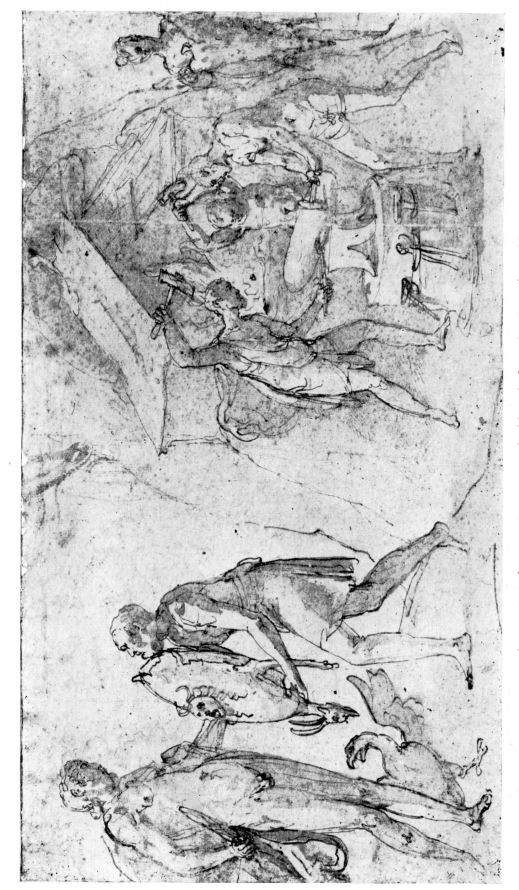

130 (cat. 191). Vulcan giving Jupiter a Shield made from the Skin of Amalthea

Louvre

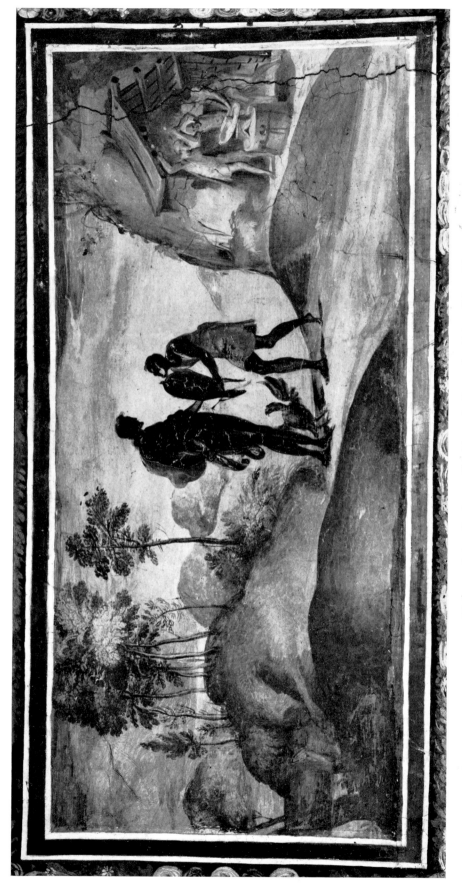

131. Vulcan giving Jupiter a Shield made from the Skin of Amalthea
Fresco: Caprarola, Palazzo Farnese

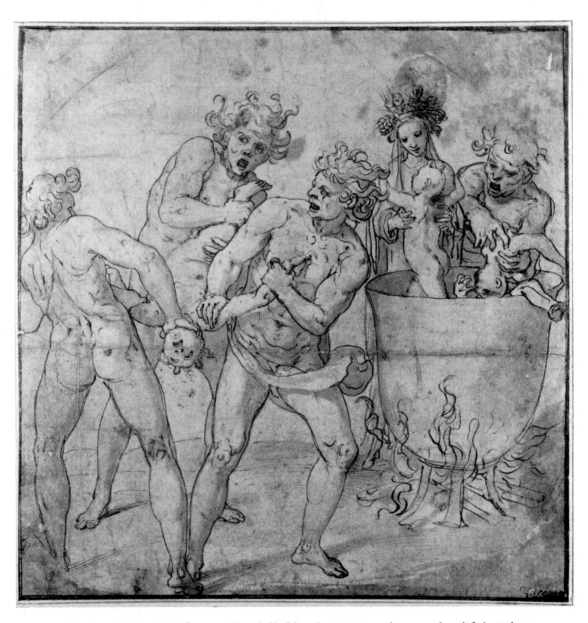

132 (cat. 116). The Infant Bacchus killed by the Titans and restored to life by Rhea
Lord Brooke

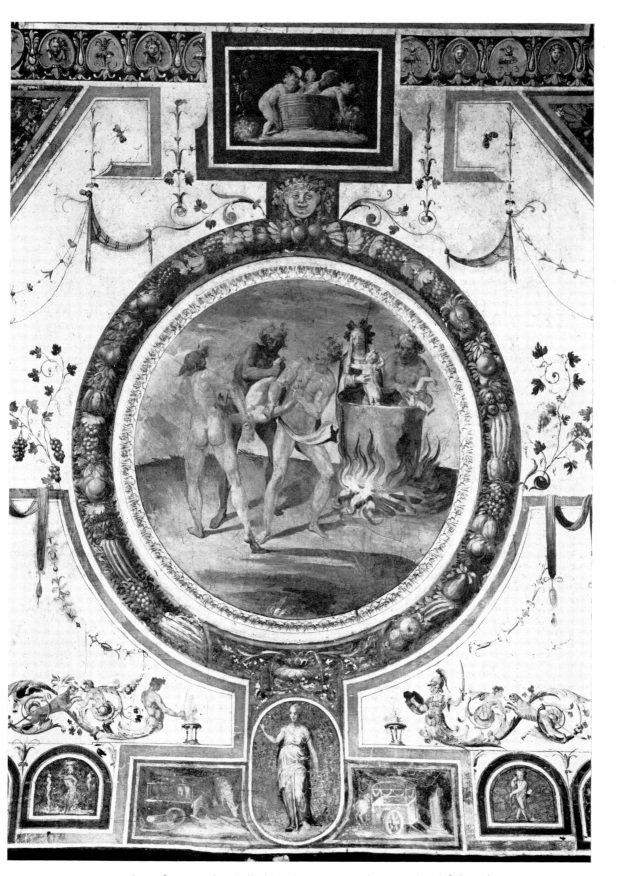

133. The Infant Bacchus killed by the Titans and restored to life by Rhea

Fresco: Caprarola, Palazzo Farnese

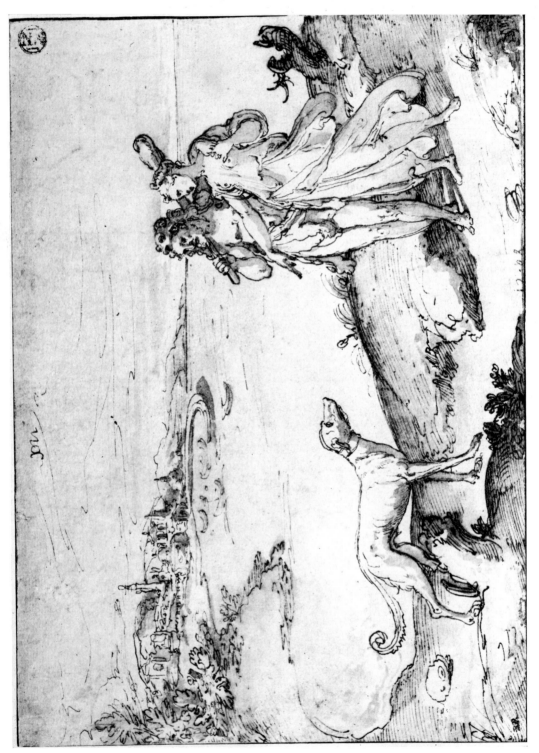

134 (cat. 192). Hercules and Iole finding the Murex

Louvre

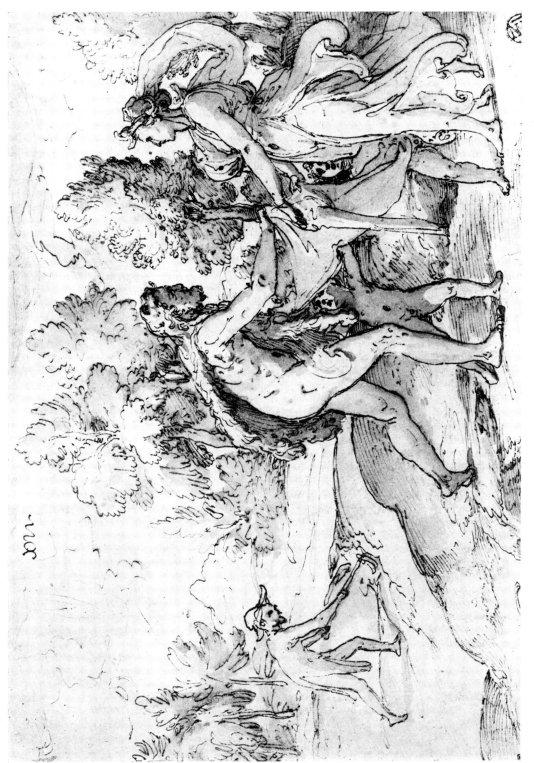

135 (cat. 193). Hercules giving Iole a Garment dyed with Murex

Louvre

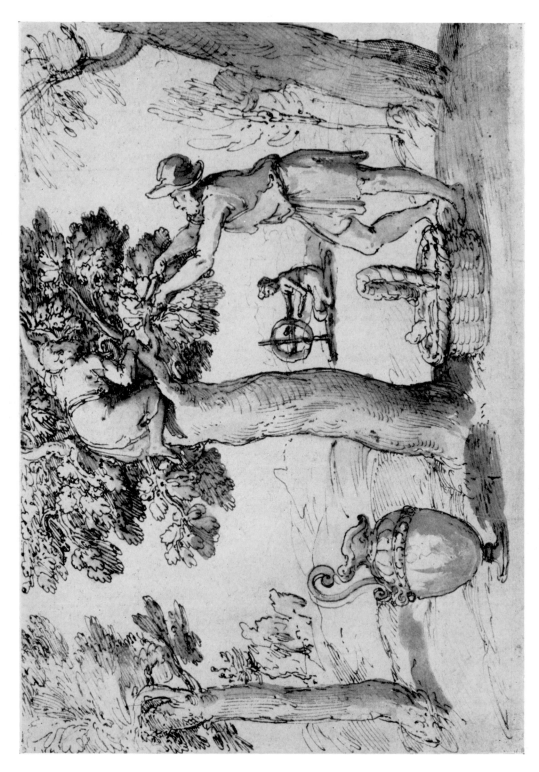

136 (under cat. 240). The Cultivation of Silkworms

Mrs. Alfred Scharf

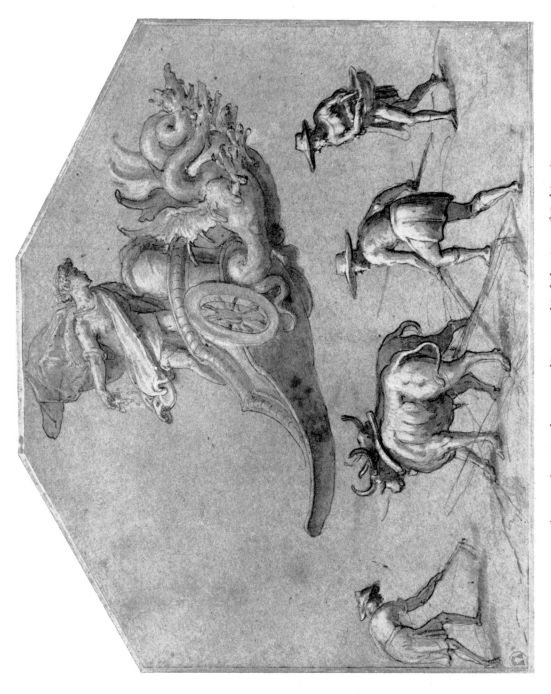

137 (cat. 163). Triptolemus teaching Mankind the Arts of Cultivation

Christ Church

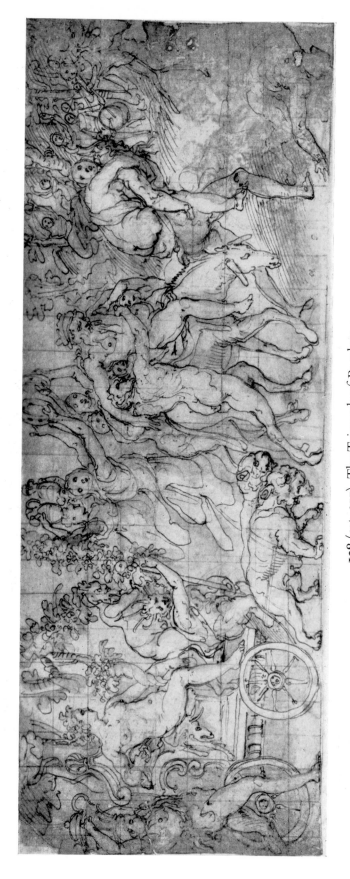

138 (cat. 217). The Triumph of Bacchus
Philip H. and A. S. W. Rosenbach Foundation, Philadelphia

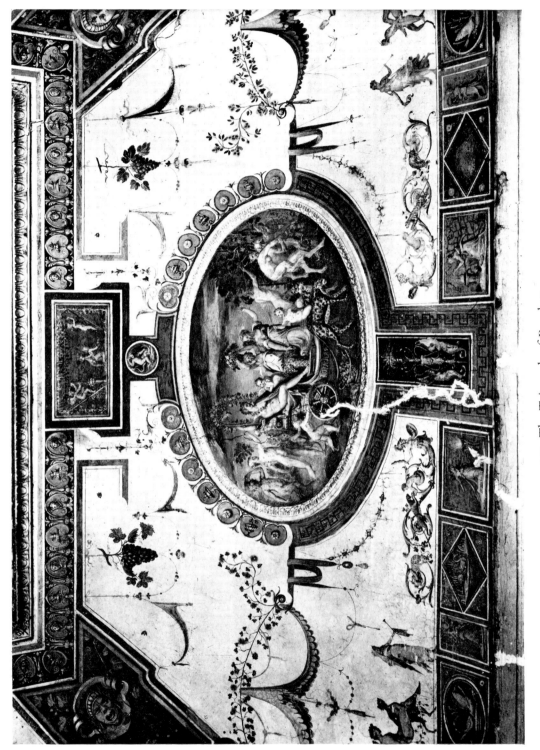

139. The Triumph of Bacchus
Fresco: Caprarola, Palazzo Farnese

140 (cat. 194). The House of Sleep
Louvre

141. The House of Sleep
Fresco: Caprarola, Palazzo Farnese

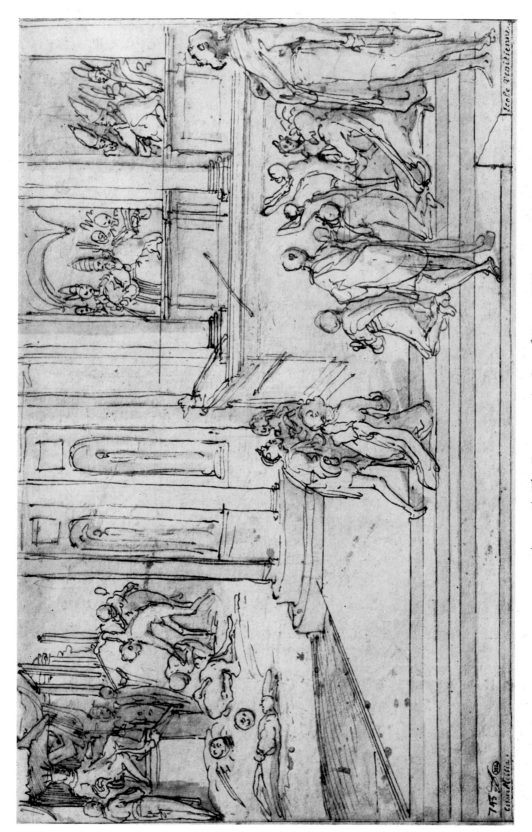

142 (cat. 198). The Excommunication of Henry VIII

Louvre

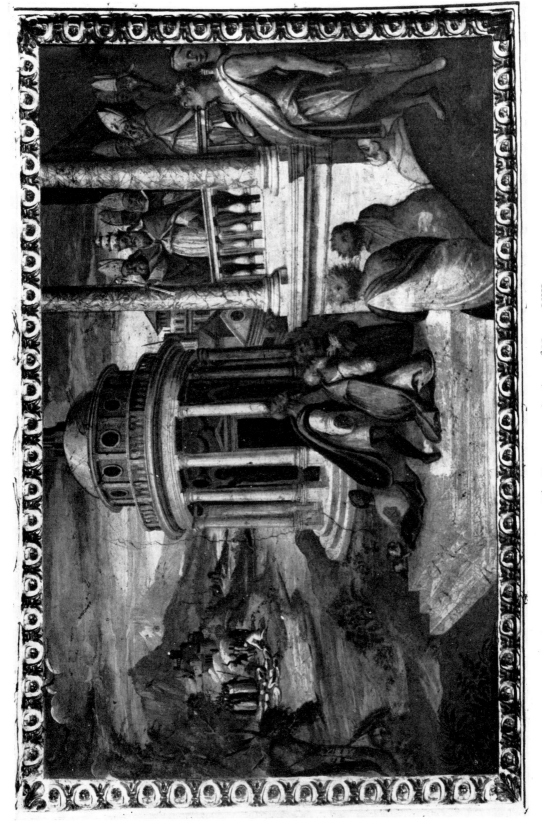

143. The Excommunication of Henry VIII
Fresco: Caprarola, Palazzo Farnese

144 (cat. 210). A Pope presenting a Standard to a kneeling Man
Academy Collection, Philadelphia Museum of Art

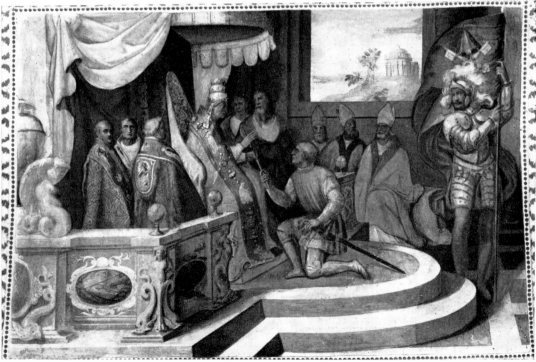

145a. Paul III creating Pierluigi Farnese Captain-General of the Church
145b. Eugenius IV creating Ranuccio Farnese Captain-General of the Church
Frescoes: Caprarola, Palazzo Farnese

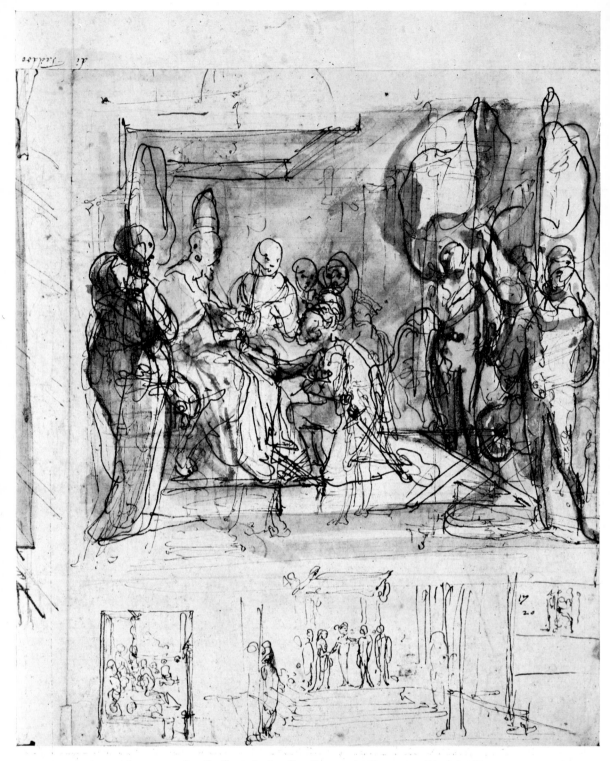

146 (cat. 148, detail of *verso*). Studies for *Paul III creating Pierluigi Farnese Captain-General of the Church* and *The Marriage of Orazio Farnese and Diane de Valois*
Mr. Janos Scholz

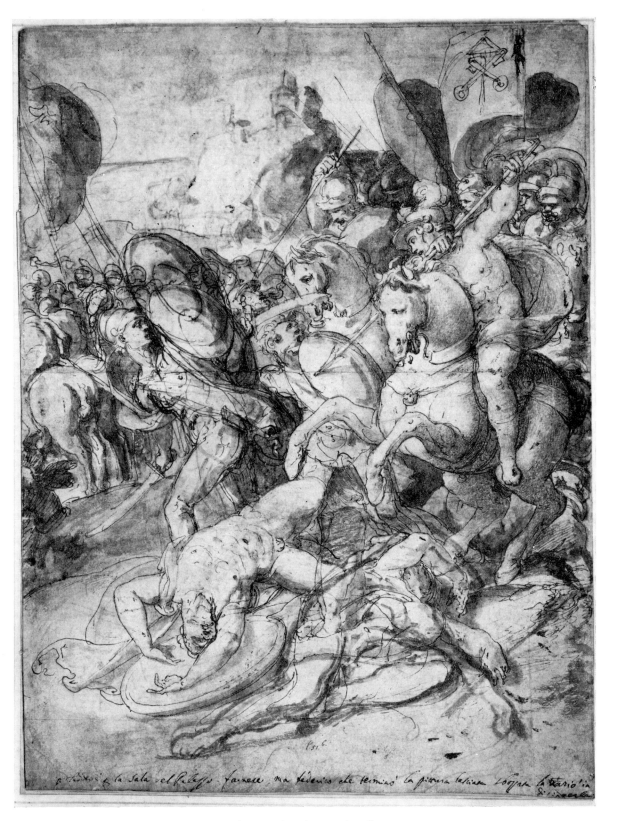

147 (cat. 215). The Battle of Cosa

Philip H. and A. S. W. Rosenbach Foundation, Philadelphia

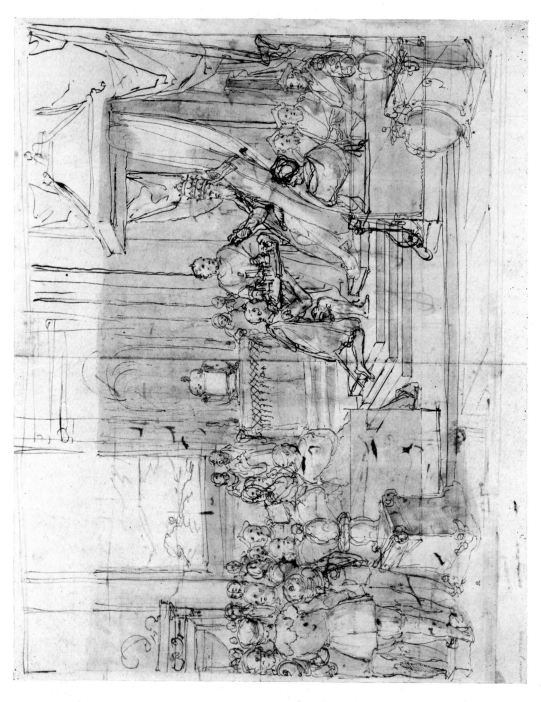

148 (cat. 149 *recto*). Julius III restoring the Duchy of Parma to Ottavio Farnese

Mr. Janos Scholz

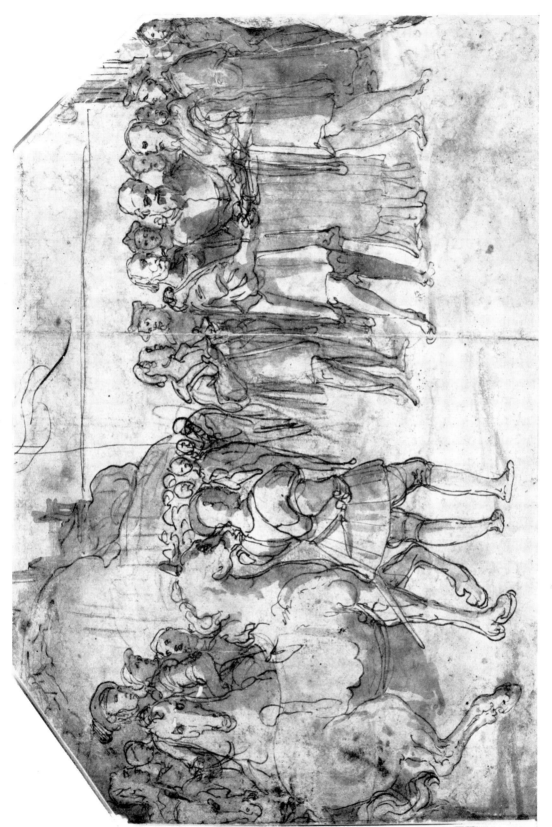

149 (cat. 229 *recto*). The Armistice between Charles V and Francis I at Nice
Stockholm

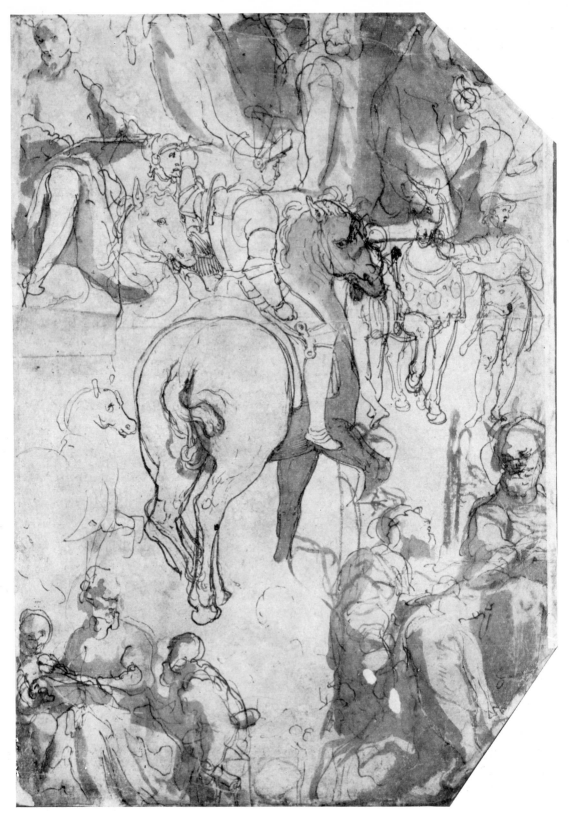

150 (cat. 229 *verso*). Studies of a Horseman in Armour and for *The Donation of Charlemagne*
Stockholm

151 (cat. 6 *recto*). Charlemagne and his Secretary
Berlin

152 (cat. 33). The Donation of Charlemagne
Edinburgh

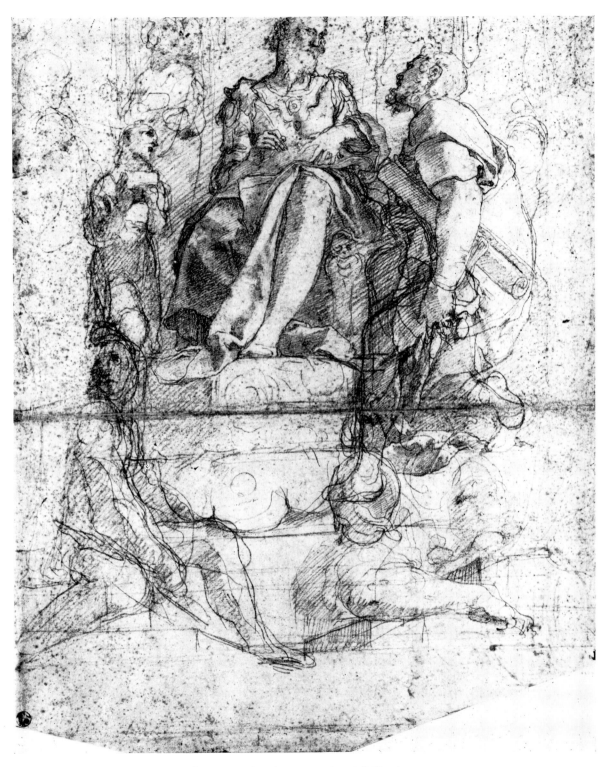

153 (cat. 5 *recto*). The Donation of Charlemagne
Berlin

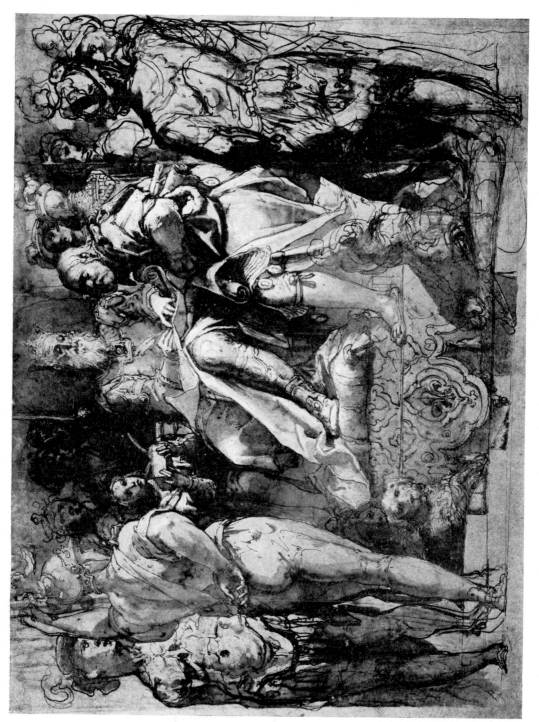

154 (cat. 104). The Donation of Charlemagne
British Museum

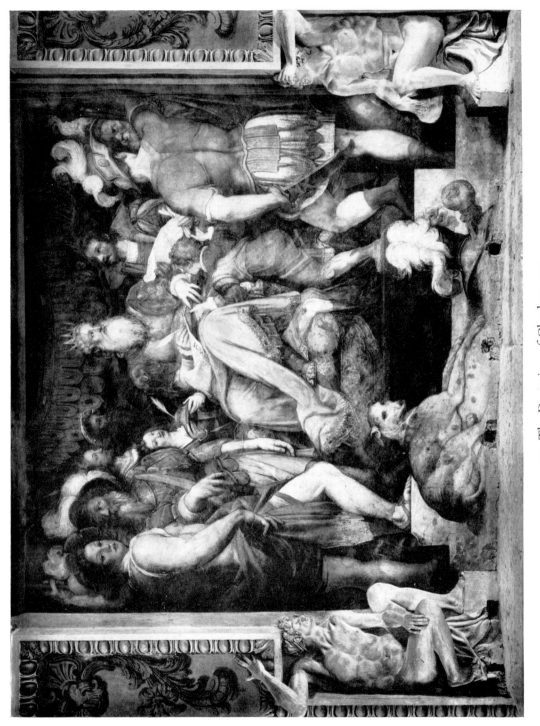

155. The Donation of Charlemagne

Fresco: Rome, Vatican, Sala Regia

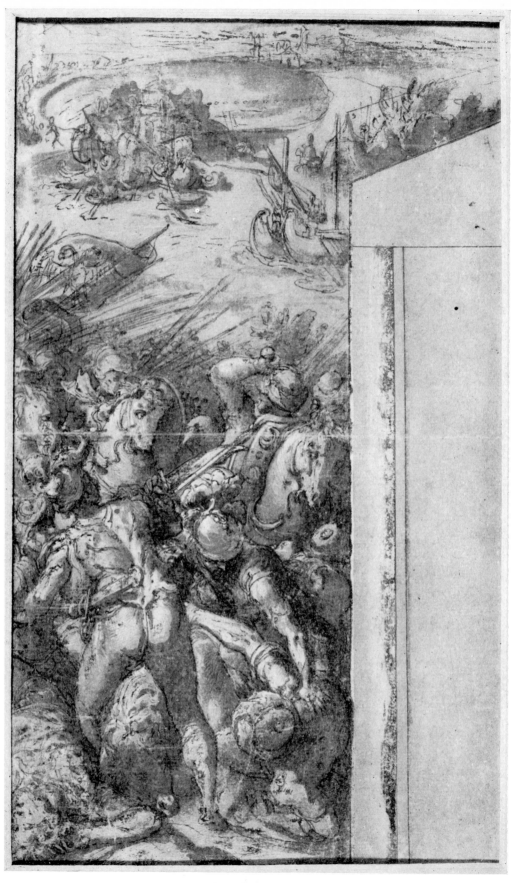

156 (cat. 166). The Siege of Tunis
Christ Church

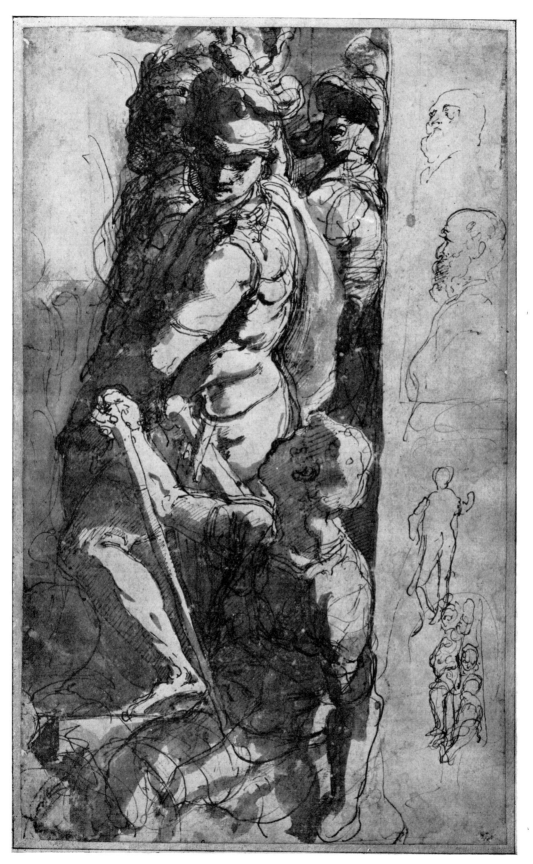

157 (cat. 97). A Group of Soldiers
British Museum

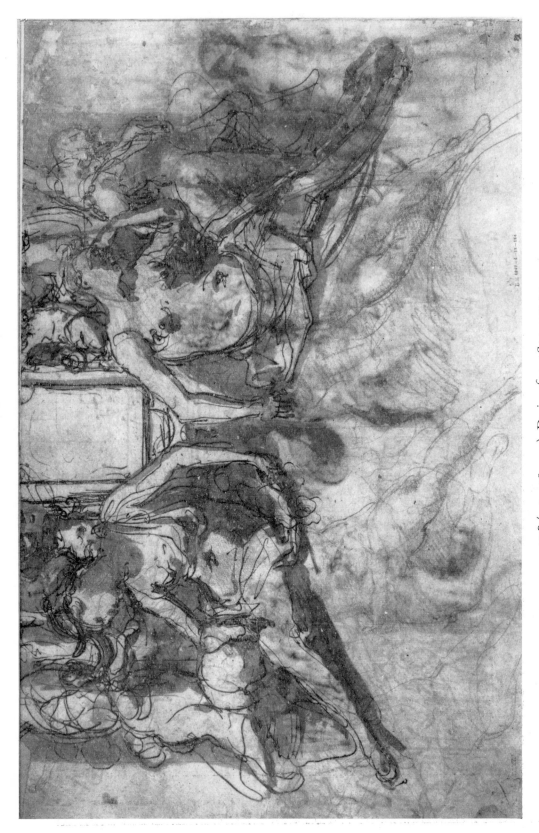

158 (cat. 108 *verso*). Design for a *Soprapporta*

British Museum

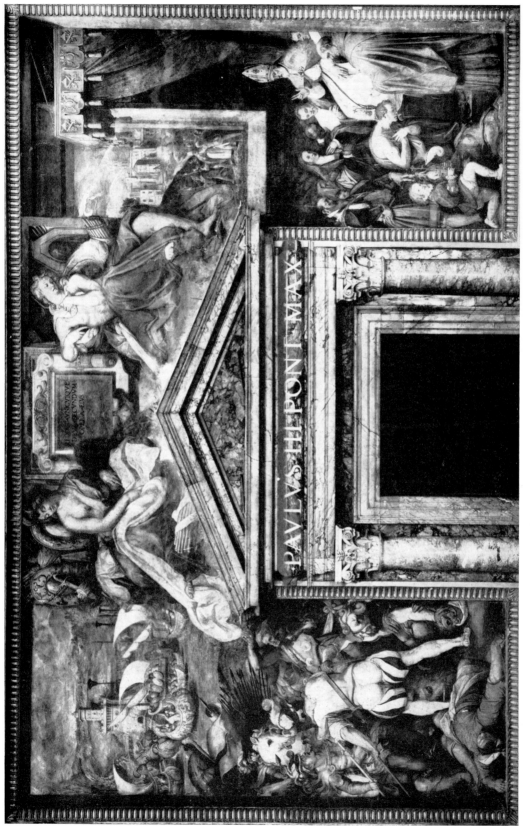

159. The Siege of Tunis; *Soprapporta* with two allegorical female Figures;
Henry IV submitting to Gregory VII
Fresco: Rome, Vatican, Sala Regia

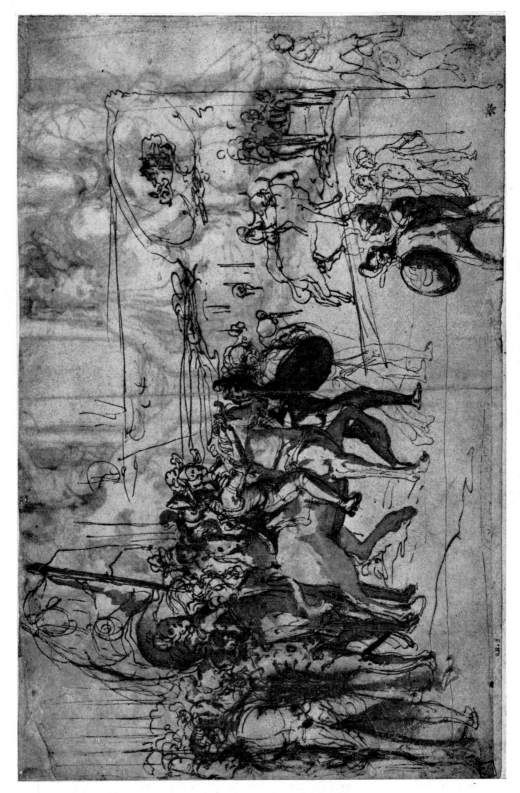

160 (cat. 108 *recto*). The Foundation of Orbetello

British Museum

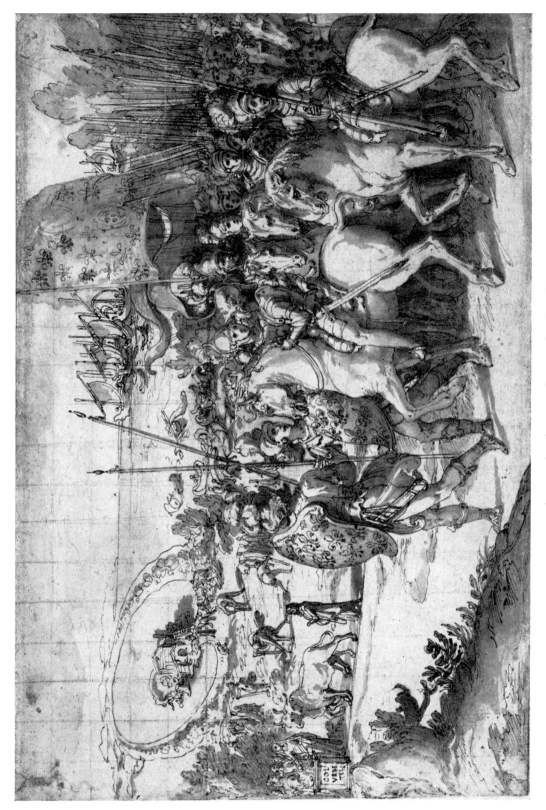

161 (cat. 150). The Foundation of Orbetello
Mr. Janos Scholz

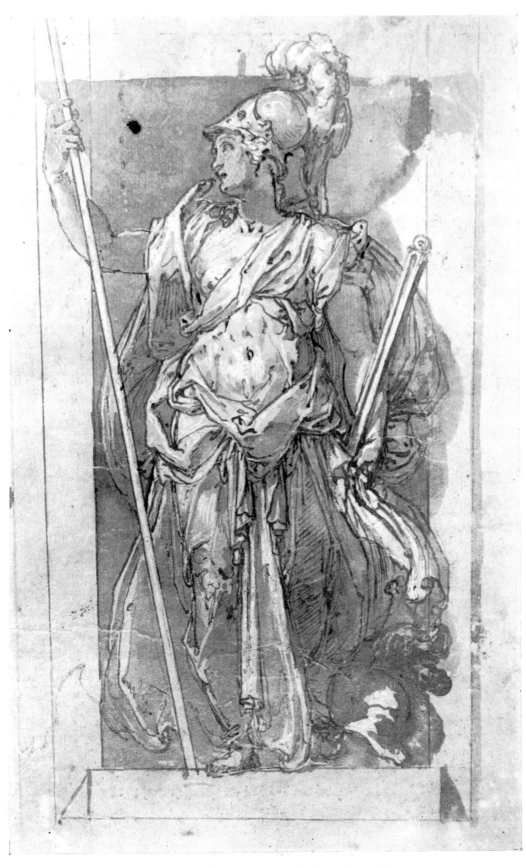

162 (cat. 94). Allegorical female figure in a Niche
Hermitage

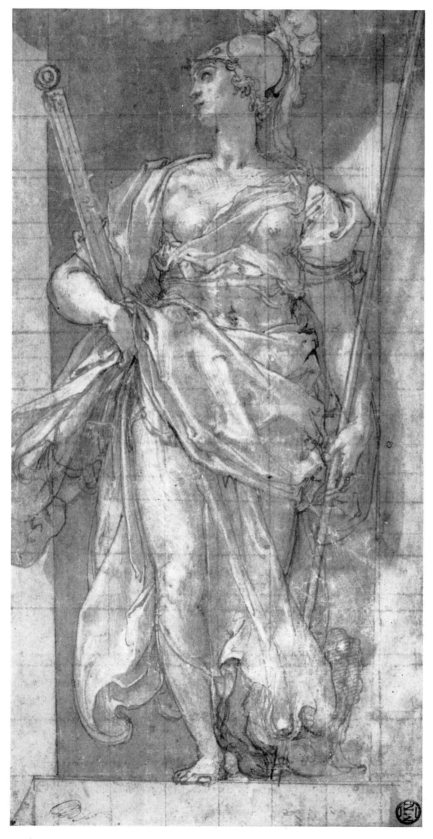

163 (cat. 177). Allegorical female figure in a Niche
Louvre

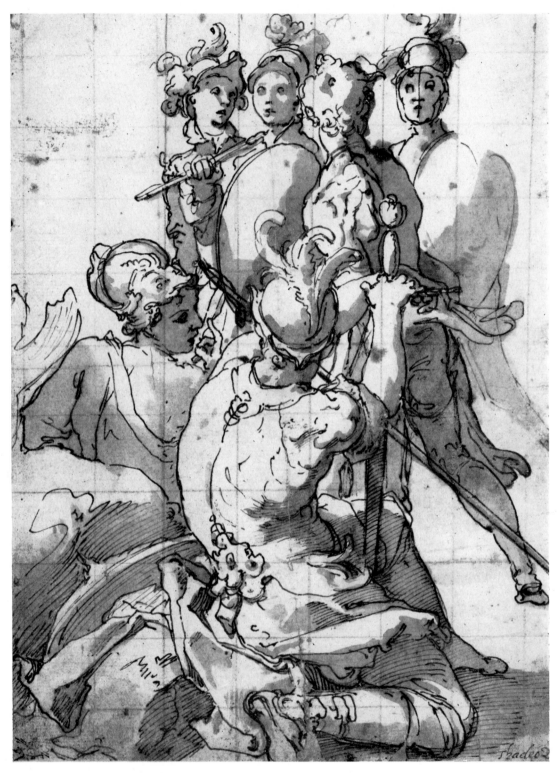

164 (cat. 151). Figures in *The Foundation of Orbetello*
Mr. Janos Scholz

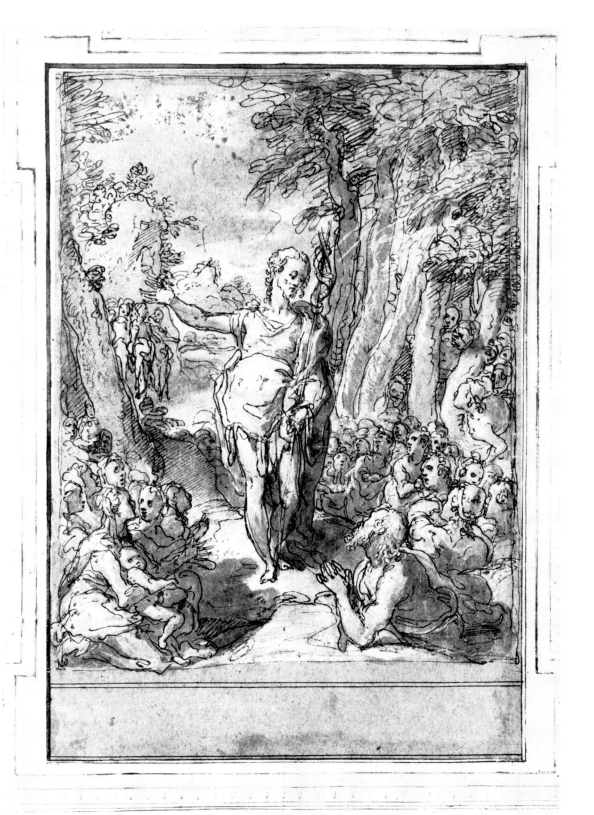

TADDEO ZVCHERO
DA S. AGNOLO.
PITTORE.

165 (cat. 152 *recto*). St John the Baptist preaching
Mr. Janos Scholz

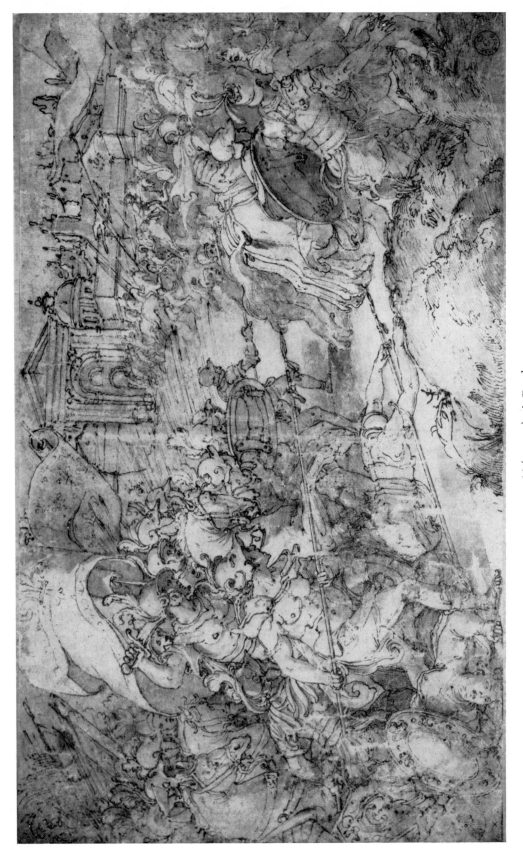

166 (cat. 39). A Battle
Uffizi

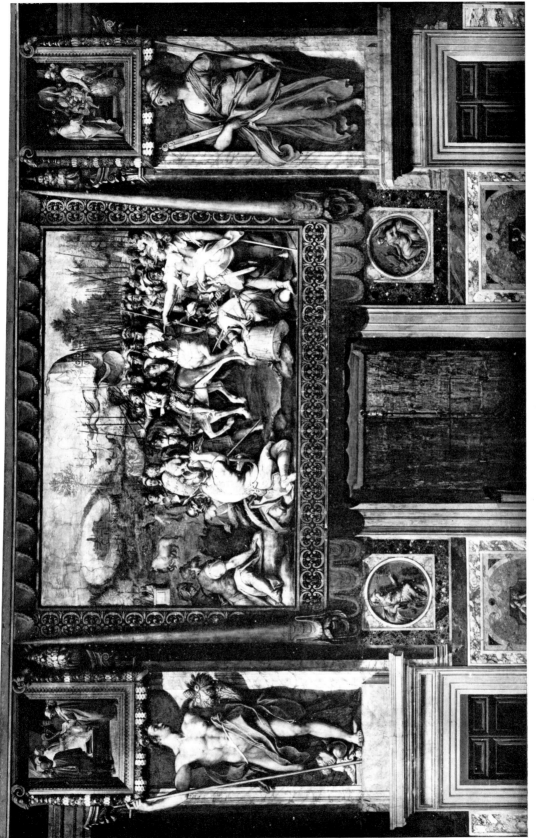

167. The Foundation of Orbetello, flanked by male and female allegorical figures and two scenes from the early history of the Farnese Family

Fresco: Rome, Palazzo Farnese

168 (cat. 205). Studies of a Woman drying herself

Louvre

169 (cat. 80). Studies of three Angels
Uffizi

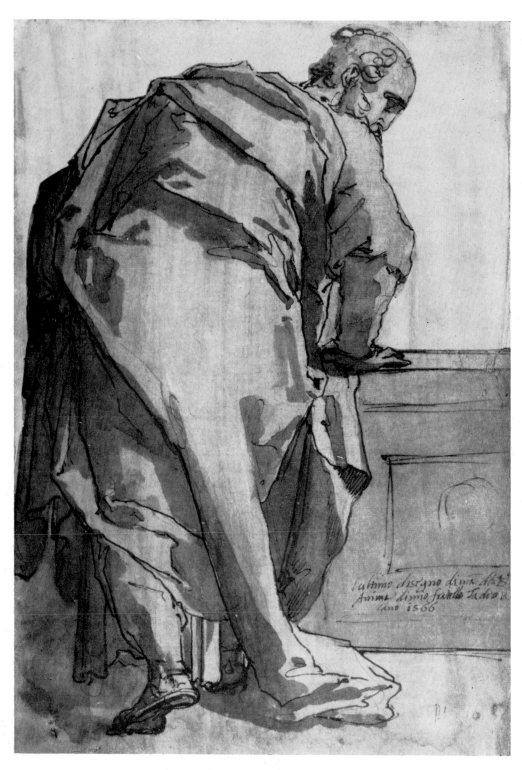

170 (cat. 157). An Apostle in an *Assumption*
Ashmolean Museum

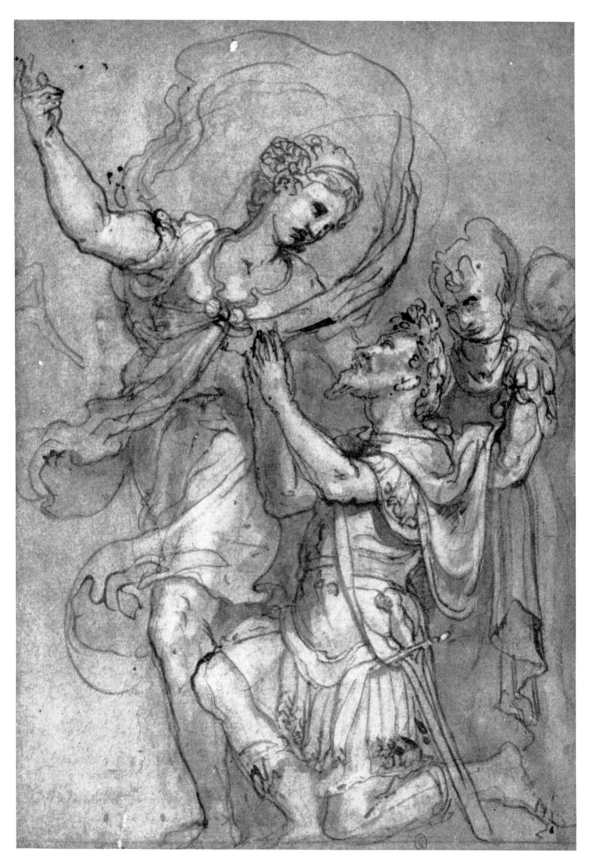

171 (cat. 190). Augustus and the Sibyl
Louvre

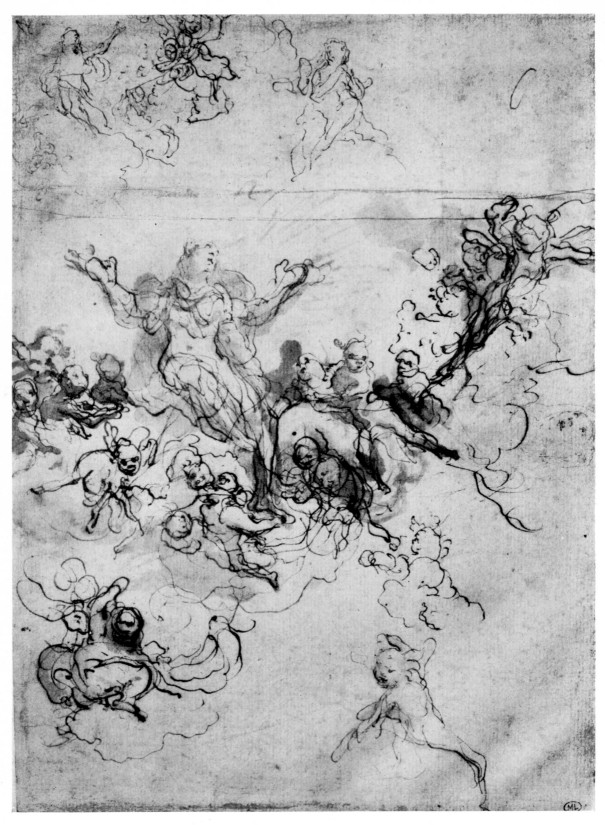

172 (cat. 209). The Virgin with Angels in an *Assumption*
Louvre

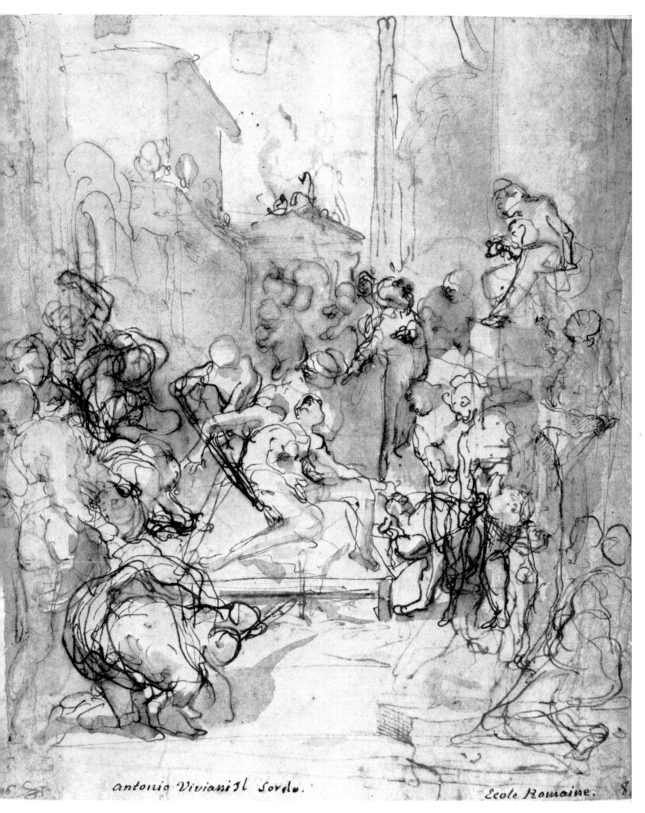

antonio Viviani Il Sordo. Ecole Romaine.

173 (cat. 158 *recto*). The Martyrdom of St Lawrence
Ashmolean Museum

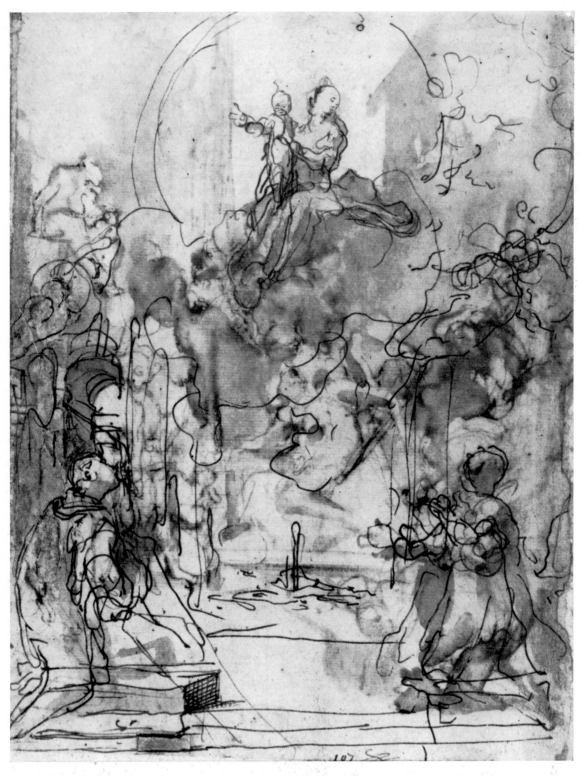

174 (cat. 158 *verso*). The Virgin and Child adored by St Lawrence and St Damasus
Ashmolean Museum

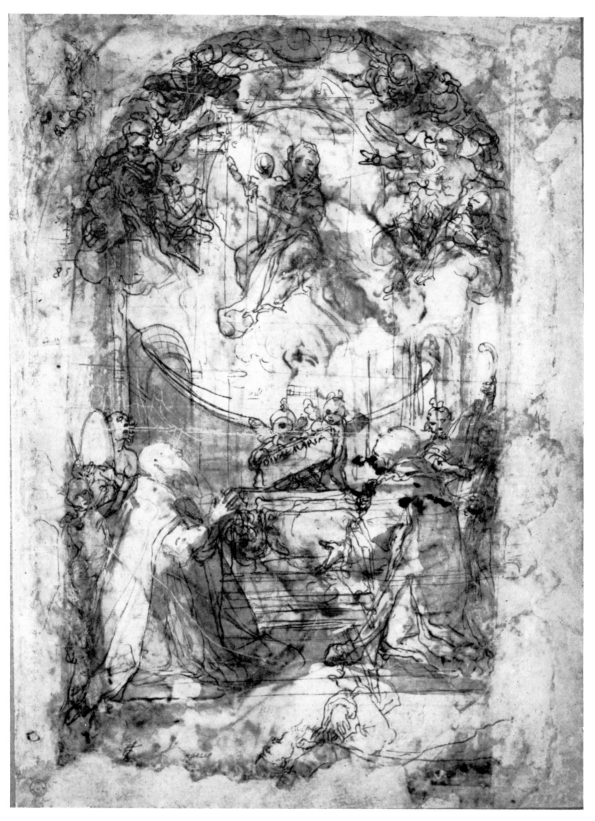

175 (cat. *52 recto*). The Virgin and Child adored by St Lawrence and St Damasus
Uffizi

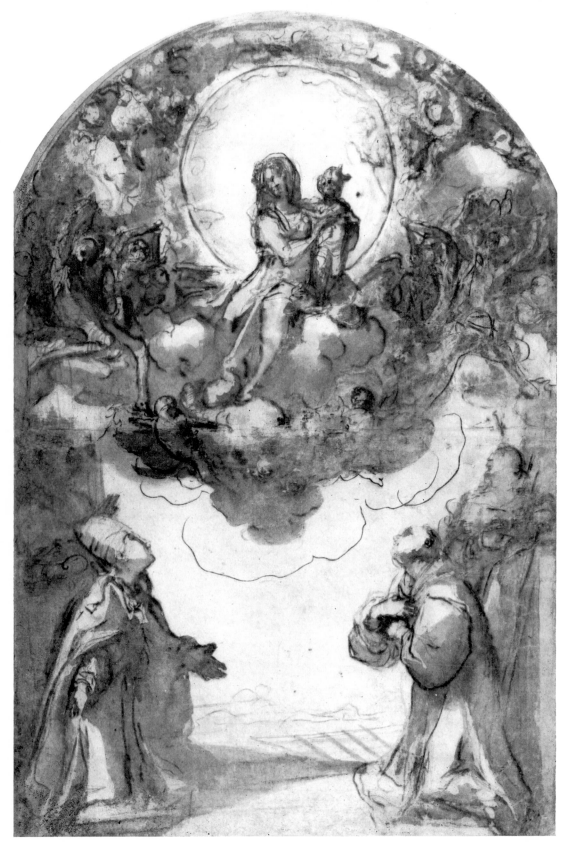

176 (cat. 159). The Virgin and Child adored by St Damasus and St Lawrence
with St Peter and St Paul

Ashmolean Museum